Avant-Garde Art

1914-1939

Avant-Garde Art
1914-1939

by Jean-Luc Daval

Grateful acknowledgment is made to the publishers of the following
books for permission to quote from them: R. G. Collingwood,
The Principles of Art, Clarendon Press, Oxford, 1938; Naum Gabo,
"The Constructive Idea in Art" and "Sculpture: Carving and
Construction in Space" in *Circle, International Survey of Constructive
Art*, Faber and Faber Ltd, London, 1937; Naum Gabo, *Gabo:
Constructions, Sculpture, Paintings, Drawings and Engravings*,
Harvard University Press, Cambridge, Massachusetts, and Lund
Humphries, London, 1957; Walter Gropius, *Scope of Total Architec-
ture*, George Allen & Unwin Ltd, London, 1956, and Collier Books,
New York, 1962; Man Ray, *Self-Portrait*, Little, Brown and Company
in association with The Atlantic Monthly Press, Boston, and André
Deutsch, London, 1963; Laszlo Moholy-Nagy, *Abstract of an Artist*,
George Wittenborn, Inc., New York, 1947; Hans Richter, *Dada:
Art and Anti-Art*, McGraw-Hill Book Company, New York, and
Thames and Hudson Ltd, London, 1965.

© 1980 by Editions d'Art Albert Skira S.A., Geneva

First published in Great Britain in 1981 by
MACMILLAN LONDON LTD
London and Basingstoke
Associated companies in Delhi, Dublin,
Hong Kong, Johannesburg, Lagos, Melbourne,
New York, Singapore & Tokyo

ISBN 0 333 31473 5

Printed and bound in Switzerland

Contents

The art of the future, freed from the narrow field of pure aesthetics, will extend its range of action and become an integral part of science and life, organically connected with them. Such a conclusion, though still hypothetical, is suggested by the law of dialectical development. If one takes the form of ''pure'' art as the thesis, its antithesis will be the present state of all fields of scientific, practical and industrial activity foreign to art. The synthesis will be the organic fusion of life and art...
Nikolai Tarabukin, ''From the Easel to the Machine,'' Moscow, 1923.

A certain period of oblivion is needed for the recent past to enter into history and permit us to see it in perspective. This is particularly true of the period between the two World Wars. And now that we have emerged from it, now that we can see it in historical perspective, we find it very much alive: its styles and fashions are being revived, and its objects are sought after on the art market. Its major creations above all, having become by now more classic than controversial, exert a fascination and raise questions.

In the field of history, the 1920s and '30s have been carefully studied and assessed. In the field of art, they have inspired a large number of exhibitions, confrontations and detailed investigations. We have come to realize how important those years were, all the more so in the light of present-day art trends. We see now how exciting, rich and inventive those years were; their creations touch us deeply both in what they achieved and what they failed to achieve. To study what was being done between 1914 and 1939 helps us to understand the role and function of art in our civilization, to see how vividly creative art may reflect the moods and mind of its time.

This period, rich and many-sided though it is, has often been thought of as a mere aftermath of the great achievements made in all fields of endeavour in the last decades of the nineteenth century and the first decade of the twentieth. This is the view taken in most of the monographs devoted to the artists dealt with here; these twenty-five years from 1914 to 1939 are often summed up in a few pages. Because this period has long been judged by the standards of the previous generation, its art has been seen as a reordering of the momentous renewal of language and space that occurred during the forty years separating the Impressionists from the first abstract artists. The example of present-day art helps us to reconsider the inter-war years with fresh eyes, and to see that art then changed not so much its form as its content, not so much its function as its usage.

Between 1914 and 1939 the media came into their own, the visual assumed a dominant position, the economic took precedence of the scientific, and the political won out over ideologies. Refusing more firmly than ever to lock themselves into an ivory tower, artists faced up to the realities of their time, acting directly on the problems of the present, using the materials the latter offered and modifying their techniques accordingly. For them, the making of art was not enough: they wished to know for what and for whom it was to be made. And they bridged the traditional gulf between artistic practices, explored the field of communications, revitalized the form-function concept, reconsidered the purpose of their activity. They took sides in the conflicts of their time and on occasion some of them were violently opposed to others. They tried out the possibilities of teamwork, not hesitating to question the value of their achievements. This period

saw the momentous advance not only of the media but of the commerce of art. Offer preceding demand, the artist found his whole work at stake, while speculators forged the concept of avant-garde art. The artists themselves did not seek novelty at any price. They wished to play their part in that total revolution of mankind which the Russian Revolution and/or the end of the First World War seemed to make possible and even necessary. For more than a decade they multiplied inventions and discoveries, until the economic crisis and the rise of the dictators eroded their freedom of expression, in some countries suppressing it altogether.

In order to convey the new awareness that present-day art gives us of this recent past, and to present it in a synthetic manner, the critic has, so to speak, to play the part of an orchestra conductor—to set in motion the voices and instruments of a score which is not of his making but whose rhythms and sounds he has done his best to master. In the result, this book takes the form of a vast collage or photomontage, two of the favourite media of this period, whose artists not only painted and carved, but thought much and wrote much. Their definitions are so lucid, their statements so telling, that we have quoted them whenever possible, as showing how clear-sighted these artists were in their vision of art and life. The author's role has chiefly consisted in the placing and ordering of the pictures and ideas, and in trying to evoke the context from which they sprang and to trace the consequences of their novelty. For the author shares the conception of time that Matisse described as follows in 1936: ''Our senses have an age of development which does not come from the immediate surroundings, but from a moment of civilization... The arts have a development which comes not only from the individual, but also from an accumulated strength, the civilization which precedes us. One cannot do just anything. A gifted artist cannot do just as he likes. If he used only his own gifts, he would get nowhere. We are not the masters of our output. It is imposed upon us.''

Never were creative artists so numerous as in this period which, fascinated by the theories of Freud and Marx, meant to be and was resolutely modern; a period which, though haunted by a collective ideal, saw the triumph of the individual. A selection had to be made. We have chosen those artists whose work seems either most characteristic or most decisive. Painting predominates, but other media (sculpture, architecture, photography, design) are well represented. In recreating the atmosphere of this period in its boldness, breadth and diversity, we have tried to bring out what connects or divides the works and the men who made them, what brought forth those works and what they open up. Without presuming to comment exhaustively on them or take their full measure, we have tried to retrace the steps that led to them and reinsert them in the life of their time.

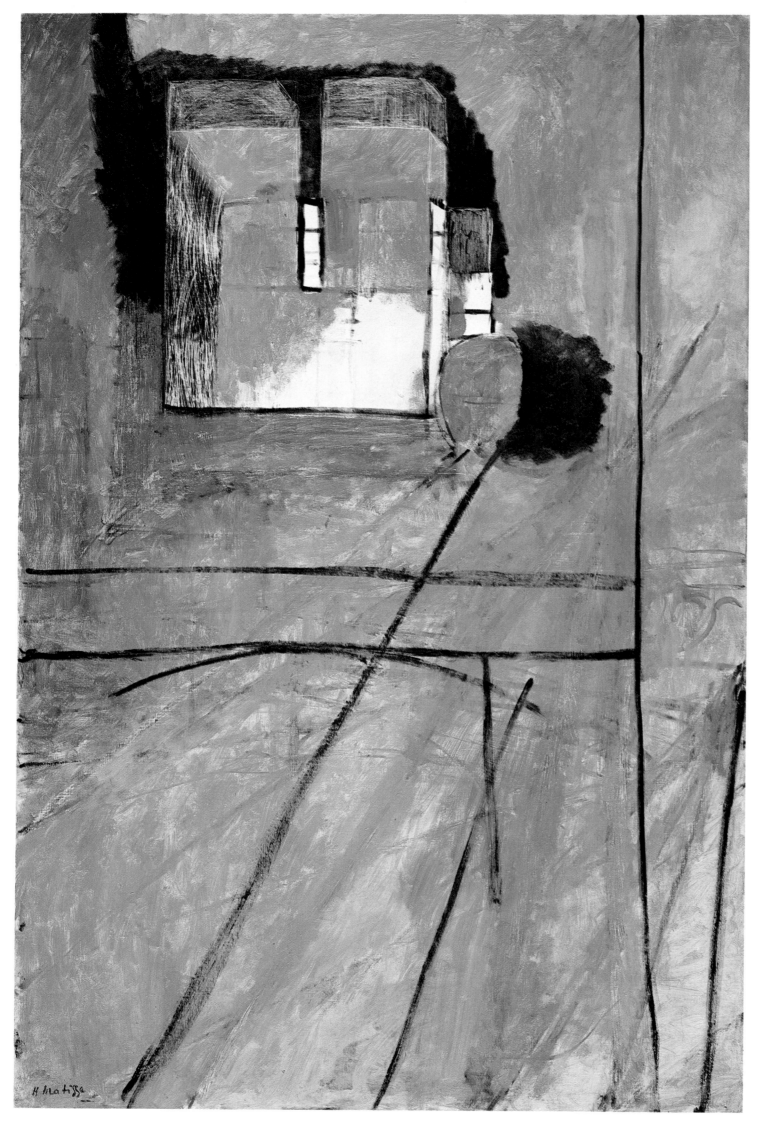

Henri Matisse (1869-1954):
*View of Notre-Dame,
Paris, 1914. Oil.*

8

The Crisis of Representation

1914-1918

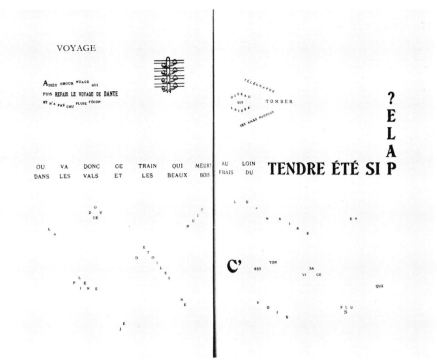

Guillaume Apollinaire (1880-1918): *Voyage, poem from "Calligrammes," 1914.*

THE WAR exploded the idea of progress inseparable from a situation of peace. The conquests of science and technology had been so momentous that men thought they were free now from the calamities and setbacks of the past. For several decades those conquests had ensured a security and prosperity whose continuance was taken for granted. Economics had acquired a prestige and power which gave it almost a religious status. Then came the war and its ravages, and with them a critical stance which necessarily gave rise to a different analysis and different conclusions. The established order had crumbled, industrial civilization had failed.

Change was in the air in 1914, and art too was bound to change. Without realizing it, the leading artists had reached heights which could only be surpassed by a fundamental reappraisal of the problematics of art. For thirty years they had focused their attention on the expressive possibilities of the constituent elements of their medium— line, form, colour, space. First Cubism then abstraction had made a complete break with nature imitation. Freed from all extraneous concerns, intent only on making the most of that freedom, these artists saw the picture as an object in its own right, functioning according to the laws of its own structure. But in the end the picture might seem merely decorative, once the impetus of discovery, which gave it its expressive power, had exhausted the possibilities of experimental reconstruction. The boldest artists had just about reached this point when the war broke up the groups and movements and scattered the artists. Many of them returned to their home country or became exiles; many were called up. The grim realities of the war, both on the front and behind the lines, forced them to reconsider their art, forced them to realize how remote it was from the realities of life.

Some, of course, fell back on their inner resources. Klee, profoundly affected by the death of his friend August Macke, killed in action at the start of the war, wrote in his *Diary* early in 1915: "The more horrible the world becomes (as at this moment), the more abstract does art become; whereas a world at peace produces realistic art." Matisse and Picasso, on the contrary, were already turning against a trend which D.H. Kahnweiler was soon to describe in the following terms: "The historiographical function which painting had exercised in a narrative manner before Masaccio, and in a dramatic manner after him, has now ceased to exist" (Kahnweiler, *La montée du cubisme*, 1920).

Matisse,
the conflict between two realities

MATISSE SPEAKS

I explain a black drawing to the open window
I explain the birds the trees the seasons
I explain the mute happiness of green plants
I explain the inhabited silence of houses

I explain shadow and transparency ever so much
I explain the feel of women their radiance
I explain a firmament of objects through difference
I explain the relation of things as it is

I explain the fragrance of transitory forms
I explain what makes the white paper sing
I explain what makes a leaf so light
And the branches which are slower-moving arms

I pay to light a tribute of justice
Motionless amidst the evil days of this age
I paint the hope in eyes so that Henri Matisse
May tell the future what man expects of it

Aragon, in *Les Lettres françaises*, 1947.

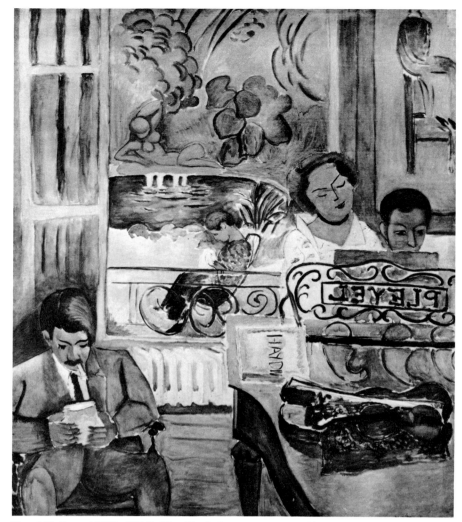

Henri Matisse (1869-1954): The Music Lesson, summer 1917. Oil.

Matisse was gloomy and restless. His mother had remained at Saint-Quentin behind the German lines, and his brother was held by the Germans as a hostage. As a patriotic Frenchman, he went with Marquet to consult his old friend Marcel Sembat, now a cabinet minister: "Derain, Braque, Camoin and Puy are risking their lives at the front. We are reluctant to remain behind... How can we best serve the country?" To which the minister replied: "By continuing to paint as well as you can." (Incident related by Raymond Escholier, *Matisse ce vivant*, 1956.) In 1914 Matisse had had a successful exhibition in Berlin; now his pictures there had been confiscated as enemy property. For him the years to come were to be among his most productive. His painting was attuned to a graver note. Never had he gone so far in expression with such economy of means and effects; but at the same time he felt the need to reinvent reality. His most important pictures, *View of Notre-Dame* and the *Music Lesson*, were done in two versions, one abstract, one figurative. Monet had laid it down that "black is not a colour." Matisse set out in his quest for colour-form to prove the contrary. Black and grey had hitherto been used only for the purpose of giving the illusion of volume by means of shading. Matisse ordered them in terms of a geometric pattern of large flat areas, charging them with an emotion which transformed them into spaces of light. This strict and abstract patterning may have owed something to Juan Gris, with whom he became friendly in 1914 at Collioure. But for Matisse the order created by geometry was not an end in itself, it was only a means of achieving pure expression, of imparting to colour a maximum intensity by the form imposed upon it. The added strain of the war years forced him to question his grasp

of both art and reality, pressing one as far as he could carry it and reconsidering the other. The evidence we have is so contradictory that it is now impossible to say whether the *Music Lesson* followed or preceded the *Piano Lesson*, but these two works on the same theme give a clue to the divided counsel to which Matisse was a prey. It was not simply a matter of elaborating on a figurative sketch, of working it out more fully. It was in fact a conflict between two realities, that of the artistic language and culture embodied in the *Piano Lesson* and that of the sensuality glowing through the *Music Lesson*. The first canvas ends the pictorial adventure begun with *Le Luxe* (1907), the second introduces that sense of release which marked his move to Nice in the winter of 1917 and his meeting with Renoir. That release, that easing of tension, was characterized by a return to more traditional expression; it had simply become impossible to go any further in the other direction. The *Piano Lesson* sums up and distils the essence of several of his pet themes; it marks the furthest limits to which the problematics of Fauvism could be carried.

And Marcelin Pleynet, in interpreting the virtuosity which he admires in another "abstract" canvas of 1916, *The Moroccans*, rightly describes it as a "skill" which prevailed over the effort required to arrive at a new, exploratory level of knowledge: "Matisse found himself at that time in a position to make the most of the economy of means which enabled him to go on painting with a smaller outlay. Relying on tradition, he set himself to practise a chosen economy of strength which would enable him, when the time came, to cope once again with the dangers involved in self-expense" (Pleynet, *L'Enseignement de la Peinture*, 1971).

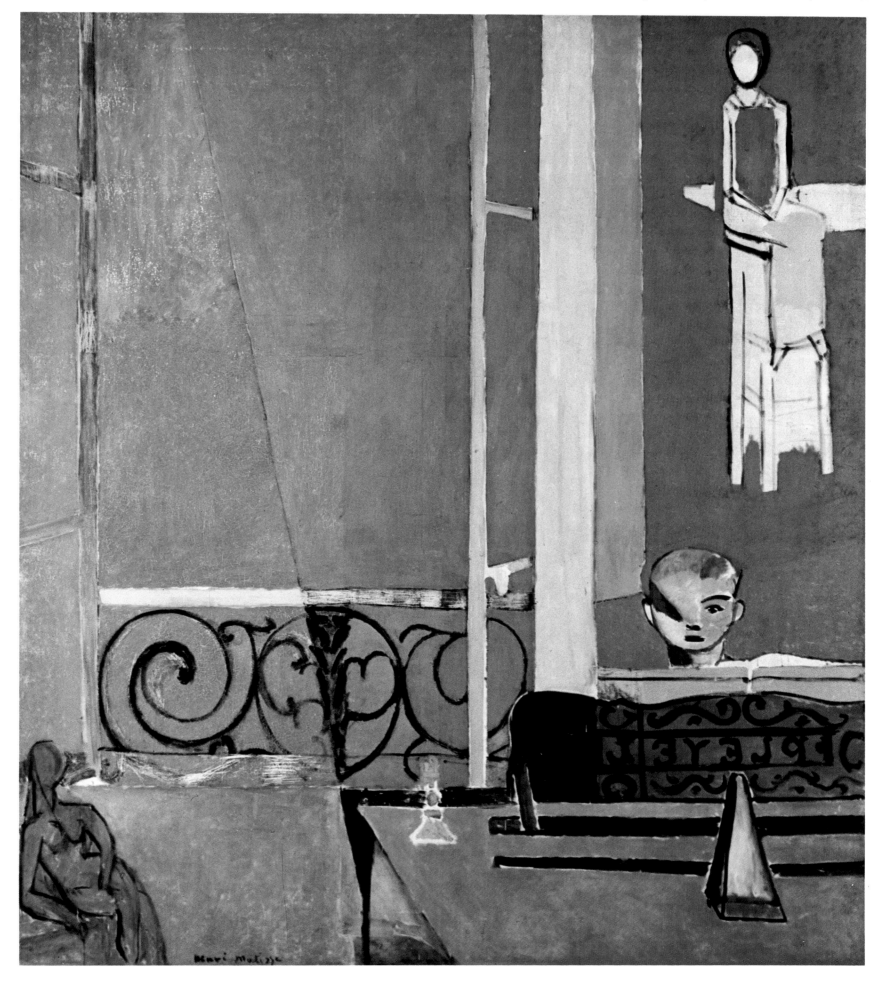

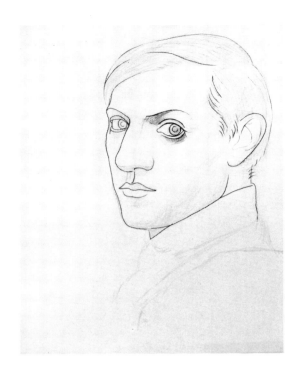

Picasso, the return to illusionism

signs. On the rest of the support, he indicated a classical space, a space stemming from nature. And the two of them communicate, function together, enrich each other. What is it then that creates the picture space?"

The same question arises in the sculpture, the *Glass of Absinth*, in which he introduces an actual object taken from reality without transposing it: a sugar spoon, a readymade which challenges, not the function of the work, but its very reality. One aspect of the cubist adventure, that aspect which bore on the constituent elements of the painter's language and which had seemed most shocking in the eyes of his contemporaries, now reached its logical conclusion in these illusionist works. It was left for Picasso to work out the consequences of a perception which was not only visual but mental; this he could not undertake until he had completed his inquiry into illusion, through a new experience of reality. This heterogeneous space was to characterize his output until the end of 1915. In it he combined with disconcerting skill the artifices of illusionist painting and actual materials which had never before been seen in painting. But already in his drawings he showed a growing tendency towards naturalism.

Pablo Picasso (1881-1973):

△ *Self-Portrait, 1917. Pencil.*

▷ *Costume of the American Manager for the ballet* Parade, *1917.*

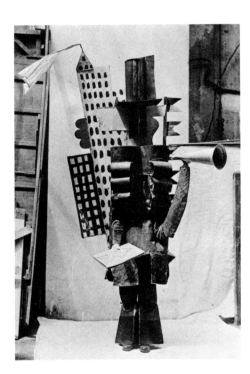

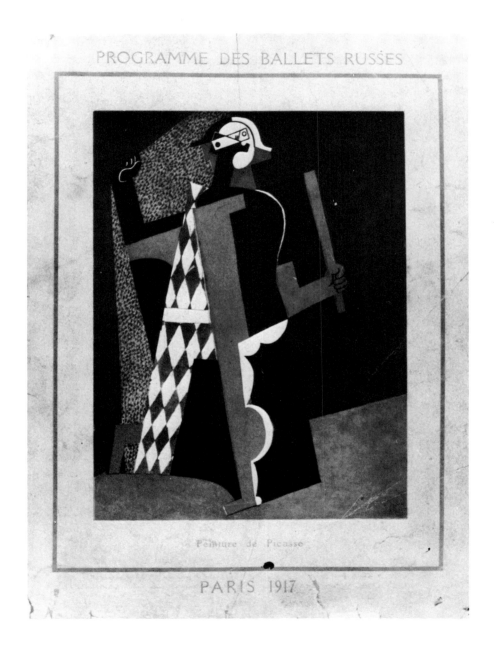

The return of Cubism to a certain illusionism or to decorative patterning represented the alternative way on which Picasso had embarked in the period just before the war. When war came, all his friends were called up except Juan Gris and Max Jacob, whom he continued to see episodically. The course followed by Picasso between 1914 and 1925 remained unclear until the works in his own possession became accessible after his death (in 1973). It is these works that give the key to the problem: what they tell us is that Picasso, like Matisse, saw that he had reached a limit beyond which he could not go until he had shifted the very basis of his research.

In his recent oeuvre catalogue (*Le Cubisme de Picasso*, 1979), Pierre Daix traces the origins of his crisis back to 1914: "Picasso now saw that he had in his grasp two kinds of picture space, two autonomous plastic languages. Moreover, he had just discovered that he could make them function together in the same picture. He had only to take a certain surface and delimit it by collage, the spreading of sawdust, pointillism or any other optical means. That surface may even assume an accidental aspect, it may be no more than a piece of torn paper. On it Picasso built up a space with an armature, with

Pablo Picasso (1881-1973): Cover of the "Programme des Ballets Russes" designed for Diaghilev, 1917.

Picasso had always used painting as an emotional outlet, a kind of private diary, and when the tensions and sorrows engendered by the war coincided with a personal bereavement (the death of his companion Eva in 1916), he was made even more painfully aware of the impossibility of keeping to the impersonal construction of Cubism. Hence the cleavage in his work between two kinds of picture, one carrying the plastic researches of Cubism to their furthest limit, the other giving free play to sense impressions and emotions.

Bewildered by Eva's sudden death, he welcomed Jean Cocteau's proposal to collaborate with him and the composer Erik Satie on a ballet for Diaghilev's famous Russian troupe which had been detained in the West by the war. In the spring of 1916 Cocteau, Picasso and Satie, together with Diaghilev's star dancer Léonide Massine, concerted their plans for the ballet *Parade* and set to work. In February 1917 they met in Rome to put the finishing touches on it. The first performance was given in Paris at the Théâtre du Châtelet on 18 May 1917, in the midst of the war. Apollinaire, in the essay he wrote for the programme, employed for the first time the term that was soon to designate a new creative experiment on revolutionary lines: "What emerges in *Parade* is a sort of *surrealism* in which I see the point of departure for a whole series of manifestations of this New Spirit."

But Apollinaire also saw in "this alliance of painting and dancing, sculpture and mimicry, the advent of a more complete art." Such in fact had been Picasso's intention. *Parade* gave him a chance to demonstrate that painting does not necessarily mean easel painting, that pictures are not necessarily made to hang in a drawing room or a museum. The curtain, with its large two-dimensional surface, gave him an opportunity of going to the very end of his new illusionism; in the costumes of the "managers," on the other hand, which were tantamount to living sculptures, he embodied the ultimate developments of collage and of cubist space and language.

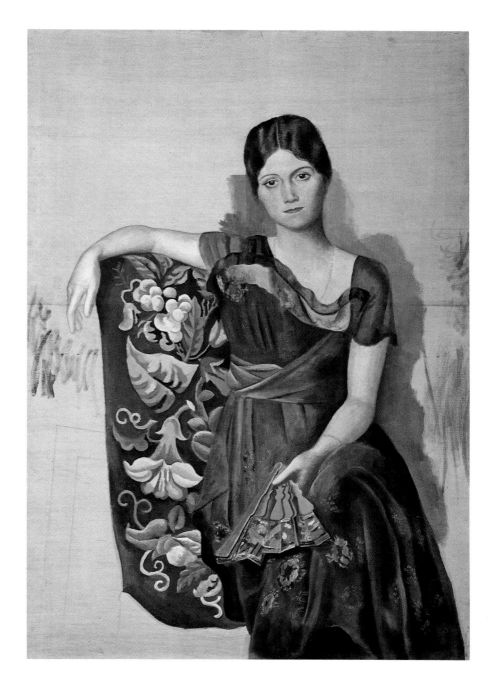

Pablo Picasso (1881-1973):

△ *Portrait of Olga in an Armchair, 1917. Oil.*

◁ *Curtain for the ballet* Parade, *1917. Size.*

It was in Diaghilev's Russian Ballet company that Picasso met the dancer Olga Koklova. Fascinated by her, he followed her to Madrid and Barcelona, where she left the troupe just before it sailed for America. Picasso and Olga were married on 12 July 1918. In painting her portrait, he availed himself of an illusionism revitalized by his discovery of the Italian Renaissance masters and the Greek sculptors.

With this new companion, he changed his way of life. Bohemian days were over (for the time being). Taking a fine apartment in the Rue La Boétie, in one of the most fashionable parts of Paris, Picasso seemed about to become a man about town. Thus began what Max Jacob humorously called the "period of the Duchesses."

Chirico, the mysteries of the subject

The deeper work will be drawn by the artist from the innermost depths of his being; there the murmur of the stream, the twitter of the bird, the rustle of leafage, fails to penetrate. What is wanted above all is to rid art of everything known and familiar that it has contained up to now: every subject, thought and symbol must be put aside.

Giorgio de Chirico, *The Mystery of Creation*, 1938.

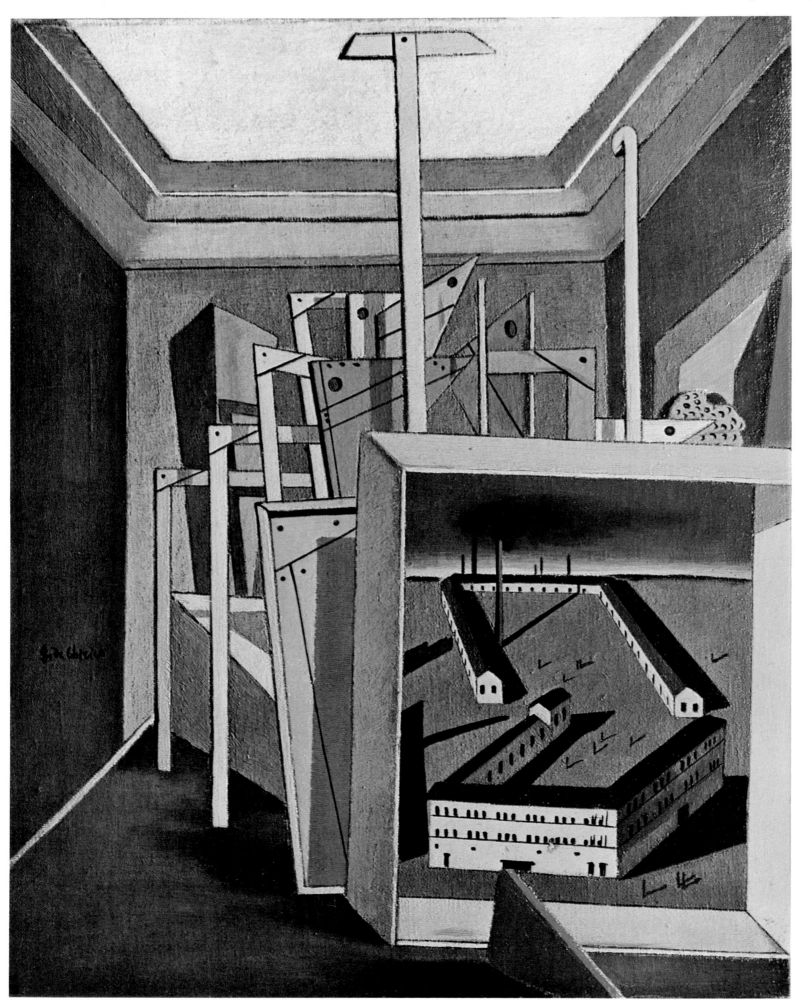

△ ▷ *Carlo Carrà (1881-1966): The Hermaphrodite Idol, c. 1917. Oil.*

▷ *Giorgio Morandi (1890-1964): Still Life, 1918. Oil.*

◁ *Giorgio de Chirico (1888-1978): Metaphysical Interior with a Small Factory, 1917. Oil.*

In May 1915 Italy entered the war on the side of the Allies. Chirico left Paris and returned to Italy, settling in Ferrara. There he created his most significant paintings, stepping up the illusionism of the representation to the point of disclosing the illusions we all carry within us. By reminding us that the world is mysterious and that he who would fathom its mystery necessarily cloaks himself in it, Chirico throws into relief the subjective Ego and opens the way to Surrealism. He thus gave to painting a whole new field of endeavour and exploration, and it proved to be one of the most fruitful of the twentieth century.

Just as Chirico was thus asserting himself, Umberto Boccioni died as a result of an accident (in 1916), while serving in the Italian army; he had been the most active and inventive of the Futurists, and the movement did not long survive him. Chirico, joined for a time by his brother Alberto Savinio, formed close ties with Carlo Carrà, who came to Ferrara in 1917. Together they developed "metaphysical painting," the term which Chirico had already used to describe his pre-war work in Paris. Giorgio Morandi later joined the Metaphysicals.

Chirico had instinctively recognized what Freud was then bringing to light in his analyses of the human mind and its workings: that between perception and consciousness there stands the barrier of the unconscious, and language (here the field of representation) is the place of its crystallization. Chirico wrote: "We experience the most unforgettable emotions when suddenly confronted by certain aspects of the world whose very existence had been unknown to us; when suddenly confronted, that is, by the revelation of mysteries which all the time were there within our ken, which we could not see because we are too short-sighted, and which we cannot feel because our senses are undeveloped" (quoted by Waldemar George, *De Chirico*, 1928).

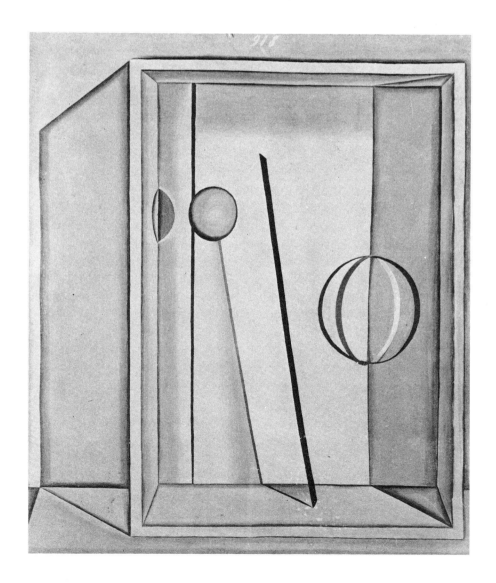

The Cubists, after Cézanne, justified a new approach to figurative painting by using the image as a relay of perception; Chirico, and after him the Surrealists, used the image for its interrogative power. The question had been reversed: beneath the signs and marks lay a hidden sense which the artist still knew little about, but which his intuition enabled him to bring to light.

The metaphysical painters kept to the illusionist space of traditional art, for it was the space that best enabled them to probe into the mysteries of reality. They only departed from visual appearances because they were intent on presenting them as a mirror of the unconscious mind. In order to raise the issues of representation, not on the level of style and expression, but on the basis of the signifier, they had to resort to this vehement and insistent illusionism which gave notice that the individual had lost his hold over the external world.

From 1915 on, Chirico peopled his silent and deserted world with manikins and pictures within the picture which raised for representational art the same questions, or similar ones, that had already been raised by Picasso: What does reality consist of and where is illusion to be found? In Chirico's *Metaphysical Interior* the picture within the picture represents a factory, seen from a distance and from above, as if it were lying at the bottom of a pit. Over the banality of the subject he thus casts an aura of mystery. The illusion is all the more gripping as it remains unaccountable.

This space and these images, taken over from Chirico by Carrà and Morandi, were to prove a revelation and a stimulus to Ernst, Tanguy, Dali and Magritte, opening their eyes to other possibilities.

15

New York, the capital of the 20th century

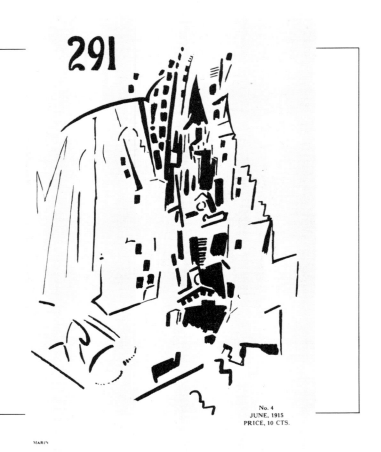

New York is a work of art in itself, an accomplished work of art. Its growth is as harmonious as that of the ripples that form on the surface of the water when you throw a stone into it. And I think you had a good idea when you pulled down the old buildings and the memories of the past. This is in keeping with the manifesto, still so much misunderstood, of the Italian Futurists who called for the destruction, symbolic it is true but they were taken at their word, of museums and libraries. The dead must not be allowed to prove stronger than the living. We must learn to forget the past and live our own life in our own time.

Marcel Duchamp, *Art and Decoration*, 1915.

John Marin (1870-1953): *Cover design of the review* 291, *No. 4, New York, June 1915.*

The war brought back to the United States all the American artists who were working in Europe. Several of them had figured prominently in the 1914 Salon des Indépendants in Paris; they had been influenced by Cubism and even more by Orphism. New York and the pace and modernity of American life were now, in turn, to mark those European artists who came to the United States as wartime exiles. There, as Marcel Duchamp recognized at once, they found the setting in which they could "live their own life in their own time."

Thanks to the war and its vicissitudes, America awoke to a sense of its importance. It was not until April 1917 that President Wilson brought the United States into the war alongside France, Britain and Italy, but that decision had momentous consequences. It speeded up the (already inevitable) shift of economic and political power from the Old World to the New. While in Europe the war marked a crisis in the centuries-old idea of progress, in the United States it brought a renewal of confidence in technology and science as generators of power. And growing power seemed to create the necessary conditions for cultural emancipation. Because it happened to be, not Cubism, but Dada that triumphed in the United States, the spiritual adventure of freedom went forward with increased momentum. Artistically speaking, the United States had remained far behind Europe up to the time of the famous Armory Show in 1913, when over 1,200 modern works were exhibited successively in New York, Chicago and Boston—in a country where until then artistic activity had never been encouraged by the prevailing work ethic, had often been frowned on as a thing of doubtful morality, had indeed been largely confined to architecture and folk art. But Americans now were ready to put something of their entrepreneurial boldness into art, and they were all the more free to do so since their enthusiasm was not checked by any great respect for tradition.

The immediate impact of the Armory Show bore in fact not so much on the trend of American art as on the taste of American collectors. Though the exhibition had been organized by and for American artists, with the idea of popularizing the more recent developments of American art by situating them in the international context, it had the effect of arousing the interest of new collectors in European avant-garde art (and this art was often lower priced, and less in demand, than that of native American artists who found their support in the local patrons of their home state or region). Matisse's *Blue Nude* and Duchamp's *Nude Descending a Staircase* created a sensation. These two pictures were found particularly outrageous by the public, because their interpretation of the human figure most directly challenged the social and moralizing illusionism to which American taste was then firmly attached.

But over two hundred pictures from the Armory Show were sold, and European avant-garde art, still little known and much misunderstood in Europe itself, thereby made a spectacular breakthrough in the United States. These new American collectors (e.g. Walter Arensberg, Dr Albert C. Barnes, Lillie P. Bliss, Katherine Dreier, Arthur Jerome Eddy, John Quinn) were shrewd, cultured and active, and they proceeded to endow their country with foundations and museums where the most significant and vital works of avant-garde art could be seen. The interest aroused in contemporary art, largely through their example, led to the opening of new galleries where European artists in exile found a ready welcome. The impetus created by the Armory Show was followed up by the Forum Exhibition of Modern American Painters in 1916 and the first exhibition of the Society of Independent Artists in 1917, both held in New York.

That contemporary art was able to take root at all in the United States was chiefly due to the photographer and dealer Alfred Stieglitz, who in 1905 opened in New York his Photo-Secession Gallery at 291 Fifth Avenue. At first, as the name indicated, he exhibited only photographs. But from 1907 on he began showing drawings and paintings and mounted Rodin, Matisse and Cézanne exhibitions. Stieglitz was the first to exhibit the Cubists in the United States. He exhibited the work of the younger American artists living in France, whose talents were detected by the photographer Edward Steichen. With financial assistance from Paul Haviland, Stieglitz also launched and edited an art magazine, *Camera Work*, which ran to fifty numbers before it ceased publication in June 1917.

A gallery magazine bearing the name *291* was also launched to give new impetus to Stieglitz' activities: twelve issues were published from March 1915 to February 1916. Paul Haviland and Marius de Zayas both played a prominent part in it.

Francis Picabia was one of the few European artists to participate in person in the Armory Show. On this, his first visit to the United States, in 1913, he was struck by the reality of New York, so much so that he began painting it and these pictures were exhibited in a one-man show organized by Stieglitz at the 291 Gallery. In a statement to the *New York American* (30 March 1913) Picabia urged Americans to have confidence in their modernity: "Your New York is the Cubist city, the Futurist city. In its architecture, its life and spirit, it expresses the modern mind. You have passed through all the old schools and you are Futurists in works, acts and thoughts."

Marcel Duchamp and Albert Gleizes were equally enthusiastic when they landed in New York in 1915. If French artists were putting the city of the future into their paintings, why shouldn't the Americans do the same? In a statement to the *New York Tribune* (24 October 1915), Gleizes said: "The skyscrapers are works of art. They are constructions in iron and stone which equal the most admired works of art in the Old World. And the great bridges that have been built here are as admirable as the most famous cathedrals."

Cubism, Futurism and Orphism formed a sequence of movements which pushed artists towards abstraction, towards the construction of a style ever further removed from visual appearances, towards geometric patterning in pure colours. The modern city, by becoming a theme, and a major theme, of painting, prepared the way for the glorification of the industrial world.

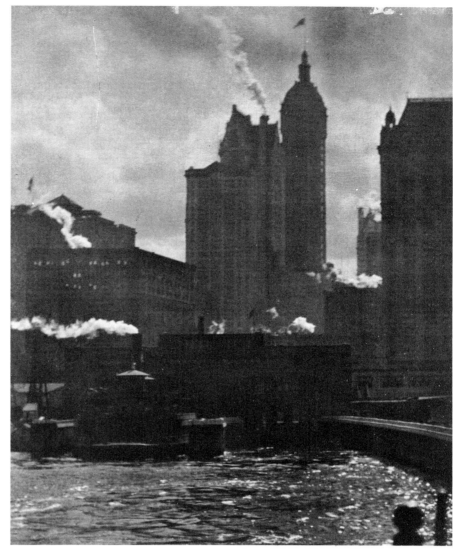

Alfred Stieglitz (1864-1946): The City of Ambition, 1910. Photogravure.

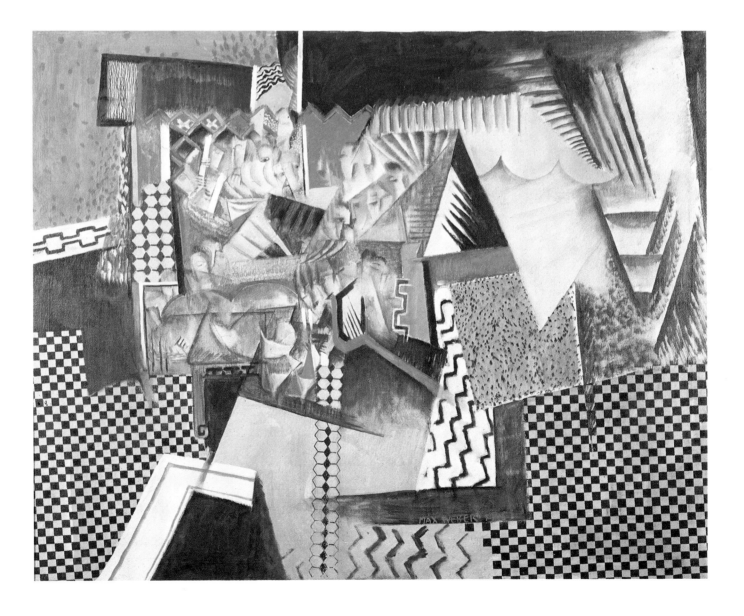

Max Weber (1881-1961):
Chinese Restaurant, 1915. Oil.

Edward Steichen (1879-1973):
Portrait of Alfred Stieglitz,
1915. Photograph.

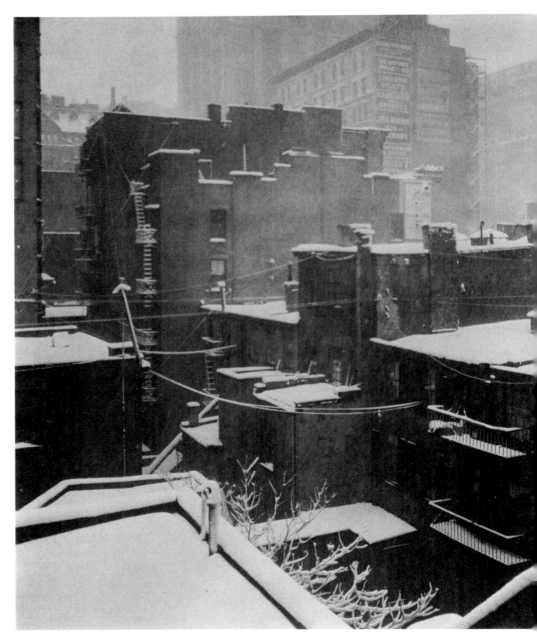

Alfred Stieglitz (1864-1946): From My Window, New York, 1915. Photograph.

From America came the revelation of photographic vision, of photography meant to be nothing else but photography: "the swift freezing of an exact instant" (Edward Steichen). Pure photography yields the immediate image of what the photographer has before him and wants to record. This was feasible even with the cumbersome apparatus of the early cameras, but it is not until we come to the work of Alfred Stieglitz and his circle that we find photographers breaking away at last from the models provided by painting.

As early as 1896, when his work was shown at the Society of Amateur Photographers, he had distinguished himself by the novelty of his vision: "Mr Stieglitz' pictures are examples of pure photographic processes—no retouching or hand drawing having been done on any of the negatives." But the invention of gelatine plates and the portable camera, above all the introduction of enlargement techniques, slowed the development of this vision by making it possible to single out a fragment of the negative, a detail of the whole.

Stieglitz hesitated before the cleavage that was opening up between pure photography and modern painting. In the pages of *Camera Work* he illustrated the experiments of contemporary painting, so persistently that in 1910 Charles H. Caffin could write: "After claiming for photography an equal opportunity with painting, Stieglitz turns about and with devilishly remorseless logic shows the critics, who have grown disposed to accept this view of photography, that they are again wrong. As long as painting was satisfied... to represent the appearances of things, photography could emulate it. Now, however, that it is seeking to render a vision of things not as they are palpable to the eye, but as they impress the imagination, Mr Stieglitz proves what he has known all along, that photography is powerless to continue its rivalry with painting."

Stieglitz seems to admit the truth of this when he describes the Armory Show as "a face-lifting clinic for the fine arts" (*New York American*, 26 January 1913), but at the same time he seemed to be doing his best to disprove it when, in 1913, he organized in his own gallery his first one-man show in fourteen years. That same year he declared that "photographers will learn to stop blushing if their photographs are considered simply as photographs." For by then photography had proved itself to be a means of discovering new forms. To do that, it was enough for it to be faithful to its own nature and conscious of its distinctive resources. This view of the matter is made explicit by a comparison of two articles of 1913 by Stieglitz' friend Marius de Zayas. In *Camera Work* (No. 41) the latter wrote: "Photography is not Art. It is not even an art. Art is the expression of the conception of an idea. Photography is the plastic verification of a fact. The difference between Art and Photography is the essential difference which exists between the Idea and Nature. Nature inspires

the advent of pure photography

Paul Strand (1890-1976): *Abstraction, Porch Shadows, 1915. Photograph.*

Alvin Langdon Coburn (1882-1966): Portrait of Ezra Pound, 1916. Photograph.

in us the Idea. Art, through the imagination, represents that idea in order to produce emotions." But in the next issue of *Camera Work* (No. 42-43) he wrote: "Photography is not Art, but photographs can be made to be Art... The difference between Photography and Artistic-Photography is that, in the former, man tries to get at that objectivity of Form which generates the different conceptions that Man has of Form, while the second uses the objectivity of Form to express a preconceived idea in order to convey an emotion. The first is the fixing of an actual state of Form, the other is the representation of the objectivity of Form, subordinated to a system of representation. The first is a process of indigitation, the second a means of expression."

Photography from now on delimited the field in which the problems of figuration arose, it was the privileged technique of the debate over realism. Lewis Wickes Hine had opened the way with the series of "photo-interpretations" which he published under the title of "human documents." But it was above all Stieglitz, Steichen, Weston, Strand and Sheeler who illustrated this new trend of photography during the war. Charles Sheeler, for example, was a painter. He took to photography to earn a living (and worked for the Modern Gallery of Marius de Zayas). From 1914 on, in his many photographs of buildings, he produced genuine abstract images thanks to his sense of geometry. "My interest in photography, paralleling that in painting, has been based on admiration for its possibility of accounting for the visual world with an exactitude not equaled by any other medium. The difference in the manner of arrival at their destination—the painting being the result of a composite image and the photograph being the result of a single image—prevents these media from being competitive" (Charles Sheeler, 1939).

Paul Strand, a photographer peculiarly sensitive to light and space, was revealed in the last issue of *Camera Work*. He went a step further in presenting reality as an abstraction. "The objects may be organized to express the causes of which they are the effects, or they may be used as abstract forms, to create an emotion unrelated to the objectivity as such. This organization is evolved either by movement of the camera in relation to the objects themselves or through their actual arrangement, but here, as in everything, the expression is simply the measure of a vision, shallow or profound as the case may be. Photography is only a new road from a different direction but moving toward the common goal, which is Life" (*Camera Work*, Nos. 45-50, June 1917). The role of the eye that chooses the image is at last acknowledged. Now the key question could be stated: where is the real, in what is seen or in the way of seeing? From now on photography merged the two together inseparably.

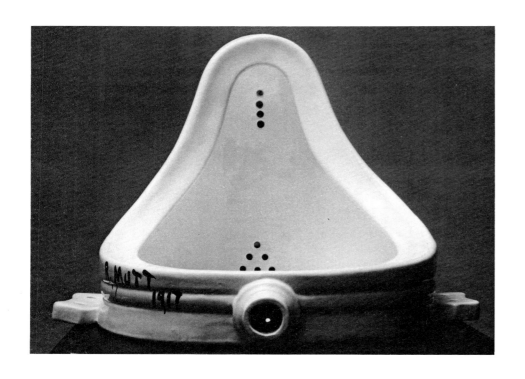

Duchamp and Picabia, the abandonment of painting

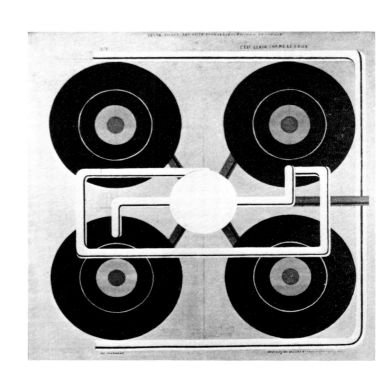

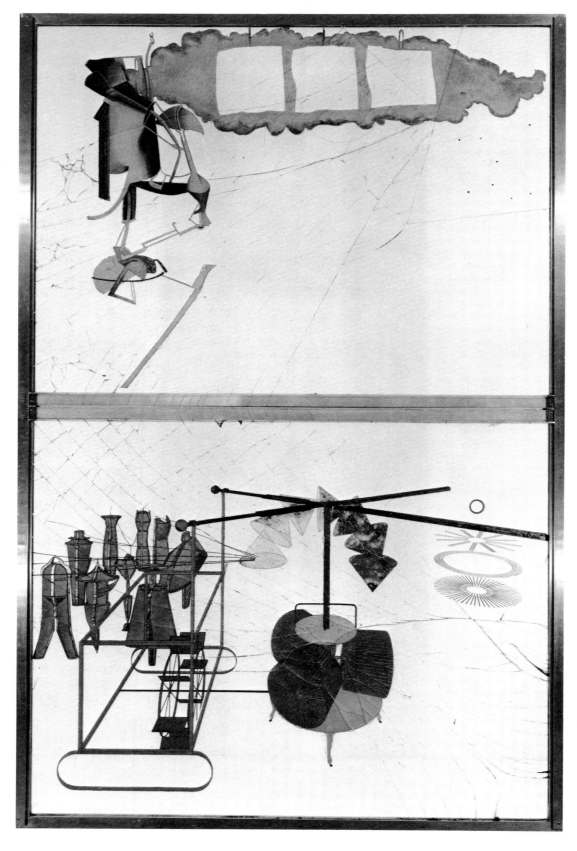

When I came to New York in 1915, I started this painting, repeating and grouping together in their final position the different details... Nine feet high, the painting is made of two large pieces of plate glass above one another. I began to work on it in 1915 but it was not finished in 1923 when I finally abandoned it, in the state you see it today.
All along, while painting it, I wrote a number of notes which were to complement the visual experience like a guide book.

Marcel Duchamp.

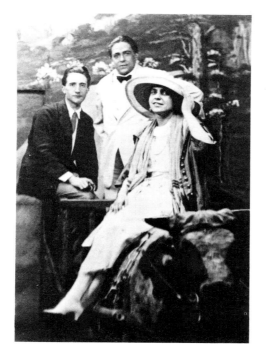

◁◁ *Marcel Duchamp (1887-1968): Fountain, 1917. Readymade.*

◁ *Francis Picabia (1879-1953): The Discs ("This thing is made to perpetuate my memory"), 1915. Oil and metallic paint.*

▽◁ *Marcel Duchamp (1887-1968): The Bride Stripped Bare by Her Bachelors, Even (The Large Glass), 1915-1923. Oil and lead wire on two glass panels.*

▷ *Duchamp (left) with Picabia and Beatrice Wood, New York, 1917.*

▽ *Marcel Duchamp (1887-1968): In Advance of the Broken Arm, 1915. Readymade.*

In New York in 1915 I bought in a hardware store a snow shovel on which I wrote: "In advance of the broken arm." It was about that time that the word "readymade" occurred to me to designate this form of manifestation. There is one point that I would like to make very clear, and that is that the choice of these "readymades" was never dictated to me by some artistic delectation. This choice was based on a reaction of visual indifference, combined at the same moment with a total absence of good or bad taste... in fact a complete anesthesia.

Marcel Duchamp, *About the Readymades*, 1961.

Gabrielle Buffet, Picabia's companion, recounts that the situation had changed when they landed in New York for the second time in 1915: "I fell in with another group to which I was introduced by Duchamp, who in the meantime had also come over to the United States, acting mainly on our advice, for we told him that he would be looked askance at in France, since all his brothers and friends were at the front, whereas in America he would be welcomed as a great man, on the strength of the publicity that his *Nude Descending a Staircase* had earned him... Marcel, then, had been very well received in the United States. Walter Pach, who had been one of the organizers of the Armory Show, had introduced him to all the local circles, and everyone had fallen under the spell of his personal charm, I would even say his magnetism. Among the lovers of modern painting was Walter Conrad Arensberg, who desired to meet him. A friendship sprang up immediately between the two men, and Marcel was taken into his home. But Marcel had set his mind on a certain freedom of movement and money, and in order to stand on his own feet he gave French lessons, or '*des leçons d'amour aux Américaines,*' as Picabia put it."

Picabia himself, having been born into a wealthy family, had no need to bother about earning a living. He became the embodiment of anti-aesthetics. "All my life I have been smoking painting." For him, life came first. In 1913 he made his first mechanical drawing, which he characteristically entitled *Motherless Girl*. In 1914 he turned his back on painting with a provocative *Portrait of Cézanne*, an outright condemnation of nature imitation in any shape or form. From now on Picabia was intent on doing something in art, or rather anti-art, "the like of which had never been seen before." He and Marcel Duchamp had been close friends since 1910 and they spurred each other on in their efforts to sap the foundations on which Art then stood. Possibly they were influenced by the French writer Raymond Roussel, after seeing his play *Impressions d'Afrique* performed in Paris in 1911. In this masterpiece of pre-surrealist humour, the plot turns on a "painting machine" and a "club of Incomparables" which prefigures the Dada in-

groups. This play of Roussel's came as a symbol of the shipwreck of European civilization and opened the flood-gates of the subconscious. Absurdity and irony became from 1913 on the offensive weapons most dextrously wielded by Duchamp and Picabia in their ruthless attack on an outworn tradition of art. Both went on to develop to the full all the implications of their anti-aesthetic attitude.

Their first enemy was Cubism, in their eyes a survival of painting for its own sake, of "turpentine addiction," which had found a wide response among both artists and collectors in the United States. As soon as he landed in New York, Duchamp began his attack: "They consider Picasso to be the leader of the Cubists, but he is not a Cubist in the proper sense of the term. He is a Cubist today; tomorrow he will be something else. The only true Cubists today are Gleizes and Metzinger. But this word Cubism means nothing at all; it has so little sense that one might have replaced it by Polycarpism. It was Matisse who ironically coined the term. There is a host of little Cubists at work today who ape the slightest gestures of their leader without understanding what they mean. They talk of nothing but discipline, a word which for them means everything and nothing."

While Picasso and Matisse moved towards a new interpretation of space and turned back at the same time to visual appearances, Picabia and Duchamp mounted a direct and merciless attack on representational painting by making play with *trompe-l'œil* effects in the name of psychological reality. They nevertheless made full use of that autonomy which the Cubists had conferred on their object-pictures and which Paul Dermée characterized as follows: "The work of art must be conceived as the workman conceives the pipe or hat or particular object which he manufactures, and all its parts must have their place determined strictly in accordance with their function and importance. What matters here is the object, and not this or that element of it" (*Nord-Sud*, Paris, 15 March 1917).

The issue had until now been between representation and abstraction, between the advocates of an illusionist three dimensional space and the advocates of a strictly

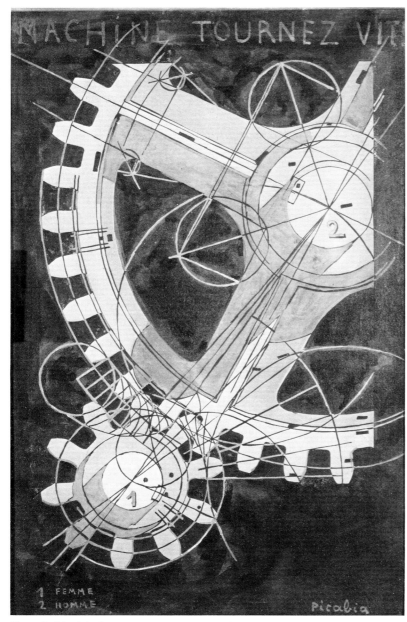

Francis Picabia (1879-1953): Machine tournez vite, 1916. Tempera.

status of the work of art: and so anti-art was born. Duchamp summed up his method and purpose in these words: "Reduce, reduce, reduce, was an *idée fixe* with me. But at the same time my aim was to turn myself inwards, not outwards." And speaking of this appropriation of objects, he said: "I had no definite reason for taking them over, no intention of exhibiting or describing them. No, nothing of the sort... But there was an element of provocation in them all the same."

In New York, as early as 1915, Picabia and Duchamp were Dadaists even before the name had been invented, for it was not until the end of 1916 that Dada was revealed to them through the first publication issued under the Dada imprint, Tristan Tzara's *La première aventure céleste de Monsieur Antipyrine* (The First Celestial Adventure of Mr Fire Extinguisher). But in bringing home so forcibly their conviction that art is not an end in itself, but only a vehicle for communicating ideas, they humbled art, they debunked it, at the very time when the other avant-gardes were going in for abstraction and thereby exalting the autonomy of art.

Duchamp was well aware of this very different evaluation of art's role: "I was interested in ideas, not merely in visual products. I wanted to put painting once again in the service of the mind. And my painting was of course regarded as 'intellectual' and 'literary.' It is true that I was trying to avoid as far as possible any kind of physically 'pleasing' and 'attractive' painting."

New York Dada was not a style. It was an attitude intent on destroying not so much art as the idea we have of it and the use we make of it. But all the New York Dadaists had the same mistrust of painting. Like Duchamp, they were only too conscious of its limits as later pinpointed by André Breton: "The increasingly necessary transformation of the world is none other than the transformation that can be carried out on the painter's canvases" (*Le Phare de la Mariée*, in *Minotaure*, 1935). And in the same article the leader of the Surrealists acknowledged that Duchamp had liberated the image by abandoning painting: "The practice of drawing and painting seems to him no

Morton L. Schamberg (1881-1918): God, c. 1918. Wood and metal.

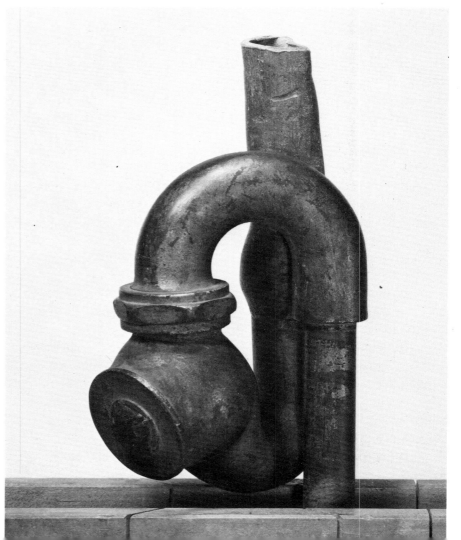

two-dimensional picture space. Duchamp and Picabia were both, in different ways, to resort to the fourth dimension by making use of the machine object.

For the time being Picabia continued to paint, and in New York in 1915 he exhibited his large machine pictures at the Modern Gallery of Marius de Zayas. But he was increasingly attracted by writing and publishing, and he helped to set the pace of Alfred Stieglitz' magazine *291* in New York, before launching his own periodical *391* (in Barcelona in 1917). During his wartime stay in the United States, he consistently emphasized the importance of the subjective as against the visual. This was the key to the combinations that went to make up his machine drawings and machine pictures.

And for his machine paintings, his *modern icons*, Picabia made up titles which cease now to be tautological, titles which give the pictures a heightened or ironical meaning, which lead the mind and eye away from appearances. His fourth dimension was the realm of subjectivity. Marcel Duchamp, with his Readymades, also cocked a snook at reality. He had already made some of these before going to the United States in 1915, but it was not until he made the snow shovel in New York that he invented the name for them. The Readymade consists of an object which imitates nothing else but itself; mimesis here becomes absolute and therefore pointless. But because Duchamp, by taking an ordinary object from the limbo of unregarded things around us, transformed into art what is not art, he challenged the

Marcel Duchamp (1887-1968): Tu m', 1918. Oil.

more than a piece of trickery: it becomes a stupid glorification of the hand and nothing else... The hand is the guilty party, and how can one acquiesce to being the slave of one's own hand? It is unacceptable for drawing and painting today to be still at the same point as writing before Gutenberg. The only way out, in these circumstances, is to forget how to paint and draw. This is Duchamp's view and he has never recanted."

The Readymade, as the ultimate in illusionism, marks the transition from a copy of nature to nature itself. With his Readymades, then with the *Large Glass* (1915-1923) and *Tu m'* (1918), Duchamp introduced another dimension, "a 'meta-world' which he has described as 'fourth-dimensional' and posited in his works as the 'unknown quantity'" (William Rubin).

Stimulated by the boldness of Picabia and Duchamp, the American artists Arthur G. Dove, Morton Schamberg, Man Ray, John Covert and even Charles Demuth also turned to machinery, twisting its meaning by giving it an ironical title or context.

It was, predictably, in the United States that artists discovered machine imagery, for there machinery was already a conspicuous aspect of daily life. For a long time it had imitated human movements. But by 1913, when Henry Ford introduced assembly-line production, machinery had come into its own and asserted its power. It was a dominant and obsessive presence. Picabia was one of the first artists to see this and act accordingly: "I have been deeply impressed by the immense spread of machinery in the United States. The machine has become more than a mere auxiliary of human life. It is really an integral part and perhaps the very soul of mankind" (*New York Tribune*, 24 October 1915). But by distorting and perverting it in their work, Picabia and Duchamp showed up the threatening side of machinery, the threat to man to which Lewis Mumford was to give a classic statement in his *Technics and Civilization* (1934). There he made it clear that, with the advent of machinery, the human experience ceased to be all-inclusive, for now it found itself grappling with new powers which are not governed by the same laws as the human body and brain. And as it loomed ever larger the machine seemed to dwarf human realities: it took on a life of its own as a power outside man and outside his control, threatening to impose its own laws upon him.

The New York Dadaists soon became well known, not to say notorious, as a result of their public appearances. On 12 June 1917, for example, they organized a lecture by the poet-boxer Arthur Cravan, who arrived drunk, insulted the audience and started pulling off his clothes, only to be taken away by the police before he could complete his strip-tease act.

The idea of the Society of Independent Artists was mooted in the circle of Walter Arensberg, and its first exhibition—the first one in America with no selection committee, open to all—was held in New York at the Grand Central Palace in April-May 1917. 1,100 exhibitors showed 2,500 works. The most memorable of them was undoubtedly the white porcelain urinal exhibited by Duchamp, which he entitled *Fountain* and signed "R. Mutt." It was a new "lesson of the master" in artistic freedom and provocation.

As for the urinal itself, thus dignified with title and signature, Duchamp would have been delighted had the organizers refused to exhibit it. But no, it was duly accepted and in fact failed to provoke the scandal he had hoped for. Before the exhibition closed, it was stolen; not, however, before it had been photographed by Stieglitz, who reproduced it in the second number of *The Blind Man* (May 1917), a short-lived review edited by Man Ray and Duchamp. These proto-Dada activities also had a meaning in the political context of that day. "All this took place in the midst of the war and the whole world was subjected to its requirements, even those who were not directly involved... Our aggressiveness was a revolt, but after all what could we do about it? We couldn't cry out, we couldn't make an official indictment of the war, of what was happening in mankind, of the absurdity of this world of horror, violence and generalized cruelty" (Gabrielle Buffet-Picabia).

The fascination of machinery

Man Ray (1890-1976): New York 17. Assemblage of wooden slats held in a vice, 1917.

Man Ray (1890-1976):
Self-Portrait, 1916.
Assemblage.

A close friend of Marcel Duchamp, Man Ray produced his first authentically Dada works during the winter of 1916-1917. Born in Philadelphia and brought up in New York, Man Ray had been introduced to avant-garde circles by Alfred Stieglitz in 1913. He intended to be a painter and *did* become a painter, but it was as a photographer that he made his most revolutionary innovations. In his hands photography became for the first time a medium of expression equal in power and scope to painting. Freewheeling, unpredictable, disconcerting, Man Ray was seen at his best and boldest in the Dada context. His ebullient imagination enabled him to make the most of chance effects, his open mind made him receptive to all possible forms. Because he had not been taught to force his ideas into the mould of traditional models, Man Ray was from the start more intent on enjoying the creative act than producing an artistic result. Poetry with him was in the play of free fancy, he preferred life to art. He was Duchamp's best disciple and friend, for he went ahead without bothering to theorize or think about art: intuition was his guide. He invented the Aerograph or "pistol painting," made by spraying the colour with an air gun. Here he achieved highly original monochrome effects, capitalizing skilfully on the sudden whims of chance, and restating the problem of the projection of a three-dimensional object on the picture surface. As an avant-garde painter he put the Aerograph to good use in his pictures: "I worked in gouache on tinted and white cardboards—the results were astonishing—they had a photographic quality, although the subjects were anything but figurative. Or rather, I'd start with a definite subject, something I had seen—nudes, an interior, a ballet with Spanish dancers, or even some odd miscellaneous objects lying about which I used as stencils, but the result was always a more abstract pattern. It was thrilling to paint a picture, hardly touching the surface—a purely cerebral act, as it were" (Man Ray, *Self-Portrait*, Little Brown and Company, Boston, and André Deutsch, London, 1963).

He also produced some disconcerting assemblages which in effect called for a different relationship between spectator and picture. He describes one of them, which he entitled *Self-Portrait*: "On a background of black and aluminium paint I had attached two electric bells and a real push button. In the middle, I had simply put my hand on the palette and transferred the paint imprint as a signature. Everyone who pushed the button was disappointed that the bell did not ring.

Another panel was hung by one corner which, inevitably, visitors attempted to redress only to have it swing back at an angle. I was called a humorist, but it was far from my intention to be funny. I simply wished the spectator to take an active part in the creation."

If the New York Dadaists were able to pursue their activities so fruitfully, it was thanks to the support given them by open-minded dealers and collectors with a genuine interest in avant-garde art. The most significant result of this collaboration between art lovers and art makers was the founding of the Société Anonyme in New York in 1920, by Katherine Dreier, Man Ray and Marcel Duchamp. This society acted as a museum of contemporary art (the first one in America), mounting exhibitions, sponsoring lectures and showing a permanent collection of avant-garde art. For the Société Anonyme Man Ray made his famous paper spiral entitled *Lampshade*, one of the first kinetic sculptures or mobiles, which may also have given Man Ray and Duchamp the idea of making multiples. On the evening before the opening day, however, the janitor threw it away: he thought it was a piece of waste paper! Man Ray at once remade it out of sheet metal and thus secured it from any further mishaps. He later made more copies of it: "I have no compunction about this—an important book or musical score is not destroyed by burning it. Only a collector who was acquiring the object for speculative reasons would hesitate to add it to his collection" (*Self-Portrait*).

But Man Ray's finest work was done as a photographer. His experiments with the Aerograph and with collage had already shown that he was more sensitive to the effects of the machine than to its symbolic presence. Photography, a mechanical technique, gave him a medium in which he could go still further in his quest for unusual effects. He proceeded to use it as a means of draining reality of its naturalistic references and bringing it before us as something unexpected, unknown, abstract, and so all the more haunting.

Man Ray (1890-1976): *Lampshade, 1919.*
Painted metal.

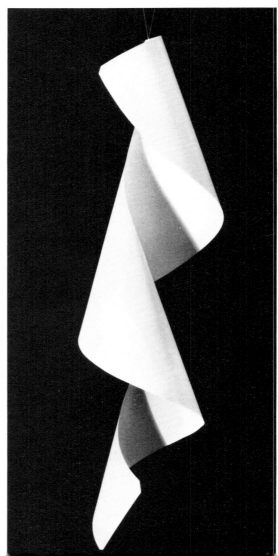

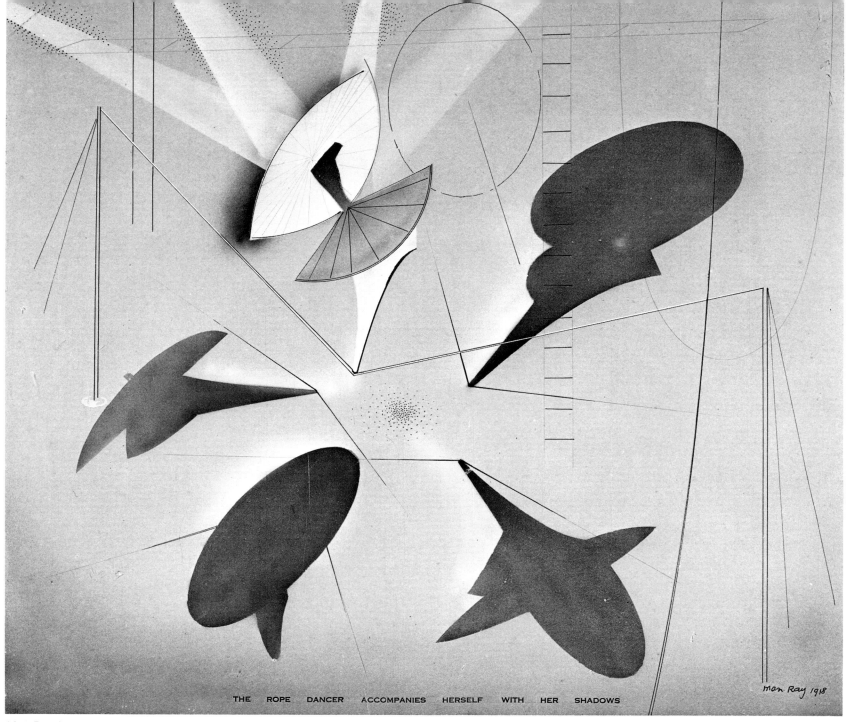

Man Ray (1890-1976): The Rope Dancer Accompanies Herself with her Shadows, 1918. Ink and watercolour.

Man Ray, the spirit of free invention

Man Ray came to photography unsuspectingly, using it at first merely to reproduce his paintings. He soon found it a good way of earning a living. But it was almost in spite of himself, against his will as a painter, that he became one of the most creative photographers of his time. Even in later years, when he wrote his autobiography and was at the height of his success as a photographer, one still feels the force of his mental reserves about a technique conventionally regarded as a minor one. "I had my camera and had become quite adept in reproducing paintings. But they were my own, the thought of photographing the work of others was repugnant to me, beneath my dignity as an artist. I had made several attempts at portraiture with Donna and Esther as models, had been quite pleased with the results. This was the solution: I'd begin by photographing anyone that came by, and make up a portfolio of specimens. Since my painting had evolved to a degree where I would never consider painting a portrait, there was no question of a conflict between painting and photography. In fact, my painting might gain by this precise separation of subject matter" (*Self-Portrait*).

As it turned out, photography forced him to find other ways of coping with the phenomena of the visible world.

Man Ray (1890-1976): Man, 1918. Photograph.

Impossible to photograph what I paint. What I paint stems from the imagination or a dream or an unconscious impulse. But what I photograph are objects that I feel no pleasure in painting, objects that really exist.

Man Ray, 1976.

Zurich Dada

Hans Arp (1887-1966):
Head of Tzara, 1916.
Painted wood relief.

"There is a great piece of destructive and negative work to be done. Sweeping away, cleaning up" (Tristan Tzara, *Dada Manifesto 1918*). This blunt statement of Tzara's was taken up by his friends in Zurich and it became the rallying cry of Dada. In Zurich, however, the Dada painters and sculptors failed to achieve the same impact as their counterparts in New York. Their activities in Zurich were but one current in the tidal wave of cultural contestation that swept over Europe after World War I, a bitter reaction against flag-waving and the hidebound patterns of behaviour that had plunged the so-called civilized world into a self-destructive war.

Dada was born in Zurich in 1916. It owes many of its features to the wartime atmosphere of this neutral Swiss city: "It was here, in the peaceful dead-centre of the war, that a number of very different personalities formed a 'constellation' which later became a 'movement.' Only in this highly concentrated atmosphere could such totally different people join in a common activity. It seemed that the very incompatibility of character, origins and attitudes which existed among the Dadaists created the tension which gave, to this fortuitous conjunction of people from all points of the compass, its unified dynamic force" (Hans Richter, *Dada: Art and Anti-Art*, McGraw-Hill, New York, and Thames and Hudson, London, 1965).

What united them was hatred of war and horror at the slaughter it had led to on the pretence of defending freedom and culture. Such an absurdity could only be answered by absurdity. Hans Arp, an Alsatian refugee, wrote: "Revolted by the butchery of the 1914 World War, we in Zurich devoted ourselves to the arts. While the guns rumbled in the distance, we sang, painted, made collages and wrote poems with all our might. We were seeking an art based on fundamentals, to cure the madness of the age, and a new order of things that would restore the balance between heaven and hell. We had a dim premonition that power-mad gangsters would one day use art itself as a way of deadening men's minds" (quoted by Hans Richter, *Dada: Art and Anti-Art*).

To some of the Dadaists art seemed pointless and indeed impossible. Such was the view of the Rumanian Marcel Janco: "We had lost the hope that art would one day achieve its just place in our society. We were beside ourselves with rage and grief at the suffering and humiliation of mankind" (quoted in *Dada: Art and Anti-Art*). So all they could do was to destroy art by producing anti-art and by taking a consistent stand against that analytical and rational cast of mind which personified European culture and which had now been bankrupted by the war which it had brought upon itself.

But Dada was in the first instance a literary movement, or indeed a movement towards a total art. The Dada spirit presided genially over the Cabaret Voltaire in Zurich, which opened on 5 February 1916, presided over by the German poet and pacifist Hugo Ball and his wife Emmy Hennings. Among the original group of artists and intellectuals who met there were Tzara, Janco, Arp, Huelsenbeck and Richter.

In the first issue of the review *Cabaret Voltaire* (15 May 1916) they announced the forthcoming publication of another review to be called *Dada*. Who coined the name? Dada is a French word meaning hobby-

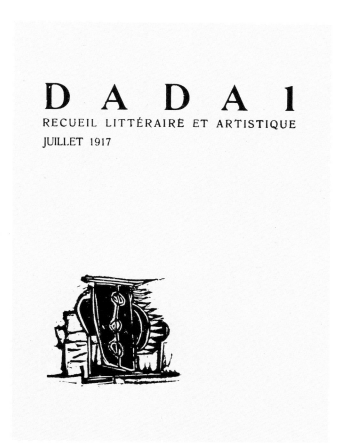

◁ *Cover of* DADA 1, *Zurich, July 1917, with woodcut by Marcel Janco.*

△ *Hans Richter (1888-1976): Dada-Head No. 4, 1918. Linocut.*

△▷ *Hans Richter (1888-1976): Music-Dada, 1918. Linocut.*

▽ *Hans Arp (1887-1966): Geometric Collage, 1916.*

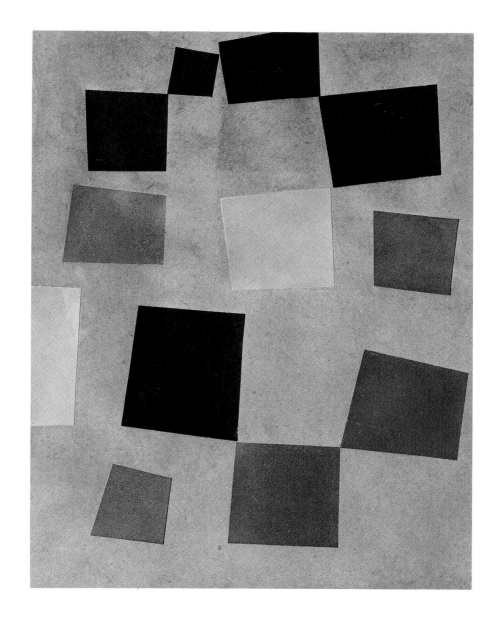

horse. There are conflicting accounts of who chose the name and how, and the truth will probably never be known. What was it supposed to mean? Everything and nothing. It sounded appropriately odd and puzzling and served as a good watchword for a group of protesters. Every night at the Cabaret Voltaire something new, amusing or provocative was staged or recited: phonetic poems or *Lautgedichte*, made up of pure sounds; noise effects, with voice, bass drum, whistle, etc.; and accidental or instant poems in several languages at once. Dada was a way of life, an overflow of anarchic spontaneity, an uprush of uncritical inspiration. Anti-patriotic and anti-nationalistic, it was a blanket condemnation of conventional attitudes. "The Dadaist is a man who has fully understood that he has no right to have ideas unless he knows how to transform them into life; he is the totally active genius, living only through action because he knows that through action he has a chance of attaining to knowledge," wrote Richard Huelsenbeck in the first history of the Dada movement (Hanover, 1920).

In Zurich likewise it was not art that mattered but action. Painters and sculptors took part first of all in the lively doings at the Cabaret Voltaire, but they also had to live. And so in mid-March 1917 Tzara and Ball opened the Dada Gallery in the Bahnhofstrasse, where they

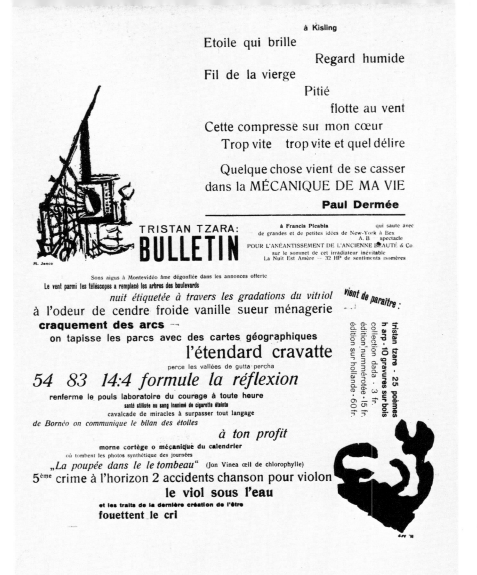

exhibited the German Expressionists and then the Dadaists, Arp in particular, who had just met the woman artist who was to become his wife, Sophie Taeuber, whose abstract paintings, in the purity and strictness of their design, finally set him free from cubist and expressionist influences. "We searched for new materials which were not weighted down with tradition... We embroidered, wove, painted and pasted static geometric pictures. Impersonal severe structures of surfaces arose. All accident was excluded. No spots, tears, fibres, imprecisions should disturb the clarity of our work. For our paper pictures we even discarded the scissors with which we had first cut them out, since they too readily betrayed the life of the hand" (Hans Arp, *Ainsi se ferma le cercle*, 1948).

Arp was opposed to "the analytical, intellectualistic and level-headed spirit" of Cubism because he was intent on releasing the insights of intuition. Working with untrammelled spontaneity he discovered those biomorphic forms which enabled the Surrealists to bypass the antagonism between representation and abstraction. Arp overstepped the limits of expressiveness inherent in traditional painting by introducing into his collages forms which he devised rather than discovered. The problem was reversed. Form was no longer the result of a stripping away: it was a reality, and a challenging one, charged with allusions to the rhythms of life. For Max Ernst, Arp's forms were the outward signs of a hypnotic language which "leads back to a lost paradise" and reveals "cosmic secrets."

But Arp also practised a purity of design which enabled him to remain on friendly terms with even the strictest abstract artists. Setting out his ambiguous, chance-born forms on a non-representational ground and avoiding any literary allusions, he opened up a new relationship between the solid and the void. His forms and space were the first example of what the Surrealists were to call "psychic automatism."

Arp, who was equally at home in French and German, also proved himself a gifted poet, writing in a manner similar to the verbal exercises of Hugo Ball. The latter noted in his diary (5 March 1917): "The image of man is gradually disappearing from present-day painting and objects are only present in a state of decomposition. This only shows, once again, how ugly and obsolete the human face has become, and how contemptible every object around us seems. In poe-

◁◁△ Hans Arp, Tristan Tzara and Hans Richter in Zurich, 1918.

◁△ Cover of the review Cabaret Voltaire, *Zurich, June 1916, with design by Hans Arp.*

△ Page from DADA 3, *Zurich, December 1918.*

▽ Simultaneous poem for three voices in Cabaret Voltaire, *Zurich, June 1916: "The admiral is looking for a house to let."*

try, for similar reasons, the time is near when language (like the object in painting) will be abandoned."

But Dada only became internationally known with the publication of its new review: *Dada 1* appeared in Zurich in July 1917, *Dada 2* in December. Tzara used it as a political weapon. He instinctively reverted to the aggressive and provocative stance of the Futurists in tract-poems whose boldness of form and sound was only surpassed by their outspoken content.

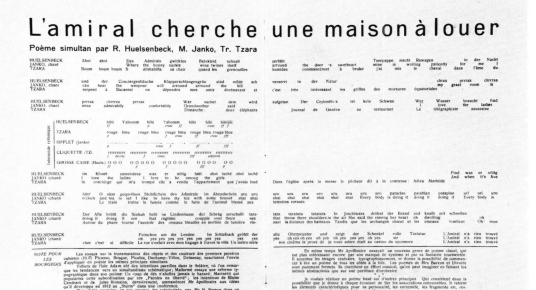

A corner of the Café Pittoresque, Moscow, 1917. Photograph.

The Russian avant-garde

The ferment of creative and provocative activity at the Cabaret Voltaire, in Zurich, had its equivalent in Moscow at the Café Pittoresque, a tavern-theatre which opened early in 1917, with the backing of the industrialist Filippov, and with Tatlin as artistic adviser. Here too painters, actors, musicians and poets found a meeting place where they could compare notes and bid defiance to a society and a time which seemed to be in no hurry to recognize them. There they could express themselves freely, even wildly, shattering the traditional conception of space in their sculptural constructions, grating on the nerves and senses in their musical innovations, snapping their fingers at critics and indulging in verbal fireworks. The fashionable bourgeoisie came there nightly to hear itself ridiculed and insulted by the poet Mayakovsky, with a spoon in his buttonhole. Executed by Tatlin, Yakulov and Rodchenko, the decorations of the Café Pittoresque were meant to symbolize "the expression of the new art movements in the world of man."

In Moscow, needless to say, the atmosphere was more tense than in Zurich. Russia was fighting for its life, the people were war-weary and distrustful of their leaders; disaffection was rife and revolution was felt to be the only way out, the only hope for a cultural and political renewal. Russian artists felt themselves called upon to play an even more subversive role than elsewhere. Three main tendencies held the field: symbolist expressionism dominated by Kandinsky, Suprematism or Purism launched by Malevich, and the Constructivism of Tatlin and Rodchenko. As each strove to outdo the other, each pressed forward on theoretical lines so bold and advanced as to outstrip their concrete achievements, which often lagged far behind their intentions.

A spate of tracts, pamphlets and manifestoes appeared, couched in terms so violent and extreme that they renewed the traditional relations between theory and practice. Hitherto theory had followed in the wake of practice, throwing light on it after the event. Duchamp alone had been an exception to this rule, producing works answering to a prior intellectual analysis made with the single-minded intention of changing a given situation. Now, in Russia too, the play of ideas and theory anticipated the actual work, defined its purpose in advance and set limits to the exploratory possibilities of its making. In this ferment of ideas, discussion was endless and certainly it helped to clarify the positions.

Futurism and Cubism were the detonators of the Russian art revolution. Futurism, with its emphasis on time and movement, brought home the importance of industry and machinery in a country which had not yet carried out its industrial revolution. "The new life of machinery and iron, the roar of motor-cars, the flash of projectors, the snarl of propellors, have awakened the soul... The dynamics of movement suggested the idea of also laying emphasis on the dynamics of picture-making. But the attempt made by the Futurists to arrive at pure picture-making, for its own sake, was unsuccessful, because they could not depart from the representational side of things in general" (Kasimir Malevich, *From Cubism to Suprematism*, 1915). At this time, early in the war, when he saw the limits of Futurism but also acknowledged its contribution, Malevich defined what for him were the distinctive features of the new artist's work: "There is creation only when there appears in the picture a form which owes nothing to what has been created in nature, but which proceeds from the pictorial masses, without repeating and without modifying the original forms of the objects to be seen in nature" (*ibid.*).

This insistence on original construction led the Russians straight to abstraction. They had derived that insistence from Cubism, with which they had become acquainted in several ways. In the first place, many works by the French Cubists could be seen in the homes of Russian collectors, and theoretical writings on the subject had already reached Russia; in *The Union of Youth* (3 March 1913), for example, Matyushin had published a Russian translation of several chapters of Gleizes and Metzinger's book *Du Cubisme* (Paris, 1912), then the most influential exposition of the principles of the cubist aesthetic. Furthermore several Russian artists, notably Tatlin, Sonia Terk, Alexandra Exter and Liubov Popova, had been to Paris before the war and had paid personal visits to Picasso, Delaunay and Léger, establishing vital and lasting contacts.

The Russians boldly reinterpreted Cubism in their own way, for what attracted them was the possibility it offered of breaking away from natural models. For them Cubism had cut the umbilical cord connecting art to nature and forcing it to keep to representation, to nature imitation. Nikolai Tarabukin, the most lucid Russian theorist of this period, put it as follows in *For a Theory of Painting*, written in 1916: "While the old art, from naturalism to early Cubism, is a 'representational' art characterized by the connection between the pictorial forms and those of the real outside world, the new art breaks off this connection, this dependent relationship, in order to create autonomous objects. And while the art of the past was opposed to the real world..., the new art is in a sense immanent to the world of reality: it creates objects, and no longer pictorial copies (naturalism) or arbitrary compositions (Cubism)... Pictorial art is not a 'vision'; this would enormously restrict the artist's work and limit its pictorial and philosophical meaning in the extreme. Just as music is not an art of imitating real sounds, so the art of painting is not 'knowledge,' for the domain of knowledge lies chiefly in science. Art is 'fabrication' and action, not a function of knowledge but before all else a voluntary function, for it establishes the primacy of creation over knowledge. Painting is not called upon to 'represent' the things of the outside world, but to fashion, make and create objects. It is not a 'representational' art but a 'constructive' art. It is this voluntary impulse which differentiates art from science, by valuing intuition in the highest degree."

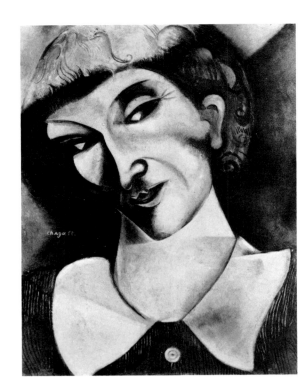

Marc Chagall (1887):
Self-Portrait,
c. 1912-1914. Oil.

Russian artists at home had already gone so far in their thinking about art that the more famous Russian painters who had been working abroad, in France and Germany, experienced some difficulty in finding their bearings when they returned home. A few days before war broke out in August 1914, Chagall had returned to his parents' home in Vitebsk. There he rejoined his fiancée Bella, who was just finishing her degree in history and philosophy. They were married on 25 July 1915, against the wishes of Bella's parents who did not want an artist in the family. With his return to Russia Chagall's painting took a more naturalistic, sentimental turn: landscapes (he often stayed in the country), genre scenes, portraits. He illustrated Yiddish texts; his prints became more abstract. But his happy marriage with Bella showed in the exhilaration of his paintings. He exhibited in November 1916 in Moscow, where the great collector Ivan Morosov took an interest in his work, and twice at the Dobichina Gallery in Petrograd (as St Petersburg was renamed in 1914). Employed there in the War Economy Office, he met the poets Blok, Yesenin, Mayakovsky and Pasternak. By the time the Revolution broke out in 1917, Chagall enjoyed a high reputation and had many connections among the new men rising to power. Before the war, in Paris, he had known Lunacharsky, who when the Soviet government took power was appointed People's Commissar for Education and Culture. Chagall's own name was put forward for a top post in the ministry of culture, but nothing came of it.

Chagall and Kandinsky

Marc Chagall (1887): The Blue House, 1920. Oil.

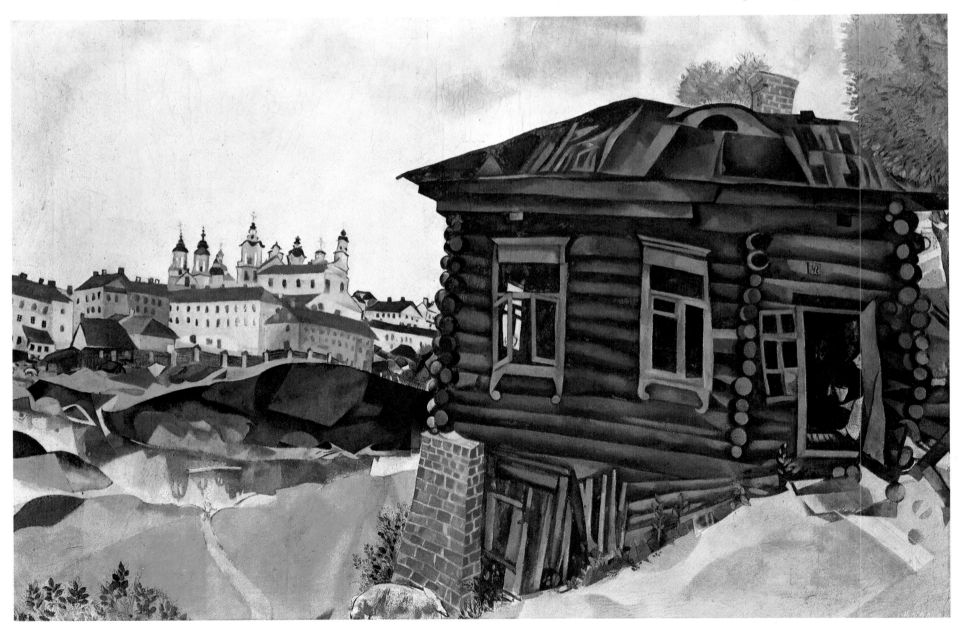

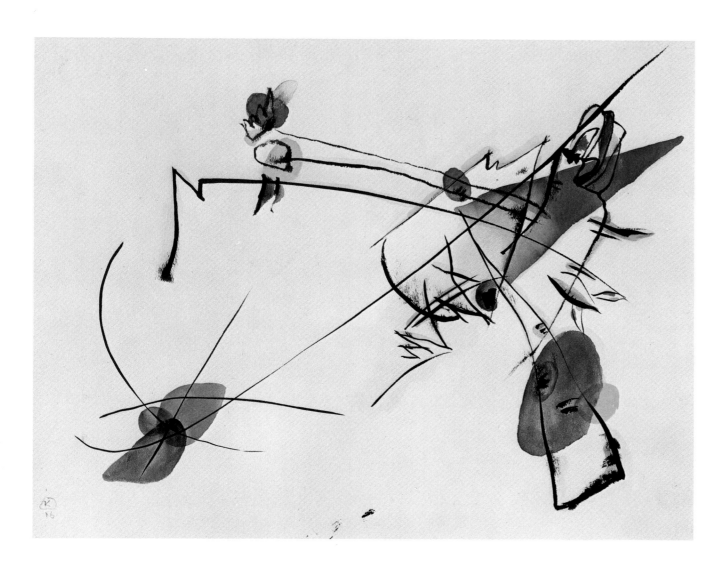

Wassily Kandinsky (1866-1944):
Simple, 1916. Watercolour.

Suddenly all was hushed.
One flash after another zigzags through space. The clouds are torn. The earth is split. And powerful explosions break the silence.
The lilac-coloured ground has turned to grey. This grey violently and irresistibly enfolds the hills. From the sieve falls a dust of strident tones.
Space quivers and echoes to a thousand voices. The world cries out.
This is an old picture of the birth of a new spring.
An old picture of the birth of a new spring, such is our period, our time: a time of awakenings, dissolutions, rebirths and storms, a time of renewed vigour and prodigious power.
In these periods of total upheaval, when white turns to black and black to white, when the world overflows with sparkling colours and rings with the echoes of a thousand voices—at such periods one becomes dizzy, struck with misgivings—is one to trust or not in that white which a moment ago was black?

Wassily Kandinsky, *Om Konstnären* (On the Artist), Stockholm, February 1916.

Kandinsky left Munich on the outbreak of war in 1914 and returned to Moscow by way of the Balkans and Odessa. He who had dominated abstraction in Germany, both by his ideas and the quality of his painting, now found himself cut off from his whole production. Taking advantage of an invitation from a Swedish gallery, he visited Stockholm in 1915-1916 and was able to recover his most important works from Germany and repatriate them via Sweden. He had another exhibition in Petrograd at the end of 1916. In the preface ("On the Artist") of February 1916 which he wrote for the catalogue of his Stockholm exhibition, he told how the war had left the abstract artists powerless but not without hope. He admitted to feeling that his art had then reached certain limits, those of a pure and spiritual art disliked, as it happened, by the home representatives of the Russian avant-garde. In this preface he distinguished between the "creative artist" and those whom he called "virtuoso artists" or decorators: "When will we cease to substitute questions related to form for the questions raised by art? When will it finally be understood that art does not originate from form, but form from art?" (Kandinsky, *On the Artist*, February 1916). And he condemned those who create "material beings without a spiritual content, whose richness is only an inner sonority, similar in this to everything that exists in the world we know, whether it is a human being, a tree, a sound, a stain." Kandinsky was convinced that the true artist is the one who "brings into play the form that is peculiar to him in order to express the spiritual content that is peculiar to him, in full awareness of what it is he wishes to reveal. It is not by the form but by the content that one recognizes the artist."

By his insistence on the individuality of the artist, intent on seeking "the projection of his inner experience," Kandinsky was excluded from the mainstream of Russian avant-garde art, which was seeking another function of art. But he was so well known as an artist that, after the Revolution, he was appointed director of the Museum of Pictorial Culture in Moscow, the world's first official museum of modern art.

The suprematism of Malevich,

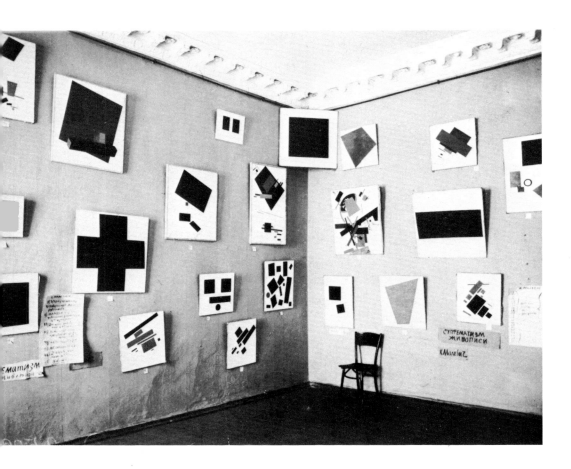

The first major confrontation between Russian artists took place in Petrograd in February 1915 under the title "Tramway V." Organized by Ivan Puni (later known as Jean Pougny), it marked the return of the artists in exile. But it retained a distinctly Cubo-Futurist character. Tatlin, however, made a new departure with his first *Corner Reliefs*, revolutionary works owing nothing to Western influence. Larionov took part, after being wounded at the front and invalided out of the army; then, later in 1915, he left Russia for good, with Natalia Goncharova, and settled in Paris. Larionov had done much to open Russia to avant-garde art; he now left the field free to Tatlin and Malevich. A second exhibition was organized by Puni in Petrograd in December 1915: this was "0.10" or the "Latest Futurist Painting Exhibition." Here, for the first time, Malevich showed his Suprematist

compositions, and the rivalry between him and Tatlin came into the open. Refusing to be exhibited together, the two artists even came to blows. Finally a compromise was reached, and Tatlin, Udaltsova and Popova were hung in one room, while in another were Malevich and his disciples Puni, Klyun and Menkov.

In 1915 Malevich published his Suprematist Manifesto (later published in German under the title of *Die Gegenstandslose Welt*, "The Non-Objective World"); and the thirty-six works illustrating it proved that he had been working along these new lines for over a year. From the time of the *Black Square on a White Ground* (1913) to his latest dynamic colour compositions, he had thought out a new conception of the picture space, which he described in a lecture given early in 1916 at the School of Decorative Arts in Petrograd. Until then, abstraction had been a matter of refining on the traditional data of painting and nature. Now, by limiting space to the surface of the frame, by restricting himself to elementary forms and pure colours, Malevich had brought painting back to zero, made a clean sweep of the past, and "wrenched the world from the hands of nature in order to build a new one over which he ruled as master."

He blamed the Cubists for not going far enough, for using flat surface patterns which were not an end in themselves but appeared in the guise of "artificial sculptures." He therefore reduced the picture to the black square, the only true pictorial realism. Suprematism marks the definitive break with the visible world, it is pure perception of form, pure consciousness of the painter's acts. Malevich explained himself at length in the manifesto of the 1915 0.10 exhibition:

"A painter who reproduces the objects and scenes of nature on which he has focused his attention is like a thief admiring his shackled feet. Only obtuse and impotent painters conceal their art behind sincerity.

"What is needed in art is Truth, not sincerity. Objects have gone up in smoke, clearing the way for a new artistic culture. The latter is moving towards autonomy of creation, towards domination of the forms of nature."

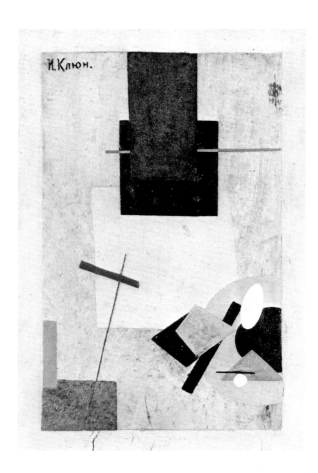

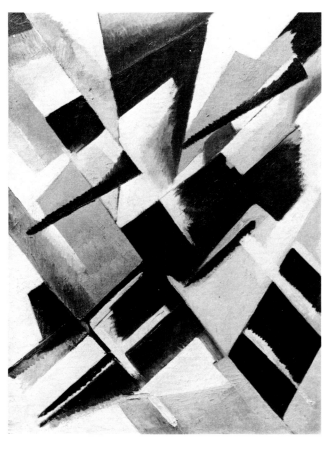

△◁ *View of "0.10" or "The Latest Futurist Painting Exhibition," Petrograd, December 1915.*

◁◁ *Ivan Klyun (1873-1943): Suprematist Composition, 1916. Oil.*

◁ *Alexandra Exter (1882-1949): Composition, 1918. Oil.*

"wrenching the world from the hands of nature"

I too was filled with a kind of timidity and hesitated to the point of anguish when it became a matter of leaving the world of will and representation in which I had lived and created and in whose authenticity I had believed.

But the sense of satisfaction I gained through liberation from the object carried me ever further into the desert, to a point where nothing more was authentic except one's sensibility alone. And so it is that sensibility became the very substance of my life. This square that I had exhibited was not an empty square: it was the sensibility of the absence of any object.

I recognized that objects and representation had been regarded as the equivalents of sensibility and I saw the fallacy of the world of will and representation.

Kasimir Malevich, *Die Gegenstandslose Welt*, 1927.

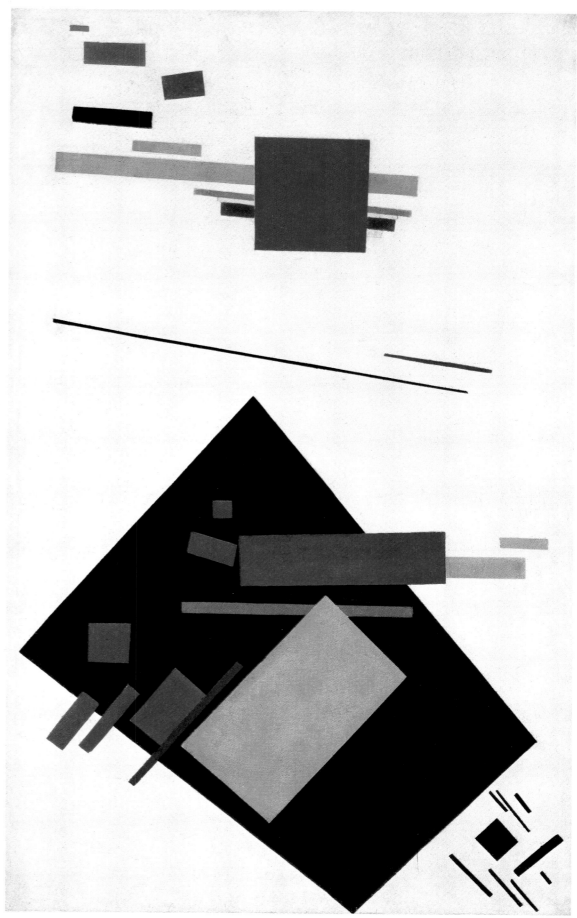

Kasimir Malevich (1878-1935): Suprematism, 1915. Oil.

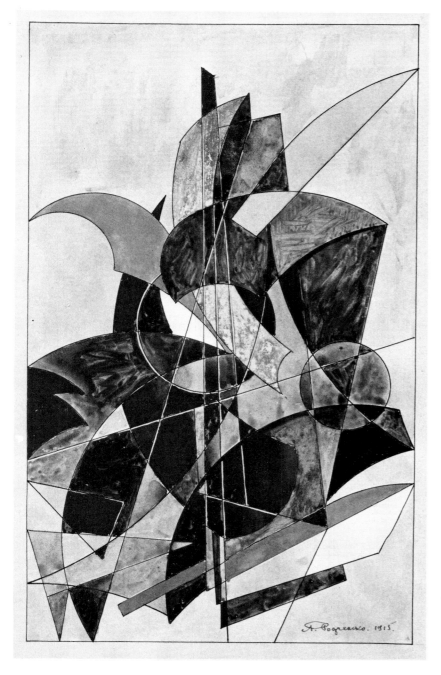

Alexander Rodchenko (1891-1956): Rule and Compass Composition, 1915. Indian ink and gouache.

33

Real materials
in real space

Like Malevich, Tatlin rejected the flat surface patterns of Cubism as not being an end in themselves. But he was opposed to the Suprematist conception of abstract art; he preferred instead to make his own exploration of real space: he thus moves on from painting to the third dimension. The visit he had paid to Picasso, in Paris at the end of 1913, when the latter was constructing his amazing assemblages, had made a deep impression on Tatlin. As early as 1914 he was thus led to use voids as an element of construction and space; for him they were a material as real as the wood, cardboard, metal and plaster which he used in constructing his reliefs. "Real materials in a real space," that was his programme. His earlier experience as a painter led him in his sculpture to free his volumes from the base, then from the frame and from any background at all. His "counter-reliefs" or "corner reliefs" supplied the model for the first sculptures suspended freely in space.

Cubism influenced Tatlin not as a system of representation but as a new model of construction. The objects he elaborated, and exhibited in 1915, led him to develop and work out that Constructivist conception which magnifies the reality of the constituent elements, and which Tarabukin describes as being the basis of sculptural realism: "As to the problem of the material itself, in painting and in art in general, it can be envisaged independently in so far as the painter has to develop his own sense of matter, to develop his feeling for the inherent qualities of each material, for it is the peculiar character of those qualities that conditions the construction of the object. It is the material that dictates the artist's form, and not the reverse. Wood, iron, glass, etc., call for different constructions. Consequently the Constructivist organization of the object depends on the material, and the study of different materials forms an independent and highly important question" (Nikolai Tarabukin, *For a Theory of Painting*, Moscow, 1916).

Naum Gabo (1890-1977): Head No. 2, 1916.
Galvanized iron.

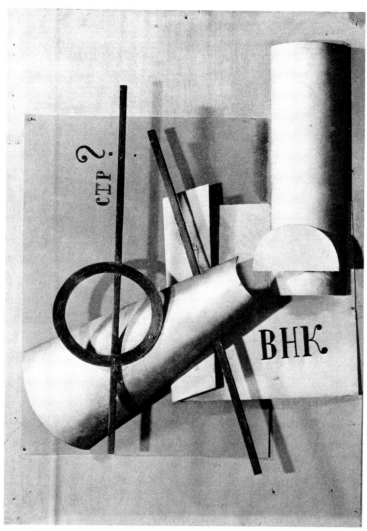

Ivan Puni (1892-1956): Composition, 1915.
Plywood and painted zinc.

his brother), born in 1890, knew at first hand the sculpture of Boccioni and the researches of Archipenko. Taking refuge in Oslo at the beginning of the war, they proceeded to pool their experience. Gabo, who had studied mathematics and physics, moved forward rapidly to a bold use of space; he also incorporated into his sculpture some of the latest advances of science. In *Woman's Head*, the first version of which was made before his return to Russia, he shows his interest in construction. The use he made of empty space, of voids, enabled sculpture to break away from the static mass. The two brothers were, however, more attracted by Suprematism, the non-objective art of Malevich, than by the functionalism of Tatlin. Much later, Gabo acknowledged that the inferences he drew from Cubism were similar to those drawn by Tatlin: "All that was before holy and intangible for an artistic mind, namely, the formal unity of the external world, was suddenly laid down on their canvases, torn in pieces and dissected as if it were a mere anatomical specimen. The borderline which separated the external world from the artist and distinguished it in forms of objects disappeared; the objects themselves disintegrated into their component parts and a picture ceased to be an image of the visible forms of an object as a unit, a world in itself, but appeared as a mere pictural analysis of the inner mechanisms of its cells. The medium between the inner world of the artist and the external world has lost its extension, and between the inner world of the perceptions of the artist and the outer world of existing things there was no longer any substantial medium left which could be measured either by distance or by mind. The contours of the external world which served before as the only guides to an orientation in it were erased; even the necessity for orientation lost its importance and was replaced by other problems, those of exploration and analysis" (Naum Gabo, *The Constructive Idea in Art*, in *Circle*, Faber and Faber, London, 1937).

This painting in terms of volume foreshadowed the break-up of the traditional genres; it announced that synthesis of the arts which was to be achieved in production art. This was seen clearly enough by Tarabukin in an article published in Moscow in 1923, *From the Easel to the Machine*, in which he analysed Tatlin's experiments: "In the past the visual arts were sharply divided into three type forms: painting, sculpture, architecture. We however, in the central counter-relief, volume constructions, and 'spatial painting,' are effecting a tentative synthesis of these forms. In them the artist recombines the architectonic construction of material masses (architecture), the volumetric constructivity of these masses (sculpture) and their expressiveness in colour, texture and composition (painting). It would appear that in these constructions the artist may consider that he has entirely broken away from the illusionism of representation, for he does not reproduce the reality of them, but takes the object as a completely autonomous value... In a word, both by the forms and by the construction and materials which he uses, the artist creates a genuinely real object."

The idea of the artist-engineer was born; it was destined to have wide social repercussions. These works were in the nature of laboratory experiments, but they played a considerable part in the acquisition of that mastery of production techniques which found its full scope in the manufacture of utilitarian objects.

When the Pevsner brothers returned to Moscow in 1917, they were thoroughly familiar with the avant-garde art of France and Germany, where they had lived for several years, and so were well equipped to play a leading role at home. Anton (later Antoine), born in 1886, and Naum (who later called himself Naum Gabo to avoid confusion with

Vladimir Tatlin (1885-1953): Counter-Relief, 1916.
Assemblage of wood and iron.

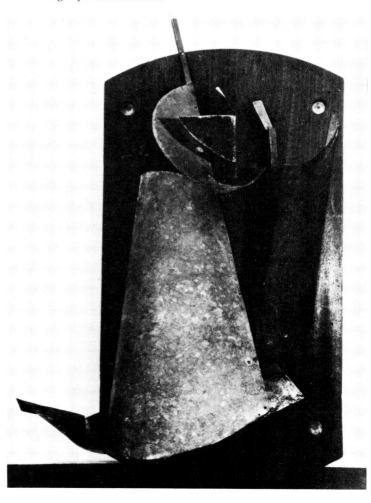

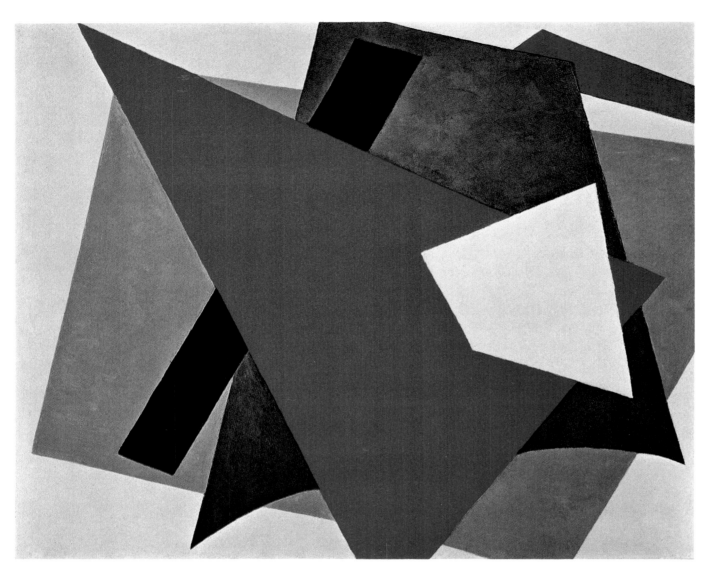

"Another order assigned to the laws of nature"

Liubov Popova (1889-1924):
Architectonic Composition, 1917. Oil.

It was at the exhibition "The Store" in Moscow in 1916 that Alexander Rodchenko made his appearance: he was soon to be in the forefront. Born in St Petersburg in 1891, he studied art at Kazan, on the Volga. After hearing Mayakovsky lecture on Futurism he joined the avant-garde. His interest in Art Nouveau had made him alive to rhythms and colours, and he early grasped the importance of developing an autonomous play of forms and colours, over and above the claims of representation. Coming to Moscow to attend the School of Decorative Arts, he met Tatlin who invited him to participate in the Store exhibition with Popova, Exter, Bruni, Klyun and Malevich. Rodchenko showed six of his abstract pen-and-ink drawings, made with ruler and compass, and these caught the attention of Malevich and Tatlin. In them he showed the originality of his experimental mind. He repudiated any decorative effect and any compositional problem, intent as he was on setting forth the forms for their own sake in their plane reality. A little later he collaborated with Tatlin on the decorations of the Café Pittoresque in Moscow and moved away from Malevich, whose idealistic views of non-objective art he did not share.

In an essay of 1921, *Line*, Rodchenko looked back over the evolution which had led him from surface to volume and touched on his rejection of painterly colour in favour of productivist ideas: "Line is a beginning and an end, in painting as generally speaking in any construction. Line is the path of progression, movement, collision; it is frontier, reinforcement, conjunction, cutting. Line has also overcome and destroyed the last entrenchments of painting: colour, tone, texture and plane surface... By stating the primacy of line as the only element permitting us to construct and create, we reject by the same token any aesthetic of colour, just as we reject handling and style (for

example, the square of Malevich)... Form, colour and handling are transformed into textures and become accessories with respect to line, which provides the whole system of the structure. Construction, in the clear and precise sense, that is as organization of real objects, can only be realized in terms of matter. This is why the suitable use of materials becomes a very important problem. We define construction as a system of executing the object implying a functional use of the material. So it is that his attempts to construct have led the artist, by way of constructions in space, to the creation of real objects, that is to production, which enables him to become a builder of material systems."

This essay makes it clear that Rodchenko's views were very close to those of Tatlin. What he writes about colour and functional objects reflects the experimental mood of Russian art in 1917. At that time, the form-colour problem was the essential problem for most Russian artists. It justified their unceasing experiments in reductivism and minimalism.

Was it the anti-traditional trend of Russian painting that favoured the emergence of so many women artists? Doubtless it was. Certainly they were far more numerous in this eventful period of Russian art than in any other place or period, and they played a decisive part. In addition to Natalia Goncharova, Larionov's companion, and Sonia Terk, who married Robert Delaunay, the new generation included Alexandra Exter, Liubov Popova, Varvara Stepanova and Olga Rosanova. A friend and follower of Fernand Léger, Alexandra Exter had acted in pre-war Paris as the link between French and Russian artists. Back in Russia during the war and the Revolution, she contributed much to the renewal of stage design. Working with A.I. Tairov, founder and actor-manager of the Moscow Chamber Theatre

(Kamerny Theatre), she helped to achieve there a veritable synthesis of the arts and laid the foundations of the Constructivist aesthetic. Olga Rosanova was one of the most characteristic artists of the Russian avant-garde. Influenced at first by Futurism, by 1916 she had arrived at a strict and thoroughgoing abstractionism. After the Revolution, she played an active part in reorganizing the art schools and renewed the concepts of industrial art. After her early death of diphtheria in 1918, at the age of thirty-two, she figured prominently in the first exhibition organized by the Soviet government, in December 1918, a retrospective ranging from Impressionism to Suprematism through 250 works. Liubov Popova was from 1914 on one of the most enterprising exponents of Russian abstractionism. In 1917 she painted some dynamic compositions in which colour-form was materialized with arresting boldness, setting an example soon to be followed by Matyushin. Colour, in her hands, is both space and dynamism.

Malevich too was pressing on with the conquest of colour. While demonstrating that the world of objects is illusory, he was led at the same time to stress the importance of the artist's powers of intuition. This point was made by Jean-Claude Marcadé in the introduction to his French edition of Malevich's writings (*Ecrits*, Lausanne, 1974): "Malevich, working with the basic signs of Suprematism, set out to dissolve them in the 'coloured movement' of the picture, which at bottom is the sole reality of painting. Painting, for him, is first and foremost the colour that shatters form from within, that immerses it: 'the coloured surface is the real living form.' The important thing in a picture is the colour that 'kills the subject' and the movement of the colour masses."

This intense involvement with colour led Malevich in time back to white. With his famous *White Square on a White Ground* (c. 1918), he restored its dignity to the act of painting and marked the perfection of the pictorial unit in the life of art. His series of *White on White* paintings was shown at the Second State Exhibition in Moscow in 1919, accompanied by a manifesto which Malevich wrote for it:

"Suprematism may be defined as a method which enables colour to follow up the long march of its culture. Painting springs from the mixing of colours, from the transformation of colour in the crucible of aesthetics, in a chaotic melting-pot, and the great painters have used objects themselves as a source of painting. I have discovered that the artist who has come closest to the phenomenon called 'painting' is

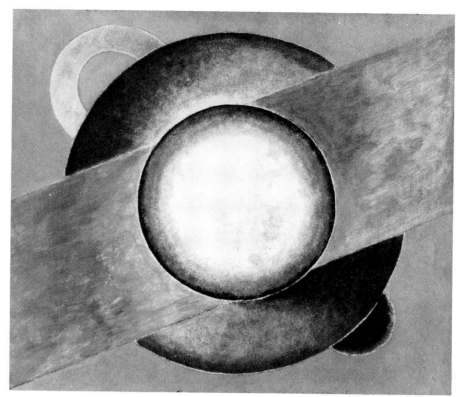

Alexander Rodchenko (1891-1956): Non-Objective Composition, 1919. Oil.

the one who has most deprived objects of their identity by breaking them up, and thus establishing another order attuned to the laws of painting. It became clear to me that the new sources of pure colour painting had to be created in such a way as to answer to the requirements of colour alone. Secondly, it appeared to me that colour, instead of being a pictorial mixture, should tend to become an independent unit, within a construction which, though functioning as one element in a collective system, is individually independent.

"A system may be worked out on its own account, in time and space, without resorting to aesthetic canons, to experiments or fashions. It may be described as a philosophical aggregate which progressively fits my new ideas into a coherent scheme.

"At the present time the human itinerary lies in space. Suprematism is the colour signal in this infinite space."

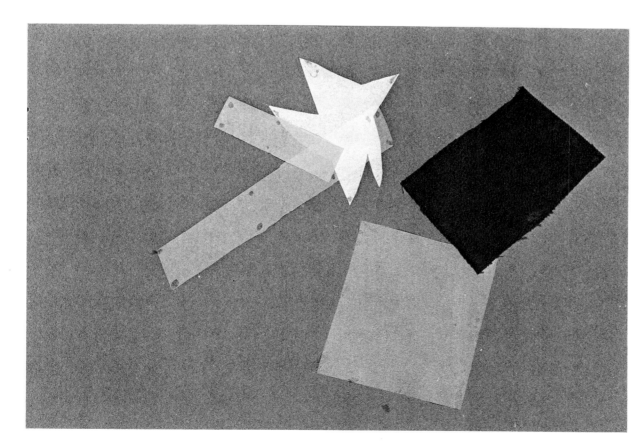

Olga Rosanova (1886-1918): The Explosion of a Case. Collage illustration for A. Kruchenykh's "Universal War," Petrograd, 1916.

Affirming
the autonomy of painting

Mondrian had left his native Holland in 1911 to work in Paris. The outbreak of war in August 1914 found him on a visit home, at the bedside of his sick father. He had then reached the limits of his early evolution, based on Cubism: he was at grips with abstraction, but abstraction condemned to decorative effects unless he could succeed in changing the motivations behind it. The one real debt he owed to Cubism was his method of breaking objects down into rhythmic patterns. Because he was not concerned with setting them in space, he was led to magnify objects until they occupied the entire picture space. This single-minded concentration on form was inspired by an idealism which focused his attention on basic principles. By a process of paring down and stripping away, he found that whatever the subject, whether seascapes, trees or church towers, his efforts yielded the same image. But at the same time he found that, depending on how that image was handled, it could produce different effects: "The male principle being represented by the vertical line, a man will recognize this element (for example) in the upright trees of a forest. He will see

Kasimir Malevich (1878-1935): Suprematist Composition: White on White, 1918 (?). Oil.

its complement (for example) in the horizontal line of the sea. A woman will identify herself rather with the extended lines of the sea and will see her complement in the vertical lines of the forest, these representing the male element. Thus the impression differs from one sex to the other" (Mondrian, *Notebooks*, 1914).

These remarks show that he was pondering on the effect produced by the work, and indeed set store by it. And since the elementary simplification of every subject led to the same pictorial result, it only remained for Mondrian now to discard the representational function of painting and to experiment with the expressive possibilities of the "pure means" at the painter's disposal for constructing the image. The surface of the canvas was his laboratory, his field of experiment. In the 1917 series of black and white pictures, done in Holland, he analysed the contrasts of verticals and horizontals without reference to the subjects which had suggested them. But as Marcelin Pleynet has noted: "The reduction of space in cubist painting is systematized and quite naturally leads the painter in the end to question the dimension thus abandoned; once he has achieved (more or less) his surface pattern, he begins to look back into the possibilities offered by depth. All Mondrian's colour-plane compositions of 1917 are devoted to that investigation of depth" (Pleynet, *L'enseignement de la Peinture*).

The piece of canvas is a starting point serving to limit or define the surfaces that will go to make it up; but these surfaces, whether devoid of colour or covered with pure colours, advance or recede, thus destroying that plastic unity which Mondrian, after the manner of Malevich, set out to build up from intuition. Working towards this desired equilibrium, Mondrian experimented systematically with different colour surfaces, contoured or uncontoured, moving progressively, as in the cubist period, from the smallest planes or shapes to the largest. Mondrian himself called this form of abstraction Neo-Plasticism, defining it as "painting which requires no more than the expression of relations by line and colour" (in *Cercle et Carré*, No. 2, Paris, April 1930). He found in this rigorous procedure a means of rising above the tragedy of the war and the petty claims of the individual.

Piet Mondrian (1872-1944): Composition in Black and White, 1917. Oil.

Bart van der Leck (1876-1958): Factory Exit, 1917. Oil.

Cover of the review De Stijl, Leyden, 1917.

△ Georges Vantongerloo (1886-1965): Construction in the Sphere, 1917. Painted mahogany.

◁ Piet Mondrian (1872-1944): Composition in Colour A, 1917. Oil.

▷ Theo van Doesburg (1883-1931): Composition in Black and White, 1918. Oil.

Piet Mondrian (1872-1944): Composition: Checkerboard, Light Colours, 1919. Oil.

The new things do not seem mature yet for the very men who launched them. The great departure, however, is an accomplished fact. This beginning has enabled us to follow up the logical consequences and give birth to Neo-Plasticism.

Piet Mondrian, in *De Stijl*, March 1922.

Living at Laren in North Holland during the war years, Mondrian became friendly with the Dutch philosopher Dr M.J.H. Schoenmaekers, who had just published *The New Image of the World* (1915) and *Principles of Plastic Mathematics* (1916). According to H.L.C. Jaffé, the historian of the De Stijl movement, Mondrian owed his peculiar terminology to this mystical philosopher, and in the latter's ideas found confirmation of his own intuition. Schoenmaekers had written: "We wish to penetrate nature in such a way that the underlying structure of reality may be revealed to us." And again: "However lively and capricious it may be in its variations, nature always functions fundamentally with absolute regularity, that is to say with plastic regularity." In Mondrian's view, art can express the fundamental characteristics of the cosmos with as much precision as mathematics.

Equally important was Mondrian's meeting with Theo van Doesburg (pseudonym of C.E.M. Küpper), poet, publicist, painter and architect, born in Utrecht in 1883; and with the painter Bart van der Leck, born in Utrecht in 1876, who had already carried out some advanced experiments in abstract design and the use of pure flat colours. The three men banded together to found the Dutch art periodical *De Stijl*, the first issue appearing in Leyden in October 1917. From the outset it was conceived as the mouthpiece for the ideas and principles of Neo-Plasticism, and in it Mondrian was able to formulate and publish his theories. The three founders were soon joined by several painters and architects: Vilmos Huszar, Georges Vantongerloo, J.J.P. Oud, Jan Wils and Robert van't Hoff; the last-named had just returned from the United States, where he had been in touch with Frank Lloyd Wright and Gerrit Rietveld. The De Stijl group felt the same imperative need as the Russian avant-garde to change the purpose and status of art. They were at one, also, in feeling that art offered a hope of liberating man from the subjectivism responsible for the war and the confusion engendered by it. They called for construction instead of lyricism, machinery instead of craft-work, collectivism instead of individualism. "Man, as he evolves towards the equilibrium of his duality, will be prompted more and more (in life as well) to create equivalent relations, that is, balanced relations" (Mondrian, in *Cercle et Carré*, No. 2, Paris, 1930). In the pages of *De Stijl* (March 1922) he justified painting as an inevitable laboratory experiment at the present stage of man's evolution: "The plastics of equilibrium can prepare the way for the plenitude of mankind and become the purpose of art. To some extent art has already begun to wreak its own destruction, but were the end to come now it would be too soon. The regeneration of art through life is not yet possible, and another art is still necessary for our time. A new art cannot be built out of the old materials."

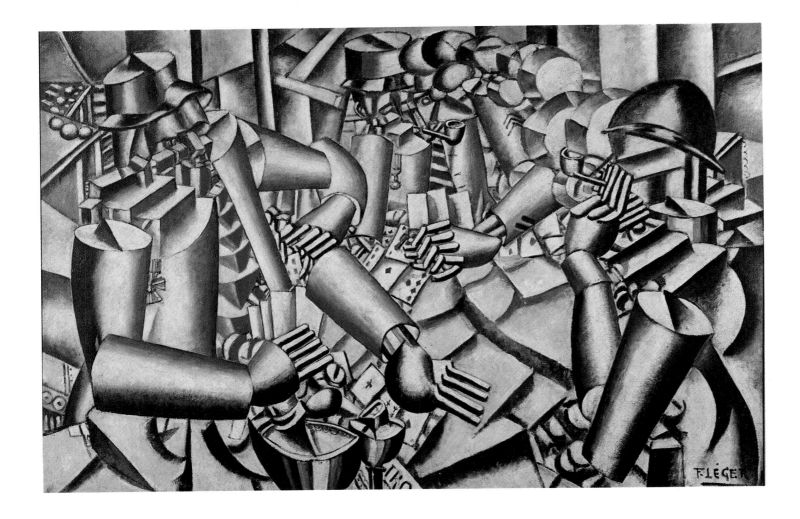

The year 1917 marked the most critical stage of the war. France and Germany were reeling from the bloodbath of Verdun, Russia was sinking into chaos, the Tsar having abdicated in March, the Communist Revolution due to break out in October. Mounting German pressure on the western front could only be withstood thanks to the United States, which entered the war in April 1917 but could not make its full weight felt until the following year. As Russia dropped out of the war, her example did much to breach the wall of national solidarity elsewhere (not least in Germany), and the unabashed defeatism of the revolutionaries reawakened and stimulated the widespread desire for peace. Strikes and mutinies on both sides betrayed the toll of physical and nervous exhaustion. At this dark hour the Allies gradually rallied and the situation was restored in November 1917 when Clemenceau became head of the French government and formed his Victory Cabinet. France was the mainstay of the western front, and it was her moral recovery and the creation of a unified Allied command under Marshal Foch, in April 1918, that led directly to the Armistice of 11 November.

Artists could not remain indifferent to the war; indeed many of them were at the front. One of these was Fernand Léger, whose evolution is significant. His wartime experience as a stretcher-bearer at the front changed his whole attitude to art. Wounded at Verdun, he was able to resume painting after coming out of hospital in 1917. "It was the war," he said later, "that made me put my feet on the ground... During those four years of war I was thrust abruptly into a blinding reality wholly new to me. When I left Paris my style was completely abstract: that was a period of pictorial liberation. Without any transition I found myself on a level with the whole of the French people. I was assigned to the Engineer Corps and my new companions were miners, navvies, workers in metal and wood. There I discovered the French people. At the same time I was dazzled by the breech of a 75-millimetre gun standing uncovered in the sunlight, the magic of light on white metal. This was enough to make me forget the abstract art of 1912-1913" (quoted by Douglas Cooper, *Fernand Léger et le nouvel espace*, 1949).

Born in Leipzig in 1884, Max Beckmann created during the war those images of violence which were to shape the course of Neue Sachlichkeit (New Objectivity) in Germany. During his war service in the medical corps, he touched the depths of human suffering and tried to express it in his art. His experience of death and violence prompted him to emphasize distortions and tighten his picture space. Influenced at first by Symbolism and Primitivism, he later harked back to the German Gothic tradition, which helped him to give a spiritual significance to the inhumanity of his time and drain it of its emotional content. The war had aroused man's lowest instincts, in circumstances of horror further protracted in Germany by defeat, hunger and domestic upheaval. Beckmann's painting is a firsthand account of the spiritual decay of Europe in his time, an account whose impact is heightened by strong design and vivid colours.

The revolution that burst forth in Russia opened an unknown world, for it was directed against the bourgeoisie born of the proclamation of the rights of man in 1789. In March 1917 Nicholas II abdicated and a ramshackle Provisional Government devoid of authority took his place, while the country drifted inexorably towards collapse and chaos. These conditions facilitated the bloodless seizure of power by the Bolsheviks in October 1917. Lenin proceeded to set up a Marxist dictatorship, ruling in the name of the proletariat. From the start the Russian communists had the proud conviction that, in their doctrines and actions, they were setting an example which the whole world would soon follow. For a few months everything seemed possible, until a new wave of terror ruthlessly eliminated both liberals and anarchists in the name of the counter-revolutionary struggle.

In the upheaval following the fall of the Tsar, the Imperial Academy of Art was closed and disbanded. Endless discussions went forward in Petrograd and Moscow as to the future of Russian culture, the new institutions to be founded, the reform of schools. The official ministry of art was opposed by a freely formed artists' union comprising three federations, the old, the central and the new federation. The latter grouped the avant-garde, with Tatlin as chairman and Rodchenko as secretary. For the artists the revolution offered a chance of creating a world in the image of their futuristic visions. The advent of a collective society and a new order based on science and technology filled them with enthusiasm: it gave meaning to their experiments. Malevich proclaimed: "Let us wrench the world out of the hands of nature and build a new world belonging to man." The artists themselves took in hand the organization of artistic life, and for four years they were able to express themselves freely, with untrammelled imagination. They did their best to make the people understand the governing ideas of the Revolution, inventing new forms of visualization in order to appeal to Russia's illiterate masses. The artist's place was no longer in the studio, before an easel; his place was in the street, in the thick of daily life. The first anniversary of the Revolution was an occasion for parades and pageantry organized by artists. In Petrograd, Nathan Altman requisitioned the Winter Palace and, with the help of Puni and Bogoslavskaya, a battalion of soldiers and thousands of citizens were mobilized to represent the storming of the Winter Palace. The square was decorated with abstract sculptures, the surrounding buildings with cubist and futurist paintings.

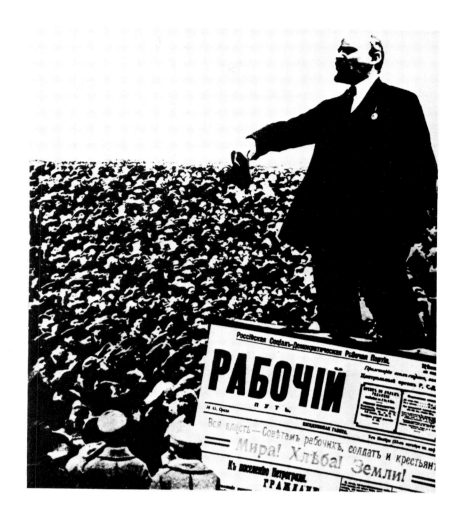

Consequences
of the war
and the
Russian Revolution

◁ *Fernand Léger (1881-1955): Soldiers Playing Cards, 1917. Oil.*

△ *Alexander Rodchenko (1891-1956): Lenin Speaking on Peace, Bread and Land. Photomontage, c. 1918 (?).*

▷ *Max Beckmann (1884-1950): Night, 1918-1919. Oil.*

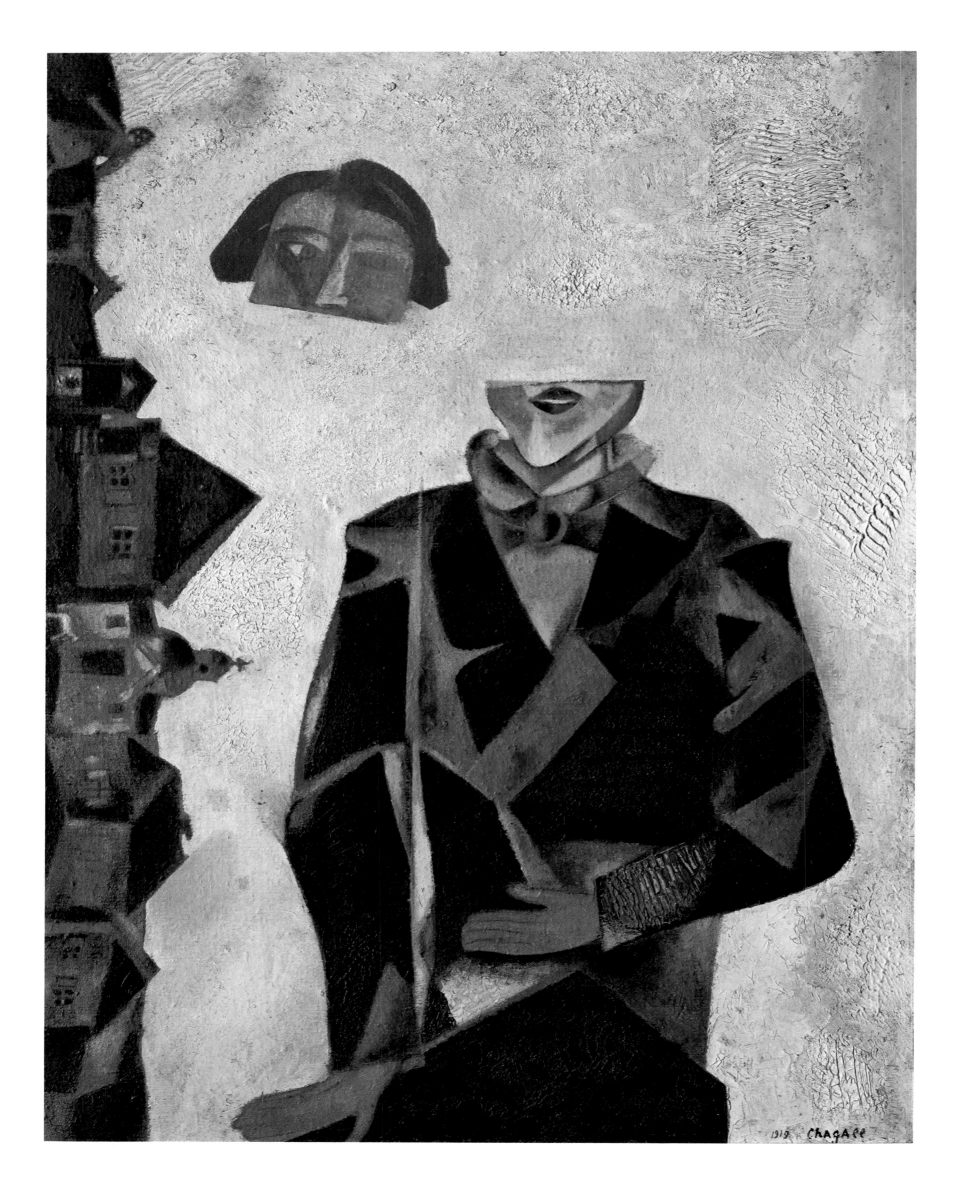

Marc Chagall (1887): Anywhere Out of the World, 1919. Oil.

The Momentum of Change

1919-1924

Lyonel Feininger (1871-1956):
Cover for Walter Gropius's
Bauhaus Manifesto, 1919.
Woodcut representing the
Cathedral of Socialism.

THE DIVERGENCE between the revolutionary attitude of the Russians and the return to tradition which swept over France and Europe went far beyond a simple opposition of styles. Tarabukin, to cite him again, enables us to pinpoint the problem: "The world today makes totally new demands on the artist: it expects from him not 'pictures' or 'sculptures' for the museum, but objects socially justified by their form and purpose. There is already enough in the museums to make it pointless to fill them still further with new variations on old themes. Life no longer justifies artistic objects which are discredited by their form and content" (Nikolai Tarabukin, *From the Easel to the Machine*, 1923). And he concludes: "In democratic art every form must have a social justification. Thus, envisaging contemporary art from a sociological point of view, we have reached the conclusion that studio art as a museum form has had its day."

Such an affirmation made it necessary to question the use made of art. For all the artists of the previous generation, and for the older artists of the present one, art had but one ultimate destination: the museum. Yet a century and a half before, no one had yet dreamt of that goal! When Tarabukin denounced the museum he was taking a position less against art than against the final aim assigned to art by a particular moment of history.

But as yet the artist did not gain access to the great museums during his lifetime; hence in the 1920s structures had to be devised to show, sell, and advertise art to industrialist and bourgeois collectors. The general exhibitions lost their importance—no Salon would henceforth produce the reverberation of those before the war—to the benefit of the art galleries, which multiplied. Larger and more powerful than the Salons, they had a more intense activity and were above all more commercial. Some of them introduced into their trade—luxury and elitist to be sure—techniques which had won their wings. Advertising, the politics of prizes, speculation, these invaded and conquered the commerce of art. The product, therefore, had to have character; it had to be individualized or novel in form. At the same time, some museums began to accept other missions than that of pure conservation: they became centres of instruction on the art of the day by displaying the work of groups; or they furthered knowledge by mounting retrospective exhibitions. The publishing trade also became interested in art. The first illustrated biographies of artists date from the twenties, and when they dealt with contemporary artists they were often supported by the galleries.

France had won the war: bled white and ruined it was, to be sure, but triumph was there. In such a context, to cast doubt on the structures which had produced victory was out of the question, and instead there was an attempt to forget the suffering of the present in dreams and celebrations...

The 1919 Salon d'Automne in Paris contained no surprises; Picabia alone raised an outcry against a "regression" which he felt on all sides. The Fauves and the Cubists, on the other hand, aspired to the re-establishment of order. Derain, who passed for one of the most daring experimenters of the pre-war avant-garde, now set the example for a return to the models of the past. In his wake grew up a tendency of nationalistic inspiration: the Jeune Peinture Française movement, which included André Lhote, André Dunoyer de Segonzac, Roger de La Fresnaye, and A. D. de La Patellière. It called for tradition, the return to painting and to nature, to fine craftsmanship and to sensuality. This was the moment of the new Bucolics. After so much grief and suffering, aspiration to the simple, the obvious, and to recognized values was a comforting response.

Bonnard scored a triumph, for by instinct he painted the joy of life, the charms of nature, the quality of feelings. In this way he overcame a rather lack-lustre output by the affirmation of his freedom and joy. The Jeune Peinture Française group chose him along with Renoir as honorary president. In 1919 two books on Bonnard were published, and the number of his exhibitions increased. He painted many landscapes with colour of unequalled power. Because he had forgotten nothing of the demands of flat composition and of optimal opposition between values which had been discovered during the time of the Nabi painters, he could make his palette burst into a thousand fires without dissolving forms; he even enjoyed going against the laws of colour-light, using blue for light and warm tone for shadow. Such is the intensity of Bonnard's painting that order seems more rigorous when he reverses it. "The painting is a series of colour patches which fuse together and end by forming the object over which the eye travels without meeting a snag," he said, just when, thanks to his sensibility, he was contriving to merge nature into painting.

There were other preoccupations which led Matisse to a reconsideration of the real, although he was no more resistant than anyone else to the general feeling of relief after the war. The Riviera also invited him to that easing of tension. "To me it seems like a paradise which I have no right to analyse, and yet, damn it all, I'm a painter and must analyse. Ah, it's a beautiful part of the world, Nice," he wrote to Camoin on 23 May 1918. For the first time in a long while he painted landscapes directly from nature. That same year he visited Bonnard at Antibes; both were to exhibit frequently, and often in the same galleries.

Above all, Matisse returned to the exploration of the third dimension, which, however, he sought to render by different means: values, the spatial position of tints or tones, a reversed expression of light. Even if some saw in this nothing but an art of pure delight and simple enjoyment, it in fact represented a need in Matisse to go back to a more direct and individualized expression to mark his love of life. A closer look at the work of Matisse and Bonnard shows that neither surrenders to facility; instead, they suffuse the surface of the canvas with that light which seals forms and space in a lyrical unity, reflect-

Pierre Bonnard (1867-1947): The Terrace at Vernon, 1920. Oil.

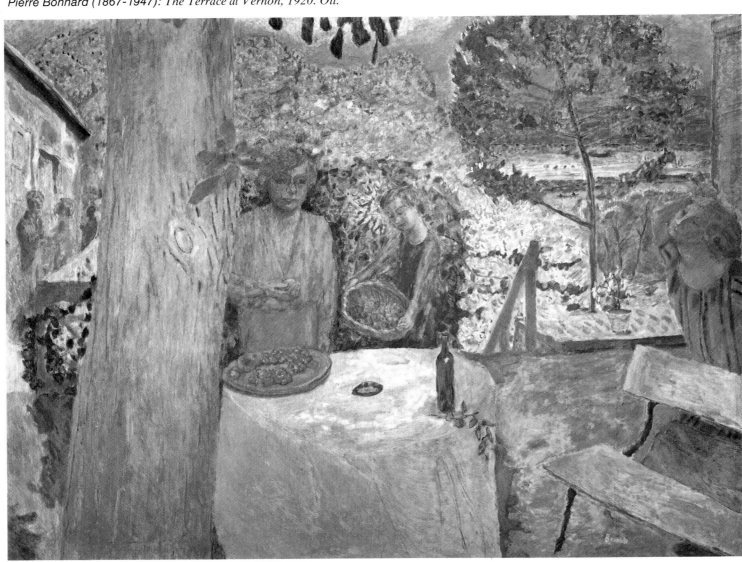

Matisse and Bonnard, a new lyrical unity

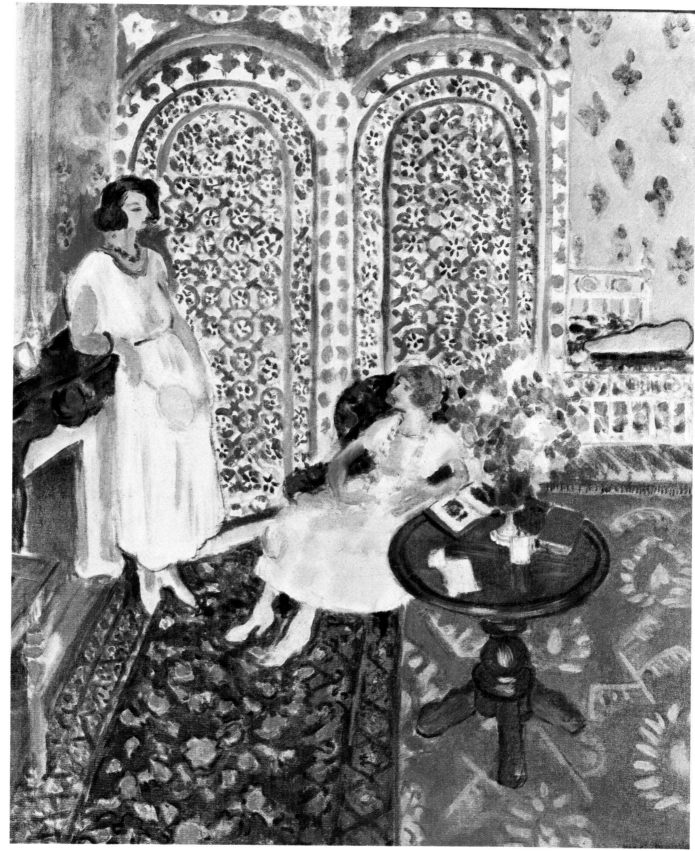

Henri Matisse (1869-1954): The Moorish Screen, 1922. Oil.

ing the artist's deep emotion. Feeling, with them, always wins out over experimentation.

Some years later, in 1929, on the eve of a new departure, Matisse acknowledged this fact: "My aim is to render my emotion. That state of soul is created by the objects which surround me and react within me: from the horizon to myself, including myself. For very often I place myself in the picture and I am aware of what there is behind me. I express space and the objects located in it as naturally as if I had before me only the sea and the sky, in other words, what is simplest in the world. I say this in order to make it clear that the unity I achieve in my painting, however complex, is not hard for me to obtain, for it comes to me naturally. I think only of expressing my emotion. What makes things difficult for an artist very often is that he doesn't take the quality of his emotion into account, and his reason leads his emotion astray. He should use his reason only to supervise" (quoted by Tériade, "Visit to Henri Matisse", *L'Intransigeant*, 14 and 22 January 1929). Matisse was seeking the mastery of the art of arrangement.

During the summer of 1919, Picasso and Derain travelled together to London, where each designed some sets for Diaghilev's Ballets Russes. It was Derain who stated at that time that Raphael was the greatest of misunderstood painters, thereby testifying to his own desire for a return to absolute classicism. Roger Bissière—then a young painter who had not yet discovered the abstract lyricism by which he became known later—shared that feeling, and the justification he gave for it is significant: "We stand at a moment in the history of art when our race, having furnished a great effort and gone through incredible convulsions, feels a desire to be calm, to add up the sum total of the treasures it has amassed. In a word, we aspire to a

beautiful but without significance, in which the hand found satisfaction while the soul, weary of the road already travelled, took its rest? Or, at a time when hatred ruled the world, when self-conscious Latin caution rose up in hostility against nebulous German metaphysics, did this painting seek to place itself specifically on the French side?" (Uhde, *Picasso et la Tradition française*, 1928).

Picasso did a great deal of work for the ballet and the theatre: *Le Tricorne* with music by Manuel de Falla in 1919, marking the return of subjects inspired by Spain, *Pulcinella* in 1920, *Cuadro Flamenco* in 1921, Cocteau's *Antigone* in 1921, *Mercure* by Satie and *Le Train Bleu* in 1924. He was very taken up by this collaboration and by the

Picasso,
the return to the subject

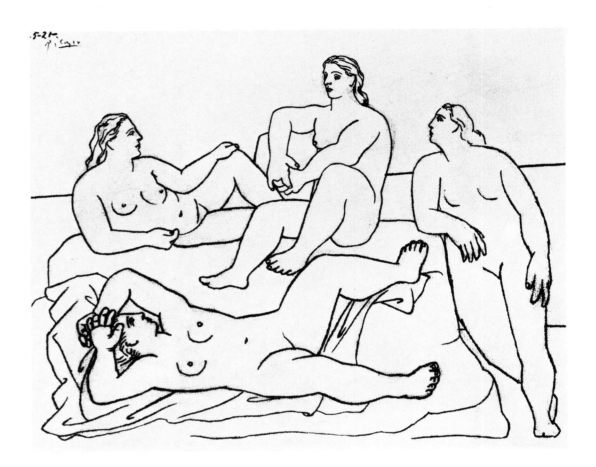

Raphael, or at least to all that he represents in the way of certitude, order, purity, spirituality. But we are not Italians... and we place all our hopes in Ingres, the only one, it seems, capable of leading us in the direction of Raphael by roads that are eminently French" (Bissière, "Notes on Ingres," in *L'Esprit Nouveau*, No. 4, 1920).

Braque's exhibition in March 1919 at the Léonce Rosenberg Gallery again prompted Bissière to draw this curious lesson from Cubism: "It will prove to have brought painting back to its traditional methods, from which we have strayed during the last fifty years. It will have taught us to have respect once again for the paints and the craftsmanship of the painter... Cubism: a 'recall to order' which has helped to save modern art" (*L'Opinion*, 29 March and 26 April 1919).

As for what was being done by the most unpredictable of modern masters, there was great confusion in interpretation: Picasso's old friends were baffled by his new manner. Wilhelm Uhde did not hide the disappointment he felt on his visit to the exhibition which Paul Rosenberg devoted to Picasso at the end of 1919. "I found myself in the presence of a large portrait in what is called the 'Ingres style'; the conventionality of the pose and a deliberate sobriety seemed to be repressing in it a secret emotion; the baroque showed through only slightly in the line, in the ordering of the principal masses. What, then, did these paintings mean? Were they an interlude, a game,

demands of the fashionable life he led with his wife Olga. His stays on the French Riviera in summer, Saint-Raphaël in 1919 and Juan-les-Pins in 1920, revealed a different kind of light to him and brought the theme of bathers back into his work. Furthermore, on 3 February 1921 his son Paul was born: the theme of mother and child became the inspiration for numerous works. That summer he painted the *Three Women at the Spring* and the *Three Musicians*.

Picasso's work seemed as split in its themes as in its forms. On one hand, in the still lifes and paintings directly inspired by the theatre and the stage, he achieved more profound plastic solutions in synthetic Cubism, without always escaping decorative effects; elsewhere he played with naturalistic forms marked by his desire for a classical style, and seemed to be heading towards neo-realism. At the end of 1918 he had lost his friend Guillaume Apollinaire, the inside observer of his adventure in Cubism. The poet, in his preface to the exhibition organized by Paul Guillaume in January 1918, had shown himself to be a prophet: "Picasso is the heir of all the great artists... He changes direction, retraces his steps, starts afresh with a firmer tread, constantly gaining in stature, becoming stronger through contact with unknown nature or by being compared with and tested against his peers of the past... Picasso is often a lyric painter..., he has greatly extended the domain of art, and in the most unlooked-for directions."

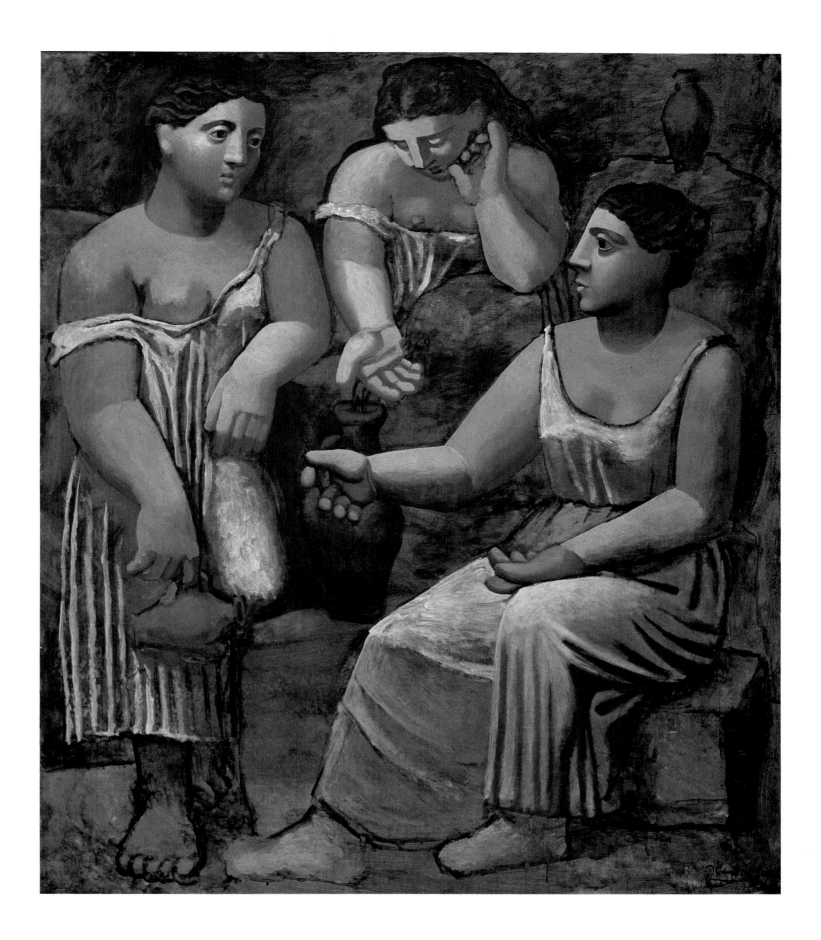

Pablo Picasso (1881-1973):

◁ *Group of Four Bathers,
1921. Pencil.*

▷ *Three Women at the Spring,
1921. Oil.*

Unquestionably at this time there was a coincidence between Picasso's return to the real, his rediscovery of Spain and its folklore, and his pleasure in watching the movement of women bathers on the beach. He renewed that experience during a stay at Dinard in 1922 and one at Antibes the following year. He seemed all the more removed from Cubism in that in 1920 he had refused to associate himself with the Cubist exhibition at the Salon des Indépendants.

His drawings inspired by bathers enabled him to develop an automatism of line previously unknown; and when he turned to the example of classical masters it was less for stylistic questions than to give a meaning to the image. He wished not to imitate those examples but to transform them into something else. Above all, Picasso redis-

covered in antique forms the myths and images of the Mediterranean world and a new possibility of figuration and narration. He also found out how to make contact again with values of civilization that had already ceased to be current before the war.

The *Three Women at the Spring* showed that the problem of representing depth remained primordial for Picasso. Beyond its statement of a theme and its classicist style the *Three Women*, in their thickness and static quality—which recalled the hieraticism of his pre-Cubist figures—betrayed a profound need to project oneself into space in a different way, no longer with the eyes alone, but with all the senses, the spirit, and the memory. This "return to order" was merely the outward sign of a return to primary sources.

◁ *Felice Casorati (1886-1965):*
Waiting, 1921. Tempera.

▷ *Giorgio Morandi (1890-1964):*
Metaphysical Still Life,
1920. Oil.

▽▷ *Ardengo Soffici (1879-1964):*
White Bottle and Apple,
1919. Oil.

In Italy the "return to order" took the form of nostalgia for the past. Chirico and his friends, in giving a new meaning to the classical representation of space, condemned the revolutionary modernism of Futurism. Even Severini proclaimed the return to the classical in a highly significant text published in 1921: *From Cubism to Classicism*. In that essay, the former Futurist showed that only by emphasizing construction could art free itself from the tyranny of individualism and singularity.

The Roman art magazine *Valori Plastici*, a monthly which first appeared on 15 February 1918, was to play a leading role in the development which drew painting inexorably back to naturalism. The most important Italian artists used it to plead for an art in which subject and feelings would fully regain their primacy. In a text published in April 1919, *Sull'arte metafisica*, Chirico wrote: "Every object has two aspects: the ordinary one which we see almost all the time and which people see in general; the other, a special or metaphysical aspect grasped only by a few rare individuals in moments of clairvoyance and metaphysical abstraction, just as certain bodies hidden by impenetrable substances are perceived, for example, by X-rays or some other powerful artificial means" (*Valori Plastici*, April-May 1919).

Chirico was already turning away from this second aspect; however, the Surrealists recognized it in his work when he came to Paris in 1924. Breton, stopping to reflect on the "signal" triggered by Chirico's objects, wrote: "With the sensorial which remained subjacent,

with the analytical procedures themselves, we pass with Chirico from Post-Impressionism to Cubism into the pure emblematic... Painting like this, which preserves of external aspects only what creates enigma or allows portents to be singled out, tends to make divinatory art one with art proper" (André Breton and Gérard Legrand, *L'Art magique*, 1959).

If at the beginning they wished only to justify a new way of painting by rehabilitating the great pictorial tradition, the Italian artists soon slipped into a naturalism that would be rapidly caught up in the rising wave of Fascism. The thing was as good as done in 1922, when the Novecento movement was founded in Milan, bringing together again most of the collaborators of *Valori Plastici* and many other artists. In March 1923, on the occasion of their first exhibition, these painters preached the determination to "make a purely Italian art, drawing inspiration from the purest sources and removed from all imported trends." In 1924 the Novecento group had its consecration at the Venice Biennale.

These painters gradually ended up in objectivism. If at the start of the twenties objects still appeared to them as if distanced in an ambience of mysterious fatality, observation subsequently won out over contemplation. Moreover, the model of the Quattrocento masters could serve as a stylistic guide only while giving their art an added charge of emotionalism and modernist miserabilism. Morandi alone avoided the pitfalls of literalism and sentimental effects. Confining his subjects to the strict arrangement of a few objects, he created a paint-

ing out of which emerged a totally poetic divination of the real, and, above all, he succeeded in endowing space with an ineffable presence.

This verism and return to tradition that was triumphing in all the European countries was also bound up with the political conditions arising out of the war. But the example of Italy is significant. There more than elsewhere a general climate of disillusionment settled in, along with the feeling that victory was far from being a paying proposition. Soon the adherents of the "Fasci" became, with Mussolini, a force capable of exploiting the latent patriotism and nationalism in that still young democracy. In the name of national unity and grandeur Mussolini lost no time imposing a totalitarian regime, thereby stifling whatever he thought might weaken the nation. Fascism employed emotionalism against rationality, and in an almost liturgical manner exploited the traditional values which enabled it to create the belief in a strong unity and individuality. This convergence of a political will and of the need shown by the artists to renew contact with their forebears would enable the members of the Novecento group to receive support from the power of the State.

Pictorially, submission to the models of the past was a way to avoid questioning the present. The tyranny of form, style or composition would henceforth be individualized only by the most superficial signs of the emotivity of each painter. The same attitude was to be found among the architects of the 1930s; in the name of Neoclassicism they became accomplices of the government in power while giving themselves the alibi of modern and national artistic creation.

51

L'Esprit Nouveau: art and science join hands

In France Purism displayed a "return to order" of a quite different nature than in Italy, basing itself on the rejection of individual differences. Its leading spirits, Amédée Ozenfant and Charles-Edouard Jeanneret (he was to take the name of Le Corbusier only in 1921), made their position known in a long manifesto of sixty pages, *After Cubism*, which accompanied an exhibition of their works at the Galerie Thomas, Paris, in December 1918. They demanded for art "stark facts, stark figurations, stark architecture—as purely and simply formal as are machines." Most of all they aspired to go beyond Cubism through the affirmation of mathematical, geometric, organic construction. Very close in spirit to the Bauhaus, developed by Walter Gropius at Weimar, they sought to reconcile art and science: "There is solidarity between scientific advancement and the progress of beauty: by giving us new lights on nature, science enables art to advance, awakening our senses to unrecognized harmonies, sensation as yet without emotion on the threshold of beauty. Science and art work together" (Ozenfant and Jeanneret, *Après le cubisme*, 1918).

The recognition of this kinship between art and science meant that artistic activity could be carried on in all the works of man, and not just within the space of a painting. Overturning the traditional hierarchy, Ozenfant and Jeanneret wrote: "We accept a hierarchy of the arts: pure sensation = ornamental art. Organization of raw sensations—pure forms and colours = superior art. The trend today is to rigour, precision, the best utilization of forces and materials, of the least scrap—in short, the tendency is towards purity. That is also the definition of art" (*ibid.*). This purity could be obtained only by starting with laws: "laws are in no way a constraint; they are the inevitable but unshakable armature of all things. An armature is not a shackle" (*ibid.*).

Ozenfant and Jeanneret made lengthy explanations to illumine all the originality of the spirit of their creation and to distinguish themselves from other tendencies on which many works of the period were based. In fact, the Cubist style was in the limelight: artists geometrized, arbitrarily fragmented space, speculated with the emotional resonance of colours and materials. Cubism became the alibi of modernist decorators, and only the most knowledgeable collectors could distinguish the geometric forms which aimed only to please from those which genuinely proposed a new order. For Ozenfant and Jeanneret the investigation had to be pushed still further: art had to be made to enter life and a new synthesis was needed between the different artistic practices: "Art, therefore, is concerned with recreating its language, with regaining awareness of its methods: Naturism, Impressionism, and Cubism have brought freedom from bad habits and ossified traditions. It remains to construct works that truly belong to our own time." And they conclude in a peremptory tone: "The worth of painting rests on the intrinsic quality of the plastic elements and not on their representational or narrative possibilities... The work of art must not be accidental, exceptional, impressionistic, inorganic, picturesque or protesting, but on the contrary, general, static, expressive of what is invariable... Art has won every freedom except that of not being clear" (*ibid.*).

These ideas were to be defended in the periodical *L'Esprit Nouveau* (Paris, 1920-1925) which allowed Le Corbusier to forge links with the other movements in which prevailed the desire to codify a "universal emotive language": De Stijl, the Bauhaus, and even the Russian Constructivists. This purist spirit was less significant in its pictorial achievements than in its applications in architecture; and it enabled the future Le Corbusier to reinvent the space and setting of daily life.

Le Corbusier was thirty when he settled in Paris for good, at the beginning of the year 1917. He was then thoroughly acquainted with the experiments in design of the Deutscher Werkbund, and more particularly with the buildings and objects designed by Peter Behrens.

But he had to assimilate the construction and dynamism of Cubism in order to renew his creative attitude and rid himself of the aestheticizing symbolism inherited from Art Nouveau. Strengthened by this theoretical and analytic contemporary experience, Le Corbusier already showed in *After Cubism* (1918) how organic and spatial requirements would renovate architecture. Before he could express

himself freely in the field of construction, he tried sculpture, which he reduced to contrasts of primary volumes, and painting, which he simplified into constructed oppositions of pure forms and colours. It was what he would call "the engineer's aesthetic." Cubism had made artists more keenly aware of essentials. Shortly afterwards, in an article in *L'Esprit Nouveau* devoted to Cubist sculpture, Le Corbusier showed, for example, how the analysis of plastic elements freed from figurative references had given him the idea for lighter and more transparent forms in architecture; he also said that "art had nothing to do with resembling a machine." The machine could be only an analogical model for creating the buildings and objects of a new world—a "pure creation of the spirit."

"The purist element," wrote Ozenfant and Jeanneret, "springing from the purification of standard forms, is not a copy but a creation, whose aim is to materialize the object in all its generality and its invariability. The purist elements are thus comparable to words with a fixed sense: purist syntax is the application of constructive and modular methods; the application of laws governing pictorial space. A painting is a whole (a unit): a painting is an artificial formation which, by appropriate methods, should tend towards the objectification of an entire 'world'... Purism attempts an art using plastic constants, escaping from conventions primarily addressed to the universal properties of the mind and the senses" (*ibid.*).

It will be seen some day soon that since 1914 there have only been two living collective tendencies: Dadaism and Purism. The two movements are apparently opposed but equally averse to the insipidities and expedients of art. Both have cleared the ground: the first by disorganizing routines by heaping ridicule on them, the second by proposing a discipline.

Amédée Ozenfant, *Art*, 1928.

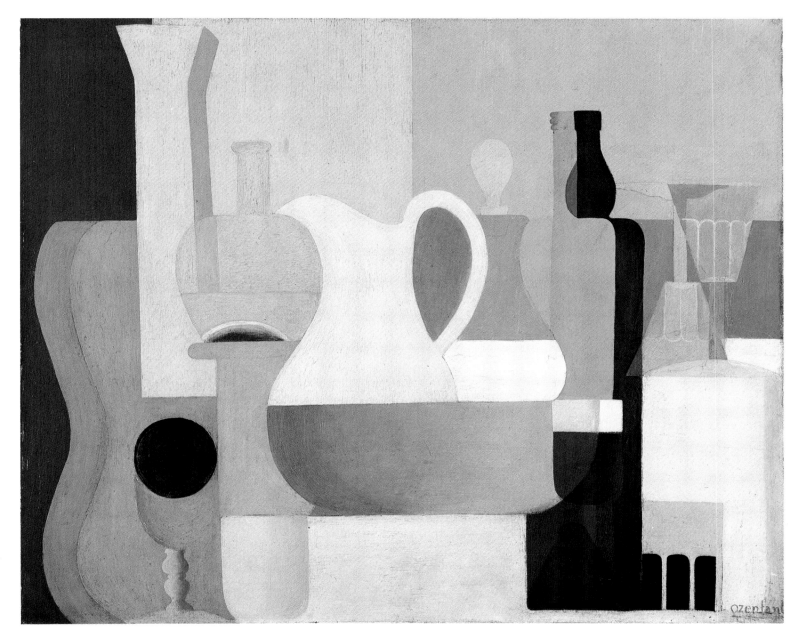

Amédée Ozenfant (1886-1966): Still Life with a Glass of Red Wine, 1921. Oil.

The rule and emotion

In a short study published after the death of Juan Gris in 1927, D. H. Kahnweiler recalled: "Braque wrote: *I love the rule which corrects emotion.* Gris replied: *I love the emotion which corrects the rule.* The work of Gris, while bespeaking the 'rule' which aims at order, at clarity, is suffused with the most profound emotion, the poetic creation of an authentic painter" (Kahnweiler, *Juan Gris*, 1928).

In Braque as in Gris, both disoriented by the veerings of Picasso, the disorders of the war had generated the need for a return to order, which became manifest in fact through "rules" tempered by emotion. The conquering and revolutionary aspect of Cubism henceforth belonged to the past. Moreover the masterpieces which constituted its affirmation would not thereafter be shown in Paris until the World's Fair of 1937, apart from the unhappy circumstances of the Uhde and Kahnweiler sales in 1921-1923, to which we shall refer presently.

Drafted into the infantry in 1914 and badly wounded, Braque was discharged in 1917. He returned to painting, seeking to reinvent the great French tradition of Chardin; he extended his range of themes, gave a privileged place to emotion, renewed his connections with myths and classical monumentality. For his part, Juan Gris, suffering from the first attacks of his illness in 1920, also arrived at a more serene, "poetic" painting. In *L'Esprit Nouveau* he wrote: "I am working with the elements of the spirit, with imagination. I am trying to make concrete what is abstract. I am proceeding from the general to the particular, which means that I start from an abstraction in order to arrive at a real fact" (No. 5, 1921). The critic Waldemar George noted a similar attitude when he spoke in the same periodical of the evolution of Braque: "This artist paints without a model. Instead of disposing the elements of a still life on a table and afterwards working on that prearranged subject, he composes directly on the canvas and imagines the motifs in obedience only to the laws of the painting... Braque transforms into objects the spots of colour which force themselves on his vision" (*L'Esprit Nouveau*, No. 6, 1921).

By letting memory take priority over experience, by limiting themselves to the exploitation of "laws" which they had discovered in advance, Braque and Gris thus progressively turned away from the avant-garde; they left the ranks of those who were forever searching somewhere else, or in other ways...

One event was to place Cubism once more at the centre of all the passions and all the debates; that was the sale of the collections of Wilhelm Uhde and D. H. Kahnweiler, two Paris gallery directors of German birth whose property had been sequestered at the outbreak of the war. In 1921 the French Government, ascertaining that the economic clauses concerning war reparations provided for by the Treaty of Versailles had remained without effect, ordered the sale of the seized goods. It was a serious matter for the avant-garde artists living in France, since, in the property of those two dealers specializing in contemporary art, a large part of their creative output was being put up for auction.

Uhde, who had discovered the Douanier Rousseau, had five of his works, along with 17 Braques, 13 Picassos and 5 Dufys, while the collection of Kahnweiler, whose contracts had practically kept the whole avant-garde alive, included 200 Braques, 150 Derains, 70 Gris, 200 Légers, over 300 Picassos and 200 Vlamincks. Apart from the artists concerned, no one perceived the irony of putting up for sale as German property works made in France and for the most part by Frenchmen. And, for a long time to come, the silence and inertia of museum curators who did not take advantage of their right of pre-emption would turn the French museums away from Cubist works. In an effort to prevent the sale, Braque, Derain, Léger and Vlaminck produced the record of their wartime military service, but they obtained no satisfaction other than a spacing out of the sales: 30 May 1921, auction of the Uhde collection; 13 and 14 June then 17 and 18 November, auctions at the Hôtel Drouot of the Kahnweiler collection, to be followed by the auctions of 4 July 1922 and 8 May 1923. Daniel-Henry Kahnweiler, moreover, had settled once more in Paris,

Juan Gris (1887-1927):
◁ *Portrait of Daniel Henry Kahnweiler, 1921. Pencil.*
▽ *Pierrot, 1919. Oil.*

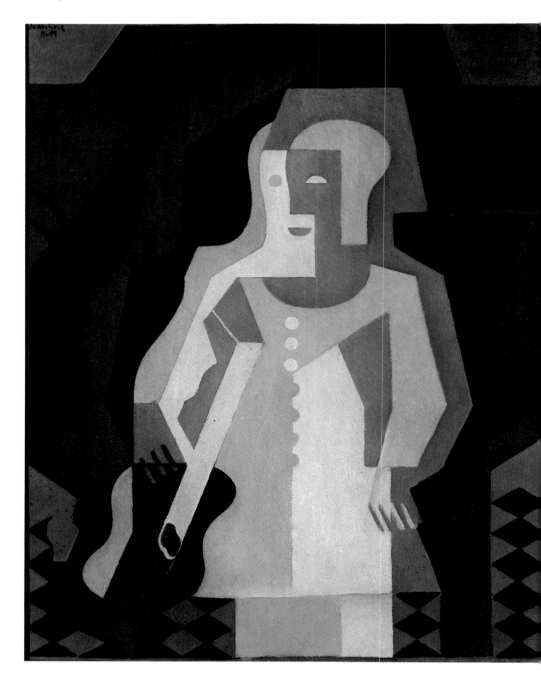

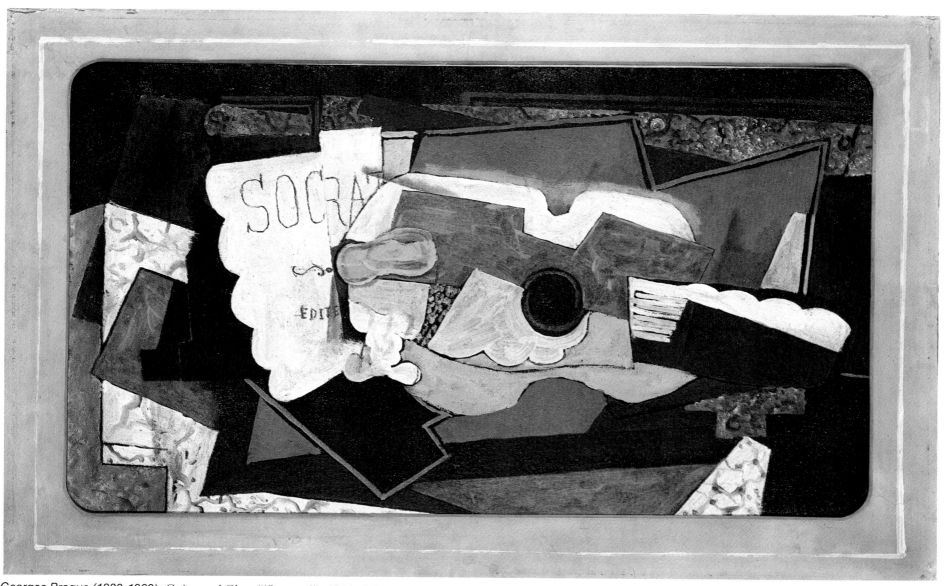

Georges Braque (1882-1963): Guitar and Glass ("Socrates"), 1921. Oil.

and in the Galerie Simon, which he directed, he resumed relations with his former artist friends.

Curiously enough, it was Kahnweiler's most direct competitor, the dealer Léonce Rosenberg, who was placed in charge of organizing the first sales. In his new Paris gallery, "L'Effort Moderne," Rosenberg marketed essentially Cubist painting. Having bought a lot of it, he found himself in a somewhat precarious financial situation and had everything to fear from a collapse of prices. As for the artists, they feared that such a flood of important works might break the momentum of a still very fragile market. From then on, the grip of the art market on artistic output was to weigh directly on the destiny and audience of the artists, depending on the financial resources, the ingenuity and talent of the dealers who supported them. And that would be true for as long as the public or official institutions turned their backs on contemporary art.

In 1921-1923, at the time of the Uhde and Kahnweiler sales, interests diverged and the situation was all the more critical in that the German and Russian art markets were closed. Many were the plots hatched in the corridors; the sales, however, were less disastrous than everyone had foreseen; the renown of the Douanier Rousseau even came out enhanced; Derain and Vlaminck obtained the strongest support: by showing their determination to go back to a more traditional art they met with numerous collectors who did not abandon them. As for the Cubists, they attracted foreigners especially. For the English and American dealers these sales were a windfall, enabling them to

invest in a period of French art which had eluded them. The modest prices quoted also allowed some French collectors to make their first great acquisitions.

These public events also made it possible for the most discriminating minds to grasp all the importance of Picasso and to obtain a better founded view of Cubism, of which so many works had never been shown before. It would be a long time before they were seen again. However, the articles which appeared in the leading Paris newspapers revealed the incomprehension which Cubism still encountered. In *L'Intransigeant* of 31 May 1921, under a photo of a Picasso painting on the first page there appeared the following text: "What does this painting mean? An entire lot of paintings of this sort belonging to a sequestered collection is being sold this afternoon at the Hôtel Drouot auction rooms. Fortunately, care has been taken to establish a catalogue supported with photographs and text, without which the buyer would have great difficulty in distinguishing a landscape from the portrait of a woman or a still life. The painting which we reproduce here is called *Newspaper on a Café Table*. Although you would never guess it, this is what is called a Cubist masterpiece." And in the *Gazette Drouot* of 19 November 1921, this sad comment appeared: "The buyers, as always, are for the most part foreigners; and we should congratulate ourselves on the fact, for it proves that the French public is amused by this kind of painting but buys little of it." There was no better way to condemn artists to follow the path of tradition.

The gap which existed between the representational styles Picasso adopted around the years 1920-1925 has several possible explanations; instead of opposing them it is better to make them converge.

In an interview he gave to Marius de Zayas in 1923 Picasso said: "I can hardly understand the importance given to the word *research* in connection with modern painting. In my opinion to search means nothing in painting. To *find* is the thing... When I paint, my object is to show what I have found and not what I am looking for. In art intentions are not sufficient... The idea of research has often made painting go astray, and made the artist lose himself in purely mental lucubrations" (*The Arts*, New York, 1923; text quoted in French in Florent Fels, *Propos d'artistes*, Paris, 1925).

In denouncing "purely mental lucubrations" Picasso may well also be expressing his condemnation of a certain kind of abstract painting, defending that new quasi-automatic painting which he was developing more secretly, or justifying his resumption of responsibility for the real. Moreover, he continued: "They speak of naturalism in opposition to modern painting. I would like to know if anyone has ever seen a natural work of art. Nature and art, being two different things, cannot be the same thing. Through art we express our conception of what nature is not."

In this interview Picasso also allowed a glimpse of a conception of art deserving of notice: "To me there is no past or future in art. If a work of art cannot live always in the present it must not be considered at all. The art of the Greeks, of the Egyptians, of the great painters who lived in other times, is not an art of the past; perhaps it is more alive today than it ever was."

Now if Picasso looked to the art of the past, it was because he himself was closely attentive to the progress of techniques of reproduction and book publishing: illustrated histories of art were appearing in increasing numbers; their authors were abandoning a descriptive style in favour of comparative analysis.

The ever-wider dissemination of art masterpieces by the media since the end of the war soon had a double effect. On one hand photography reproduced the masterpieces in a much more faithful and complex way than engraving did, at the same time enabling

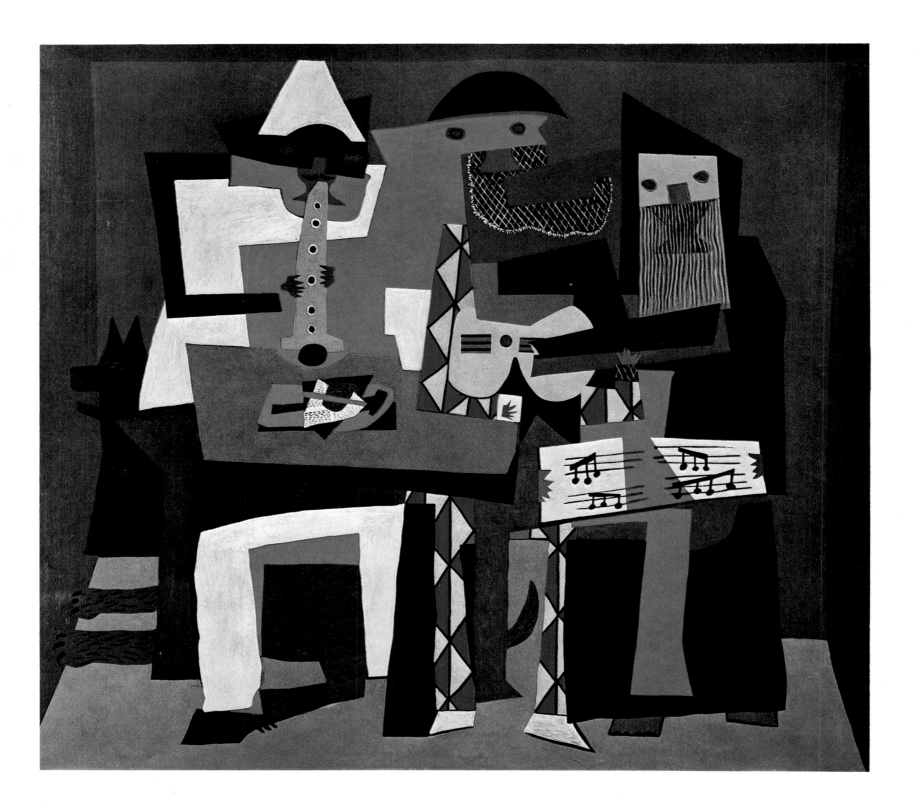

Picasso:
"To find is the thing"

everyone to become familiar with works that were dispersed geographically, or even inaccessible. But on the other hand, the birth of this "imaginary museum" in the sense André Malraux gave the term, altered the traditional relation which the creator maintained with his work. He felt himself much freer in knowing that he would be judged no longer by a limited number of works, but by the essential part of his production. No longer constrained to translate the totality of his expression into each of his works, he would be able to devote himself to other experiments; and even if they appeared contradictory, his testimony would be drawn from the whole of his output and no longer from isolated fragments of it. The retrospective exhibition and the illustrated monograph discourage contemplation, but impose new criteria of appreciation. It was the detachment produced by the "memory of the media" which offered the modern artist, particularly Picasso, the chance to attempt the most daring explorations, which only his curiosity and thirst for truth justified.

And Picasso in fact did step up the number of his exhibitions: in 1918, 1919, 1920 at Paul Rosenberg's in Paris; in 1921 at the Lancaster Gallery in London, in 1922 at the Thannhauser Gallery in Munich, and in 1924 at Rosenberg's once again. He was not neglected by book publishers: in 1921 the first monograph on him, by Maurice Raynal, appeared in German and was reissued in French in 1922; it was followed by Jean Cocteau's *Picasso* in 1923 and monographs by Pierre Reverdy and Waldemar George in 1924. That does not include the many newspapers and periodicals which reproduced, analysed and circulated his work.

For him, Cubism was no more an end than it was a style of transition. To Marius de Zayas, once again, Picasso confided the necessity he felt to go beyond it when his consciousness renewed itself: "Cubism is not either a seed or a foetus, but an art dealing primarily with forms, and when a form is realized it is there to live its own life... Cubism has kept itself within the limits and limitations of painting, never pretending to go beyond it. Drawing, composition and colour are understood and practised in Cubism in the spirit and manner in which they are understood and practised in all other schools. Our subjects might be different, as we have introduced into painting objects and forms that were previously ignored. We have kept our eyes open to our surroundings, and also our brains. We give to form and colour all their individual significance, as far as we can see it..."

He used his new liberty to the full. *The Three Musicians* of 1921, like several still lifes of that period, continued his research and his demands for a new pictorial ordering. Soon he allowed an instinctive and rounded calligraphy to appear—it triumphed in his costumes and sets for the ballet *Mercure*—, which heralded the automatism of the Surrealists, especially of Miró. The latter was fully conscious of it. He told the story: "It was in 1925. Picasso showed me a canvas and I said to him, 'It's curious, I'm just now doing something in that vein.' He answered me then in exactly these words: 'Yes, because we live in the same neighbourhood.' The same intellectual neighbourhood—that's fine, that is!" (Miró, *Ceci est la couleur de mes rêves*, conversations with Georges Raillard, 1977).

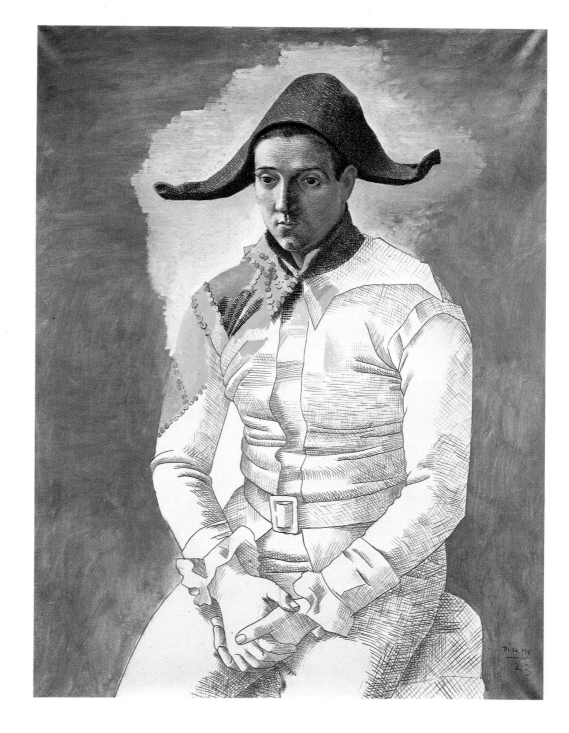

Pablo Picasso (1881-1973):
◁ *Three Musicians, 1921. Oil.*
△ *The Painter Salvado dressed as Harlequin, 1923. Oil.*

But in contradiction with this, Picasso multiplied paintings directly inspired by everyday life: his son Paul and his wife Olga, favourite subjects; depictions of Harlequin or of bathers, inspired by his relations with the stage or his summer stays at the seaside; everything which the world offered to his eyes. Here he developed a more psychological and sentimental register, by means of a very close attention to the orchestration of line and colour. Recalling this period, Gertrude Stein wrote: "During the year 1923 Picasso took an immense pleasure in drawing; he repeated almost the fertility and the happiness of the Rose Period; everything was rose."

More mythological themes animated the sets which he designed for *Antigone* by Cocteau, staged in Paris by Charles Dullin in 1922. They exploded in a stylistic renovation on the stage curtain he painted for the ballet *Le Train Bleu*, a show which caused a scandal in 1924 and marked the end of his collaboration with Diaghilev. The evocation of Mediterranean bathers favoured a new realistic representation of myths and of Greek style; and in fact the figuration implied a certain narrative writing or meaningful argument. Once rediscovered these themes soon interested Picasso less as a painter than as a draughtsman and engraver.

Léger, thanks to his war experience, was able to escape two kinds of esoterism: that of an art which functions only for itself and according to its own laws, and that of painting addressed only to a select group of initiates. Having measured the value of human solidarity in the trenches, and having reconsidered the problems and interests of workers and peasants, his brothers in arms, he became convinced of the necessity for an art that would explain the present times to everyone, the need to become the illustrator of modern reality. But this aspiration to express a new modernity was more complex than that which Baudelaire urged upon the Impressionists; to be sure it implied finding new subjects to paint—and to represent on canvas objects so uncultural as a cog-wheel, a stencil-letter or a ship's funnel was at that time a veritable act of defiance—but it also meant portraying them in a language bound up with the optical and dynamic reality of an era devoted to mechanical production and commercial rivalries.

"The man of 1921," wrote Léger, "after his return to normal life, kept within him that physical and moral tension of the hard war years. He was changed; economic struggles had replaced the battles of the front lines. Industrialists and shopkeepers clashed, brandishing colour like a weapon of advertising. A debauch without precedent, a chaos of colour exploded from the walls. No restraint, no law moderated that overheated atmosphere which shattered the retina, dazzled you and drove you mad" (Léger, "Colour in the World," in *Europe*, 1938).

Thanks to his Cubist adventure Léger had been freed of all necessity of illusionism; he knew that painting had other realistic requirements than that of imitating on a two-dimensional surface what the eye recorded in a three-dimensional universe. He would never retract his statement of 1913: "The quality of a pictorial work is in direct proportion to its quantity of realism... Pictorial realism is the simultaneous ordering of three great plastic qualities: Lines, Forms and Colours" (Léger, "Origins of Contemporary Painting and its Expressive Value," *Montjoie*, No. 8, 1913).

In 1920 Fernand Léger met Charles-Edouard Jeanneret, the founder, along with Ozenfant, of Purism and of the periodical *L'Esprit Nouveau*, with which he felt a spiritual communion from the outset. It was the future Le Corbusier who interested Léger in the relation between art and architecture, through monumental painting. Both men were alive to the renovation of forms and rhythms brought about by industrial civilization. Maurice Raynal, in an article in *L'Esprit Nouveau* devoted to Ozenfant, lost no time in emphasizing the spiritual kinship between Léger and the Purists. All created an order out of the raw material of the contemporary world. "The *raw material* question in art is extremely serious. Many artists become lost as a result of their first instinct, which is falsified and leads them to make a mistake in selecting raw material. Usable raw material is everywhere around us; it is a matter of making the right choice. You cannot use heavily decorated elements. I have made much use of the modern street, with its coloured elements, its typographical characters (for me that is raw material)" (Léger, "Notes on Present Plastic Life," in *Kunstblatt*, Berlin, 1923).

There was thus a very meaningful displacement between that contingent material which Léger took as his subject and the more traditional material to which Matisse and Picasso then had reference. Léger did not wish to give free rein to his emotions, but to become the poet of his age, to give it meaning and create its legend.

The tyranny of the machine had changed men and the landscape. It also threatened to change art. Léger did not hesitate to challenge the meaningfulness of easel painting. Easel painting was necessary, however, as long as it remained the painter's most direct and natural means of communication. "If, taking things to extremes," he wrote, "the majority of manufactured objects and 'department store displays'

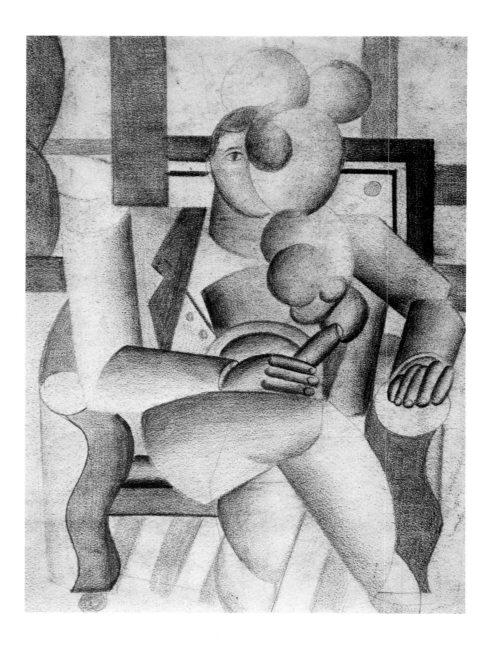

Léger, the alphabet of the modern world

were beautiful and artistic, at every step we painters would lose our reason for existing. There is a need for beauty scattered throughout the world; it is a question of supply and demand. The thing is to satisfy it. At present I recognize that we painters are still very useful as 'producers.' The manufactured object only rarely competes in beauty. That is the situation at present. But in the future? It is a rather new and disturbing situation. Personally I try to find a solution by a pictorial process of my own, by seeking the state of organized pictorial intensity" (*ibid.*).

Léger, it can be seen, came very close to sharing the ideal of the Russian Constructivists, but he departed from it because he persisted in regarding the exemplary status of painting as necessary. Now the conditions of existence, of exhibition and distribution were very different for an artist living in France and for one living in a Marxist Russia which had not yet completed its industrial development.

Léger was impressed by machinery not only at the level of subject matter; he also sought to carry out his painting with the conceptual methods and precision of an industrial programme. Le Corbusier shared this sentiment when he wrote: "Machines are the solutions to given problems, a lesson in method" (Le Corbusier, in *L'Esprit Nouveau*, No. 14). And Léger went further: "I was sharply criticized in 1918-1919 for having taken up the mechanical element as a pictorial possibility. I should like to make clear that although I am the first to

Fernand Léger (1881-1955):

◁ *The Smoker. Pencil.*

▽ *Three Women (Le Grand Déjeuner), 1921. Oil.*

I consider that pictorial beauty is in general wholly independent of sentimental, descriptive or imitative values. My aim is to try and impose this: that there is no set notion of the Beautiful, no hierarchy of the Beautiful... Beauty is everywhere, in the order of your saucepans on the white wall of your kitchen perhaps more than in your eighteenth-century drawing room or in the official museums.

Fernand Léger, *L'Esthétique de la Machine*, 1924.

have made pictures based on that element, I have no intention of claiming that there is nothing else but that element. The mechanical element is a means, not an end. I consider it merely as 'raw material' for pictures, like the elements of a landscape or a still life. But depending on the individual purpose, depending on the needs of an artist for the real, I think that the mechanical element is to be strongly recommended for whoever seeks amplitude and intensity in the work of art'' (in *Kunstblatt*, Berlin, 1923).

The alphabet of the modern world is characterized by its intensity, its dynamism and its syncopated rhythms; to complete it Léger had to introduce the human figure, establish a figuration which escaped from all sentimental or expressionist daydreams. Cubism had decomposed, even dislocated, the human body. Léger had to reconstruct it, give it a face. That face had also to be as little individualized, as anonymous as the one bestowed by the Egypt of the Pharaohs, which was equally suspicious of styles dominated by the desire to express. Léger explained his conception of the human body: ''An artist must not seek

to reproduce a beautiful thing but to work in such a way that his painting is a beautiful thing. For me the human figure, human bodies, have no more importance than keys or bicycles. They are nothing but objects of pictorial value that I must use as I see fit.'' *Three Women (Le Grand Déjeuner)* is the most significant painting in this search for a type of human representation, carrying that contrast of volumes and that coloured dynamism which was to make twentieth-century men conscious of the new type of beauty that their industrial society could bring into the world. The sky, trees, houses had been painted; why, asked Léger, shouldn't one have the right to paint machines? ''It is absurd. Art is subjective, I grant you, but it is a controlled subjectivity which rests on an 'objective' raw material. That is my unqualified opinion. The picture is the 'equivocal state' of those two values: the real and the imaginary. To find the equilibrium between those two poles is the difficulty, but to cut the difficulty in two and take only one or the other, pure abstraction or nature imitation, is to duck the whole question'' (*op. cit.*, in *Kunstblatt*, Berlin, 1923).

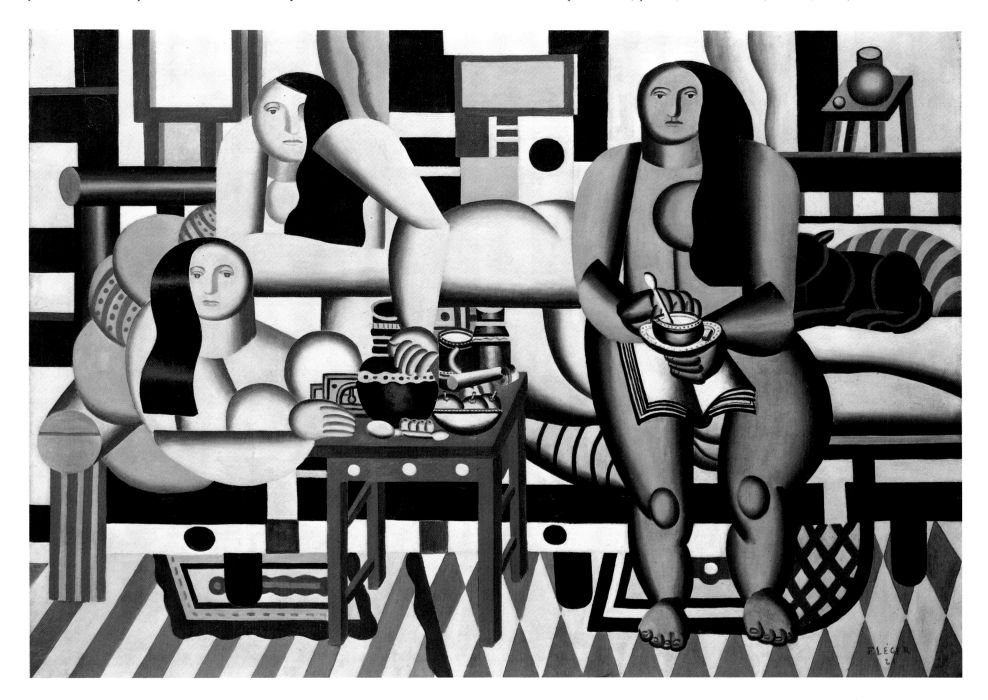

There was nothing accidental in the fact that painters became interested in the cinema as soon as the war was over. Many of them were weary of the cultural closed circle of the easel painting and the art galleries. Besides, the war had put them into relation with other strata of society and made them receptive to a more political and popular activity. Some of them had already tried the theatre or photography; others, especially the Dadaists, went beyond Cubist collage by creating the photomontage or the photographic collage; several were to grasp the potentialities of the film through curiosity about that new form of space made accessible by the cinema: duration in time.

It must also be observed that the Dada exhibitions overstepped the limits of traditional forms of expression to reach others in which sound, image and movement combined, simultaneously bringing in music, theatre, poetry and sculpture. Visual poetry, the use of noises, speech sounds, action and typography were, for Dada, no longer competing genres. And the cinema, although still silent, was able to appear as the medium best adapted to preserve these displays of strictly narrative character; along with the ballet and the theatre it also represented a field especially suited to achieve that synthesis of the arts which preoccupied many creators.

But the cinema was attractive for another reason: it had not yet been given the status of the seventh art. The film image could thus provide the opportunity to produce a work of art without the public's being too aware of it and reacting against a creativity from which it quickly shied away if it was labelled as art.

On the cinematic front the war had broken off an exploration in full swing. Only America possessed the means of maintaining its output, but its economic system pushed it irreversibly towards the "star system" and mammoth productions (for example, Cecil B. De Mille's *The Ten Commandments*, 1924). Charlie Chaplin, Harold Lloyd and Buster Keaton were packing in the crowds; a new heroic genre appeared with the western (*The Mark of Zorro* in 1921; Ford's *The Iron Horse* in 1924). Closer to the popular novel than to visual art, the American cinema had no need of painters.

Things were different in Europe, which ruined by the war, had to reinvent everything, and with limited resources. The fact was that the cinema relied on narration and sentiment at the very time when they were no longer live sources for modern painting. The film image, therefore, gave nostalgic artists the possibility of developing what they could not make visible in a painting. This was particularly significant in Germany; when expressionist painting died expressionist cinema was born. And it owed its first impact to the painter-designers.

The majority of the German people had of course welcomed the war with enthusiasm; and beneath their faith in their national supremacy and military might lay a will to the cultural affirmation of "German genius." But the war only temporarily effaced the political and social conflicts which re-emerged violently when victory proved indeed an illusion. After 1918 the internal situation completely deteriorated: the naval forces mutinied, workers' and soldiers' councils seized power, the Kaiser abdicated and took refuge in Holland, and on 9 November 1918 the republic was proclaimed in Berlin. In December a system of parliamentary democracy was voted; the Spartacist revolts were crushed by the army; the new State consolidated its position by appealing to the army of the old order and of defeat, which thus found itself rehabilitated.

Many German artists had expressed their revolutionary sympathies in the Novembrists' manifesto (1918), but they were not long in being disappointed. The great painter and engraver Käthe Kollwitz (1867-1945) summed up their feeling by writing, on 28 June 1921: "In the meantime, I participated to the end in a revolution and convinced myself that I am not a revolutionary... If only real revolution had had

From painting to film

Viking Eggeling (1880-1925): Diagonal Symphony, film sequence, 1921.

the face we expected of her—but since she appeared in reality under the most terrestrial of appearances, full of cinders, robbed of the ideal; and since all revolutions may look that way, we have had enough of her" (Käthe Kollwitz, *Tagebuchblätter*).

Before the war, German Expressionism had identified itself with a certain nationalist consciousness which was completely called into question after the defeat. However, the collapse of the Reich, squalor, anguish and inflation brought a return to self. Raymond Lenoir, who analysed this phenomenon in *L'Esprit Nouveau*, wrote: "And since the world has once more become a problem and the poet finds only chaos before him he turns back on his inner self. But psychology teaches us as little as anatomy about man's essential nature; it is incapable of seeing that the same mysterious forces are in us that first

Hans Richter (1888-1976): Prelude, section of scroll drawing, 1919. Pencil.

formed the world, and it is still more incapable of grasping them by the aid of a language forged solely for the expression of social relations. It is therefore the ecstatic consciousness of the divine, of the eternal within us, that we must bring to birth, like an ardent prophecy, the lyric cry that can win the world and spread the word of the coming of a new humanity" (*L'Esprit Nouveau*, No. 2, Paris, 1920).

Expressionism had attained its pictorial limits; it had burst out violently just when painters were testing the expressive possibilities of the components of their language, but it lost its force thereafter through repetition. In utilizing the cinematographic fiction it would on the contrary regain its provocative brilliance. Painters and directors collaborated in creating that climate of magic, terror or foreboding which gave the spectator new powers of perception. Arising from the real or out of dreams, the fantastic triumphed, for it diverted the spectator from the everyday horror by revealing another underneath, unimaginable.

The scenario was entrusted to the painter—the *Film-Architekt*—before the director. The first expressionist film, *The Cabinet of Dr Caligari* (1919), owed everything to the enthusiasm of two artists, Walter Reinmann and Hermann Warm. It was they who imagined the setting and scenery, drawing inspiration directly from the effects of expressionist woodcuts and from their rhythms and contrasts, filled with aggressiveness. The distorted settings even dictated the staccato movements of the actors, like those of Werner Kraus, personifying the famous Dr Caligari. The expressionist film was first of all style and vision. *Dr Caligari* had little success in Berlin but made a great hit in Paris. "The rhythm imposed the word END with the sharpness of a slap," wrote Louis Delluc, who welcomed the film as a cultural event. *The Golem* (1920) also owed much to its painter-architect Hans Poelzig, the collaborator of Max Reinhardt. "The film must become a graphic art," proclaimed Warm.

But the expressionist cinema had such success that it was soon transformed into a commercial enterprise, thereby losing some of its violence. The best directors who came after it were not expressionists: Fritz Lang (with his *Mabuse* cycle, 1922), F.W. Murnau (with *Nosferatu*, 1921-1922) or G.W. Pabst (with *The Treasure*, 1923). However, they could not resist the power of expressionist style, and kept on the same architect-designers for their first productions. They were aware that painting alone could create those effects of space and light also found in the German and Russian theatre.

In parallel with Expressionism, and at the opposite pole from it, the first experiments in the abstract cinema were getting under way in Germany. The Zurich Dadaists Viking Eggeling and Hans Richter returned to Germany, to Klein-Kölzig. Gradually they came to use film space, as Richter testifies: "There, for three years, we marched side by side, although we fought on separate fronts. In 1919, on the basis of what Eggeling called 'Generalbass der Malerei,' we produced our first scroll-pictures: variations on formal themes, drawn in pencil on long rolls of paper. Eggeling's was called *Horizontal-Vertikal-Messe* and mine, *Präludium*. In 1920, we began our first film experiments, based on the implications of motion contained in these rolls. Eggeling finally made a film of his second roll, *Diagonal Symphonie*, and I made one called *Rhythmus 21*. Both were abstract films, but very different in spirit and in their approach to artistic problems. Eggeling started out from the line and I from the surface. Eggeling orchestrated and developed forms, while I renounced form altogether and restricted myself to trying to articulate time in various tempi and rhythms" (Hans Richter, *Dada: Art and Anti-Art*, McGraw-Hill, New York, and Thames and Hudson, London, 1965). The cinema forced itself upon them as a solution to the problems posed by painting. Eggeling died young in 1925; Richter henceforth never stopped experimenting with the space of time in film, alongside his activity as a painter.

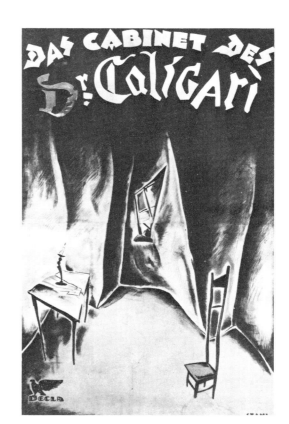

▷ *Poster for the Robert Wiene film* The Cabinet of Dr Caligari, *1920.*

▽ *Werner Krauss in the role of Dr Caligari.*

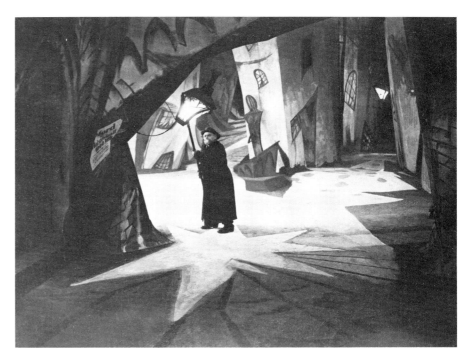

Still from the Henrik Galeen film The Golem, *1920.*

Berlin, hotbed of revolution

"We have lived through the total shipwreck of the only value in which a godless age really had any faith: money. Money evaporated, grew diluted in astronomical figures. Seven and a half billion marks to the dollar!... An authentic Dürer is worth two bottles of whiskey. Herr Krupp and Herr Stinnes are unloading their debts. The small fry are the ones who pay. Who complains? Who protests? In palaces smugglers are dancing the foxtrot!... Berlin is the nerve centre where the emotions and intuitions, the longings and resentments of the German people are formulated with scientific exactness and journalistic verve. The metropolis does not create; it represents. If the Berlin of the Kaiser had ostensibly represented the dynamism of young German nationalism, the Berlin of the first post-war years reflected with equal brilliance the apocalyptic mood of the vanquished nation" (Klaus Mann, *Der Wendepunkt*, 1952).

It was in Berlin that the fruits of defeat were most bitterly savoured, that the disturbances and squalor were most acute. Despite the crushing of the Spartacists, the hope of political change remained keenly alive. Seeing capitalism as the culprit responsible for the downfall of Europe, many agitators arrived to stir up this revolutionary ferment after having realized that they could not bring about a political overthrow in their own countries.

In Berlin, because of the famine and the social tensions, everything seemed possible. The intelligentsia clung together; many wished only to live and amuse themselves in order to forget; others were fascinated by the Russian example, broadcast by numerous spokesmen. In the cafés and ateliers the activity was intense: congresses, lectures, exhibi-

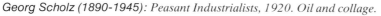

Georg Scholz (1890-1945): Peasant Industrialists, 1920. Oil and collage.

tions, publications multiplied and contradicted each other. The confusion was total; the artists divided among themselves. The proponents of free art and those of committed art clashed sharply. The November Group, too heterogeneous, flew apart beneath the blows of the Dadaists. An open letter signed by—among others—Dix, Grosz and Scholz denounced those who had exploited for their own profit the hopes which this group represented at its creation: "None of the leading members gave a moment's thought, for example, to clarifying their attitude with reference to the working-class revolution, to seriously giving up their regular place in the first rank of the groups of bourgeois artists; they had only brought about a confusion of ideas by their hypocritical phrases, the better to reinforce, in the time-honoured sordid manner of artists, their individual pretensions, thanks to the increased number of followers whom they viewed with scorn from the height of their celebrity. Instead of seeking to reject the role of parasite and prostitute which capitalist society forced upon the artist, these superstars did everything to assert themselves and make their own interests prevail" (*Open Letter to the November Group*, in *Der Gegner*, No. 8-9, 1920-21).

"Expressionism is dead," observed the art historian Wilhelm Hausenheim in 1920. In fact, whatever the individualized shouts of its representatives had contained of the irrational and prophetic had been surpassed by the horror and reality of the war. Even Herwarth Walden, the celebrated editor of the Berlin review *Der Sturm*, which had given Expressionism the chance to assert itself, now became interested in other experiments, those of artists who had newly arrived in Berlin: Puni, Moholy-Nagy, Laszlo Peri. Gradually, Expressionism was swamped by abstract Constructivist and Productivist art, and the evolution of the spirit of the Bauhaus, created in 1919, confirmed this trend. Kokoschka's personal movement is particularly significant. On the eve of the war he had been among the most striking and original of the Expressionists, utilizing painting as the field for his own psychoanalysis. Wounded on the Russian front while serving in the Austro-Hungarian army, he found himself back in Dresden in 1917, where he worked at putting his ego on stage in a vehement painting which affirmed his opposition to the anonymity of abstract painting and, simultaneously, to the forces that restrict individual liberty. But the war caused him to shun humanity; and, the better to escape real life, he chose an object on which he could freely imprint the content of his imaginary world, and which gave him inspiration for several paintings. This was a life-sized doll which he ordered from a dressmaker, and which he carried with him to the mountains, where he hid himself away "to forget disgusting reality and to work."

Kokoschka was to become the target of revolutionaries and Dadaists, who denounced him as the model of the bourgeois artist. While he was teaching at the Dresden Academy a street fight between workers and activists left 38 dead and 150 wounded, but in addition a stray bullet pierced a Rubens painting on display in the art museum. Kokoschka exclaimed: "Class struggles should be settled in the circus, in order that art may be protected." The Dadaists replied, in a manifesto entitled "The Scum of Art", signed by Grosz and Heartfield: "Workers, turn your eyes towards Dresden! There you will see the cradle of your lucky children and the bank account of O. Kokoschka... This high school teacher is a symptomatic personality, with conceptions of art common to all art functionaries, the art market, and public opinion about art; by attacking him we wish to strike at all the stupidity, vulgarity and arrogance of art which hides behind him. All the hypocrisy of the art and culture of our time! Kokoschka's words are typical of the mentality of the entire bourgeoisie. The bourgeoisie places its culture and its art above the life of the working class!" (George Grosz and John Heartfield, *Der Kunstlump*, in *Der Gegner*, No. 10-12, 1919-1920).

Oskar Kokoschka (1886-1980): Man with Doll, 1922. Oil.

Born in Berlin in 1893, George Grosz had not been indifferent to Expressionism. After being wounded in 1916 he returned from the front with an aversion to that patriotic nationalism whose consequences he had been able to judge for himself. In Berlin he joined the Dada group and found in its anti-aestheticism the attitude that enabled him to express his hatred of a society of débauchés and profiteers. He also militated alongside the communists, where he met Georg Scholz: an affiliation indicative of the political attitude of many artists who wanted a change but who in reality could not long share a belief in the Marxist utopia. Otto Dix, born in 1891, had also passed through Expressionism before his war experience led him to join Dada. He and Grosz were the most interesting representatives of a verist tendency marking the return to a "naturalist" art opposed to the illusionist tradition. In the style of moralists and caricaturists, both emphasized above all the reality of what was ugly; it was the most visible scar left by the war and human baseness. The scrutiny of everyday life left them no illusions. Their ruthless realism denounced horror, misery and absurdity. Art was a safety valve no longer; it became the weapon with which to expose daily crimes, for Grosz especially.

Their denunciation was the more effective in that it was inspired by, and spoke of, daily life in a "popular" form, as Grosz confessed: "To arrive at a style which expressed energetically and without detours the harshness and insensitivity of my objects, I studied the most immediate manifestations of the artistic instinct; I copied folk drawings in public urinals: they seemed to me the most condensed expression and translation of strong feelings. In this way I attained a style as pitiless as a knife, which I needed to render my observations dictated by an absolute negation of man" (George Grosz, *Autobiography*, 1946). Between this critical figuration of the Germans and the lyricism of Bonnard in France, the whole range of possibilities of representation was redeployed.

The reaction of revolutionary Berlin artists against the attitude of traditionalist painters was more violent precisely because they invented new forms of expression which forced art to leave the ivory tower of the Museum, because indeed they used art as a combat weapon. Grosz, Dix and Scholz laid the basis for what came to be called the New Objectivity (Neue Sachlichkeit), a figurative painting with emotional and social content. They replied to escapist art by a denunciation of present realities, which they asserted with a dry and harsh realism anchored in a clinical and critical attention.

▷ *Otto Dix (1891-1969):*
Cripple Selling Matches, 1920. Oil and collage.

▽ *Heinrich Hoerle (1895-1936):*
Out of Work, 1920. Lithograph.

"The doll tossed aside by the child or the coloured dish-cloth are more necessary expressions than those of any ass who desires to immortalize himself through his oil paintings hung in beautiful drawing-rooms," declared Raoul Hausmann in his manifesto *Synthetic Cinema of Painting* (1918). And he continued with a formal attack against other movements: "Cubism and Futurism express a visual intellectuality with the grand gesture of a behavioural breakthrough in the fourth dimension; they are therefore nothing more than attempts at a broadening of the complexes of apperception of chemical and optical tropisms. In Dada you recognize your true condition: miraculous constellations in genuine materials: barbed wire, glass, cardboard, tissue corresponding organically to your own brittle or rounded fragility" (Raoul Hausmann, *Synthetisches Cino der Malerei*, 1918).

By insisting on the truth of the materials used by Dada, on their possibilities for distancing or denouncing, Hausmann emphasized that Berlin Dada was resolutely parting company with the history of painting; that it was inventing new methods which it placed at the service of man and his political activity. Because in Berlin Dada became a marching column of revolution, it would have a much greater following and repercussion there than anywhere else.

Richard Huelsenbeck had already left Zurich in 1917 for Berlin, where he found a climate favourable to the propagation of Dadaist ideas. In February 1918 he delivered his first Dada speech in the New Secession room, where he proclaimed the importance of the manifesto as a form of expression; and the manifestoes were to come thick and fast. Recalling this period, Richter relates: "There can be no question that it was Huelsenbeck who introduced the Dada bacillus to Berlin. On the other hand, Hausmann... had been infected with a similar bacillus from birth. His aggressive, hell-raising propensities needed no prompting from Dada. Thus we do not know who was the real father of the Berlin Dada movement, but, as the two candidates for the title both have the same initials, the chronicler can best avoid error by awarding the disputed honour to 'RH' and leaving the vexed question of Dada's paternity open" (Hans Richter, *Dada: Art and Anti-Art*, McGraw-Hill, New York, and Thames and Hudson, London, 1965).

George Grosz
(1893-1959):
The Engineer Heartfield, 1920. Collage and watercolour.

Berlin Dada and photomontage

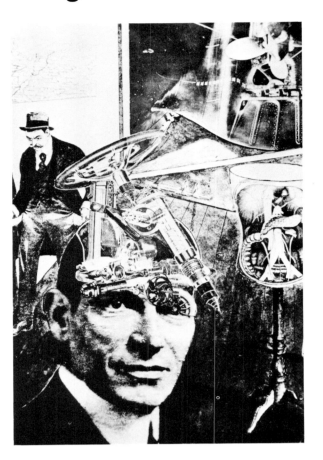

Raoul Hausmann
(1886-1971):
Tatlin at Home, 1920. Photomontage.

A Dada club was formed in 1918. It brought together the most turbulent Berliners, Franz Jung and Raoul Hausmann, publisher and editor of *Die Freie Strasse*; the Herzfeld brothers, Helmut and Wieland, editors of the review *Neue Jugend* (1917), the former of whom anglicized his name to John Heartfield; the extravagant Johannes Baader; George Grosz, and others. Huelsenbeck's first Berlin Dada manifesto was dated 12 April 1918. It was part of a sharp anti-aesthetic attitude which it justified in the name of social and political commitment: "Art depends in its execution and direction on the time in which it lives, and artists are the creatures of their epochs. The highest art will be that which represents in the content of its consciousness the manifold problems of the age; that which, if it has been shaken by the explosions of the previous week, draws its limbs together beneath the blows of the most recent day. The best artists, the most remarkable ones, will be those who, at every passing hour, pull the tatters of their bodies together in the hubbub of life's cataracts, and, coming furiously to grips with the intellect of the times, bleed from their hands and their bodies... The word Dada symbolizes the most primitive relation with surrounding reality; with Dadaism a new reality takes possession of its rights" (Richard Huelsenbeck, *Dadaistisches Manifest*, 1918).

In June 1919 the review *Der Dada* appeared in Berlin under Hausmann's editorship, but Huelsenbeck was already thinking of *Dadaco-Dadaglohle*, the "greatest reference work in the world," "a working atlas for Dadaists" on which all should collaborate. This scheme started the exchanges between the members of Paris Dada and those of Berlin Dada: Heartfield was to do the typography for the project and Tzara would act as editor. In 1920 the Dada Almanac of Huelsenbeck was all that remained of this vast plan for a Dada encyclopaedia.

Highly organized and articulate (not to say vociferous), the Berlin Dada group multiplied its public displays and speeches, reaching its peak in June 1920 with the First International Dada Fair which as-

sembled 176 works. Its manifestations generally had a political character. The Dadaists were all the more drawn to communism, which seemed to them the only movement bearing some promise of freedom in that they themselves were seeking a new definition of human freedom, used up and battered by the war.

The Dadaists set the life of the streets and social squalor against the artistic salons; they portrayed "man's actual existence." The Weimar Republic soon appeared to them as the renaissance of "Teutonic barbarism," the crushing of every drive towards freedom. In a violent pamphlet against the spirit of Weimar in 1919, Raoul Hausmann wrote: "I announce the Dada world. I laugh at science and culture, those miserable assurances of a society condemned to death... I am not only against the spirit of Potsdam, I am above all against Wei-

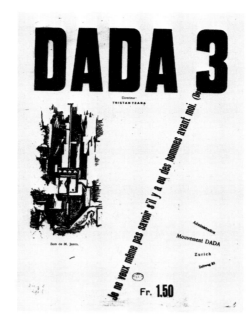

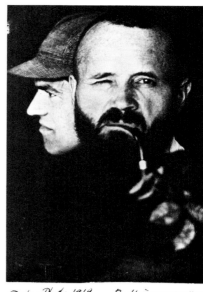

Dada-Photo 1919 R. Hausmann

perspectives, on distortions and the gap between the image and its caption, between mask and reality. But photomontage was the most utilized of all the methods, for in its very technique it questioned the objectivity of appearances. All adopted the extraordinary expressive possibilities of this medium, whose paternity they would later dispute, and which gave collage a wholly new meaning.

Today it is thought that Raoul Hausmann was the inventor of the photomontage. This artist, born in Vienna in 1886, had arrived in Berlin in 1900. He quickly attracted attention and, at the start of the war, he had already established contact with those who would matter in the avant-garde of the 1920s.

mar." And he concluded: "We want to create by ourselves our own new world" (in *Der Einzige*, 1919). All Dadaists shared in this critique of bourgeois values, and they had the genius to express it in striking forms which could be propagated by the rapidly expanding mass media. The opposition parties quickly understood the importance of these methods, and in this context John Heartfield would create his most violent montages.

Not only did the Dadaists construct their world with materials taken from life, but—and this is one of the most original things about their attitude—they had no intention of "making art." The work of the artist was only "a means of struggle for liberty and revolution," as John Heartfield declared: "We must learn to put all our force into our work and to express revolutionary ideas through it." Heartfield also recognized the importance of the Russian model: "In the present era, that of the decadence of capitalism and bourgeois society, a new society is being born in the Soviet Union, from new strong ideas. Based on socialist construction and labour, genuine art is taking shape."

All implicitly admitted that the use-value of art is life; a sentiment which Huelsenbeck summed up as follows: "Dada considers it necessary to campaign against art because it has unmasked its fundamental imposture, which makes of it a moral safety valve" (Richard Huelsenbeck, *En avant Dada, Eine Geschichte des Dadaïsmus*, 1920). This liberation from "the idea people have of art" was achieved in new areas of artistic practice—the tract, collage, and photomontage especially. These forms reduced art to simple and direct discourse, to an effective and critical figuration, bypassing aesthetic problems of language to exploit the data of communication. Art had to be put within the reach of all men. The tract became an image, the idea of a slogan was made more striking by the use of letterpress and an arrangement of the letters that brought out visually the meaning of the words; the poster, on the contrary, made it possible to play on disconcerting

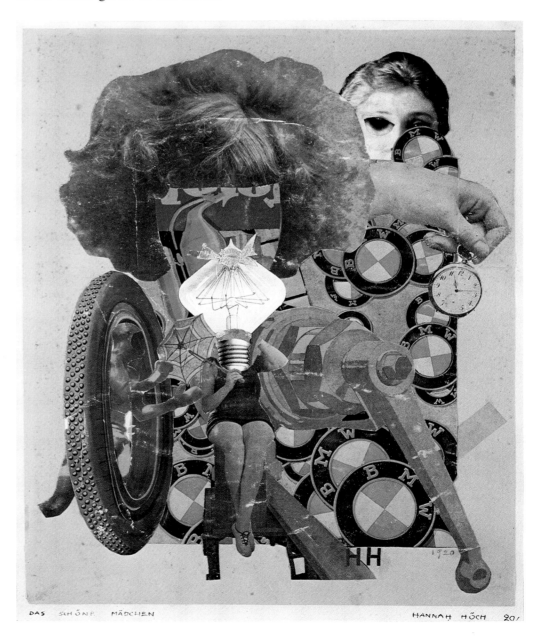

DAS SCHÖNE MÄDCHEN HANNAH HÖCH 20'

Cologne Dada, another dimension of collage

"On the first of August 1914 Max Ernst died. He was resurrected on the eleventh of November 1918 as a young man who aspired to find the myths of his time. Occasionally he consulted the eagle who had brooded the egg of his prenatal life. (You may find the bird's advice in his works.)," wrote Max Ernst himself.

As an image-maker Max Ernst was one of the most important personalities of both Dada and Surrealism. Born in 1891 in the Rhineland, at Brühl near Cologne, he was profoundly marked by his childhood and his family circle. His father, an accomplished amateur painter, opened his mind not only to art but to the problems of psychology and philosophy. Max Ernst's entire œuvre has an autobiographical character. Because he found in his memory and inner life the subjects and substance of his work, he used painting as a method of self-analysis. He invented or instinctively hit on the automatic techniques of Dada and Surrealism, which favoured self-discovery by an interplay of associations closely related to the psychoanalytical method. In art he found the medium that enabled him to record what he saw with his inner eye.

In 1912, after taking a degree in philosophy at Bonn University, Ernst devoted himself to painting, under the initial stimulus of August Macke and the "Das Junge Rheinland" group. From the start he showed an unusually inventive mind and was well informed about the art of his time. In Cologne in 1914, just before the war, he met Jean (Hans) Arp. Of this meeting he later wrote: "Arp made a great impression on me and we spent some delightful days and evenings together. Even then our talk ran chiefly on painting and automatic drawing. I remember very well our saying that the only way to do painting is to do it with your eyes shut, or else in a very automatic way."

Ernst served throughout the war in the German army. But by 1917 he was able to resume painting and procure some art magazines. August Macke had told him: "You have too much talent, you should use it seriously instead of toying with it." But when "toying" with his talent he was often experimenting very seriously. Evoking this period of often contradictory but always fruitful experiments, Werner Spies writes: "Some self-destructive urge is ever present. From this one would like to deduce that Max Ernst was trying to *close off* the shortest path to painting. His essential skill was never to be used to play the edifying game of the parental world. He used it to carry out these experiments which, as we know today, led him on logically to the comprehensive, highly positive *de-creation* of Dada" (Werner Spies, *The Origin as a Distant Echo*, Max Ernst catalogue, 1975).

From the first, he placed himself "beyond painting," preferring disparity to the mark of a style. He was continually attracted to materials considered to be non-artistic. This need to strike out in new directions was part and parcel of an all-consuming love of freedom and justifies his discovery of collage. "One rainy day in 1919 in a town on the Rhine, my excited gaze is provoked by the pages of a printed catalogue. The advertisements illustrate objects relating to anthropological, microscopical, psychological, mineralogical and palaeontological research. Here I discover the elements of a figuration so remote that its very absurdity provokes in me a sudden intensification of my faculties of sight—a hallucinatory succession of contradictory images, double, triple, multiple, superimposed upon each other with the persistence and rapidity characteristic of amorous memories and visions of somnolescence. These images, in turn, provoke new planes of understanding. They encounter an unknown—new and nonconformist. By simply painting or drawing, it suffices to add to the illustrations a colour, a line, a landscape foreign to the objects represented—a desert, a sky, a geological section, a floor, a single straight horizontal expressing the horizon, and so forth. These changes, no more than docile reproductions of what is visible within me, record a faithful and fixed image of my hallucination. They transform the banal pages of advertisement into dramas which reveal my most secret desires" (Max Ernst, *An Informal Life of M.E. as told by himself to a young friend*).

Max Ernst himself explained what he found in this image-making technique: "I am tempted to see in it the exploitation of the *chance*

Max Ernst (1891-1976):

◁ *Self-Portrait: The Punching Ball or*
The Immortality of Buonarroti, 1920.
Collage, photograph and gouache.

▽◁ *Dada Degas, c. 1920-1921. Collage and gouache.*

▽ *Lithograph from* Fiat Modes: Pereat Ars,
Cologne, 1919.

▷ *Katherina Ondulata, 1920. Mixed media.*

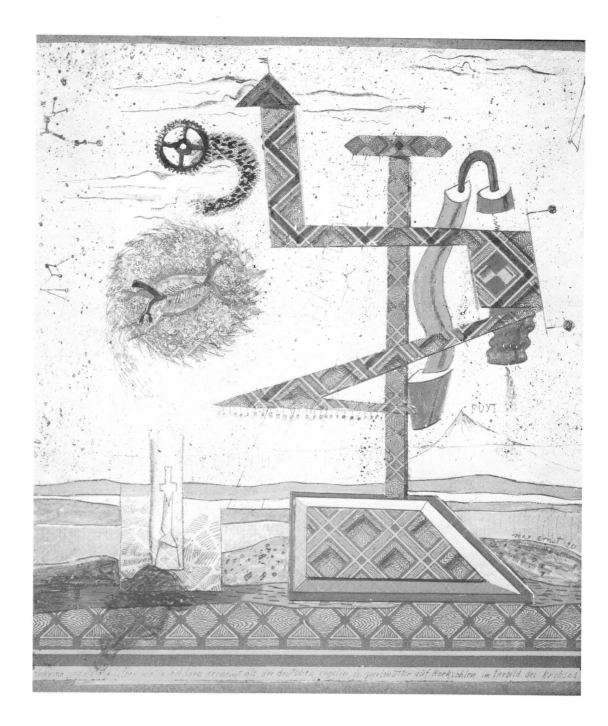

meeting of two remote realities on an unfamiliar plane (to paraphrase and generalize the famous remark by Lautréamont: *Beautiful as the chance meeting on an operating table of a sewing machine and an umbrella*); or, to put it another way, it is a matter of cultivating the effects of a *systematic bewilderment*, according to the view of André Breton" (in Max Ernst, *Ecritures*, 1970).

In 1919 Max Ernst came across the work of Chirico: he was fascinated by its uncanny combinations of alien, exotic or paradoxical elements. At the same time he found his own poetic world and a technique enabling him to enter it at will: collage. The moment of illumination and perception caught and summed up in the collage released the springs of inner memory and enabled him to give pictorial expression to "objective chance," as defined by André Breton: that is, the meeting between an external cause and an inner purpose.

In design and conception, Max Ernst's collages are very close to the photomontages of the Berlin Dadaists. It was Arp who served as the connecting link between these artists, paying long visits to Cologne and Berlin in 1919-1920. Thanks to his energy and talent, his knowledge of languages (he was bilingual in French and German), his open, inquisitive, wide-ranging mind, Arp played a leading part in the diffusion of avant-garde ideas throughout the inter-war period.

After the armistice Cologne was part of the British occupation zone and censorship was strict. Cologne Dada made its public début in February 1919, with the first number of a small magazine, *Der Ventilator*, edited by Max Ernst and his friend the painter Johannes T. Baargeld (whose father was a banker and financed the venture, only too happy to see his son a Dadaist rather than a communist). When it was banned as subversive by the British military authorities, in March, they started up another paper, called *Die Schammade*, to which Arp also contributed. The Dada exhibition of April 1920 was closed by the police. But Cologne Dada, for all its activity, did not have the political potency of Berlin Dada. Ernst himself was never directly concerned with politics, and the ironic mockery of his and his friends' works was aimed rather at the intellectuals and the bourgeoisie. "The Dadaists attached much less importance to the mercantile exploitation of their works than they did to the impossibility of exploiting them as objects of contemplative meditation. One way, and not the least, which they found of achieving that impossibility, was the systematic use of dilapidated materials" (Walter Benjamin).

Among the most provocative and indeed revolutionary works of Cologne Dada were the Fatagaga collages (the word stands for "Fabrication de tableaux garantis gazométriques"). In these collective, anonymous collages, Ernst, Arp and Baargeld inaugurated the technique of the "exquisite corpse" (as the Surrealists later called it). This collective endeavour they jokingly described as "Central W/3 (W = Weststupia, 3 = Arp, Baargeld, Ernst)."

Before the return of the war-time exiles and the influx of foreigners after the Armistice, the Dada movement in Paris was hardly more than a trickle. Of Dada art there was none, only a small output of poetry and prose. The first signs of the Dada spirit appeared in Pierre Albert-Birot's magazine *Sic* (1916-1919), distinguished by its eccentric typography; and then, more significantly, in *Littérature* (1919-1924), a periodical launched by André Breton, Louis Aragon and Philippe Soupault, three formidable personalities who formed the nucleus of French Dada. The steady exchange of publications and collaboration between New York, Zurich and Germany prepared the way for the warm welcome Paris gave the Dadaists. For all its negative intensity, Dada has this positive achievement to its credit: that it broke down for good the barriers between the different art forms, and indeed broke down the barriers that had divided artists from each other.

Picabia returned to Paris in the spring of 1919, but he did not establish contact with Breton until the end of the year, while Duchamp had already compared notes with him during the summer.

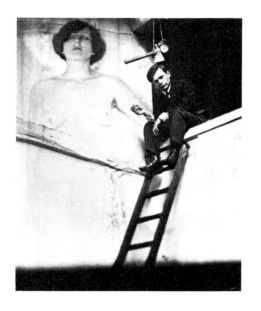

◁ *Tristan Tzara photographed by Man Ray, 1921.*

▷▽ **Max Ernst (1891-1976):** *Santa Conversazione, 1921. Photograph of a collage.*

Paris Dada, then, only really began in 1920. Before that, Picabia had published much, painted a little (enough, though, to create a scandal at the 1919 Salon d'Automne with his anti-paintings), and made himself known chiefly as a socialite and dandy; and Duchamp had produced a few Readymades, like L H O O Q and *50cc of Paris Air*. It was Tzara's arrival on Picabia's doorstep in January 1920 that set Paris Dada in motion. A few months before, in *Littérature* (October 1919), Breton and Soupault had published the opening chapters of *Les Champs Magnétiques*, of which Breton later wrote: "Unquestionably this was the first piece of Surrealist (and by no means Dada) writing, for it was the outcome of the first systematic applications of automatic writing." The truth is that Picabia and Tzara (to mention no others) were already past masters in the practice of spontaneous writing.

Breton's first visit to Picabia was made on 4 January 1920. Germaine Everling, Picabia's new companion, was present: "I saw a young man come in who was both shy and sumptuous. He had thick chestnut-brown hair, swept back from his brow in the manner of the Romantics. Large horn-rimmed spectacles gave him a serious look" (G. Everling, *C'était hier*). In his Dada period Breton made a point of wearing glasses "because noses were made to wear glasses on." Tzara moved into Picabia's flat on 17 January. Now that these two had joined forces, things were to move fast: "The first acute phase was triggered off by the meeting of Picabia and Tzara on the one hand and the *Littérature* group on the other. It came to life with a sudden plethora of manifestations (the Friday evenings of *Littérature*, and

demonstrations at the Grand Palais, the Club du Faubourg, the Maison de l'Œuvre, etc.) in which Dada faced its Paris public for the first time. The audience went wild as the incongruous mixture of elements was brewed and stewed and sifted. After this baptism of fire, round about the month of July 1920, the Dadaists paused for breath, both to recruit their strength and to take stock of the situation. The first thing that became clear, very quickly, was that the common front shown before the enemy masked some profound divergences... But a curious change of direction was already taking place at the centre of the movement. The activist trend of Tzara and Picabia, dominant at first, was on the decline, while the trend represented by Breton was gaining ground. The Zurich Dadaists, averse to any organization and fervent adepts of the game of truth and chance, could offer no serious opposition to the editor of *Littérature* who, on the strength of his calm determination and his remarkable dialectics, contrived to thrust the Dada movement in the direction of his choosing" (Michel Sanouillet, *Dada à Paris*, 1965). By the summer of 1921 Paris Dada was breaking up.

Meanwhile, in 1920, Duchamp had again left Paris for New York, where with Man Ray he tried to line up a Dada team and launched a new periodical, *New York Dada*, the first issue appearing in April 1921. Duchamp was back in Paris in May 1921 (Man Ray in July), and very sporadically he worked on his *Large Glass*, this historic moment being recorded by Man Ray's photograph, *Dust Breeding*, taken in Duchamp's Paris studio. In the United States the most notable event was the founding of the Société Anonyme in New York by Duchamp, Katherine Dreier and Man Ray: it opened on 30 April 1920 with an international exhibition, "From Post-Impressionism to Present Art." The Société Anonyme then proceeded to organize regular exhibitions, initiating the American public into the latest experiments of avant-garde art. The organizers made no secret of their intentions, declaring on opening day: "We do not claim that all the movements we show will endure or will become a component part of art, but we feel that the serious forms of expression should be seen and studied. One of the main objectives of the directors of the Société Anonyme is to rise above personal tastes and provide a show place free of any preconceived judgement."

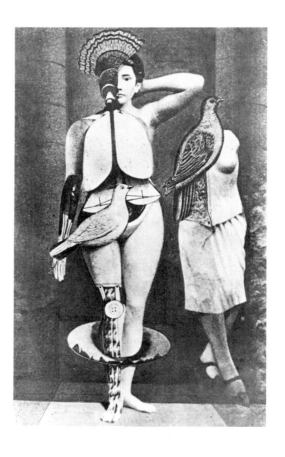

Paris Dada: "Beyond painting"

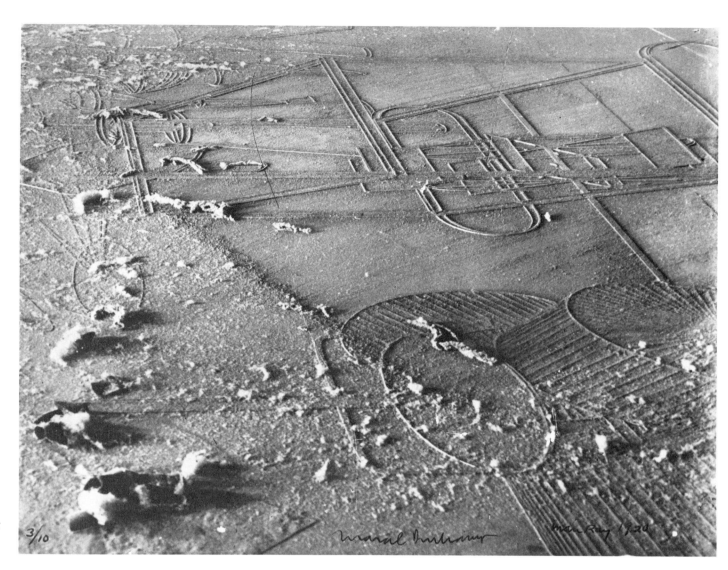

Marcel Duchamp (1887-1968): Dust Breeding, photograph by Man Ray, 1920.

Man Ray arrived in Paris on 14 July 1921. There he was to reveal the expressive possibilities of photography, replete with surprises and sophistication, at the very time when Max Ernst was taking the French art world by storm. In May 1921 fifty-six of Ernst's collages were exhibited at the Galerie Au Sans Pareil in the Avenue Kléber; and he even extended the poetic range of his collages by branching out into some photomontages.

The Max Ernst exhibition inspired André Breton to write his first essay on art; it also aroused the enthusiasm of Louis Aragon and Paul Eluard. The invitation card bore the heading "Beyond Painting," thus summing up the artist's intention in a couple of words, in the most telling way. The revelation of Max Ernst gave the French Dadaists a decisive push away from Picabia, whose wayward, unpredictable character irritated them. Until then he had been the only painter of Paris Dada. Now Ernst took over, and Breton saw to it that his exhibition got plenty of publicity, even hailing the Cologne artist as "the Einstein of painting"! No. 19 of *Littérature* (April 1921) was a Max Ernst issue. Breton later wrote: "I remember the emotion, of a quality we never again experienced, that gripped Tzara, Aragon, Soupault and myself when we discovered these works from Cologne, at Picabia's flat, where they had just arrived at that moment (1921), while we were with him. The external object had been removed from its usual setting, its component parts had somehow been released from it, in such a way as to enter into entirely new relations with other elements" (André Breton, *Genèse et perspective artistique du Surréalisme*, 1941).

This famous exhibition opened on 2 May 1921, being staged by Breton as a noisy demonstration in the purest Dada style. The collages themselves were enough to create a sensation: nothing like them had been seen in Paris, which knew nothing of the new twist given to this technique in Central Europe. The future Surrealists were particularly delighted by the fanciful titles of the collages, written on them by Ernst himself, some in French, some in German. From that moment Ernst felt at home in Paris and settled there in August 1922.

Francis Picabia (1879-1953): L'Œil Cacodylate, 1921. Oil.

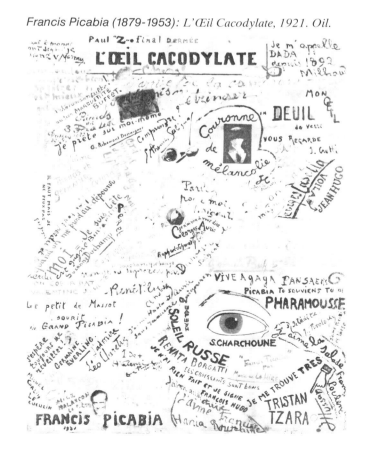

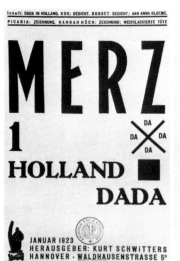
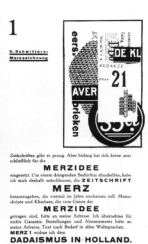
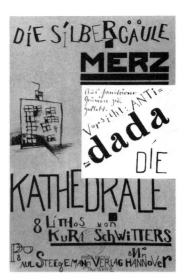

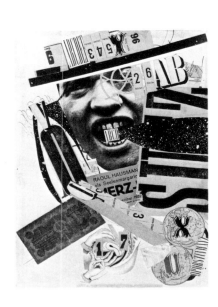

Hanover Dada, the invention of Merz

"We had met in 1918 in Berlin. One evening at the Café des Westens, Richard, the hunch-backed, red-haired newsboy, came over to my table and said to me: 'There's a gentleman here who would like to speak to you.' So I went over to him. Really, a man of about my age was sitting there, he had chestnut-brown hair, blue eyes, a straight nose, a rather soft mouth, a not very energetic chin, all this on top of a high neck and a dark necktie. The man got up. 'My name is Schwitters, Kurt Schwitters.' I had never heard the name before. We sat down. I asked him: 'And what do you do?' 'I'm a painter,' he said, 'I nail my pictures.' This was something new and attractive. We went on questioning each other and I learned that this man also wrote poems. He recited some of them for me. They struck me as still being under the influence of Stramm, but one of these poems seemed to me good and new." Thus does Raoul Hausmann, in his *Courrier Dada* (Paris, 1958), describe his meeting with Schwitters, the Dadaist who never actually belonged to the Dada Club, because Huelsenbeck dismissed him as a romantic and Tzara put him down as a bourgeois: "A machine-age romanticism, linked up with the blue flower of the German lower middle class, constituted one of the essential sources of his very peculiar humour" (Werner Schmalenbach, *Kurt Schwitters*, 1967). And in fact Schwitters never shared the anti-artistic and anti-aesthetic attitudes so distinctive of Dada, even though he himself may be said to have invented Hanover Dada. Only the New York Dadaists recognized him as one of their own and included some of his collages in one of the first exhibitions sponsored by the Société Anonyme.

Born in Hanover in 1887, Kurt Schwitters lived there until 1937. From 1909 to 1914 he studied at the art academies of Dresden and Berlin, reliving in his own way the whole adventure of modern art, from Expressionism to abstraction, into which he was initiated by the circle centring on Herwarth Walden and the Berlin periodical *Der Sturm*. He spent the war in an office behind the lines, where he wrote verse. In 1918 he suddenly turned his back on the traditional forms of painting which he had learned. In 1930 he looked back on this period: "During the war all this was fermenting. What I had got from the art academy was of no use to me. The new, which might have been of some use, was still in the process of developing, while all around me there was this frightful struggle over things that left me indifferent. And suddenly it was the glorious revolution. I don't care much for this kind of revolution. Men have to be ripe for it. It's like those times when the wind blows the unripe fruit off the trees. Much damage is done. But at least that deception which men call war was over. I left my work without even giving notice, and full steam ahead! But it was only then that the real fermentation began. I was free and I felt the need to sing out my joy in the face of the world. To do so, and because I had to be thrifty, I took what I could find. For the country was very much impoverished. One can create very well with odds and ends and that is what I did, sticking and nailing them together. To these objects I gave the name Merz, and that was my prayer to celebrate the victorious end of the war, because for me peace was tantamount to victory. In any case everything had been destroyed, and the point now was to build something new with the pieces" (*ibid.*).

Schwitters became the most astonishing maker of collages and assemblages, but he had no intention at that time of indicting society by throwing its own rubbish in its face; this sociological interpretation, quite unfounded, was only applied to him later. His work was radically distinct in spirit from the Dada collages of Berlin and Cologne, for he took no account of the significance of the remnants he used, he cared nothing for the revelation of chance encounters. He cut out more than he tore up, and the pieces became part of an interconnected whole very close in its rhythm and plastic shaping to the works of the Cubists and Futurists. Lettering and textures were used in a similar though exclusively plastic way. He aimed, not at eliciting new meanings, but at constructing a new space, a more modern reality. "Merz," he insisted, "always strives to achieve art." Oil painting had been invented to answer the needs of illusionism, of nature imitation; materials taken over or recuperated were better suited to an art which refused to imitate nature. And collage, consisting of a bold combination of incongruous elements, was especially well suited to express the contrasts and dynamism of modern life. "Schwitters' discovery of collage at the turn of the year 1918-1919 was for him an unexpected liberation. It set him free from painting, which he was in no position to exploit to the full, and gave him access to a new world of expression of which he had had no conception hitherto, and in which he was now to make himself more at home than anyone before him. His genuine, highly artistic dilettantism found in collage a medium of expression which suited him, and here he contrived to outdo himself. His highly personal taste for tinkering was sublime and he made it an art" (Werner Schmalenbach). It was this experimental attitude and his keen sense of design and structure which cemented his friendship with Theo van Doesburg, with whom he made a Dada tour of Holland in 1922-1923.

In 1927 Schwitters himself (in "Katalog," *Merz* No. 20) explained how he coined the name Merz and why he applied it to everything he had done since 1919: "I called my new works that employed any old materials Merz. This is the second syllable of Kommerz [i.e. commerce]. It arose in the Merz Picture, a work which showed, underneath abstract shapes, the word Merz, cut from an advertisement of the Kommerz- und Privatbank and pasted on. This word Merz had

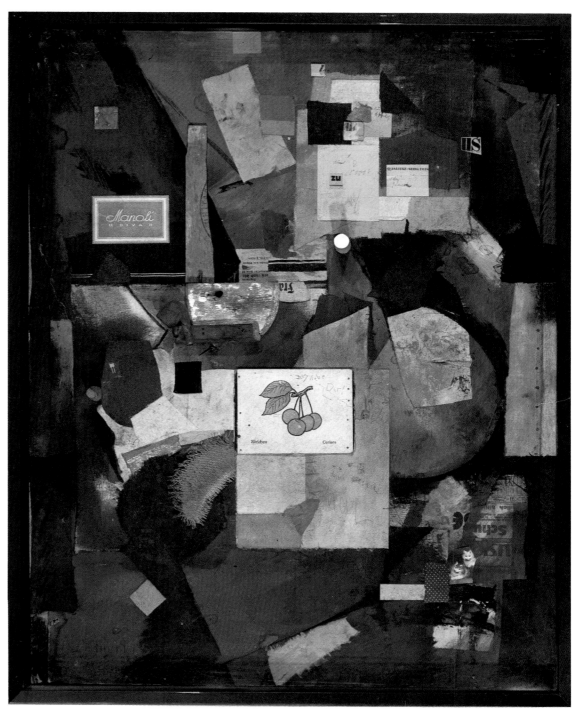

I could see no reason why old tickets, driftwood, cloakroom tabs, wires and wheel parts, buttons and old rubbish found in the attic and in refuse dumps should not be a material for painting just as good as the colours made in factories. This was, as it were, a social attitude and, artistically speaking, a private hobby, but particularly the last.

Kurt Schwitters, in *Merz*, 1927.

itself become part of the picture by adjustment to the other parts, and so it had to be there. You will understand why I called a picture with the word Merz the Merz Picture, just as I named a picture with the word 'and' the And Picture... And now, as I exhibited these pasted and nailed pictures at the Berlin Sturm gallery for the first time, I was looking for a collective term covering this new style... So I named all my work as a species after the characteristic picture—Merz pictures. Later I extended the use of the word Merz, first to my poetry, for I have written poetry since 1917, and then to all my related activities."

Schwitters' nonsense collage-poem *Anna Blume* was published in 1919; it was followed by another, called *Ursonate*, in 1924-1925, and he recited them in Leipzig and Prague with Raoul Hausmann and in Holland with Theo van Doesburg. "Abstract poetry must be given credit for having liberated the word from its associations and placing the value on word against word, more particularly on concept against concept, taking only sound into account. This is a stricter system than the development of poetic feelings, but not yet strict enough. What abstract painting tries to achieve, the Dada painter is after too, but in an even more rigorous manner, by opposing real objects to each other, sticking and nailing them side by side. Here the concepts are much more clearly perceptible than in the metaphysical meaning of words" (Kurt Schwitters, in the review *G*, No. 3, 1924).

Schwitters dreamed of a total art, and as early as 1920 he began building in his Hanover home, in the Waldhausenstrasse, his first Merzbau, an environment/sculpture made of chance-gathered detritus which grew until, after sixteen years, it filled two floors (it was destroyed in an air raid in 1943). In 1923 he launched a periodical called *Merz*, which served as a link between Dada and Constructivism. It continued to appear until 1932, giving more and more space to the Neo-Plastic and Constructivist ideas of De Stijl, as formulated by Mondrian and El Lissitzky. In *Merz* No. 2 (April 1923), co-signing with Van Doesburg, Arp and Tzara, Schwitters emphasized all that set him apart from the other Dadaists: he never mixed politics and art; they did, especially in Berlin. "It is the duty of art," he wrote, "to arouse by its own means the creative forces of man, and it is aimed at any man who has come to maturity, not just the proletarian or the bourgeois. Only talents of small scope, either because they lack culture or because they have no eye for what is great, will deliberately narrow their intentions to something they call proletarian art (which means politics in the form of painting). Not so the true artist, who has nothing to do with the specific field of social organization. Art, as we wish to see it, is neither proletarian nor bourgeois, for it brings into play forces which are powerful enough to influence all culture instead of allowing themselves to be influenced by social relations."

The assemblage

Kurt Schwitters (1887-1948): Breite Schmurchel, 1923. Wood.

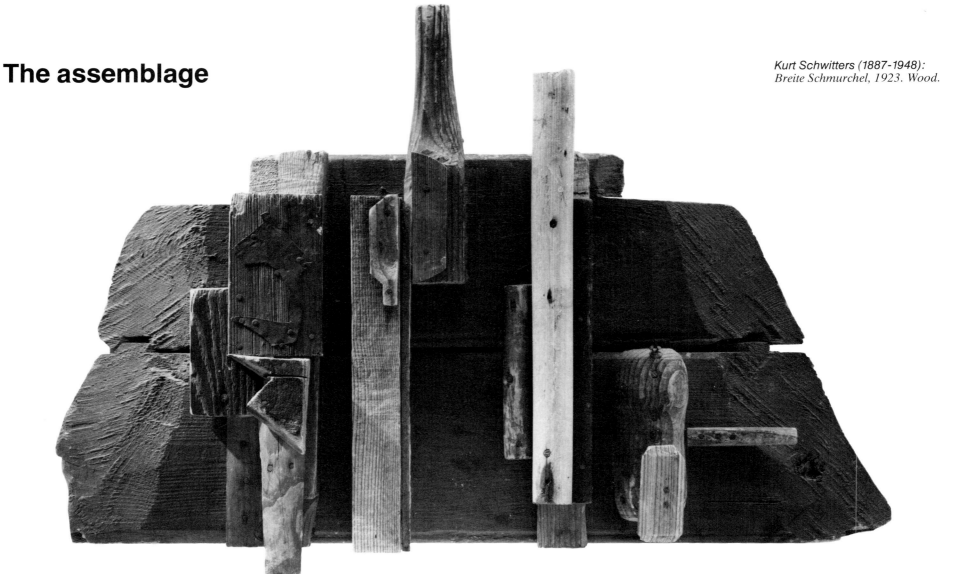

The collage, made by gluing paper or [] fabrics to the canvas or panel, was invented by the Cubists in 1912: it was two-dimensional. The next step, very soon taken, was the assemblage, which in effect is a three-dimensional collage, a free-standing or mounted combination of various elements or objects. Historically speaking, the introduction by Braque and Picasso of these two art forms or practices fundamentally renewed the problematics of modern painting and sculpture.

Braque, in his first pasted papers, introduced elements alien to painting in order to reinforce the signified. Picasso went much further in his constructions of 1912-1914, which disregarded the traditional frontiers between painting and sculpture, so merging them as to make them indistinguishable. In experimenting with the expressiveness of materials, he discovered the importance of the void, of empty spaces, when he came to confront illusion with reality, to oppose imitation to production. In breaking away from the homogeneity and luminous transparency of oil painting, and from the traditional mass of the self-contained, self-enclosing piece of sculpture, the Cubists demonstrated the effective use of found materials, alien to art in their origin and purpose: these, when assembled in a construction, led to a new understanding of space and a new use of space.

The assemblage very soon became one of the most distinctive media of modern art, for based as it was on a combination of different elements it opened the way to an art language of rupture, opposition and contrast, closely corresponding in its essential features to the dynamics and the syncopated rhythms of the modern cityscape and modern life. It was left to Umberto Boccioni (1882-1916), in his manifesto of Futurist sculpture (1913) and in his actual sculptures, to set art free from its lingering trammels and make it possible for the artist to use new materials without reference to the visible world and without natural models. With Boccioni, the "found" material was used for its own sake, independently; it was taken up in the work without its meaning being distorted by any sense of its original use or purpose.

The Readymades of Duchamp and the machine drawings of Picabia did not have the same plastic consequences. Even in 1920-1921, when Picabia took to collage in the context of Paris Dada, he played essentially on the metaphorical resonance of the elements he used, and on the referential or symbolic expressiveness of the associations they evoked. Arp was the first to take full advantage of the freedom offered by the assemblage, and as soon as he settled in Zurich in 1915 he began to set his hand to all sorts of materials, using them as the free play of his imagination or mood prompted him. Arp's influence on the others was strong, all the more so for the fact that, from Zurich to Berlin, from Cologne to Hanover and Paris, we find him active on all fronts, in all the Dada publications and manifestations.

Arp was fully aware of the importance of this new medium of expression, which not only enabled him to make the most of chance but to produce "as nature produces," unrestrained by any tradition, by any concern to imitate the visible world. "Dada," he said, "denounces the infernal wiles of the official vocabulary of wisdom. Dada is for meaninglessness, which is not the same thing as nonsense. Dada is meaningless as nature is. Dada is direct as nature is. Dada is for infinite meaning and definite means." At that time Arp fell back on collages and assemblages as his exclusive techniques. And of his works "made according to the laws of chance," he could say: "The natural beauty of these objects is inherent in them, like that of a bunch of flowers picked by children." He had found the technique which enabled him to disregard any "ridiculous resemblance to something else." His plastic works were more organic than his writings in which he resorted to collage-similes rich in associations, typical already of that psychic automatism so dear to the Surrealists.

Max Ernst also made a few Dada assemblages, and in these we find a more constructive and plastic use of the given materials than in his collages. The meaning attaching to the materials from their origin is less important than the way in which they are integrated into the morphology of the work.

For the German Dadaists, as noted by Eberhard Roters, the collage was chiefly used as a gesture of self-defence or a statement of refusal. "Collage and photomontage conjure up the fragmented image of the world that has taken hold of our mind from the beginning of the industrial revolution and all the time it has lasted, driving out the old projections of a self-contained, homogeneous world. To this, however, is added something more. This fragmentation has concretely released a whole aggressive drive, evidenced in the very snip of the scissors. The war was a mammoth process of smashing to pieces, in this unique of its kind, a battle of men and material in which everything was destroyed, in which the whole was shattered into disconnected fragments, in which everything precious was rendered worthless by brute force. The soldiers and their officers were therefore haunted by unfathomable anguish, by phantasmal visions of being cut and hacked to pieces: these became only too real during the war and continued to obsess men long after the war ended. Collage and photomontage offered an artistic medium in which this anguish, these phantasms of slashing and cutting, were subjected to a process of cultural sublimation and found release in pictorial representation" (Eberhard Roters, *Kurt Schwitters et les années 20 à Hanovre*, in the catalogue *Paris/Berlin*, Centre Georges Pompidou, Paris, 1978).

The triviality and worthlessness of the materials used heightened the aggressiveness of the work by thus embodying a sorry, shabby, outworn reality referring back directly to the woes and drudgery of daily life. Such was the impression Tzara felt when he saw Schwitters' work in 1922: "His pictures are made with natural means, with the help of anything he can find in the street. Scraps of rusty metal, old padlocks, broken wheels. His pictures do not come from his studio brand-new, as they do from other artists, and then begin to age. No, they come half-shattered, rusty and dirty, for, as he says, everything gets worn down, and there is nothing quite clean in this life of ours, neither men nor furniture nor feelings. Why should artists suppose that they can create something materially clean and eternally new? Art long ago gave us a glimpse of the subtle and indefinable side of Einstein's relativity" (Tristan Tzara, *Le Roman de la Révolution Allemande*).

But Schwitters pointedly emphasized that for him the elements of his assemblages represented a new means of drawing and painting: "Any means can be resorted to, so long as it answers the purpose... It doesn't matter what the material was or meant before it was embodied in the work of art, only provided that the latter confers its artistic significance upon it" (Kurt Schwitters, *Dada Complet*, in *Merz* No. 1, January 1923).

One can understand, reading these comments of his, why the other German Dadaists shied away from Schwitters: they felt, quite rightly, that he was more of an artist than a revolutionary. It was through the assemblage, in which Schwitters pioneered, that the artist broke free from the rigid frame of the picture. With him, as also with Christian Schad, the work of art jumped out of the "window of the painting" and began freely creating its own space.

Schad, born in Bavaria in 1894, also participated in Zurich Dada, but in 1918 he settled in Geneva and made his career there. His colour reliefs were shown at the Neri Salon in Geneva in 1920: "I wished by means of commonplace realities to show my hostility to tradition," he later said. "Archipenko, who had just arrived in Paris, discussed them eagerly with me, insisting on the psychological element in art, an element which seemed to him primordial and which he failed to find in my Dada creations. I told him that the psychological element was the very thing I was trying to get rid of, for I considered it a remnant of Expressionism, a motivation and fixation, and therefore a handicap" (interview with Irmeline Lebeer, in *Cahiers du Musée National d'Art Moderne*, No. 1, Paris, 1979).

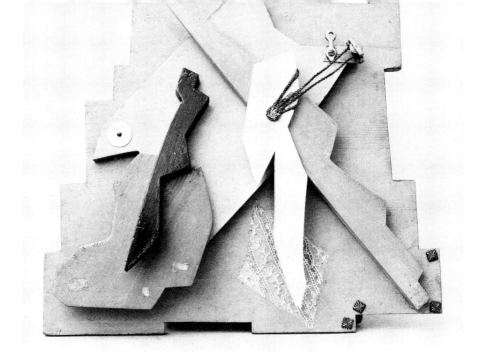

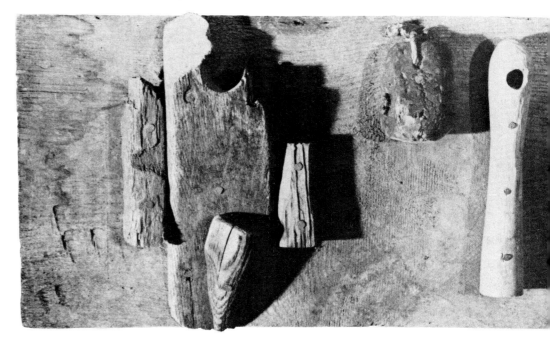

△△ *Christian Schad (1894): Erotik, 1920. Wood relief.*

△ *Hans Arp (1887-1966): Castaway's Kit, 1920-1921. Wood partially painted.*

◁ *Francis Picabia (1879-1953): Feathers, 1923-1925. Oil and collage.*

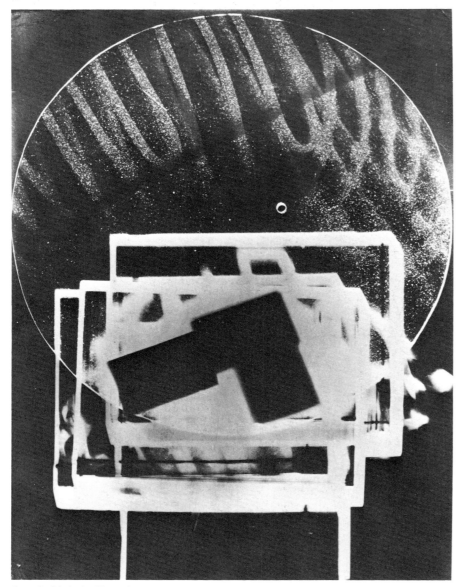

Laszlo Moholy-Nagy (1895-1946): Photogram, 1922-1926.

Christian Schad (1894): Schadograph, 1918.

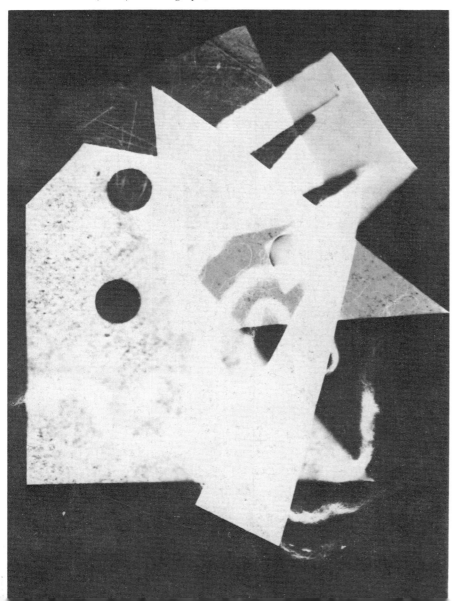

New forms of photography

From the time of its invention in 1839, photography for decades entertained stormy and uncertain relations with painting. In spite of the work of Alfred Stieglitz and his friends, those relations grew even more strained, until the day when the Dadaists took photography in hand and entirely renewed its use and possibilities with the invention of the photomontage and the photogram. Foreseeing the resources offered by these new techniques, André Breton gave an ambiguous interpretation of photography: "The invention of photography dealt a fatal blow to the old media of expression, both in painting and in poetry, in which automatic writing appearing at the end of the nineteenth century came as a veritable photograph of the mind" (André Breton, *Les Pas perdus*, 1924).

The old insistence on the representation of visible things maintained its hold, even when the photogram had gone beyond it. Raoul Hausmann was one of those who succeeded in putting photography on a level of expression technically equal to painting and drawing, and he thereby reconciled art and figuration without making either dependent on or subordinate to the other. He has taken the trouble to explain what photography meant to the Dadaists. Photography had all too often been used as a "dead mechanical" device reflecting all the concepts of an unchanging society. The Dadaists, by inventing the photomontage and the photogram, at once transcended this notion. Photomontage offered a way of destroying the harmony of appearances and taking one's critical distance.

Photomontage had a very considerable impact. It became a singularly effective political weapon (more will be said about this later). From a purely visual point of view, it had a liberating effect on the artist. Breton recognized this in discussing the works of Max Ernst: "But the faculty of the marvellous, even while remaining within the field of our experience, reaches out to two remote realities and throws a spark across the gap between them; it brings within the scope of our senses certain abstract figures, lending them the same intensity, the same salience as others; and it cuts us off from any system of reference and bewilders our very memory. What this artist does and conveys, is just this. He who is endowed with that faculty may be made by it something even more than a poet" (André Breton, *ibid.*).

The same point was brought home to Hausmann in a different way: "Our eye has a tendency to set in optical relations a certain customary order of things; it does not distinguish or, through the operation of our will, does not want to distinguish the multiplicity of forms, which only become visible when the reins of the conscious mind are dropped. Seeing, after all, is something of a social function; things are rendered commonplace for us by a visual allegorism which eliminates their manysided meaning... Our perception is apt to fail totally when it comes to the depths and reaches between things; and it is precisely this that the photomontage makes us see" (Raoul Hausmann, *Je ne suis pas un photographe*, 1975).

As Hausmann notes, the transition from the collage of photographs to the manipulation of negatives was soon made. It was in the photo lab that the photogram was invented. Its inventor was in fact W. H. Fox Talbot (1800-1877), who as early as 1839, at the very time when photography was being invented, succeeded in recording the imprint of actual objects on light-sensitive paper. Christian Schad was the first Dadaist to discover the expressive possibilities of this practice. At Geneva where he settled in 1918, he hit on this technique of "cameraless photography" which, in his own estimation, was his most important contribution to Dada. Publishing some of these works in *Dadaphone* in 1920, Tzara dubbed them "Schadographs."

"Taking found objects and setting them out as fancy prompted on photographic paper such as was used at the time, I found that they were directly printed on it under the influence of daylight, thus taking on a wholly new reality. It was Walter Serner who at once grasped the interest and novelty of these photographic images, and who conjured me not to disregard them. For him, I had opened a door—the door through which technique burst into art. Through him the Schadographs were sent on to Tzara and the Dada publications in Paris" (Christian Schad, interview with Irmeline Lebeer, in *Cahiers du Musée National d'Art Moderne*, No. 1, Paris, 1979).

It was also by chance that Man Ray discovered the photogram. In 1917 he was already making glass prints, done by working directly on the negative and involving some actual drawing. In Paris in 1921, while he was making some photographs for the couturier Paul Poiret, an error led him to discover the possibilities of direct exposure on proof paper: "Again at night I developed the last plates... It was while making these [contact] prints that I hit on my Rayograph process, or cameraless photographs. One sheet of photo paper got into the developing tray—a sheet unexposed that had been mixed with those already exposed under the negatives—I made my several exposures first, developing them together later—and as I waited in vain a couple of minutes for an image to appear, regretting the waste of paper, I mechanically placed a small glass funnel, the graduate and the thermometer in the tray on the wetted paper. I turned on the light; before my eyes an image began to form, not quite a simple silhouette of the objects as in a straight photograph, but distorted and refracted by the glass more or less in contact with the paper... I made a few more prints... I took anything I could lay my hands on... the key of my hotel room, a handkerchief, some pencils, a shaving brush, a piece of string" (Man Ray, *Self-Portrait*, 1963).

In the resourceful hands of Man Ray, camera and light became the ever-ready collaborators of the artist, but the external reference remained important at all levels. The photograms of the Russian artists, on the contrary, surprise us by their purely pictorial and even abstract value. When the Hungarian artist Laszlo Moholy-Nagy turned to this technique, he may have been familiar with El Lissitzky's photograms. Born in 1895, Moholy-Nagy was wounded in the war while serving as an artillery officer in the Austro-Hungarian army. During his convalescence in 1917 he took up art. In Budapest in 1919 he was associated with the MA group which tried to combine art with the communist revolution launched by Bela Kun. When the latter failed, Moholy-Nagy moved on that same year to Vienna, where with Ludwig Kassak he edited the review *MA* (Today), a forum for avant-garde ideas. By the time he settled in Berlin in 1920 he was thoroughly familiar with the work of the Russian artists and appeared himself to be a Constructivist. However, as his collages abundantly show, he was not indifferent to Dada. His meeting with Lucia Schultz, whom he married in 1922, opened his eyes to photography. He was also attracted by the transparency and play of light in space. He wrote: "The capacities of one man seldom allow the handling of more than one problem area. I suspect this is why my work since those days has been only a paraphrase of the original problem, light" (Laszlo Moholy-Nagy, *Abstract of an Artist*, George Wittenborn, Inc., New York, 1947).

It was in 1922 that he began his experiments with photograms, but with him they were part of a Constructivist line of research: "My photographic experiments, especially photograms, helped to convince me that even the complete mechanization of technics may not constitute a menace to its essential creativeness. Compared to the process of creation, problems of execution are important only so far as the technique adopted—whether manual or mechanical—must be mastered. Camera work, photography, motion pictures, and other projective techniques clearly show this. It may happen that one day easel paint-

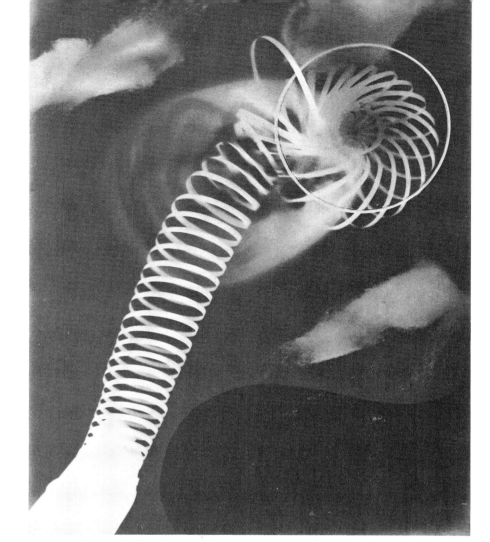

Man Ray (1890-1976): Champs délicieux, 1921-1922. Rayograph.

ing will have to capitulate to this radically mechanized visual expression. Manual painting may preserve its historical significance; sooner or later it will lose its exclusiveness. In an industrial age, the distinction between art and non-art, between manual craftsmanship and mechanical technology is no longer an absolute one. Neither painting nor photography, the motion pictures nor light-display can be any longer jealously separated from each other" (*ibid.*).

In the work of such artists, Dadaism and Constructivism met and mingled, the more so as both groups were keenly interested in the possibilities of the new photography. In the 1920s the latter came into its own as a direct means of expression. The photogram in particular required from the artist a power of decision by no means foreign to that recourse to the "laws of chance" which appeared with Dada.

El Lissitzky (1890-1941): Composition with Spoon, 1920. Photogram.

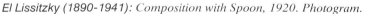

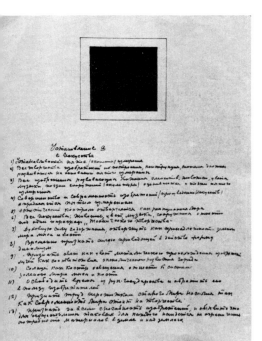

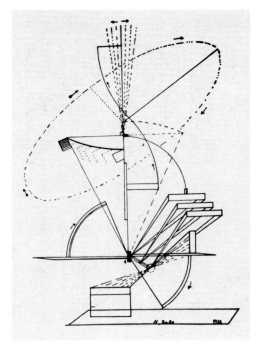

Kasimir Malevich (1878-1935):
Handwritten page from his
lithographed pamphlet
On the New Systems in Art,
Vitebsk, 15 November 1919.

Naum Gabo (1890-1977):
Design for à Kinetic
Construction, 1922.

"Now that the fourth dimension, the time dimension, has become as inevitable for the human mind as the other three, the spatial dimensions, we can no longer content ourselves with placing the work in definite spatial conditions but must also take into consideration the time factor which determines this awareness. The painter who disregards the present day, who refuses to take into consideration the conditions of the period in which he has to work, confines himself entirely to the limited setting of the three-dimensional Euclidean philosophy and inevitably becomes an eclectic" (Nikolai Tarabukin, *For a Theory of Painting*, 1923). This reflection of Tarabukin, from an essay written in 1916 but only published in 1923, shows how keenly aware the Russian artists were of the peculiar circumstances of their own time; it also shows how eager they were, in the full tide of their revolutionary enthusiasm, to break with tradition and build a new society.

The heroic years that in Russia followed the 1917 Revolution are among the most interesting in the history of modern art, not only for the bold innovations then made but above all for the importance of the theories being worked out and tested. After the October Revolution, it seemed possible to reinvent everything, to shape the future as desired. But the lines of action opening before those who had helped to install the new regime soon led to an impasse, as the politicians and bureaucrats took control.

As Commissar for People's Education, A. V. Lunacharsky created in 1918 the Department of Fine Arts (IZO). The progressive artists were given responsible positions in it and within a few months they reorganized Russian cultural life. They followed up new artistic and educational theories, they devised new communications structures, they were never at a loss for new ideas and new initiatives. They made every effort to see that the great art collections housed in the mansions of aristocrats and wealthy merchants were not looted and destroyed, and with these works the IZO, between 1918 and 1921, founded dozens of new museums throughout the country, for the express purpose of promoting artistic education. These new museums were generally planned to include a historical section, a modern section in which avant-garde art figured prominently, and also exhibition rooms. The civil war and the fight against external enemies, Poles, Germans and Allied interventionists, continued until 1921, with great devastation and suffering. Yet the Soviet government invested two million roubles in the work of the IZO, for art appeared to promise much for the new society in the making. For the first time in modern history, the artists themselves assumed both moral and economic responsibility for their activity. Hence the ardent enthusiasm of these Russian artists.

The first exhibition organized by the new regime, in December 1918, was a tribute to Olga Rosanova (1886-1918), a pioneer of Suprematism and head of the industrial art section of IZO, who died prematurely in November 1918. In 1919 came the Tenth State Exhibition, which brought to light some of the tensions between opposing groups and individuals. Subtitled "Non-Objective Creation and Suprematism," this show featured the whole avant-garde and, at the same time, sounded the knell of Suprematism. Malevich sent in his famous *White on White* series, to which Rodchenko replied with his *Black on Black*.

This was the last group exhibition of the new Russian painting. Thereafter the partisans of Malevich's spiritualism and the partisans of Tatlin's constructivism became irreconcilable enemies. Each side defended its positions with manifestoes, essays and lectures—an outpouring of thoughts and theories about art and its purpose and use. All, however, acknowledged themselves to be non-objective creators; all, that is, wished to escape from representation, to eliminate external references from the practice of their art. Taking this point of view, they used the term "realist" in a way of their own, defined by Tarabukin: "I employ the concept of *realism* in its broadest sense, not confusing it with naturalism, which is only one aspect of it... The artist, in the forms of his art, constitutes his own reality and conceives of realism as awareness of the authentic object, autonomous in both its form and its content. This object is not a reproduction of something in the external world but is built up piece by piece by the artist outside the lines of projection which might connect it with reality" (Nikolai Tarabukin, *From the Easel to the Machine*, 1923).

The critic Nikolai Punin had already proclaimed that the art of tomorrow could not remain within the traditional limits of painting and sculpture. This was in a famous lecture given on 24 November 1918 and reprinted in the periodical *Iskusstvo Kommuni* (Art of the Commune): "The bourgeoisie has made art something sacred and set up artists as priests of art. The bourgeoisie has kept art in a shrine which could only be entered with fear and trembling. Thanks to the bourgeoisie, artistic creation has become a kind of pious rite. The proletariat cannot entertain any such idea of art... The proletariat, having overthrown everything, must also create the new art. No proletarian art yet exists, but one may chart the path which it will follow in order to take shape. The proletariat is a great creator; day after day it creates true values. The proletariat extends the artistic conception to our everyday environment, to our daily life... An entirely new era must be opened in art. The proletariat will create new houses, new streets, new objects of everyday use."

Many Russian artists endorsed this view. Ivan Klyun, for example, an ex-Suprematist, wrote in the catalogue of the Non-Objective Creation and Suprematism exhibition of 1919: "Today this corpse of bedaubed nature lies in its coffin sealed with the black square of Suprematism, and its sarcophagus has been exhibited in the new graveyard of art—the Museum of Artistic Culture." And Rodchenko was equally emphatic: "My development began with the collapse of all the Isms hitherto known to painting. The death-knell of colour painting is being tolled, and to that knell we now accompany the last of the Isms to its final resting-place. The last hopes and love itself are going up in smoke, and for my part I am leaving the season of dead truths" (quoted in German Karginov, *Rodchenko*, 1975).

Suprematism, which in 1918 "had flowered in all Moscow," was now doomed. Malevich foresaw the end and took no further part in the group exhibitions. The great retrospective devoted to him at the

end of 1919, bringing together 153 of his works under the heading of "From Impressionism to Suprematism," practically marks his farewell to painting. From that time on, he devoted himself essentially to teaching and to theoretical experiments, for what he had to defend was the philosophical basis of the work of art, whose ontological status was being challenged. He left Moscow in 1918 for Vitebsk, where Chagall had been appointed director of the art school; taking advantage of the latter's temporary absence, Malevich brazenly took over the directorship himself and forced Chagall out. Renaming the school "Unovis" (a Russian acronym for New Art College), he there developed the teaching methods and philosophy which are set forth in his book *Die Gegenstandslose Welt*, published by the Bauhaus in 1927. Although he refused to admit it, Malevich's art practice was based on idealism, and in this he was in flagrant contradiction with the official dogmas of Marxist materialism.

In an essay written at Vitebsk in 1919, Malevich stressed the importance of intuition and denounced the Constructivists: "Intuition prompts the creative principle, but to put it into practice it is necessary to discard the figurative, to create new signs and transfer the concern for the figurative to the new art, to photography and cinema. For our part, we should create our whole life in the same way. Having succeeded in cancelling the figurative out of art, we shall take the creative path of devising new shapes and we shall avoid any juggling with various objects on the tightrope of art, which is what the art schools are doing now and trying to promote" (Kasimir Malevich, *From Cézanne to Suprematism*, 1920).

Abandonment of the figurative or representational system of painting meant for Malevich the possibility of expressing what is universal in man, by bypassing "nature and her elemental forces so that they will cause me no disasters or anxieties. I strive to overcome the elemental forces in mankind, for the latter is a thousand times stronger and more disquieting than the elemental forces of nature; I tend towards brotherhood and unity, so that through brotherhood and unity I may be calm and full" (*ibid.*).

Malevich tried however, by laying down the principle of economy, to give a Marxist justification to Suprematism: "Suprematism may be divided into three stages according to the number of squares, black, red and white ones: the black period, the coloured period, and the white period. In this last were executed the white forms on white. These three periods go from 1913 to 1918. These periods were constructed in a purely plane development. The basis of their construction was the fundamental principle of economy: to render visible by the plane surface alone the force of the static or else the force of the dynamic rest... If each form appears as an expression of purely utilitarian perfection, then the Suprematist form too is nothing else but the signs of the recognized force of action, the signs of the utilitarian perfection of the concrete world which is coming" (Kasimir Malevich, *Suprematism, 34 Drawings*, 1920).

After his return to Moscow from the West in 1917, Gabo, even more than his brother Pevsner, produced a large amount of work as a sculptor. His heads of women renewed the problematics of sculpture by introducing voids as a basic element of the construction. He went still further with his *Standing Wave* (1920), the first kinetic sculpture, creating virtual volumes; that is, by its oscillations it defines a volume without using an actual mass, thanks to the introduction of mechanical movement. For the rod was set vibrating by an electric motor.

Gabo and Pevsner shared the ideas of Malevich. Like him they felt that the purpose of art is to materialize man's vision of the world. "The conflict in our ideologies, between Tatlin's group, who called themselves productivists, and our group only accelerated the open break and forced us to make a public declaration. Tatlin's group called for the abolition of art as an outlived aestheticism, belonging to the

The death of painting

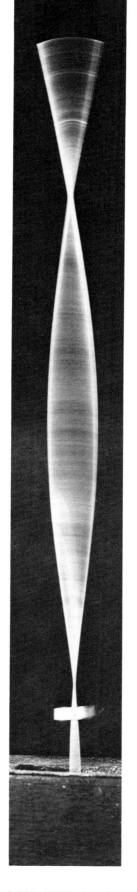

culture of capitalistic society, and they were calling on those artists who were doing constructions in space to drop this 'occupation' and start doing things useful to the human being in his material surroundings—to make chairs and tables, to build ovens, houses, etc. We were opposed to these materialistic and political ideas on art and in particular against this kind of Nihilism" (Naum Gabo, *Constructions, Sculpture, Paintings, Drawings and Engravings*, Harvard University Press, Cambridge, Mass., and Lund Humphries, London, 1957).

On 5 August 1920 Gabo and Pevsner published their "Realist Manifesto." It was a revolutionary statement of the position of the modern sculptor. They affirmed their conviction that art would continue to live because it is an indispensable expression of human experience. "No new artistic system will withstand the pressure of a growing new culture until the very foundation of Art will be erected on the real laws of Life. Until all artists will say with us: All is a fiction, only life and its laws are authentic" (*ibid.*).

Malevich having retreated to Vitebsk and left them a free hand in Moscow, the Constructivists imposed a new programme of their own: "art in life." Tatlin and his friends wanted to transform work into art and art into work, and this was the basis of the theory of production art which they were then developing. Rodchenko stood out as the boldest experimenter among them, for by 1920 he had reached the limits of painting and sculpture; he had reached a point which could not be overstepped without changing the nature and purpose of creative activity—which in practice meant closing the Museum and reinserting art in everyday life by giving a new meaning to work. This was what Tarabukin had in mind when he laid the theoretical bases of this sublimated realm of art beyond art: "The mark that reveals the essence of art lies solely in the process of the actual work itself, a process conducing to the greatest perfection of workmanship. Art is the most perfected activity applied to the shaping of the material" (Nikolai Tarabukin, *From the Easel to the Machine*, 1923).

From 1918, as an active executive member of the Department of Fine Arts (IZO), Rodchenko took a leading part in reorganizing the decorative arts section. In doing so he focused his attention on sculpture and initiated himself into architecture. Experimenting with equilibrium and dynamism, he made some constructions of suspended planar forms repudiating mass. In his painting, his new concerns soon led him to adopt an attitude which might be described today as one of extreme minimalism. He pressed it to its ultimate consequences in 1921, as was made clear by the "5 × 5 = 25" exhibition held in Moscow in September 1921, consisting of five pictures by five artists, Rodchenko, Stepanova, Vesnin, Popova and Exter. This show had to be relegated to the Pan-Russian Poets Club, outside the official circuit, because the position of the five participants was too advanced. As it was, Rodchenko found himself accused of "social uselessness." In the catalogue he summed up the breathtaking evolution of his art (which would by no means have seemed out of place in the 1970s!) by simply setting out a few dates and facts: "1918. At the Non-Objective Creation and Suprematism exhibition I affirmed spatial constructions for the first time, and in the painting *Black on Black*. - 1920. At the State Exhibition No. 19 I affirmed *The Line* for the first time as a factor of construction. - 1921. In the present exhibition the three fundamental colours are affirmed in art for the first time." What he showed there were three monochromes: pure red colour, pure blue colour, pure yellow colour.

On 20 August 1921, a few days before the "5 × 5 = 25" exhibition opened in Moscow, Tarabukin read a paper at the Institute of Artistic Culture (known as Inkhuk). It was entitled "The Last Picture Has Been Painted." In it he announced that non-objective art had reached its critical breaking point; it had culminated in the absolute analytical purity of the painting material.

Naum Gabo (1890-1977): Standing Wave, 1920.
Kinetic construction. Metal rod and electric motor.

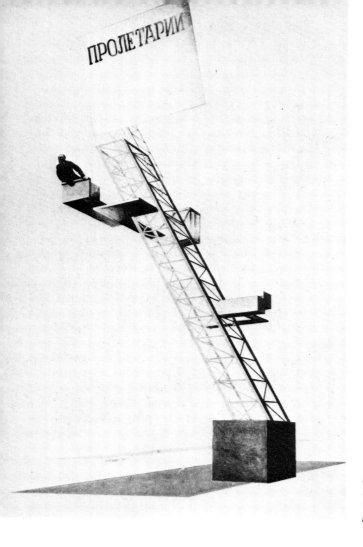

El Lissitzky (1890-1941):
Project for a Lenin Tribune
(UNOVIS), 1920. Gouache,
pencil, ink and collage.

Art
changes
purpose

and the artist set themselves the common aim of constructing the object, the artist goes further than the functional stage, because he develops an "emotional" relation with his material. The "culture of materials" was a reasoned approach to a useful end which was to be worked out in the course of an experimental process combining aesthetic and physical data with the possibilities of the materials.

The idea of production art was backed and encouraged by the Russian government, which saw in it a positive contribution to economic recovery. But the production of objects was only one step towards a more ambitious construction project, defined by Alexei Gan, the theorist and ideologue of the Constructivist group:

"A communist city, as projected by the Constructivists, is an initial step towards an organization of the human mind, it is the first attempt to give the citizens a clear idea of what is meant by collective ownership. The days of pure applied art are over. It has now been succeeded by a period of social experiments. We intend to introduce the utilitarian object, with a form of its own acceptable to all. Nothing will be left to chance, nothing will be gratuitous.

"As regards cultural organization, the only valid criterion is the degree to which culture is connected with the general tasks of the Revolution... Art is dead! There is no place for it in the world of human activity. Labour, technics, organization! So let us drop the speculative activities of art and find the road leading to genuine labour, applying our knowledge and skill to sound, living, useful works" (Alexei Gan, *Constructivism*, written in Moscow in 1920, published in Tver in 1922).

Rodchenko, who had just cemented his friendship with the poet Mayakovsky with whom he henceforth collaborated regularly, was even more active in publishing statements and slogans, intended to illustrate his teaching course at the Vkhutemas (the Moscow art school that has been called the Russian Bauhaus) in 1921: "The artist of our time is the man who knows how to organize his life, his work and himself. We must work for the sake of life, not for the sake of palaces, churches, cemeteries and museums." In their experiments with materials Tatlin and Rodchenko were not far removed from the researches of Gabo and Pevsner into space and dynamism with industrial materials set free from the mass and embodying movement. At this level sculpture and architecture became one, as indeed they do in Tatlin's extraordinary *Monument to the Third International*, which he began designing in 1919 but which was never built.

This monument dedicated to the Revolution, meant to be set up in the centre of Moscow, remains symbolic of the heady Utopian ideals of that period. The axis of the tower was, in the artist's conception, an extension of the earth's axis. Soaring into space, it was to be both the telegraphic communications centre and the international rallying point of world communism. It was to be built of glass and iron and rise to twice the height of the Empire State Building. The cylindrical tower, housing the party offices, was to revolve on its axis once a month, while the cube at the top (the communications centre) was to revolve once a day. The news of the day was to be broadcast by loudspeakers and slogans were to be projected on screens and even on the clouds!

From the start the critic Punin embraced the idea of the tower with enthusiasm: "The artist Tatlin brings forward a project which he has already thought out in its main lines... This project indicates the direction in which the artist will have to work when he gets tired of heroes and busts. The artist must above all disregard culture understood in its narrower sense. The forms of the human body are no longer of any use today as an artistic model. Form will have to be rediscovered" (Nikolai Punin, *A Monument*, in *Iskusstvo Kommuni*, 1919). Tatlin's tower answered perfectly to the decree of 12 April 1918 regarding Monuments for the Republic. Inspired by Lenin, this "pro-

In its insatiable eagerness for novelty, the Russian avant-garde made common cause with the Revolution, which seemed to open up the practical possibility of actually creating that new world to which it aspired. It refused to accept the museum as the final end of the creative adventure; the museum seemed like a relic of the past, ready for the scrap-heap (like so much else). "Non-objective painting has left the museums; non-objective painting is the street itself, the squares, the city, the whole world," declared Rodchenko in 1920. And indeed most of the leftist artists turned away from "mere painting" to enter new fields of application offering a more practical purpose to their creative activity. They reformed the educational structures and most of them took up teaching posts and actively participated in the experiments of "laboratory art."

Tatlin, at the Institute of Artistic Culture (Inkhuk), worked out his theory of the "culture of materials" which he developed along two lines: *Theory of the different branches of art* and *Combination of these different arts for the creation of a monumental art*. To decorative art, in the traditional sense of the term, was opposed production art, whose purpose was the creation of utilitarian objects. For Tatlin "technique must be placed by the artist within a new set of relations between the form of the material and its workmanship. But in his approach to technique the artist can and must breathe new life into the set technical methods." In this context, the object became the substance of creation and bore its value in itself. The review *Veshch-Gegenstand-Objet*, founded in Berlin in 1922 by El Lissitzky, thus defined what came to be called "veshchism": "Any organized creation (a house, a narrative poem or an image) is a rational object... For Veshch, poems, pictorial shapes, vision, everything is a rational object." Tatlin, Rodchenko, Popova, Stepanova and Vesnin henceforth devoted themselves essentially to design, to a working process which might be called that of the artist-engineer. Art and industry are governed by the same economic and technical requirements. But while the engineer

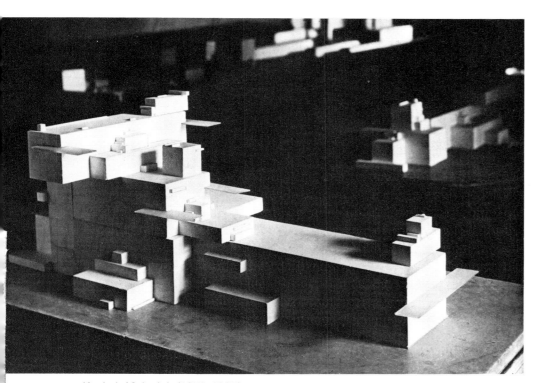

Kasimir Malevich (1878-1935):
Suprematist Architekton, c. 1923-1926. Model.

Kasimir Malevich (1878-1935):
Suprematist Architecture, 1923. Photomontage.

Vladimir Tatlin (1885-1953): Monument to the Third International, 1920. Photograph
of the model, Tatlin in the foreground.

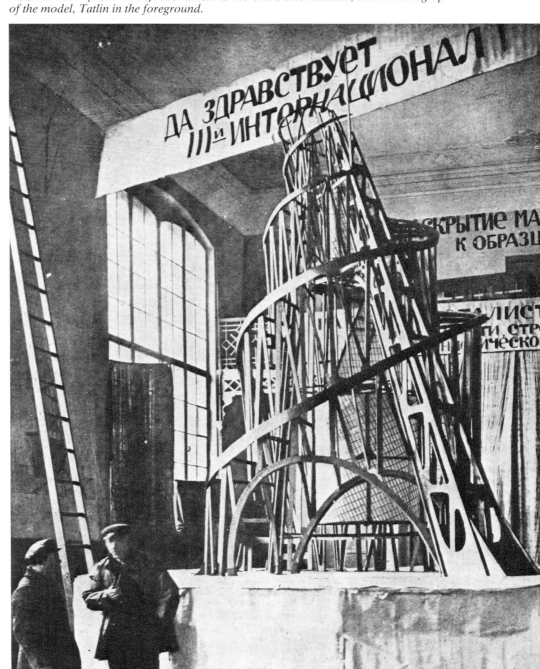

paganda project for monumental art" was intended to stimulate initiatives designed to give the cityscape a new appearance in keeping with the communist vision of the world.

The constructions of El Lissitzky and the Vesnin brothers were inspired by the same ideas. Born in 1890 in the province of Smolensk, Eleazar (El) Lissitzky played an important part in revolutionary art; above all he acted as a link between the Russian avant-garde and that of the West. While studying engineering and architecture in Darmstadt before the war (1909-1914), he had travelled widely in France and Italy. When the Revolution broke out he was in Moscow, then in Vitebsk where he worked with Chagall and Malevich; in 1920-1921 he took part in the Inkhuk experiments in Moscow. A man of many talents, he practised painting and architecture, also photography, and proved himself a highly innovative typographical designer. He organized and arranged, on Constructivist principles, "the most important and the only comprehensive exhibition of Russian abstract art to be seen in the West" (Camilla Gray), at the Van Diemen Gallery in Berlin in 1922, afterwards shown also in Amsterdam. In Germany in 1921 he had contacts with the Bauhaus. He became friendly with Schwitters. In 1925, with Hans Arp, he wrote *Die Kunstismen* (The Isms of Art), in which, under Constructivism, we read: "These artists see the world through the prism of technique. They do not set out to give any illusion with colour on canvas. Instead they work directly on iron, wood, glass, etc. In this the short-sighted see only machinery. Constructivism proves that the borderline between mathematics and art, between an art object and a technical invention, cannot be determined."

The three Vesnin brothers distinguished themselves with their May Day decorations for the Red Square and the Kremlin in 1918. Victor had trained as an architect, Alexander and Leonid as engineers. They were all active members of the Constructivist movement and executed some important works in that spirit.

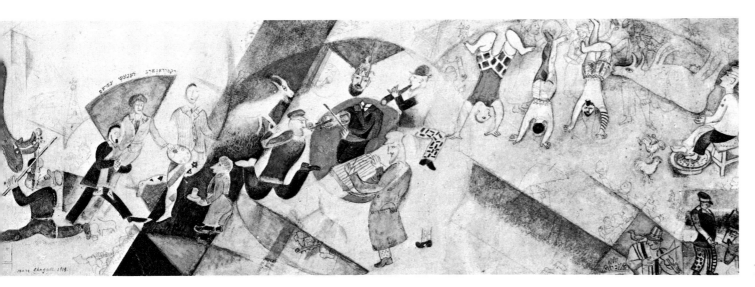

"Our streets are brushes..."

Marc Chagall (1887): Design for a wall decoration in the Jewish Theatre, Moscow, 1919.

"Our streets are brushes, our squares are palettes." This rousing slogan by Punin—from a poem by Mayakovsky—figured on the first page of *Iskusstvo Kommuni* (Art of the Commune) on 5 January 1919. It reflects the mood of the Russian avant-garde at that time. The first anniversary of the Revolution had just been celebrated with spectacular pageantry devised by the artists themselves.

The government relied heavily on artists to popularize revolutionary ideas in a country where illiteracy ran as high as 80 per cent in rural districts. The art of propaganda was therefore a primary concern with artists, who found in it an exhilarating test of their creative resources, while at the same time it gave them some of that social and political responsibility for which they yearned. The revolution opened up unprecedented possibilities of cultural demonstration. Artists were called on to devise methods of communication capable of touching every citizen, to share actively and indeed commandingly in the construction of a new life, to discredit the old beliefs and promote a new way of seeing and feeling.

In 1919 Mayakovsky signed a revealing manifesto: "Artists and writers are expected to take in hand without delay their colour palettes in order to paint and beautify, with the brush of their gifts the hips, brow and breast of our cities and stations, as also of the railway carriages perpetually speeding away." One of the most spectacular manifestations of propaganda art was the creation of propaganda trains and boats which, sent out from Moscow, Petrograd, Kiev and other centres, criss-crossed the entire country, making brief stops at every station, to bring the news of revolution and the hope of a better future. Each train was turned into a moving piece of painting and sculpture, its gaudy decorations inspired by the folk art of the region where it operated. Posters naturally played a large part in such propaganda art, and poster design was entirely renewed, being reduced to the simplest means used in a terse, expressive style. They were generally handmade and stencilled, conveying information in the most concentrated and telling way. The greatest artists took a hand in poster design: it was here that Mayakovsky the poet and Rodchenko the painter began their close collaboration.

Monumental art after the revolution was very different from what it had been before. Works had to be numerous, economical and rapidly executed. Their purpose was social and not aesthetic. They therefore tended to be temporary and ephemeral, like the huge stage sets and backdrops of which only photographs now remain. Projects of all kinds flourished, and many of them were carried out, all over the country. From the little that remains of them, one is struck by their formal innovations, but at the same time they made a fresh use of symbols with a view to creating a new social consciousness.

In his *Report on People's Festivals* (November 1919) M. Kergencev summed up the desired spirit of the demonstrations held on the First of May and the 25th of October: "In our day of socialist revolution, the people's festivals are more than a means of political education for the masses. Thanks to these festivals, the masses are brought into touch with art in all its forms: poetry, painting, music, theatre, etc. The people's festivals must be based on the creative activity of the masses... In the country especially, the people's festivals are the most effective means of fighting against religion. The influence of the Church in all countries is largely due to the magnificent pageants it provided for believers, sometimes with their own participation" (quoted in *Cahiers du Musée National d'Art Moderne*, No. 2, Paris).

These demonstrations fell in with the views of A. A. Bogdanov, the chief theorist of Proletcult (as the official "Organization for Proletarian Culture" was called): "Art is a social product conditioned by the social environment. It is also a means of organizing labour... The proletariat must have its own class culture in order to organize its forces in the struggle for socialism." For Bogdanov there were three roads leading to socialism, the economic, the political and the cultural roads, and he considered the latter to be independent of the party. Not surprisingly, the party bosses disagreed. For them, art like everything else had to be enlisted in the exclusive service of the party.

Liubov Popova (1889-1924): Set design for Fernand Crommelynck's The Magnificent Cuckold, *Meyerhold Theatre, Moscow, 1922.*

Thus in October 1920 we find Lenin acrimoniously blaming Lunacharsky for having allowed Proletcult to assert itself as the representative of people's culture. In December he brought Proletcult under the direct control of one of his disciples; its pretension to represent proletarian art he ridiculed as "ideologically and practically baneful."

Actually it was within the framework of Inkhuk (Institute of Artistic Culture) that the pictorial basis of a monumental art was being laid. Its laboratories carried out the experiments required for an industrial application of the theories of production art—which proved largely illusory owing to the backwardness of Soviet industry, which was still in the craftwork and handmade stage.

The last sector in which artists were still free to realize their artistic schemes and social programme was the theatre, which at that time attracted a genuinely popular audience and had vitality enough to renew its spirit and structures. The Russian theatre of the 1920s represents one of the most prestigious moments in the history of the modern stage, conceived as a synthesis of all the arts.

If Chagall turned to the theatre, it was because he was driven by necessity. He had given it no thought when Lunacharsky put him in charge of the Vitebsk art school in 1918; there, in his native town, he proceeded to reorganize the museum and successfully exhibited his own work. But in 1920 Malevich, in his unscrupulous, overbearing way, ousted Chagall and put the accent on production art, for which Chagall cared nothing. So in May the latter left Vitebsk for Moscow, where he was invited to work at the Jewish State Theatre by the director, Alexis Granowsky. This was a golden opportunity and Chagall poured his imagination freely into sets and costumes for three plays by Sholom Aleichem; he even painted the walls of the theatre. But—an unpolitical artist if there ever was one—he was not in favour with the authorities; he was not the man to toe the party line, and in 1922 he left Russia for good.

When the ideas of production art were applied to the theatre, as they soon were, the result was a new form of realism. In the hands of these artists the stage became like a piece of sculpture, built up with various materials, within a specific and autonomous space and light. These abstract architectural settings determined the staging and the acting.

Alexander Tairov, director of the Moscow Kamerny Theatre (Chamber Theatre), employed Alexandra Exter and above all Alexander Vesnin as scenic designers. There they staged Claudel's *L'An-*

Alexander Vesnin (1883-1959): Set design for G.K. Chesterton's The Man who was Thursday, *Kamerny Theatre, Moscow, 1923.*

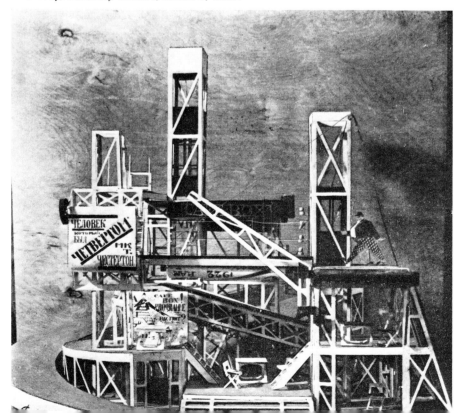

Men of the future,
for you
 nimble sturdy ones,
I a poet
 have cleaned up
the pulmonary spittings
with the rough tongue
of the poster...
For
the sole purpose
 of defending
the Republic
 of the Soviets
Helping
the defence
 the purge
 the construction.

Vladimir Mayakovsky (1893-1930),
At the Top of the Voice.

*Mikhail Cheremykh (1890-1962):
Poster: "And for this the Tsar
has issued orders...", 1920.*

nonce faite à Marie in 1920, Racine's *Phèdre* in 1922 and Chesterton's *The Man who was Thursday* in 1923. The traditional distance between actor and spectator was eliminated in these productions, which led eventually to the conception of the "theatre in the round." The producer V.E. Meyerhold was also very close to the Constructivists; for his sets he called on Varvara Stepanova (Rodchenko's wife), Liubov Popova and the Stenberg brothers.

When on 23 March 1923, for one day, sets and designs from the Russian theatre were shown in Paris at the Paul Guillaume Gallery, the critic Waldemar George wrote in the introduction to the exhibition catalogue, entitled *L'esthétique du Théâtre Kamerny*: "The Kamerny Theatre has put an end to the ornamental decor, as conceived by the French and foreign easel painters who had proved incapable of reshaping the stage and discovering its functional principles... The figures now, as they evolve, set up precise dimensional relationships... and form new rhythmic patterns. In their production of *Phèdre*, Exter and Tairov create a powerful synthesis of planes and volumes which clash and interpenetrate within a reduced space. The stage becomes a virtual and a living space, instead of a mere piece of eye-fooling illusionism."

This new Russian theatre was not conceived as an evening's entertainment for the public, but as a school of life. S.M. Eisenstein himself, coming to the cinema from the theatre and crowd pageants in the early 1920s, was influenced by the spirit and practice of the Constructivists. The avant-garde was able to carry on in the theatre and in typography for a few years more, but it was riddled with conflicts, and owing to these divergences it lost ground to the conservative artists, who regrouped and retrenched themselves in 1921 in the New Painters Association, which in 1922 openly sounded the cry for a struggle against "the speculative art of the productivists" and called for a return to "realistic and representational" painting.

In 1924 Inkhuk (Institute of Artistic Culture) was dissolved and its "object" aesthetic attacked. The NEP (New Economic Policy) launched by Lenin in 1921, to save the country from economic collapse, was based on an outright revival of private interests. It favoured the rise of a new bourgeoisie and the reversion to a non-revolutionary art.

New ways of sculpture

Between 1912 and 1914 Cubism and Futurism had contributed powerfully to a renewal of sculpture, for they had set artists free from the reliance on external models; they had discredited the notion of mass and attached importance to the notion of the void and the notion of space. During the 1920s, Boccioni having died in 1916 and Picasso having temporarily turned away from three-dimensional expression, the Cubists were marking time. Archipenko, Lipchitz, Laurens, Zadkine, Czaky, all those who had contributed to the resurrection of sculpture, seemed to have lost their momentum. They nevertheless found an opportunity of creating some monumental works and several of them were already moderately successful. Marked by the spirit of the age, they did not remain unresponsive to the solicitations of architecture. Lipchitz was on friendly terms with Le Corbusier, who built a house for him; Laurens collaborated with Mallet-Stevens on some designs for a building in Paris commissioned by Jacques Doucet. But such ventures remained sporadic, and instead of re-exploring the constructive possibilities already contained in Cubism, these sculptors turned back to the problems of volume and mass. European sculpture in the 1920s was threatened chiefly by a revival of decorative academicism; the commissions then being made prompted artists to produce objects which were modern enough in their design, but in which the sculpture was reduced essentially to a surface treatment. There was a return to representation, counterbalanced only by a few noteworthy pieces of formal abstraction, inspired by the sculpture of the previous decade. This is especially true of Archipenko.

If contemporary sculpture was able to get its second breath, this was due to the example set by the Russians. It was in post-revolutionary Russia that materials were given a new import, it was there that a new use was made of space. While the constructions of Rodchenko often remain highly theoretical in their "minimalist" formulations, the works of Gabo and Pevsner on the other hand tellingly reveal the potentialities contained in the new use of space and time.

In their Realist Manifesto published in Moscow on 5 August 1920, they wrote: "We renounce volume as a pictorial and plastic form of space... We affirm depth as the only pictorial and plastic form of space.

"We renounce... the mass as a sculptural element... But you sculptors of all shades and directions, you still adhere to the age-old prejudice that you cannot free the volume of mass. Here we take four planes and we construct with them the same volume as of four tons of mass.

"Thus we bring back to sculpture the line as a direction and in it we affirm depth as the one form of space.

"We renounce the thousand-year-old delusion in art that held the static rhythms as the only elements of the plastic and pictorial arts. We affirm in these arts a new element the kinetic rhythms as the basic forms of our perception of real time" (Naum Gabo, *Constructions, Sculpture, Paintings, Drawings and Engravings*, Harvard University Press, Cambridge, Mass., and Lund Humphries, London, 1957).

Some years later Gabo aptly characterized the underlying principles that were to give a fresh momentum to modern art and save it from the pitfalls of "decoration": "The basis of the Constructive idea in Art lies in an entirely new approach to the nature of Art and its functions in life. In it lies a complete reconstruction of the means in the different domains of Art, in the relations between them, in their methods and in their aims. It embraces those two fundamental elements on which Art is built up, namely, the Content and the Form. These two elements are from the Constructive point of view one and the same thing. It does not separate Content from Form—on the contrary, it does not see as possible their separated and independent

existence. The thought that Form could have one designation and Content another cannot be incorporated in the concept of the Constructive idea. In a work of art they have to live and act as a unit, proceed in the same direction and produce the same effect" (Naum Gabo, *The Constructive Idea in Art*, in *Circle*, Faber and Faber, London, 1937).

This attempt to merge content and form was interpreted differently however by the Constructivists on the one hand, who were idealists and for whom "art has an existence and value only in so far as it is a creative act" (Gabo), and by the Productivists on the other. Typical of the latter are Tatlin and Rodchenko, whose views are well expressed by Tarabukin: "Art today finds itself in a terrible impasse. By working at 'pure' form and at that alone, the artist has ended up by depriving his creative activity of any meaning, for we are never satisfied with bare and empty form, intent as we always are on seeking out a content... Repudiating aesthetics, the Constructivists should set themselves a new aim proceeding logically from the very idea of Constructivism; they should, in other words, set themselves a utilitarian aim" (Nikolai Tarabukin, *From the Easel to the Machine*, 1923). It was this intense concern with a utilitarian purpose that led Tatlin to design his *Monument to the Third International* and Rodchenko to design and build furniture; it was this concern that turned them both away from sculpture for its own sake, indeed from any kind of art practised for its own sake.

The constructions of Georgii and Vladimir Stenberg, on the contrary, remain sculptures, even while utilizing the latest possibilities of research and embodying the new relations between labour and technique. Belonging to the Obmokhu group (the Russian acronym for Society of Young Artists), which helped to develop the ideology of "laboratory art" (i.e. the ideology of the artist-engineer as opposed to the easel painter or "pure" artist), the Stenberg brothers elaborated their *Space Constructions*, which they presented in a three-man show, with Kasimir Medunetsky, at the Moscow Vkhutemas in January 1921. In these open spatial compositions, which they specifically described as non-utilitarian, they made full use of the inherent resources of the materials and thus achieved what Tarabukin defined as true realism in sculpture: "It is the material that dictates the artist's form, not the reverse. Wood, iron, glass, etc., impose different constructions. The Constructivist organization of the object therefore arises from the material itself, and the study of different materials constitutes an important question in its own right" (Nikolai Tarabukin, *For a Theory of Painting*, 1923). Taking materials produced by contemporary technology, iron and glass rather than wood and stone, the Stenberg brothers occupy empty space with remarkable sobriety. The dynamism of their assemblages seizes hold of space, whose presence is reinforced by the lightness or transparency of the elements composing the work. Playing on diagonals, they invent evident structures such as we find again in the sculpture of Moholy-Nagy. For these non-objective sculptors, volume is an organic reality obtained by the logic of the construction.

Moholy-Nagy arrived at sculpture—that is, at the materialization of forms in space—in Berlin in 1921. Having come under the joint influence of Constructivism and Dada, he had just created some mechanical pictures of remarkably pure design. They were described as follows by Ernst Kallai: "If in other hands Dada can be a deadly critical instrument directed against morality and society, in those of Moholy-Nagy it celebrates the untold resources of form and movement, the realities of the big city and modern techniques. It becomes the sudden discovery of a new world" (in *MA*, No. 12, 1921). In the same number of that review, Moholy-Nagy also presented his "glass architectures," his first ventures into transparency, permitting the sculptor to penetrate into the interior of volumes, these being mate-

Constantin Brancusi (1876-1957): Adam and Eve, 1921. Wood.

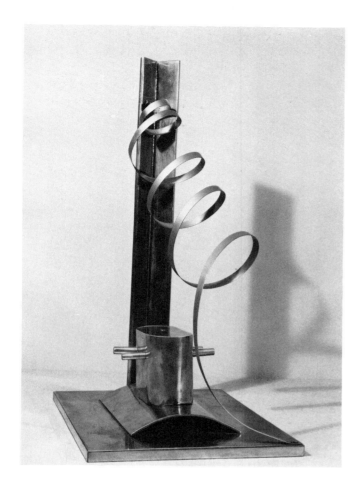

rialized now only in the tension of their contours. Using iron and other materials of contemporary technology, he extended his plane geometric patterns into the reality of space. Thus in modern visual language Moholy-Nagy expressed a pure and multiple space which utilizes in unexpected ways the possibilities of light, the basic pictorial element.

Some ten years younger than the pioneers of contemporary art, Moholy-Nagy appeared on the Berlin art scene in 1920 as one of the boldest innovators, integrating into a dynamic unity visual stimuli which were new to art. "Here is our century of technology, machinery, socialism. Do not shy away from it. Accept the task that falls to

your lot." His work sums up in itself the aspirations and experiments of both the Dutch purists of the De Stijl movement and the Russian creators of Constructivism and Suprematism.

Constantin Brancusi did not share the new conception of space: for him, as a sculptor, mass remained the essential thing. He succeeded, however, in endowing the sculptor's material with a new nobility by cutting it off from nature and chance and lifting it to a plane of transcendental reality by means of sheer formal perfection. Even after the war he can scarcely be said to have tackled any new themes. "I can begin something new every day," he said, "but to finish it is another matter." Behind the multiplicity of visual appearances he groped for an authenticity and essence which he felt and glimpsed: "Simplicity is not an aim in art, but one achieves simplicity in spite of oneself by approaching the real meaning of things." Brancusi was now living in Paris in the Impasse Ronsin (having left his native Rumania in 1904). During the war he turned to woodcarving and remained very fond of this medium. His first one-man show had been held by Alfred Stieglitz at the Photo-Secession Gallery in New York in 1914, but he himself did not visit the United States until 1926.

While the Constructivists in their revolt against tradition turned to modern technology for the materials of their sculpture, Brancusi simply took what nature had to offer—such materials as the craftsmen of every period had learned to master and had endowed with spirit. Unlike the other sculptors of his time, he tackled his material directly, without any preliminary design or model, and made the most of its substance and peculiarities, working his way down to its very core. "Direct cutting is the true road to sculpture, but also the most dangerous for those who don't know how to walk." Slowly, progressively, he gained control over matter in order to "sum up all forms in one form and make that form alive." But Brancusi was not unreceptive to the dynamic forms of his time, and to the massive volumes of archaic sculpture he opposed the taut, elongated forms which would conquer space on the strength of their inner vitality. Like Mondrian he renounced any kind of subjectivity and depersonalized his images in order to bring out "that hidden principle, that truth, which lies in all things."

△ *Laszlo Moholy-Nagy (1895-1946):*
Nickel Construction, 1921.
Nickel-plated iron, welded.

▷ Space Constructions
of the Stenberg brothers
shown at the Obmokhu
exhibition in Moscow,
1921. Photograph by
Alexander Rodchenko.

KOMEN
VAN VERRE
NAAR
DE
AARDE
EN

V 10/11 1922 283

El Lissitzky (1890-1941): Design for the review De Stijl, No. 9, 1922.

The international
of geometric abstraction

Berlin at that time was the focal point of the international avant-garde. Berlin, from its geographical position, became the meeting place between East and West. Artists responded at once to its stimulating atmosphere; the defeat had, for the time being, damped any nationalistic impulses and foreigners felt at home there and fitted in easily. Herwarth Walden's Der Sturm Gallery held open house to all the latest art trends: it was the showplace of avant-garde art and exhibited the work of the Russian, Hungarian and Czech dissidents as soon as they arrived in Germany. Geometric abstract art held the field at first, for its reductionism, its formal neutrality, favoured the search for a simple, effective, community idiom in keeping with the norms of modern industrial life.

The year 1922 was marked by two outstanding events in Germany: the spring exhibition of Russian art at the Van Diemen Gallery in Berlin, organized by El Lissitzky, and the Düsseldorf congress of avant-garde artists held on 29-31 May. It was in the course of preparation for this congress that a meeting occurred between four key exponents of the avant-garde, from four different countries: Van Doesburg, representing De Stijl, Moholy-Nagy, representing the Hungarian review MA, El Lissitzky, who arrived just as the blockade against Russia was lifted, and the veteran Dadaist Hans Richter.

The international congress of progressive artists at Düsseldorf achieved nothing, except to show once and for all that the views of the individualistic artists were irreconcilable with those of the Constructivists, who insisted that "the new art is not subjective but stands on a general basis which can be scientifically defined and which is of a constructive nature. The artist, the scholar and the engineer are the brothers of the workers" (Moholy-Nagy and Ilya Ehrenburg, in Veshch-Gegenstand-Objet, Berlin, 1922). The collective-minded artists also called for a working community: "Then we shall no longer be tossed about between two societies, one of which has no need of us and the other does not yet exist, and we shall be in a position to transform the present world" (Hans Richter).

The sharp difference of views between the individualists and the collectivists was commented on as follows by Moholy-Nagy, representing the MA group: "The publication of the fourth number of the review De Stijl has made us only too well aware of the fundamental differences of opinion and objectives between ourselves and the organizers of this congress. They put the emphasis on the concerns of the 'individual artist,' while we can only envisage life from the social point of view... Our initial task is to make people understand that art as the expression of a psychic experience has lost all meaning and that it must now express the objective requirements of our time. Art must not be afraid of solving the problems of its relations with present-day life, which until now have remained in abeyance. It must find its path, with new supports and new collaborators, and work on a collective, unlimited basis."

This ferment of ideas was voiced in the art magazines of the twenties: MA, edited by Kassak and Moholy-Nagy (Vienna); De Stijl, edited by Van Doesburg (Leyden); Veshch-Gegenstand-Objet, edited by El Lissitzky and Ilya Ehrenburg (Berlin). All pursued a collectivist ideal and all hoped to see it realized by an effort of international collaboration. That effort was further reflected in the review G (standing for Gestaltung, i.e. design), launched in Berlin by Hans Richter; the first number opened with a manifesto by Van Doesburg, Elementary Modulation. The desired exchange of ideas was also achieved by group exhibitions of international scope.

Mondrian left Holland and returned to Paris in 1919, just as the review De Stijl was gaining in prestige and authority. Van Doesburg, its editor, was the chief spokesman of the ideas summed up in the De Stijl manifesto of November 1919, in which the opposition between individualism and universalism was made explicit: "(3) The new art has brought up to date what is contained in the new knowledge of the time: equal proportions of the universal and the individual. (4) The new knowledge of the time is ready to be realized in everything, even in external life. (5) The traditions, dogmas and prerogatives of individualism (the natural) are opposed to this realization." If Van Doesburg was the spokesman, Mondrian was the thinker, and their collaboration lasted until 1924. In Paris in 1920, under the imprint of Léonce Rosenberg's Galerie L'Effort Moderne, Mondrian published the French version of his essay on the new plastic art, Le Néo-plasticisme; it sums up his views and shows that the Dutch artists, who at that time knew nothing of the Russian experiments, nevertheless shared many of their ideas. For Mondrian painting was now ready to depart from its traditional paths and enter more fully into life; the enemy to be overcome was romantic or (as he described it) tragic individualism; the natural had to be replaced by a new reality, by neo-plasticism, a pure creation and construction of the mind: "The future of the new practice and its realization in painting lies in the chromo-plastics of architecture. It applies both to the interior and to the exterior of the building, and to everything which, in the latter, plastically expresses relations in terms of colour. But neither chromoplastics nor the 'New Plastics as picture' which prepares the way for it is a 'decoration.' It is an entirely new painting in which all painting, both pictural and decorative, is resolved" (Piet Mondrian, Le Néo-plasticisme, 1920). However, like Malevich, Mondrian refused to countenance the disappearance of easel painting demanded by the productivists. According to him, only easel painting can give the artist the freedom he needs to express himself to the full, untrammelled by outside pressures and contingencies. In De Stijl (March 1922) Mondrian wrote: "The plastics of equilibrium can prepare for the plenitude of mankind and become the aim of art. Art has in part already begun its own destruction, but if the end were to come now it would be too soon. The regeneration of art through life is not yet possible, and another art is still necessary for our time."

Van Doesburg arrived in Germany in 1920 and there met the architect Walter Gropius. He visited the Bauhaus in Weimar, but criticized it for remaining under the influence of Expressionism, by which he meant individualism. In 1922 he returned to the Weimar

Bauhaus and gave some private courses for free students, the Stijlkursus; his influence created some tensions within the school and by imposing his Constructivist vision Van Doesburg prepared the way for Moholy-Nagy. After exhibiting his own work at the Kestnergesellschaft in Hanover in 1922, he and Mondrian organized a group exhibition of De Stijl at Léonce Rosenberg's L'Effort Moderne Gallery in Paris at the end of 1923. In Paris Neo-Plasticism met with little response, but its principles of design were propagated in Germany by the Bauhaus.

The first exhibition of Russian art of all tendencies since the Revolution was held in Berlin at the Van Diemen Gallery in the spring of 1922. Sponsored by Lunacharsky and organized by El Lissitzky, it brought together 600 works. It was an event. Gabo relates that when Moholy-Nagy saw the show he said: "Look, they have already done everything." Forming a retrospective of Russian art over the past two decades, it was shown in Amsterdam later that year and Western Europe was thus made aware of the importance of the Russian avant-garde. The impact of this exhibition was all the more telling because El Lissitzky installed it on revolutionary lines, the works being so arranged as to create a veritable environment in their interrelations and divergences. The space where they were shown became a living

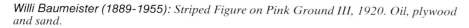

Willi Baumeister (1889-1955): Striped Figure on Pink Ground III, 1920. Oil, plywood and sand.

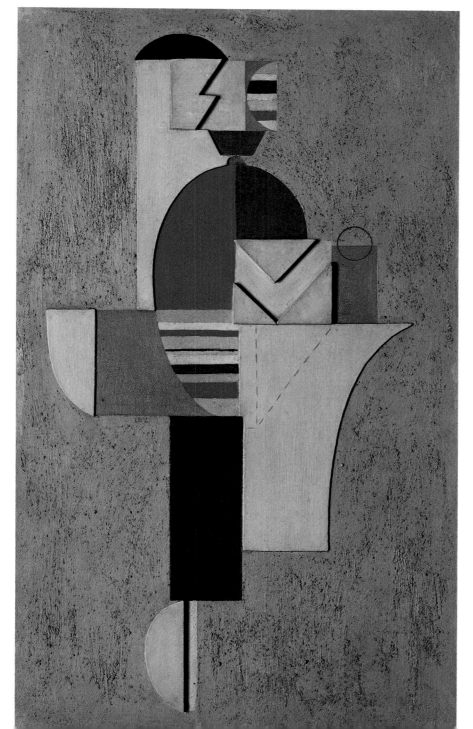

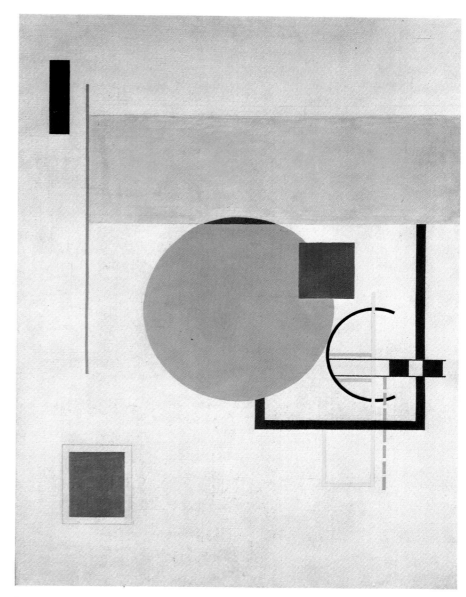

Friedrich Vordemberge-Gildewart (1899-1962): Red Constructed, 1924. Oil.

entity. El Lissitzky played a seminal role in Germany, where he had lived before the war and where he was a constant visitor between 1922 and 1928. He paved the way there for the post-revolutionary Russian émigrés, first Gabo, then Pevsner. It was in Berlin, in 1922, that El Lissitzky published his epoch-making set of ten lithographs called *The Story of Two Squares*. It is the metaphorical expression of his idealistic conception of the Russian Revolution: the red square triumphs over the chaos represented by the black square and establishes the harmony of a new world.

El Lissitzky was deeply influenced by the Suprematism of Malevich, whose abstract geometrical formulations he took over. But he sought now to integrate them into a space which would triumph over the surface of the picture. And so, in 1919, he painted his first *Proun*, as he called his abstract paintings (apparently an acronym of the Russian words meaning "Project for asserting the new"). Like his friend Moholy-Nagy, he was an optimist, with faith in science and confidence in the future, intent on using art and space in new ways. Referring to his *Prouns* he said: "He who constructs Proun pictures concentrates in himself all the elements of modern knowledge, all the systems and methods of this age, and with that he composes plastic organisms which may be likened to the simple elements of nature, as for example H (hydrogen), O (oxygen) and S (sulphur). He combines these elements and obtains an acid which eats into anything it touches; that is, it acts on all levels of life" (quoted in Michel Seuphor, *L'Art abstrait*, 1972). In their experiments both Moholy-Nagy and El Lissitzky give a new dimension to space.

The picture breaks out of the frame

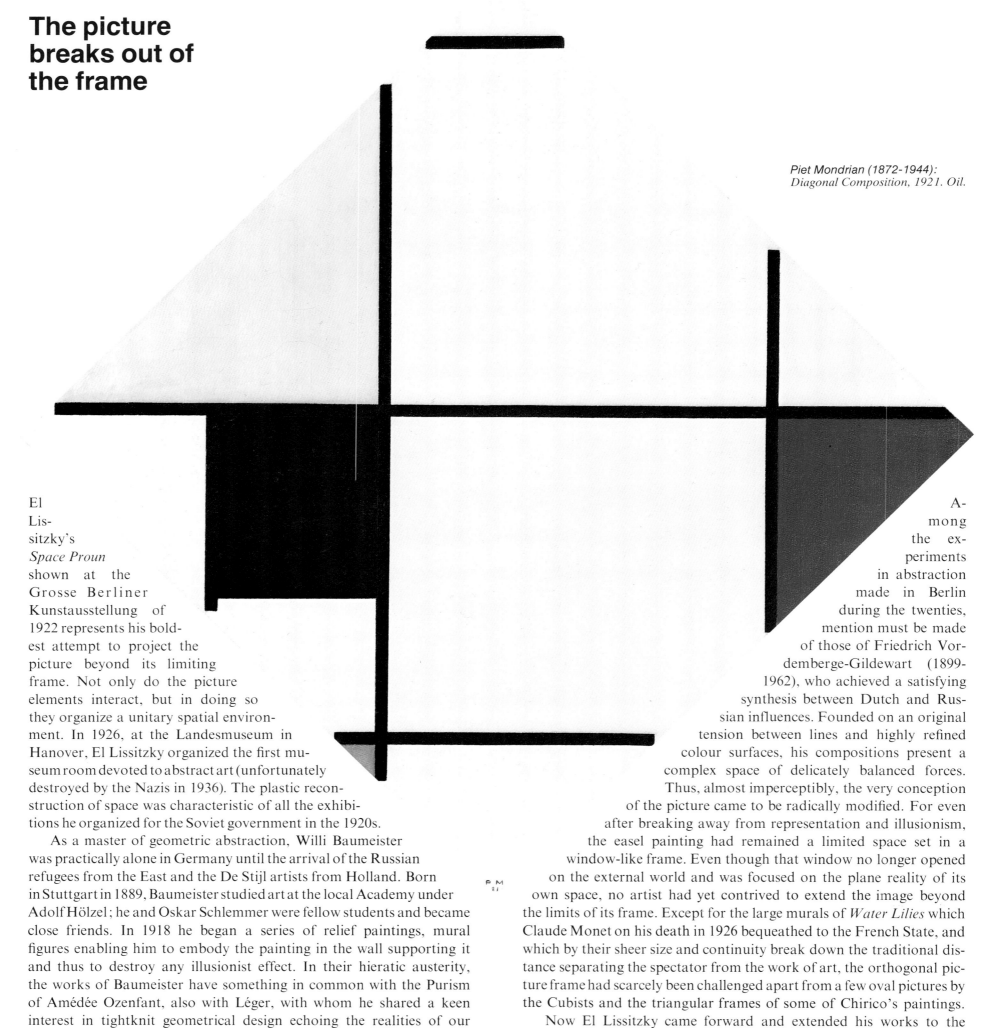

Piet Mondrian (1872-1944):
Diagonal Composition, 1921. Oil.

El Lissitzky's *Space Proun* shown at the Grosse Berliner Kunstausstellung of 1922 represents his boldest attempt to project the picture beyond its limiting frame. Not only do the picture elements interact, but in doing so they organize a unitary spatial environment. In 1926, at the Landesmuseum in Hanover, El Lissitzky organized the first museum room devoted to abstract art (unfortunately destroyed by the Nazis in 1936). The plastic reconstruction of space was characteristic of all the exhibitions he organized for the Soviet government in the 1920s.

As a master of geometric abstraction, Willi Baumeister was practically alone in Germany until the arrival of the Russian refugees from the East and the De Stijl artists from Holland. Born in Stuttgart in 1889, Baumeister studied art at the local Academy under Adolf Hölzel; he and Oskar Schlemmer were fellow students and became close friends. In 1918 he began a series of relief paintings, mural figures enabling him to embody the painting in the wall supporting it and thus to destroy any illusionist effect. In their hieratic austerity, the works of Baumeister have something in common with the Purism of Amédée Ozenfant, also with Léger, with whom he shared a keen interest in tightknit geometrical design echoing the realities of our technological civilization. In his book *Das Unbekannte in der Kunst* (The Unknown in Art), published in 1947, he wrote: "Art has lost its connection with nature observation; it has freed itself from that just as it has freed itself from other bonds in the course of centuries. The more it frees itself from all bonds, the more it exhausts itself."

Among the experiments in abstraction made in Berlin during the twenties, mention must be made of those of Friedrich Vordemberge-Gildewart (1899-1962), who achieved a satisfying synthesis between Dutch and Russian influences. Founded on an original tension between lines and highly refined colour surfaces, his compositions present a complex space of delicately balanced forces. Thus, almost imperceptibly, the very conception of the picture came to be radically modified. For even after breaking away from representation and illusionism, the easel painting had remained a limited space set in a window-like frame. Even though that window no longer opened on the external world and was focused on the plane reality of its own space, no artist had yet contrived to extend the image beyond the limits of its frame. Except for the large murals of *Water Lilies* which Claude Monet on his death in 1926 bequeathed to the French State, and which by their sheer size and continuity break down the traditional distance separating the spectator from the work of art, the orthogonal picture frame had scarcely been challenged apart from a few oval pictures by the Cubists and the triangular frames of some of Chirico's paintings.

Now El Lissitzky came forward and extended his works to the dimensions of the room, while Laszlo Peri and Mondrian embarked on experiments which may have seemed formally less ambitious, but which were to have far-reaching consequences. Both refused to see the picture as a "space in résumé" but conceived it rather as a focal centre radiating energy. Their experiments were not to be followed up until

Laszlo Peri (1889-1967): Three-Part Construction in Space, 1923. Painted concrete.

much later, in the 1960s, by the American minimalists, in particular Frank Stella and Kenneth Noland.

Laszlo Peri set the external boundaries of the picture free from any geometrical constraint; his picture elements answer to each other and by their formal and chromatic dynamism they neutralize the empty surface which they occupy. Born in Budapest in 1889, Laszlo Peri made a trip to Russia in 1920 before joining the Berlin Constructivists, among whom he found his compatriot Moholy-Nagy.

With Mondrian, innovation was a subtler, more secret process, but it was equally decisive. The picture does not reproduce space, and the canvas presents itself as one element in the division of the surface which carries it and which seeks to qualify it by its presence. Since 1917, when the picture appeared to him as an autonomous rather than a referential world, he had sought to occupy it in order to recognize the effects of colour and line: "Neo-plasticism has succeeded in obeying the principal law of painting, which only requires the expression of relation through line and colour," he wrote in *Cercle et Carré* (No. 2, 1930). The format of the canvas binds and defines the linear and chromatic organizations which occupy it. Very gradually Mon-

drian progressed from highly divided surfaces to enlarged organizations. Beginning in 1919, the white ground plays an architectural role; line organizes surfaces covered exclusively with the principal colours or with non-colour (black, white, grey). The relations between colour and non-colour, between solid and void, bring into existence that "equilibrium of duality" which he set himself to achieve: "Man evolving towards the equilibrium of his duality will create (also in life) more and more equivalent relations, that is, equilibrium" (*ibid.*).

The enlargement of the painting surfaces soon constituted a challenge to the frame defining them, as a notable French critic has pointed out: "If colour is texture, if white is the void, what remains of the object (the picture) if not an architectural structure allowing itself to be destroyed as object by the space which it has for its very purpose to mark off by unmarking itself; in other words, it loses its autonomy because of the differential nature of its situation" (Marcelin Pleynet).

By the enlargement of its constituent elements—which repeat the frame—the picture ends up by overstepping the frame when the lines are prolonged to the edge and when the colour also fills the external surfaces. This conquest is particularly evident in *Diagonal Composition*. The orthogonal vertical-horizontal rhythm, which Mondrian never departed from, strikes a contrast with the frame which cuts across it diagonally without being able to close it off, and which thus favours its subjective extension beyond its own limits. Such a painting does not convey a glimpse of the world external to it; it is a rhythmical ordering of the space that contains the painting. This effect is all the more telling because, in his logic, Mondrian uses only a strict minimum of complementary elements. "We learn now to translate reality in our imagination by constructions which can be controlled by reason, in such a way as later to retrieve these same constructions in the reality 'given' by nature, thus arriving at a penetration of nature by means of the plastic vision."

Mondrian began to embody these views in his work in 1921, the picture for him being a construction in space. "Art, though an end in itself, is like religion a means by which the universal may be known; that is, made visible to the intuition" (in *De Stijl*, No. 1). Art by leaving its frame creates a space which liberates man and finds its *raison d'être* in its exemplariness. "A man can only escape from the tragedy by finally becoming One, which is much less easy to achieve in external life than in abstract life. The unity of the One and the Other can be achieved by art in the abstract; art is therefore an advance on real life" (*ibid.*).

El Lissitzky (1890-1941): Proun Room, 1923. Painted wood.

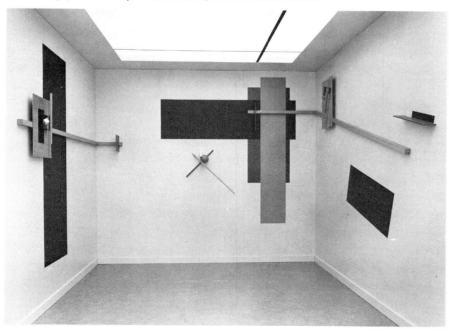

The Bauhaus staff on the terrace of the Bauhaus building, Dessau, 1926.
Left to right: Albers, Scheper, Muche, Moholy-Nagy, Bayer, Schmidt, Gropius, Breuer, Kandinsky, Klee, Feininger, Stölzl, Schlemmer.

Special issue of the review Junge Menschen, devoted to the Weimar Bauhaus, November 1924.

The Bauhaus is the most famous school of design of this century. It was a centre of thinking, making and meeting. Its ideal was the practical fusion of art, design and industry, but it also fostered the development of abstract art in general and promoted another current of "production art," giving a new meaning to handicrafts by means of education through work. Around this school were to gravitate some of Europe's most advanced creators. The evolution of the Bauhaus, in the short period of its existence (1919-1933), cannot however be understood without reference to the economic and political context of interwar Germany and the terrible bloodletting of the First World War. In both France and Germany the war had gone far towards wiping out the generation of men who in 1920 would have been between twenty and fifty. This absence of mature minds explains the rapid rise of younger men to key positions, and also explains the boldness of their vision.

Weimar, until 1918, was the seat of the Grand Duchy of Saxe-Weimar-Eisenach. In 1915, when Henry van de Velde gave up his post as director of the Kunstgewerbeschule (School of Applied Arts) and the Hochschule für Bildende Kunst (School of Fine Arts) in Weimar, he recommended to the Grand Duke that Walter Gropius should succeed him. The latter, when he took up his job in March 1919, merged the two schools into one, under the name of Das Staatliche Bauhaus Weimar: in other words, no distinction was to be made between "fine" and "applied" arts. In April appeared Gropius' manifesto-programme emphasizing the importance of architecture and the interdependence of all the arts: "Architecture is the aim of all creative activity. To complete and embellish it was once the principal task of the plastic arts. They formed part of architecture, they were indissolubly connected with it.

"Today each of them leads a life of its own, and that autonomy can only be broken off by the conscious and concerted effort of all craftsmen. Architects, painters and sculptors must rediscover the fundamentally complex character of architecture. Only on this condition can their works fully regain the peculiarly architectural spirit which they lost with the 'art of drawing-rooms'...

"Architects, sculptors and painters, we must all return to craft work! There is no such thing as 'professional art.' There is no difference in nature between the artist and the artisan. The artist is only an inspired artisan. There are rare moments, moments of illumination when beyond his will and by heaven's grace the work of his hands becomes art. But every artist must necessarily possess technical skill. Therein lies the true source of the creative imagination.

"Let us therefore form a corporation of a new kind, a corporation without that class separation which sets up a wall of disdain between artisan and artist. Let us all together conceive and realize the new architecture, the architecture of the future, in which painting, sculpture and architecture shall be one, and which, from the hands of millions of workmen, shall one day rise into the sky, the crystalline symbol of a new faith" (Walter Gropius, Bauhaus Manifesto, 1919).

This basic statement at once defined the aims of the school: to return to the fundamentals of craftsmanship and design and to work together collectively towards the building of a new world. Gropius gathered around him some outstanding artists and teachers: Lyonel Feininger, Johannes Itten and Gerhard Marcks in 1919; they were joined in 1920 by Georg Muche, in 1921 by Paul Klee and Oskar Schlemmer, in 1922 by Wassily Kandinsky, in 1923 by Laszlo Moholy-Nagy. The life of the Bauhaus coincided with that of the Weimar Republic.

Many years later Gropius summed up his intentions: "I tried to put the emphasis of my work on integration and co-ordination, inclusiveness, not exclusiveness, for I felt that the art of building is contingent upon the co-ordinated teamwork of a band of active collaborators whose co-operation symbolizes the co-operative organism of what we call society.

"Thus the Bauhaus was inaugurated in 1919 with the specific object of realizing a modern architectonic art, which like human nature was meant to be all-embracing in its scope. It deliberately concentrated primarily on what has now become a work of imperative urgency—averting mankind's enslavement by the machine by saving the mass-product and the home from mechanical anarchy and by restoring them to purpose, sense and life...

"What the Bauhaus preached in practice was the common citizenship of all forms of creative work, and their logical interdependence on one another in the modern world. Our guiding principle was that design is neither an intellectual nor a material affair, but simply an integral part of the stuff of life, necessary for everyone in a civilized society" (Walter Gropius, Scope of Total Architecture, George Allen & Unwin, London, 1956, and Collier Books, New York, 1962).

For his teachers Gropius turned chiefly to painters, for the study of art history had shown him that they are the ones who at all times have renewed forms. He could not then found a new cultural unit of comprehensive scope without their collaboration. The teaching staff of the Bauhaus consisted at first of two kinds of masters: on the one hand, the Formmeister, who dealt with the theoretical principles of form and space, not so much communicating their own experience as familiarizing their students with "the objective existence of elements

of form and colour," of concepts applicable to all fields of practice; and on the other, the *Technische Meister*, who dealt at first hand with craftwork and design. After the transfer of the Bauhaus to Dessau in 1925, the curriculum was revised and the work of the "form master" and the "technical master" was now vested in a single person. This was made possible by the fact that a number of Bauhaus students, trained in both disciplines, were now ready to take up teaching posts: Josef Albers, Herbert Bayer, Marcel Breuer, Joost Schmidt, and Gunta Stadler-Stölzl.

For the Bauhaus it was man, the individual, who stood at the centre of plastic research and it was up to him to find and fulfil himself. This was the substance of the teaching, as Oskar Schlemmer saw: "In the end I realized that nothing was more unwelcome to Gropius and to the students than what came from the masters, especially from those masters who, instead of keeping to a theoretical

pose of all education is to reveal the general rules that govern the world of form and the world of colour, and to increase the student's powers of creative expression" (Johannes Itten, *Pädagogische Fragmente einer Formenlehre*, in *Die Form*, 1930).

Itten's methods reflected a mystical attitude which was to be sharply criticized by Van Doesburg, Moholy-Nagy, El Lissitzky and Hans Richter during the Weimar Congress of the Constructivists in September 1922. Feeling himself under fire, Itten resigned from his post in March 1923. The preliminary course was thereupon taken over, and revised, by Moholy-Nagy, whose views were much more materialistic.

Under pressure of economic necessity the Bauhaus was being converted to functionalism. The credits allotted by the government of Thuringia, which so far had backed the Bauhaus, were now reduced and Gropius saw that it could only survive by interesting the German industrialists in its researches; that is, by developing in the school

 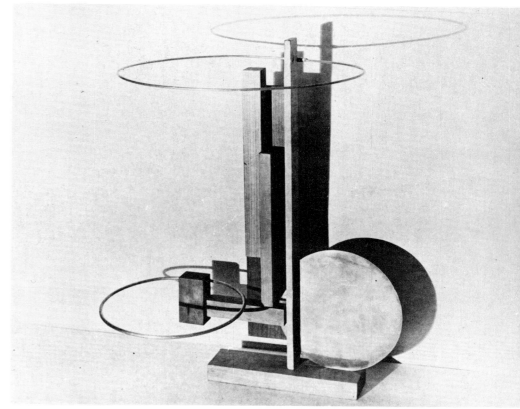

Oskar Schlemmer (1888-1943): Homo Figur T, 1919-1920. Pen and ink. ● *Josef Albers (1888-1976): Visual exercises for his course at the Bauhaus, 1923-1933.* ● *Laszlo Moholy-Nagy (1895-1946): Studies in equilibrium for his preliminary course at the Bauhaus, 1923-1928. Wood, stainless steel, aluminium.*

neutrality, expressed themselves actively and directly. The students want to do things themselves, or at least to have the illusion of doing them themselves!" (Schlemmer, *Briefe und Tagebücher*, 1958). The emphasis laid on unity of thought and action, of thinking and doing, meant that particular importance attached to the compulsory preliminary course of six months (*Vorkurs*), which was designed to develop and ripen the student's intelligence, senses and ideas, to deepen his awareness of his own personality. Up to 1923 the preliminary course was taught by the Swiss artist Johannes Itten. It included a basic introduction to the physical and psychological properties of forms, colours and materials. An idealist, Itten overlaid his instruction with a tinge of Oriental philosophy calculated to stimulate the workings of intuition. "My teaching does not pursue any well-defined external purpose. The object of my efforts is the individual himself; that is to say, a being who can be shaped and developed... Each student in himself sets a problem of education. His work is meaningful only in so far as it is done individually, only in so far as it is unique and original. When it is a question of schooling creative artists, the pur-

itself the idea of production, filling orders for specific pieces of work and industrializing the new designs produced by its workshops. In 1923 Gropius organized a Bauhaus exhibition in Weimar, its theme being "Art and Technics, a New Unity." Its purpose was to show the results of the first four years in the life of the Bauhaus; and, at the same time, by appealing to an international audience, to answer the criticisms publicly levelled against it by conservative members of the Thuringian Landtag. That same year, in conjunction with the exhibition, the school issued its first publication: *Staatliches Bauhaus in Weimar 1919-1923*; Gropius, Kandinsky and Oud gave a series of lectures; the painters and their pupils exhibited their works; and a parallel presentation showed the new architecture in Holland, Czechoslovakia and (above all) Germany, with Le Corbusier representing France and Frank Lloyd Wright the United States. Further manifestations gave the 1923 exhibition the character of a Bauhaus festival: *Triadisches Ballett* by Schlemmer, concerts by Busoni and Hindemith, and *L'Histoire du Soldat* performed in the presence of Stravinsky himself. All very impressive and a well-deserved success.

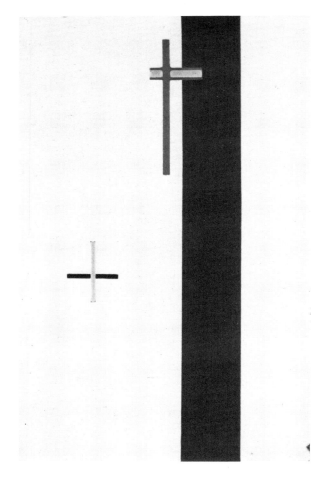

Laszlo Moholy-Nagy
(1895-1946):
Telephone Picture
EM 2, 1922.
Porcelain enamel
on steel.

In charge of the metal workshop at first, Moholy-Nagy soon took over Itten's preliminary course. In one respect he remained attached to his predecessor's views: the necessity of developing the student's personality. But he took a completely different approach to this notion, integrating it into the contemporary problematics of production. He put into practice an instruction based on experience and on the nature of those materials which best enabled him to communicate his own experience of space, design and construction. In his book *Von Material zu Architektur* (Bauhaus Books No. 14, 1929), Moholy-Nagy summed up his attitude: "The first year's programme had as its objective to develop and mature the senses, sensibility and mind, in particular of those young people who, because of their traditional education, had accumulated a considerable and barren sum of book knowledge. After this first year of maturation began the real specialized training, chosen within the framework of the Bauhaus activities. But in the course of this training the primary objective always remained the man, that man who when living in his natural milieu is capable of facing life with a new and instinctive assurance, who no more allows himself to be overmastered by industry, hustling and the appearances of an all too often misinterpreted 'machine culture' than the man of Antiquity wished to be dominated by the powers of nature."

Gropius found in Moholy-Nagy the all-round creative artist and teacher whom he most needed. The latter came to the Bauhaus in 1923, after having carried out a revolutionary experiment with *Em*, a picture executed by telephone. He thus showed that even painting could be produced by industry: "In 1922 I ordered by telephone from a sign factory five paintings in porcelain enamel. I had the factory's colour chart before me and I sketched my paintings on graph paper. At the other end of the telephone the factory supervisor had the same kind of paper, divided into squares. He took down the dictated shapes in the correct position. (It was like playing chess by correspondence.) One of the pictures was delivered in three different sizes, so that I could study the subtle differences in the colour relations caused by the enlargement and reduction... My belief is that mathematically harmonious shapes, executed precisely, are filled with emotional quality, and that they represent the perfect balance between feeling and intellect" (Laszlo Moholy-Nagy, *Abstract of an Artist*, George Wittenborn, Inc., New York, 1947).

This experiment had far-reaching consequences, for it was one of the first to show that the finished object is less important than the process of its elaboration. As a teacher Moholy-Nagy laid great emphasis on a new organization of space and familiarized his students with contemporary issues of architectural construction; he familiarized them too with contemporary methods of production and industrial reproduction. He made his classroom not only a place of training but a place of production.

But opposition to the Bauhaus gained the upper hand in Weimar. When in 1924 a conservative government took over from the social democrats in Thuringia, the school's fate was sealed, and Gropius announced that for lack of funds it would close on 1 April 1925. Luckily Fritz Hesse, the mayor of Dessau came forward and persuaded his town council to take over the Bauhaus as it then stood, with its 16 masters and 89 students. The Bauhaus was accordingly transferred to Dessau in 1925, and a new building was erected there to house the school.

The trend supported by Gropius and Moholy-Nagy towards the design of works and objects intended for mass production, for profits that would enable the Bauhaus to pay its way, was for other teachers there a disturbing trend. Klee, Kandinsky, Feininger and Schlemmer reacted against this challenge to pure art. As they saw it, this trend increased the risk of a cleavage between creation and production, and such a cleavage would violate the letter and the spirit of Gropius' preliminary declaration. The fact is that at the Bauhaus we find the same opposition as in Russia between the advocates of a spiritualized, individualistic art, opposed to mass culture, and the advocates of an integrated activity employing all modern means of production.

Paul Klee insisted on the importance of intuition. It was intuition that gave him his subjects and images, that suggested to him the light and poetry which he developed with a severe control of his creative means. Written in 1918 and published in 1920, his *Schöpferische Konfession* (Creative Credo) is a statement of his conception of art's purpose and his views on the subjective nature of creative art. But he laid stress even then on the economy of the pictorial means, an economy which he arrived at by unremitting work and experiment and analysed with great lucidity. He touched on this in the lecture he gave at Jena in January 1924:

"But what one brings up from this plunge into the depths (which may be called by whatever name you like, dream, idea, imagination) cannot really be taken seriously until it is joined with the appropriate plastic means and becomes a Work.

"Only then do Curiosities become Realities. The realities of art which expand the bounds of life as it ordinarily appears.

"Because those realities do not reproduce the visible with more or less of temperament, but make visible to us a secret vision. With, I said, the appropriate plastic means. For it is here, at this point, that one finds out whether pictures are to emerge or something else. Here, too, that one finds out what kind of pictures."

To explain the artist's function and experience, Klee resorted to the simile of the tree, which enabled him to present the creative artist as an intermediary between what is and what becomes:

"Let me use a simile, the simile of the tree.

"Our artist, then, has managed to cope with this manysided world pretty well, we shall assume, in his own quiet way. He has found his bearings well enough to set order into the swirl of his impressions and experiences. This orientation among the things of nature and life, this order with all its many ramifications, I liken to the roots of the tree.

"From these roots comes the sap that streams through the artist and through his eye, for he is the trunk of the tree.

"Under the pressure of this mighty flow, he infuses what he sees into his work.

"And just as the foliage spreads out in time and space, visible from all sides, so grows the artist's work...

"Neither obliging servant nor absolute master, but simply an intermediary, the artist thus occupies a modest position. The beauty of the foliage he cannot claim as his own, it has only passed through him" (Jena lecture, 1924).

All Klee's work and the originality of his style spring from this conception of the artist's function and led him to express a totality with a minimum of plastic means. "Art does not reproduce the visible; it makes visible. By its very nature graphic art readily and justifiably leads one to abstraction. The spectral, fairy-like shapes of the imagination are brought to light and at the same time expressed with great precision. The purer the artist's graphic work is (in other words, the more he stresses the formal elements on which linear expression is based), the more ill-equipped he is for the realistic rendering of visible things. Pure art implies the *visible* coincidence of the spirit of the content with the expression of the formal elements and the expression of the formal organism" (Paul Klee, *Schöpferische Konfession*, in *Tribüne der Kunst und Zeit*, Berlin, 1920).

The artist however can only arrive at communication by way of "a certain simplicity of construction, a certain ease of interpretation, which must not be taken for indigence and which in no way belies the assurance and skill which he may have" (*ibid.*).

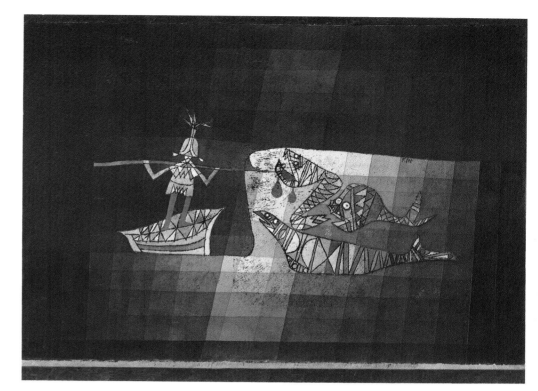

Paul Klee (1879-1940): War Scene from the Fantastic Comic Opera "The Navigator," 1923. Oil and watercolour.

Paul Klee, intuition and decision

Paul Klee (1879-1940): Dance of the Sad Child, 1921. Pen and ink.

The work of art springs from the unconscious, but its gestation is complex and presupposes observation, analysis, meditation, technical mastery. This is the theory which Klee set forth and developed in his "Pedagogical Sketchbook" (*Pädagogisches Skizzenbuch*, Munich, 1925).

While Klee occupies a high place in the select band of modern poet-painters (and as such is mentioned by André Breton in the *Surrealist Manifesto* of 1924, and Breton saw to it that his work was included in the first Surrealist exhibition of 1925), his concentration on the pictorial means sets him apart from the Surrealist practitioners of psychic automatism. For Klee there was no distinction between inspiration and means of realization, between subjectivity and objectivity.

"Precious is the knowledge of laws, provided one refrains from any schematism that confuses mere law and living reality. Such mistakes lead to construction for its own sake, and this is the obsession of asthmatic timid souls who give us rules instead of a work. Understand that, if one tries to lay down laws and confronts the works with them, one does so in order to see how the latter contrive to depart from the works of nature without going astray. Understand that laws are only the common substructure of nature and art" (Paul Klee, *Exakte Versuche im Bereiche der Kunst*, in *Bauhauszeitschrift für Gestaltung*, Dessau, 1928).

Klee worked out at the Bauhaus a course of instruction that was both theoretical and practical, that aptly defined the expressive possibilities of all the means at the painter's disposal, placing emphasis on the sense and importance of movement, reconciling art and science, laying bare the essence of things.

Klee shared the views of Malevich who now, first in Vitebsk, then in Petrograd, devoted himself entirely to teaching and who wrote: "In aspiring to become the master of the world, the factory says at the same time that in order to do so it is necessary to learn everything, to know everything, to be aware of everything, to study, to found everything scientifically, for only then is it possible to be the master of the world and to lead it, when one knows everything" (Kasimir Malevich, *God is not cast down. Art, Church, Factory*, Vitebsk, 1922). In the same essay he also insisted on the artist's role as intermediary and he condemned (just as Klee condemned) a purely materialistic conception of art: "Thus two men imagined the Universe in different ways. One sees in it the spiritual principle, the other the material principle. One creates on the spiritual principle, he sees something greater over and above what the materialist sees; the materialist, for his part, sees the world as matter devouring itself. What is greater in the spiritual lies in this, that the spiritual creates not in order to devour itself, but for the sake of its non-figurative side. The materialist, for his part, sees creation in the same way as something to be devoured, he creates objects for the sake of his appetite. But on the other hand the scientifically proved evidence tells us that matter cannot disappear, that it cannot be burnt, cooked or eaten. How then are we to understand the materialistic view of matter as that which cannot be eaten, which cannot be cooked in a cauldron and eaten without leaving remnants?" (Malevich, *ibid.*).

When in 1922 Gropius offered Kandinsky a teaching post at the Bauhaus, the latter accepted, and he was well qualified for it. For in the work he had just done in reorganizing Russian art life after the Revolution, Kandinsky had set himself to redefine the aims and methods of art education. It is interesting to note how topical in the 1920s was this problem of artistic schooling, and how much time and effort were spent on it by creative artists. Things had changed radically. Up to the First World War the best artists were those who held aloof from official teaching. Now, after the war, there was scarcely one leading artist, from Kandinsky to Klee, from Malevich to Léger (Picasso being a notable exception), who did not do some teaching or at least map out a teaching system for art students.

Kandinsky, the role of teaching

Kandinsky, Gropius and Oud at Weimar in July 1923. Photograph.

Academicism was a mere repetition of set formulas ill-suited to the conditions of modern life. Schooling on fresh lines was obviously necessary if there was to be any chance of developing that New Man which modern civilization called for and which the creative artist might well help to shape. Like science, with which it goes hand in hand, art has to be learnt; it requires reflection and experiment, theory and practice.

No other artist had assumed such responsibilities as fell to Kandinsky in the years immediately after the Russian Revolution: a member of the directorate of the Department of Fine Arts (IZO) and teacher at the Vkhutemas art workshops in Moscow from 1918, organizer of the Museum of Pictorial Culture in Moscow and of many new provincial museums in 1919, founder of the Institute of Artistic Culture in Moscow in May 1920, chairman of the art sections at the conference which laid the basis for the reorganization of the Commissariat of Education (Narkompros), member of the advisory commission for the creation of a Russian Academy of Artistic Sciences in 1921. So that when he returned to Germany in 1922 Kandinsky had an unrivalled experience of art theory and education.

Kandinsky in his educational views is close to Malevich, who said: "Art schools and workshops should be set up not on a plastic basis but on a creative basis. No master and no student should be a decorative artist nor a lackey or a buffoon on class lines. No one can ever become an artist so long as he sees before him the nostalgic and stupid bourgeois or tradesman whom he must amuse with a portrait of his bloated face, and to whom he must reveal his emotional pangs. Neither nature nor man should be in the service of anyone or play up to anyone... It is through the great experience of the natural law according to physical nature that we find our stabilities and introduce our pan-human body for the real edification of the world. Such an awareness should exist in our experimental workshops according to nature. All the workshops should be on an equal footing, whether they are for painting, sewing or crockery. In everything we should see a single whole, a mutual dependence and the fusion of unity in a single organism" (Kasimir Malevich, *Concerning Plastic Art*, 1921).

An opposite view was taken by Tarabukin, who reflected the atti-

tude of the productivists: "What we call talent was hitherto something innate, it was considered a gift of nature. But if through technology we have succeeded to a large extent in bending nature to our will, we must now do likewise in the sphere of culture and artistic creation. We can no longer wait for talents to drop from heaven, and so they must be bred artificially. The reform of science and teaching is to be tackled on the basis of a technical mastery of production and construction" (Nikolai Tarabukin, *From the Easel to the Machine*, 1923).

Kandinsky had distinguished three sources of inspiration: direct impression, spontaneous impression, and slowly formulated expression. The great thing, for him, was to break away progressively from external sources by drawing on plastic resources as so many symbols whose working would permit the artist to give communicable form to an inner necessity. Like the language of music, the language of painting should be accurately keyed to the emotions of the artist. While back in Russia (1914-1921) Kandinsky grew and matured, both as a man and an artist. He overcame the spontaneous and tragic lyricism which had characterized his pre-war pictures and moved on to a controlled play of geometric shapes. Was this the influence of Suprematism or quite simply his confidence in the possibility of constructing a new world? Idealist that he was, the Revolution had aroused in him the irrepressible, if utopian, hope for a new and better world, and with it a sense of strength and peace which he acknowledged in an interview of July 1921: "After the Revolution I painted quite differently. I felt within me a great peace of mind. Instead of the tragic, something peaceful and organized."

From then on, in keeping with his moods and purposes, Kandinsky worked out a metaphorical language of his own, intended to convey by analogy the metamorphosis of natural forms, the dynamism of the world and its infinite space as revealed by science. Like Klee, Kandinsky relied on intuition. The artist, he felt, must gain an awareness of his inner needs before he can communicate them; to do so, he has to find correspondences between his emotion and the pictorial symbol that translates it into a language not only universal but mathematically precise. The search for non-figurative and symbolic expression led to a stripping away of over-individualized sentiments. He aimed not at denying reality but at signifying it.

His experience as a teacher first in Moscow, then at the Bauhaus, led Kandinsky to formulate a theory which he set forth in his book "Point and Line to Plane" (*Punkt und Linie zu Fläche*, Bauhaus Book No. 9, Munich, 1926). In it he attempted to define the primary function and meaning of two basic elements of painting, point and line, to which he had already devoted two articles published in a German art encyclopaedia before his departure for Russia. Of this book Carola Giedion-Welcker has written: "It no longer proclaims the gospel of a new inner world with an all but religious fervour. It sets forth, often with an extremely precise and almost scientific rigour, a new formal theory of the elements of drawing, whose basis is for him always the same notion of 'irrational and mystical' spiritual unity. Modern art can only be born when signs become symbols. Point and line are here detached from any explanatory or utilitarian aim and transposed into the realm of logic. They are lifted to the level of autonomous expressive essences, as colours had been earlier" (in *Wassily Kandinsky*, edited by Max Bill, Paris, 1951).

Klee and Kandinsky, in the context of the Bauhaus, created works informed by the need to experiment with the constituent elements of painting, and to experiment with them to as precise a degree as possible. They were in fact testing out for themselves the ideas and theories which they communicated to their students. With their colleague Lyonel Feininger and their old friend Alexei von Jawlensky, they formed in 1924 the group called Die Blauen Vier (The Blue Four) and

as such exhibited together in Europe and America. Paul Klee summed up their views:

"We are building and building ceaselessly, but intuition continues to be relied on. Much can be done without it, but not all... When intuition is combined with exact experiment, it speeds up the progress of the latter amazingly. And exactness given wings by intuition sometimes has the upper hand.

"But exact experiment being what it is, it can—whatever the pace—answer the purpose even without intuition. In its peculiar essence, it can dispense with it... In art, too, one finds a sufficiently wide field for exact experiment, and the gates giving on to it have been open for some time... Exercises in algebra and geometry, and exercises in mechanics (balance and movement), can train the mind to cling to essentials, to the function and not to the external impression. One learns to see behind the façade, to take a thing up by the roots. One learns to recognize the underlying forces: one learns the prehistory of the visible. One learns to delve into the depths, one learns to lay things bare. One learns to demonstrate, to analyse. One learns to set little store by formalism and not to accept ready-made things as such. One learns that peculiar way of progressing which consists in turning back to that which gives birth to what is to come.

"This is all very well, and yet something is missing: intuition, in spite of everything, cannot be entirely replaced. One props up, stea-

dies, demonstrates; one builds and organizes: so far, so good, but that is not enough to make a whole" (Paul Klee, *Exakte Versuche im Bereiche der Kunst*, in *Bauhaus Zeitschrift für Gestaltung*, Dessau, 1928).

In the preface to his book *Punkt und Linie zu Fläche*, Kandinsky also emphasized the connection which must exist between the analysis of particular phenomena and the expression of that whole which he called Unity, or the Human, or the Divine: "In this book we deal with two basic elements, point and line, which form the starting point of every picture, without which no start would be possible, and which at the same time already provide a complete body of material for this autonomous domain of art: drawing."

So we must begin with the original element of painting: the point. The purpose of any experiment is to examine each single phenomenon carefully, to examine the reciprocal effect of phenomena, and to reach a synthesis, a general conclusion following from those two examinations. Only by way of such a microscopic analysis can the science of art lead us towards a larger synthesis which, transcending the limits of art, shall attain the realms of "Unity," of the "Human," of the "Divine." That is the perceptible but still distant aim before us today.

Wassily Kandinsky, *Punkt und Linie zu Fläche*, 1926.

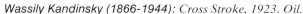
Wassily Kandinsky (1866-1944): Cross Stroke, 1923. Oil.

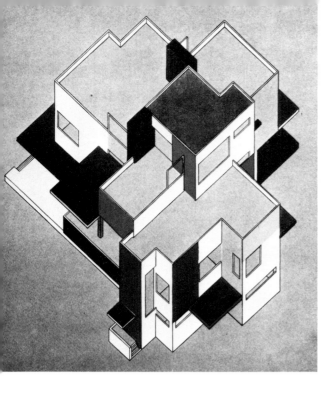

The invention of design

Theo van Doesburg (1883-1931):
and Cornelis van Eesteren (1897):
Architectural Design, 1923.

In 1907, in association with Henry van de Velde, Hans Poelzig and Josef Hoffmann, Hermann Muthesius had founded the Deutscher Werkbund for the purpose of improving the aesthetic quality of engineering construction and product design. Now, in the 1920s, it seemed possible at last to realize the ideas of the Werkbund. For not only did the most advanced theorists envisage an industrial purpose for art, but industrialists themselves had come to see that changing fashions could lead to advantageous renewals of production. Industry was ready to convert itself to design. Possibilities of production were such that for the first time industry found itself compelled to cater systematically for the consumers by utilizing all the resources of modern publicity and multiplying trade fairs and exhibitions.

On the theoretical plane artists had already gone far. In 1921 Rodchenko declared that the only purpose of Constructivist art was to produce objects and thus defined an early form of functionalism: "Form, colour and workmanship are transformed into matter of different kinds and become subordinate to line which provides the whole system of the structure. Construction in the clear and precise sense, by which I mean the actual organization of real objects, can only be carried out in matter. This is why the suitable use of materials becomes a very important issue. We define construction as a system for the making of objects which presupposes a functional use of the materials. So it is that the effort to build has led the artist, by way of constructions in space, to the creation of real objects, in other words, to production, which enables him to become a constructor of material systems" (Alexander Rodchenko, *Line*, 1921).

In 1923, in the first issue of *Lef*, the Moscow review of the Constructivists, we find this manifesto: "The material formation of the object will replace its aesthetic combination. The object will be treated as a whole, as a simple industrial product like a motor-car or an aeroplane, and this will eliminate any trace of style. Constructivism resides in a purely technical organization of the materials, based on three principles. 1. Architecture (act of creation). 2. Workmanship (manner of creation). 3. Construction." The Constructivists accordingly took an active part in economic life: Tatlin in a metallurgical plant, Popova and Stepanova in textile mills, Rodchenko and Mayakovsky in the making of books and posters. They did this with all the more conviction because they saw the purpose of their activity as educational rather than economic. "We have arrived at the problem of art's role in production, at the problem of transforming life, everyday life, through art. The 'art industry' cultivated by 'applied artists' beautified the forms of external life without changing them, whereas the productivist mastery of art, applying itself to all stages of product manufacture, transforms first of all the work itself, by bringing its action to bear not only on the products but also on the producer, the worker" (Nikolai Tarabukin, *From the Easel to the Machine*, 1923).

Unfortunately the technology of Russian industry was not sufficiently advanced to allow these artists to carry out their programmes. It was still at the stage of mechanized craftwork, and many projects were therefore doomed to remain in the stage of unrealized models. However, as Gabo has emphasized, the Russian artists were eager and ambitious; they were intent on renewing the design and creation of all common forms, from clothes to houses, from objects to entire cities. "The Constructive idea has given back to sculpture its old forces and faculties, the most powerful of which is its capacity to act architectonically. This capacity was what enabled sculpture to keep pace with architecture and to guide it. In the new architecture of today we again see an evidence of this influence. This proves that the constructive sculpture has started a sound growth, because architecture is the queen of all the arts, architecture is the axis and embodiment of

Gerrit Thomas Rietveld (1888-1964): A Child's Chair, 1919. Wood.

human culture. By architecture I mean not only the building of houses but the whole edifice of our everyday existence" (Naum Gabo, *Sculpture: Carving and Construction in Space*, in *Circle*, Faber and Faber, London, 1937).

The revolution of industrial design was completed in Holland, a country which remained neutral throughout the First World War. There the De Stijl group gave urban civilization the first example of everyday objects of advanced design. In 1920, in his essay on Neo-Plasticism, Mondrian wrote: "Decorative objects disappear in Neo-Plasticism, while the applied arts and crafts (furniture, pottery, etc.) are brought into being by the simultaneous action of the new architecture, sculpture and painting and are automatically regulated in accordance with the laws of the new plastics." For the formalists of De Stijl, art stands above reality: generated by a collective spirit, artistic activity called for the integration of all disciplines, and everyday life had to become the field of application of that synthesis of the plastic arts which they preached.

De Stijl numbered several architects among its members and they set out to produce the forms, spaces and rhythms of the new world in the making. They were intensely conscious of that unity of space which Georges Vantongerloo (1886-1965) described in these words: "Volume and void equal space. So volume + void make up space; that is to say, the contours of a volume, at the point where the void begins, have to be balanced with the void and the volume, and vice versa. Likewise for the unity of bookkeeping. If I have 100 francs and out of this sum spend 75, then $75 + 25 = 100$ francs. If then the space equals 100 and the volume occupies 75, the void will be 25. So everything has its place, is balanced and in harmony. Such is sharing,

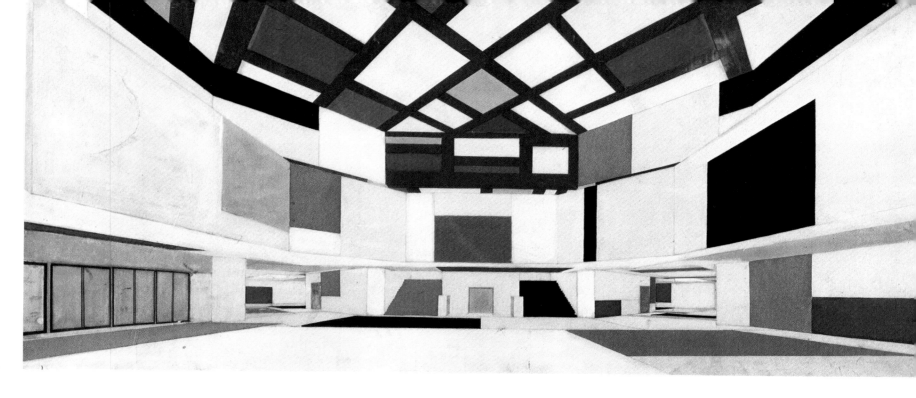

Theo van Doesburg
(1883-1931):
Design for the
interior decoration
of the main hall
of a university, 1923.

such is pure division in space, creating unity. This is not a convention, it is a reality" (Georges Vantongerloo, in *De Stijl*, No. 9, 1922).

As the spokesman in Europe of the De Stijl spirit, Theo van Doesburg informed the German artists about the first applications of Neo-Plastic concepts, those made by Rietveld in furniture design and those so boldly made by Oud in architecture. For the latter, the house was only one element of a total space which it condensed and extended in the continuity and fluidity of its volumes. Over and above their purist, formalist appearance, Oud's buildings emphasize the organization of space. He stated that "the basis of a new organic art of building cannot proceed from external forms but only from inner necessities. The interpretation of a tradition, whether ancient or modern, reduces the art of building to an event, to a matter of taste."

It was not until the Bauhaus was compelled to pay its way, from 1924 on, that the frontiers between art and applied art were broken down; not until then that in theory and practice art could be integrated into architecture, and that momentous results could be achieved on the level of design. The general economic situation had become favourable. The time had come to rebuild what the war had destroyed, to devise new cityscapes, to renew production by taking full advantage of the progress made in industrialization and making full use of recently discovered synthetic materials. Invention was the order of the day.

Gropius, who had already taken part in the activities of the Deutscher Werkbund, found at the Bauhaus in the twenties a favourable context for the application of his ideas about functionalism. He shared many of the Russian artists' views about construction and production, but he had at his disposal a much more advanced economic and industrial structure. His concern was not to invent a style but to transform the prevailing state of mind: "Our ambition was to rouse the creative artist from his other-worldliness and to reintegrate him into the workaday world of realities and, at the same time, to broaden and humanize the rigid, almost exclusively material mind of the businessman... [This] gave rise to an erroneous idea that the Bauhaus had set itself up as the apotheosis of rationalism. In reality, however, we were far more preoccupied with exploring the territory that is common to the formal and technical spheres, and defining where they cease to coincide. The standardization of the practical machinery of life implies no robotization of the individual but, on the contrary, the unburdening of his existence from much unnecessary dead weight so as to leave him freer to develop on a higher plane" (Walter Gropius, *Scope of Total Architecture*, George Allen & Unwin, London, 1956, and Collier Books, New York, 1962).

A new term, "functionalism," was soon to designate the conception of those who, at the Bauhaus and elsewhere, were designing the everyday products turned out by industry. To make an object that "functions well" involves a study of its function, that is, of its purpose, its intended use, and its form will depend on that function. The latter is defined in the course of a reflection which sets out the different aspects of its use, in the course of experimentation which takes account of scientific and technical knowledge, of the requirements of industrial manufacture, of the scope and possibilities of given materials. Industrial design is the outcome of a determination "to manufacture objects organically in keeping with their own laws, without fancy-work and without romantic wastage," so that they may be sound, practical, cheap and attractive. For the Constructivists beauty was necessarily connected with a purity which they found in the use of elementary forms and primary colours. Only by a concerted effort could men "work out a unified conception of the world such as might liberate spiritual values from their individual contingencies and raise them to the level of objective creations" (Walter Gropius).

Ludwig Mies van der Rohe (1886-1969): Design for a brick country house, 1923.

Walter Gropius (1883-1969): Model of the Bauhaus building erected at Dessau in 1925-1926.

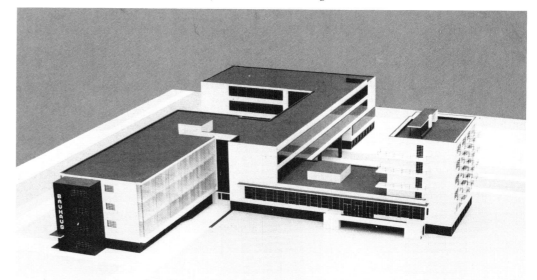

The spirit that presided over the elaboration of the functionalist view of art is easier to grasp in its application to objects, but only assumes its true meaning on an architectural scale. In an article on the "machine aesthetic" (*Bulletin de l'Effort Moderne*, January 1924), Fernand Léger recognized the primacy of architecture in demonstrating that the Beautiful can and should be replaced by the Useful:

"One may say this: a machine or a manufactured object can be beautiful when the relations of the lines set up by these volumes are balanced in an order equivalent to that of architecture in previous times... If the aim of the architecture of previous times was the Beautiful predominating over the Useful, it is undeniable that, in the mechanical order of things, the dominant aim is to be useful, strictly useful. Here everything tends to usefulness with the greatest possible severity. And the drive towards usefulness need not prevent us from achieving a condition of beauty.

"The evolution of motor-car design is an intriguing instance of what I am trying to say; a very curious instance indeed, from the fact that the more the car has been adapted to useful purposes, the more beautiful it has become... The existence of this relation, in motor-cars, between the beautiful and the useful does not mean that perfect usefulness must result in perfect beauty; this I deny until the contrary is demonstrated." While Léger, then, admitted that the useful may not in itself suffice to bring about beauty, his conclusion is characteristic of the outlook of many Western artists and designers: "Chance alone presides over the creation of beauty in the manufactured object."

As regards architecture, the situation was much more complex and ambiguous. At first sight, the builders of the modern city appear to have been guided by an allegiance to utility and science, but in reality they relied even more on their creative intuition. The study of these interwar years has by no means been thorough and there is still no end to the contradictory conclusions drawn from the works of this period. The fact is that in architecture the notions of form and function need to be reconsidered: does form determine function or vice versa?

Before the First World War the best architects had already succeeded in capitalizing on the possibilities afforded by the new techni-

Alexander (1883-1959) and Victor Vesnin (1882-1950): Design for a Palace of Labour, Moscow, 1923.

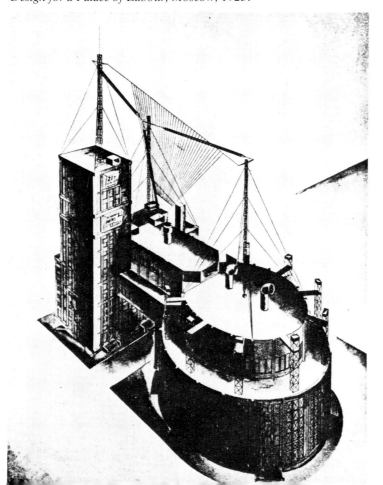

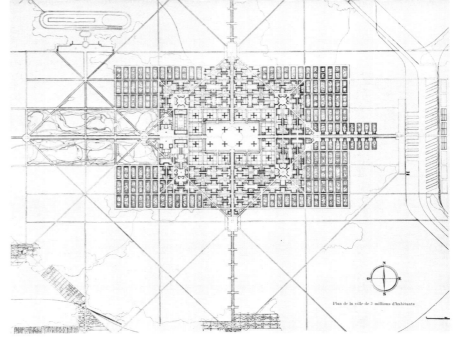

Le Corbusier (1887-1965): A Contemporary City of Three Million Inhabitants, plan presented at the Salon d'Automne, Paris, 1922.

ques: concrete, glass, iron, steel. They had shaped the architectural envelope in terms of interior requirements; they had called for "honesty in the use of materials" (Adolf Loos) and had renewed the organization of volumes by returning to a simple, transparent geometry. Considering the façade as a membrane separating the internal space from the space of nature, they had laid emphasis on organic necessities and condemned the fanciful façade to which the traditionalists remained attached. Engineers, making a better use of contemporary technology, had often outdone architects in the boldness of their conceptions. With the end of the war, architects were given a second chance, but before they could make the most of it they had to become town-planners; this meant in practice that the architect also had to be something of a politician, philosopher and sociologist. The climate and context of the twenties drove him to this. For Europe had not only been bled white by the war, but some regions had been devastated. Entire cities had to be reconstructed, and this sudden necessity altered the architect's function and responsibility.

Hitherto any new building had to be integrated into an existing urban setting (except in the case of a few utopian designs); it had to answer the needs defined by the client. In 1920, on the contrary, utopia seemed achievable, for the immediate need was to build fast, much, and cheaply, and for an anonymous client, the State. Taken unaware, having no set views and no programme, faced by pressing needs of immense scope, the State delegated responsibility to the builders, and the latter found themselves transformed from architects into promoters. They found themselves possessed of a power and authority whose consequences they were unable to gauge or foresee. They met the challenge gladly, for like the painters and sculptors, to whom they were very close (and many of these architects were themselves painters and sculptors), they felt themselves to be invested with a privileged role, justified by their creative powers, and they set themselves with a will to the task of shaping the personality of a new type of man by imagining the new living conditions that would produce him.

The sureness and boldness of their proposals often encouraged the State to give these architects dual responsibility as designers and builders. The politicians being incapable of inventing the future, it was left to the architects to do so. Before their drawing boards, in the solitude of their studios, they were often tempted to transcend present realities and let their imagination run free. They conceived of new cities as so many laboratories for a new organization of space and life such as would transform and reshape the people living there. They dreamed of other types of human relations and new social organizations better adapted to the century of technology and science.

For these architects, construction was no longer a matter of forms, it was one element in a new structuration of life. Taking into account the modern reality of space-time, they designed cities adaptable to a steady population growth, allowing for easy access and traffic flow. They put the emphasis on community life, because they were convinced that the ruin of Europe was a direct consequence of the rampant individualism of the nineteenth century. This was the governing idea in their replanning of city life. Caught up in their dreams of an egalitarian industrial society, they designed the "housing unit," developed community spaces to the detriment of individual space, and separated the places of work, rest, and recreation. Standardization, whose baneful shortcomings were yet to be experienced, appeared to be the most effective means of civic education.

But their plans were so vast and ambitious that until about 1925 they remained in the designing stage. It was in the field of theory, of pure design, that developments were most rapid. Only a few private clients were prepared to trust these futuristic architects for the building of their own homes. Construction needs were most pressing in the USSR, but the economic situation made any extensive building impossible. The new ideas were brought forward mainly in competitions, like the one organized for a Palace of Labour. The specifications called for a building in the centre of Moscow which, in its size and qualities, would exceed anything ever built in the capitalist world. The most spectacular and revolutionary design submitted was that of Alexander and Victor Vesnin, but it was set aside in favour of a more traditional design.

The Vesnin brothers considered architecture as the best medium for expressing the ideas of the future, and Alexander maintained this view until his death in 1959. In the full tide of the return to classicism, he wrote: "The development of Soviet architecture must be determined by the new content of our existence, by the social way of life, by the new technology, by the new horizons opening before us. A new content requires a new form" (Alexander Vesnin, 1957).

Revolutionary architecture met with unrelenting opposition, even in the country where revolution had won the day. At the Agricultural and Handicrafts Exhibition in Moscow in 1923, the victory of the traditionalists, with their sentimental references to Russian folklore, was overwhelming. But things were little different in France, where a regionalist architecture flourished—though denounced by Le Corbusier in the pages of *L'Esprit Nouveau*. In opposition to it he presented at the 1922 Salon d'Automne his "Contemporary city for three million inhabitants," a perfectly utopian design. Le Corbusier was all for functionalism, but in reality he was more of a designer than a builder. His "Three Reminders to Architects," published in the first two issues

of *L'Esprit Nouveau*, in 1921, met with full agreement at the Bauhaus. "Architecture," he wrote, "touches our animal instincts through its objectivity; it solicits our highest faculties through its very abstraction. Architectural abstraction is peculiar and magnificent in this, that being rooted in brute facts it spiritualizes them, because brute facts are nothing but the materialization and symbol of the possible idea..."

Le Corbusier and Gropius had known each other before the war, when both worked in the office of the Berlin architect Peter Behrens. Gropius became a main force in German architecture, by his own work, by his position at the Bauhaus and by the influential theories he developed there.

As co-editor of the Berlin periodical *G*, with Theo van Doesburg and El Lissitzky, Mies van der Rohe was also one of the makers of modern architecture. He was in full sympathy with the De Stijl spirit, whose principles he illustrated in his project for a brick country house (1923).

The international competition for the Chicago Tribune Tower in 1922 attracted entries from all over the world. They illustrate the different tendencies at work. This architecture of the future is opposed to nature both in the strictness of its volumes and the lightness of its plans; at the same time it lets nature in through a multitude of openings. Equally striking is the internationalist character of the designs submitted, both in the outward forms and in the uniformity of the materials.

Imagining the function of architecture

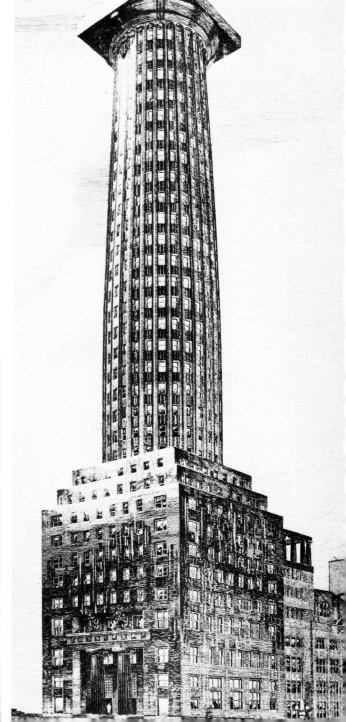

Four designs submitted for the Chicago Tribune Tower competition in 1922. From left to right: Max Taut; B. Bijvoet and Johannes Duiker; Walter Gropius and Adolf Meyer; Adolf Loos.

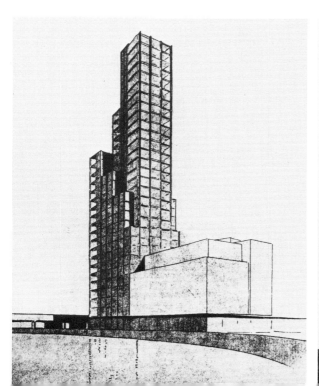

Contemporary science and technology provided artists with new media of expression and new fields of application. Thus light and movement entered into twentieth-century art with dazzling effect. Naturally they were most at home and most effective in the cinema and certain forms of cinematic expression. But after 1920 they also gave birth to a new form of sculpture, known as kinetic sculpture.

Not only do light and movement represent new media of artistic expression, they also act and react upon our senses, they modify and renew appearances, they divide up space, they shift our awareness of reality. The evolution of stage design and stage space, for example, is directly connected with the expressive and perceptual possibilities provided by artificial lighting, and the evolution of sculpture was also affected. The light and airy works of the Constructivist sculptors thus gained an extension of their dimensions thanks to the use of light projections running counter to the very notion of mass. Natural light went to emphasize the volumetric impression obtained by the carving of stone and wood; electric lighting, on the contrary, so extended the dynamic lightness of a construction, those for example of Pevsner, as to give it the dimensions of the environment.

A new type of relation was now possible between the solid and the void. Among the different experiments made by artists in the handling of movement and light, those of Moholy-Nagy are perhaps the most explicit and novel. He proceeded to test out all their possibilities, and did so in the many different sectors of his activity, for Moholy-Nagy worked simultaneously as painter, photographer, film-maker, sculptor, architect and designer. In 1922 the use of transparent or highly polished materials opened his eyes to the importance of light; this was also the period of his first photographs. The modifications of light which he recorded in the transparency of his sculptures led him to renew his painting technique by the use of glazes. He then wholly reconsidered what he knew or thought he knew about colour-light.

In 1925 Moholy-Nagy drew an inference from the difference between light and colour by integrating celluloid and bakelite into his paintings, then by pulverizing or encrusting colour directly into the metal of his sculptures. This is what he called "painting with light." "In working with these materials—uniformly coloured, opaque or transparent plastics—I made discoveries which were instrumental in changing my painting technique. This had inevitable repercussions on my thinking concerning light problems. To produce true, primary relationships, my former idea of an 'objective' painting, was not the only reason for my use of smooth flat surfaces. It was also nearest to the transition of light into colour and colour into light, something like an objective texture invention for a delicate and evasive medium. By producing real radiant light effects through transparent dyes on plastic and through other means, one has no need for translating light into colour by painting with pigment" (Laszlo Moholy-Nagy, *Abstract of an Artist*, George Wittenborn, Inc., New York, 1947). Experiments with light structures led him in the 1920s to create his "Light Prop" or "Light Space Modulator," the light-display machine that served as a decisive reference for further experiment in the optical and kinetic arts and even in environmental practice. The project was first presented at the Decorative Arts exhibition in Paris in 1930. That same year he was able to have it built thanks to financial aid from the giant German electrical combine AEG, and it took its place in the Raum der Gegenwart centre at the Hanover Museum. Using all the resources of the most advanced technology, the Modulator is the most perfect expression of light and movement. Even the artist was surprised by it: "When the Light Prop was set in motion for the first time in a small mechanics shop in 1930, I felt like the sorcerer's apprentice. The mobile was so startling in its coordinated motions and space articulations of light and shadow sequences that I almost believed in magic" (*ibid.*).

Other artists had also turned to light and movement. Marcel Duchamp, for whom painting "was only one means of expression among many others and not an aim intended to fill a whole life," incorporated them in his work from 1918 on. The *Large Glass* (1915-1923) already made much of movement (representation of machines) and light (glass with its reflections and transparency), but it was chiefly in *Tu m'*, his last oil painting, a mural made to decorate Katherine Dreier's library, that he pointed the way towards expression in space. Here he employed colour as the result of the prismatic breakdown of light. He played with illusionist effects by fastening a simulated rent in the painting with real safety pins; he suggested mobility by juxtaposing different effects in the shifting shadows of two Readymades (a coat-rack and a corkscrew). Such was *Tu m'* (1918). Thereafter Duchamp abandoned painting to become a contriver of anti-machines whose movement proved their uselessness or the illusion of it. *Precision Optics* (1925) was the outcome of an experiment in stereoscopic cinema carried out with Man Ray; this was an optical device of metal, painted wood, velvet and glass driven by a small electric motor. In 1925-1926 he extended this experiment with *Anemic Cinema* (the first word is an anagram of the second), a short-reel film produced in collaboration with Man Ray and Marc Allégret, in which moving discs convey a simulated depth. The *Rotoreliefs* or *Optical Discs* (1935) are the final result of his researches into movement and optics: "turning at an approximate speed of 33 revolutions per minute the discs give an impression of depth, and the optical illusion will be more intense with one eye than with two" (Marcel Duchamp).

In Los Angeles in the 1920s Stanton Macdonald-Wright, who had been associated with Orphism and Robert Delaunay in Paris, devised a light machine which projected pictures in movement on a screen. For his brother Willard, a well-known critic, this was the last Ism of painting: "The color organ is in fact the logical outcome of all the modern experiments in the art of color... With the coming of this new medium, the art of color will be totally dissociated from the art of painting, not only as the conception and impulse of the work but also in the attitude of the world towards it" (Willard Huntington Wright, *The Future of Painting*, 1923).

Russian artists were also experimenting in this field. In Paris in 1913 Léopold Survage (born in Moscow in 1879 as Leopold Sturzvage) composed some abstract gouaches intended for filming. At the end of the war D.V. Baranov-Rossiné devised an "optophonic piano" whose keys projected moving colours and shapes; he patented this invention in Paris in 1926. In Paris, too, the Georgian painter Kakabadze made some reliefs with metal and lenses, set with bulbs which enabled light to be projected from them; he patented this in 1923 as a stereocinematograph. For the sets of *Aelita* in 1923-1924 Alexandra Exter constructed a telescope, a kind of kinetic sculpture rich in optical effects and symbolic implications—sufficient proof of her interest in light and movement. And as early as 1916 the Italian Futurist Giacomo Balla had integrated light and movement for Stravinsky's *Feux d'artifice*, a lumino-kinetic ballet without dancers, commissioned by Diaghilev and performed in Rome on 16 December 1916.

In Germany the work in this field of Niklaus Braun, Ludwig Hirschfeld-Mack and Kurt Schwerdtfeger, notably their *Coloured Plays of Light* (1922), had some influence on Moholy-Nagy and on the Bauhaus conception of stage design. But it was in the cinema that light and movement were to find their most natural realm of expression.

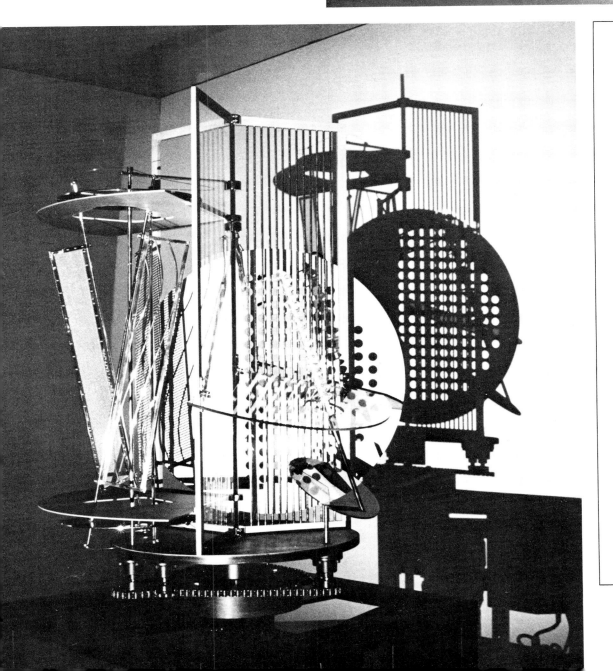

△◁ *Man Ray (1890-1976): Photograph of Marcel Duchamp behind* Precision Optics, *New York, 1920.*

△ *Antoine Pevsner (1884-1962): Projection into Space, 1927. Oxidized bronze.*

◁ *Laszlo Moholy-Nagy (1895-1946): Light Space Modulator, 1922-1930. Metal, plastics and wood, motor-driven.*

▽ *Alexandra Exter (1882-1949): Construction for the film* Aelita, *1924. Iron and glass.*

Expressive realities of the artist film-makers

Fernand Léger with his wooden model of Charlie Chaplin, made for Ballet Mécanique, *1924.*

In Arp and Lissitzky's book *Die Kunstismen* (The Isms of Art, 1925) we read under the heading of Abstract Film: "Like modern painting and sculpture, the cinema too begins to deploy and shape its specific material: movement and light."

These words were directly inspired by the experiments of Viking Eggeling and Hans Richter. For in their experiments these two avant-garde film-makers laid the groundwork on which many subsequent film artists were to build. Around 1925 some momentous developments occurred in the field of the art film. Until then a story line and a stage influence had been characteristic of film-making, in spite of the absence of sound. Now, with the abstract cinema, light and movement become the subjects of the film. Even Malevich, though he never had anything to do with the cinema, recognized its expressive possibilities in a letter written to Moholy-Nagy (12 April 1927): "Photography and film are in my opinion merely new technical means which painters must absolutely make use of, just as they have used brush, charcoal and colour from time out of mind. It is certain however that photography and film must also become as evocative for the sensibility as the pencil, charcoal or brush."

Discovering in film the reality of light, of movement, of time-sequences, creative artists found at their disposal a new vehicle for the exploration of space-time, that joint continuum which was beginning to obsess them, and they took to the cinema with the same interest and enthusiasm which they had already shown for the stage and the dance. They very soon contrived to "denaturalize" the cinema, turning it away from play-acting in order to develop its specific resources of expression. In this sector, too, they made it clear that they meant to sacrifice "representation," to break away from any "functional dependence on the external world." This, for Tarabukin, was the attitude most distinctive of contemporary art: "While previous art, from naturalism to early Cubism, is a representational art characterized by the connection between the pictorial forms and the forms of the actual external world, the new art breaks off this connection, this dependent relation, in order to create autonomous objects. And while the art of the past was opposed to the real world (hence the creation of the 'projected' forms of so-called pure art), the new art is in a sense immanent to the world of reality: it creates objects, and not pictorial copies (naturalism) or arbitrary compilations (Cubism) of objects in the real world. It is not the purpose of painting to 'represent' the things of the external world, but to make, shape, create objects. It is not a representational art but a constructive art" (Nikolai Tarabukin, *For a Theory of Painting*, 1923).

Collage and photomontage also had a shaping influence on film technique, for they impressed on artists the importance of montage, of the articulation and succession of images. In the hands of the avant-garde, the film, instead of proceeding in a continuous sequence, exploded in time and space.

But the film image, as an extension of the possibilities of painting, also modified the traditional relations between man and the visible world. Fernand Léger, who took enthusiastically to the new medium, recognized this in an article on Abel Gance's *La Roue* (1920-1922), for which Arthur Honegger wrote the music called *Pacific 231:* "The justification for the cinema's existence, and the only justification, is the *projected image*. The image, coloured but motionless, has always captivated children and men. And now we find it moving. Motion pictures have been created and the whole world bows down to this wonderful image that moves. Mind you, this formidable invention does not consist in imitating the movements of nature. It does something quite different, it *makes us see pictures*. The cinema need not seek its justification anywhere else but here. Project your fine image, choose it well, style it, put the microscope over it, do whatever necessary to get the maximum yield out of it, and you will have no further need of text, story, perspective, sentimentalism, actors. Both in the infinite realism of the close-up and in pure inventive phantasy (the simultaneous poetics of the moving picture), the new event is there with all its consequences" (Fernand Léger, in *Comoedia*, 1922).

In the make-up of Gance's *La Roue*, Léger noted how well the montage heightened one's awareness of reality. When he himself turned to film-making and in 1924 produced *Le Ballet Mécanique* with photography by Man Ray and music by George Antheil, Léger made the most of his long experience of construction and machinery. This film, the first without a scenario, gave him a chance to explore the workings of light and rhythm, to turn the current of his creative mind in a fresh direction—towards popular communication. Above all, the *Ballet Mécanique* represents a further stage in his quest for a new realism: "The film is first of all a proof that machinery and ordinary manufactured objects are *possible* plastic subjects... The fact of giving *movement* to one or more objects may render them plastic. Then there is also the fact of achieving a plastic event beautiful in itself without being obliged to find out what it represents" (Fernand Léger, *Autour du Ballet Mécanique*). In film-making the painter could dispense with the

Stills from the film Ballet Mécanique *directed by Fernand Léger and Dudley Murphy, photography by Man Ray, 1924.*

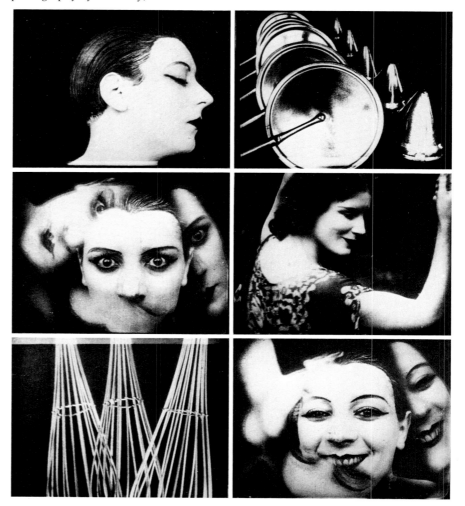

scenario because he had already dispensed with the subject in painting: "Contrasts of objects, of slow and quick passages, of pauses and intensities. *The whole film is built on that*. I have used the close-up, which is the one invention made by the cinema. I have also made use of the fragment of an object; by isolating it I have *personalized* it. All this work has led me to consider the *event of objectivity* as a new and very topical value" (*ibid.*).

The Dadaists also tried their hand at film-making. Picabia's *Entracte* (1924) has become a classic example of a montage made in defiance of visual appearances. This burlesque phantasy, filmed in collaboration with René Clair, set the cinema free from everything that is not purely cinematographic, it created the adventure of the screen. Written in twenty-four hours and shot in three weeks, this short-reeler was intended (as its name indicates) to fill up the interval between a change of sets in *Relâche*, an Erik Satie ballet mounted in Paris by the Swedish Ballet Company. *Relâche ballet instantanéiste en deux actes et un entracte cinématographique et la queue du chien de Francis Picabia* was created at the Théâtre des Champs-Elysées in December 1924 and was the last Dada manifestation in Paris. "We have created *Relâche* rather in the way God created life," was Picabia's throw-away comment on it.

Before shooting *Ballet Mécanique*, Léger and the architect Mallet-Stevens had already worked together on the Marcel L'Herbier film *L'Inhumaine* (1924). This collaboration between painting, sculpture and cinema was an important feature of the 1920s. In the cinema, as also on the stage, painters and sculptors intervened essentially on the aesthetic plane. They set the style of the show by endowing it with modern forms and colours, and a modern sense of space, and in this collaboration they found a way of initiating the public into the guiding spirit of contemporary art. And through the cinema they reached a popular public which they could never have reached through the galleries and museums. Soviet artists went so far as to introduce on the stage the prototypes of objects which they hoped to produce on an industrial scale.

This experimentation with a modern space was actively pursued in the stage activities of the Bauhaus. For Lothar Schreyer the stage was but one more form of art testifying to "the unity of life by the multiplicity of the living." Oskar Schlemmer in his Diary (1929) gave an excellent description of the work of the Constructivists in the theatre: "The recipe followed by the Bauhaus theatre is very simple: as few prejudices as possible; approach the world as if it had just been created, don't brood things to death, but let them develop, cautiously but freely. Be simple, not poor ('simplicity is rather too grand a word!'), better to be over-simple than finicky or pompous; don't be sentimental but witty, which is to say all and say nothing! Again, start out from the elementary, what does that mean? Start from the point, the line, the simple plane, start from the simple composition of surfaces; start from the body, start from the simple colours, red, blue, yellow and black, white, grey, start from textures, experience the different textures of glass, metal, wood, etc., and assimilate them. Start from space, from its laws and mystery, and let oneself be 'bewitched' again. Everything is said and nothing is said, so long as these words and ideas have not been experienced and become pregnant with meaning."

Enthusiastic experimenter that he was with all new forms of expression, Moholy-Nagy naturally took a keen interest in film: "The huge development of information media, of typography, film and radio is due not only to curiosity, not only to economic considerations, but to a profoundly human interest in everything that concerns the world," he wrote in 1925 in his epoch-making book *Malerei Fotografie Film*. More than anyone else, Moholy-Nagy was attracted by "the new sources of artificial light, the possibility of regulating light effects and all those elements which have contributed to a formal renewal of expression."

In his films Moholy-Nagy made use of direct lighting and boldly explored all the resources of montage. He broke up the classic unity by setting up oppositions of place, time and .space. Above all he renewed the camera eye in dynamic plunges and counter-plunges, in surprising effects of recession and enlargement.

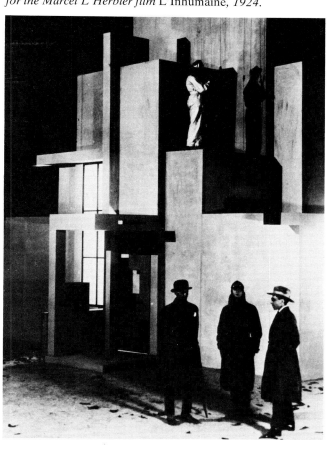

Robert Mallet-Stevens (1886-1945): Architectural set for the Marcel L'Herbier film L'Inhumaine, *1924.*

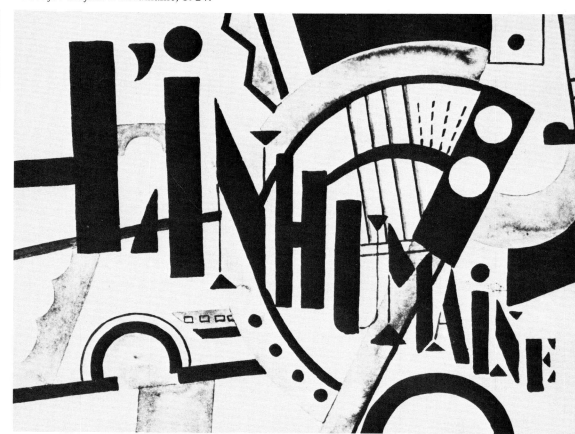

Fernand Léger (1881-1955): Poster for the film L'Inhumaine, *1924.*

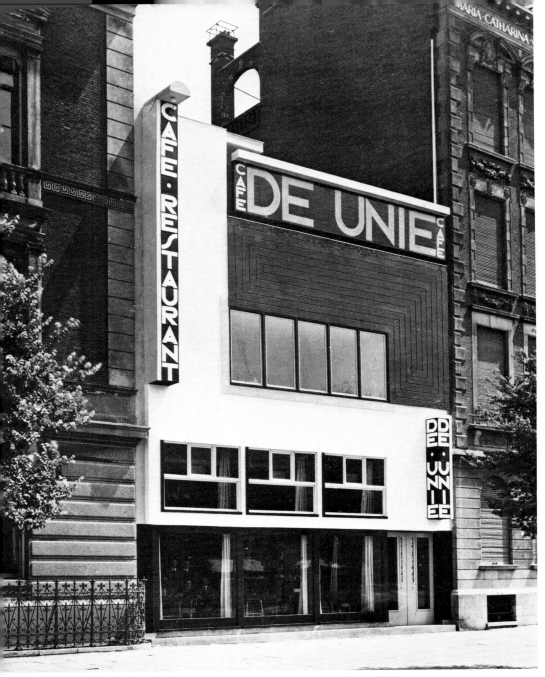

J.J.P. Oud (1890-1963): Café De Unie in Rotterdam, 1925.

was multiplied by the imaginative use of collage and montage. Some of the best artists turned their attention to page make-up and book design, and the books published by the Bauhaus are models of their kind. The geometric purism of that period obliged designers to envisage the surface of the sheet or wall as a two-dimensional reality and to occupy it—as if it were the surface of a canvas—only with rhythms and contrasts of colour and texture. This conception led to a revolution in the tradition of typography. The latter no longer intervened as a neutral signified referring to an anonymous signifier, but acted on the eye and mind through its presence alone, in challenging and thought-provoking ways. Through the size and rhythm of the typeface, the designer, on occasion, almost contrived to suggest sound.

In the Dada reviews that proliferated from 1916 on, the page layout and typography were the object of unceasing invention and fanciful innovation; each issue was distinctive in its visual aspect. The inventiveness shown by these artists soon caught the eye of businessmen, who realized that there were profits to be made out of such striking and explicit imagery.

Avant-garde artists were eager to exploit all the resources inherent in page make-up and lettering. Referring some years later to these developments in typography (in *Qualität*, No. 3-4, 1932), Raoul Hausmann emphasized the importance of considering the page as a composition and the page layout as a montage: "The Futurists and above all the Dadaists have recognized that reading, and indeed phonetic communication, can only be effected visually. This physio-optical principle was worked out consistently for the first time in certain typographical pages executed in 1919. It is not by chance that the phonetic poem was invented and based on an optical typography of a new kind. The photomontage, also put forward by the Dadaists,

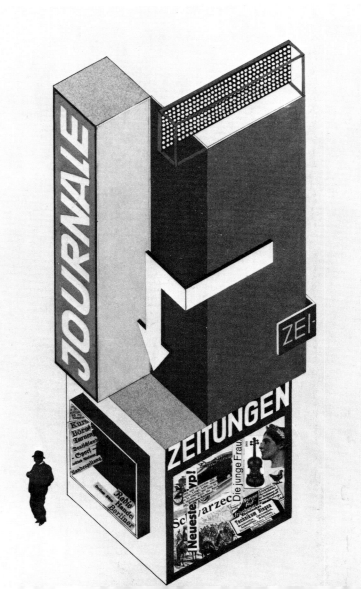

Herbert Bayer (1900): Design for a Newsstand, 1924. Collage.

The experimental theatre of Meyerhold in Moscow and Piscator in Berlin reveals a very similar orientation. Relying on artificial lighting and the projection of colours, pictures and even filmstrips, they completely "denaturalized" the stage, emphasizing the specific features of the scenic space. The theory of distanciation arose from the complexity of the new stage conception and created a new relation between actor and spectator, which Piscator expressed in *Red Revolution Revue* (1924) in which he introduced film sequences, thus bringing about a provocative disruption of the traditional stage. He set out not to tell a story but to explain events, and for this purpose he introduced into the theatre the montages, close-ups and travelling shots peculiar to the cinema.

All forms of visual communication underwent radical changes. Advertising came into its own in the twenties. It assumed an ever more prominent place in the economy. It even played a part in functional architecture, and the need for illuminated lettering made it possible to introduce colour and difference. Even the political parties called in artists to design their badges and develop their propaganda.

The Constructivist spirit and the use of photography contributed to a radical change in the visual forms of both advertising and typography. Both diffused among the public the results of the experiments carried out in the manifestoes, pamphlets and periodicals issued by the Futurists, Dadaists and Constructivists. And their effectiveness

Revolutionizing the tradition of typography

Typography is an intermediate realm between art and technics, between seeing and hearing, and it is one of the most effective means for man's permanent psycho-physiological self-education. The very figuration of typography, evoking conceptual phonetic images in a very special way by the different sizes of each letter and their differing proportions, calls for a peculiar power of perception which we may call the perception of structures. In this field of perception which has never allowed of any freehand, any individual drawing, each stroke has a precise meaning attaching to it and leads on logically to further strokes, equally precise and definite.

Raoul Hausmann, in *Qualität*, No. 3-4, 1932.

Stuart Davis
(1894-1964):
Odol, 1924. Oil.

had the same purpose: to renew and reinforce the physiological perception of typography. Already at that time it was recognized that the ever greater need of the image, that is the need to redouble the text by a visual illustration, could not be answered by merely setting text and image side by side; what was required was an optical construction built on a linguistic and conceptual basis."

In Germany both El Lissitzky and Schwitters had the opportunity of working in the field of advertising design, and they proved to be brilliant innovators. In his review *Merz* (No. 11, 1924) Schwitters published his views on typography. He emphasized the connection between form and text content and laid down some basic guidelines: "Where typography is concerned, one can establish any number of laws. The main one would be: never do as anyone else has done before you. Or else one might say: always proceed differently from others. Here, to begin with, are a few general rules of typography: 1. Typography may in certain circumstances be an art. 2. Originally there was no connection between the text content and its typographical form. 3. Design and form are the essence of all art: typographical design is not a mere representation of the text content." Schwitters added (taking over a view of El Lissitzky's): "Typographical design is the expression of the tensions at work in the text content."

In all their photographic work the Dadaists and Constructivists made a point of holding aloof from natural models, and this is equally true of their publicity montages, which from this very fact gained a new forcefulness. In their poster designs, too, the signifier is freed from any dependence on the signified. Form and colour act in abstract terms and the poster loses its documentary value and leaves the artist free to treat it as he would a painting, an independent work of creation. This was implicitly recognized by Moholy-Nagy when he said: "Representation when done from an original standpoint tends towards creation."

This approach to photography renewed the awareness of objects, because it ignored their utilitarian purpose in order to bring out their form and emphasize their constituent fragments. Léger, who dreamed of inventing a new figuration, was accordingly attracted by this ap-

proach. His vision, though all his own, yet had something in common with that of the montage makers.

And when he evokes his manner of composing his paintings in order to give them "breadth" and "intensity," Léger again has in mind the example of the modern, mechanical object as revealed by photographic "objectivity": "A picture as I understand it, which must equal and exceed in beauty the 'fine object' produced by industry, must be an 'organic event' like the object in question, like any human manifestation brought into being. Every objective human creation is dependent on absolute geometric laws. Every pictorial human creation stands in the same relationship. The relation of volumes, lines and colours demands an absolute orchestration and order. All those values are unquestionably latent and dispersed in modern objects, like aeroplanes, motor-cars, agricultural machinery, etc."

This new relation with the object, worked out on the basis of photography, advertising design and typography, also gave new life to the work of the American realist painters. What happened in the 1920s directly anticipates what was to happen in the 1960s with Pop Art.

Diffused by the Paris review *L'Esprit Nouveau*, the influence of Léger and Purism was very strong in the twenties. In the United States it answered a need and made it possible for American artists to express an almost atavistic attachment to reality in a context of modernity. When in 1924 Léger and Ozenfant opened their studio school in Paris, they had many Americans among their students; Florence Henri is one of the best known. Léger's influence was further extended when he later moved into the field of photography.

But to reintroduce the object into painting the Americans scarcely needed the stimulus of European artists: they had only to look about them. This is what Stuart Davis—who did not go to Paris until 1928-1929—had in mind when he said: "I'm an American, born in Philadelphia. I have studied art in America, in other words I paint the American scene." His *Odol* of 1924 is highly characteristic of this new figurative vision which owed its effectiveness to the flat forms and colours imposed on modern art by French artists from Matisse to Léger.

Charles Sheeler (1883-1965): Self-Portrait, 1923. Conté crayon, water and pencil.

At the 291 Gallery in New York, during the period of its activity (1905-1917), Alfred Stieglitz exhibited a wide range of modern artists and photographers, not only European but also American. The American realists based their work on the new awareness of reality that arose as a result of the photographic experiments of the Stieglitz circle. The photographic image had come to record an appearance seized on for its own sake, without any sentimental or expressive intentions, and also without any functional or utilitarian purpose. In the American press and periodicals, advertising design and especially fashion design now made abundant use of "pure photography": close-ups, contrasting light effects, geometric patterning. While American painters were eagerly exploiting this new objectivity, they had not yet achieved that mobility of the camera eye which, in France, had been taken over by an artist like Robert Delaunay in his plunging, sharp-angled views of the Arc de Triomphe and the Eiffel Tower.

Stieglitz, who had not shown any of his own photographs since before the war, exhibited again in 1921 at the Anderson Gallery in New York. The editor of *Photo Miniature*, John Tennant, commented: "Never was there such a hubbub about a one-man show. What sort of photographs were these prints, which caused so much commotion? Just plain, straightforward photographs... In the Stieglitz prints, you have the subject itself, in its own substance or personality, as revealed by the natural play of light and shade about it, without disguise or attempt at interpretation." This pure photography came from a new vision thus defined, as early as 1917, by Paul Strand in *Camera Work* (No. 49-50): "The objects may be organized to express the causes of which they are the effects, or they may be used as abstract forms, to create an emotion unrelated to the objectivity as such. This organization is evolved either by movement of the camera in relation to the objects themselves or through their actual arrangement, but here, as in everything, the expression is simply the measure of a vision, shallow or profound as the case may be. Photography is only a new road from a different direction but moving toward the common goal, which is Life."

In the twenties the American economy was vigorous and thriving. The public at large was hostile to avant-garde art, to everything that relied on intuition and subjectivity. It was much more receptive to realism, to works based on a certain material and pictorial objectivity. Charles Sheeler practised both painting and photography and he is a good representative of this realistic tendency. He was well aware of the extent to which the camera eye had modified the traditional way of seeing. "My interest in photography," he said, "paralleling that in painting, has been based on admiration for its possibility of accounting for the visual world with an exactitude not equaled by any other medium. The difference in the manner of arrival at their destination—the painting being the result of a composite image and the photograph being the result of a single image—prevents these media from being competitive" (Charles Sheeler, in the catalogue of the Sheeler exhibition, Museum of Modern Art, New York, 1939).

Gerald Murphy—whose astonishing personality inspired Scott Fitzgerald to create the character of Dick Diver in *Tender is the Night* (1934)—was also fascinated by everyday objects and their enlarged presence in painting. In his pictures he endowed them with a riveting, challenging power. Thus featured, thus probed into and studied under all its facets, the object of daily use became one of the distinctive marks of modern painting.

But these artists could not always resist the temptation to be decorative or to tell a story. Such were the risks inherent in this fresh outburst of realism, of which Bertolt Brecht was to give a political definition in 1938 (in *On Realism*): "The realist is he who discloses the complex causality of social relations; who denounces the dominant ideas as the ideas of the dominant class; who writes from the viewpoint of the class that holds ready the broadest solutions for the most pressing difficulties in which human society is entangled; who emphasizes the moment of evolution in everything; who is concrete while facilitating the work of abstraction... Let the artist be allowed to devote to this his imagination, his originality, his humour, his power of invention."

Gerald Murphy (1888-1964): Razor, 1922. Oil.

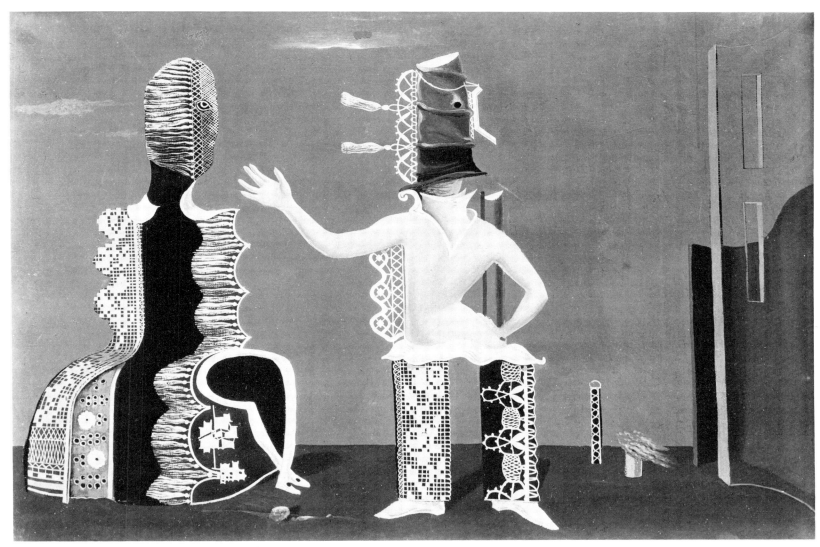

Max Ernst (1891-1976): The Couple, 1923. Oil.

The advent of Surrealism

Among all the ways of showing the object, of constructing the image, of exploiting space-time which came to the fore in the twenties, those opened up by the Surrealists are peculiarly their own. The images they proposed are disquieting and questioning. They body forth an inner need which André Breton described as follows in the *Surrealist Manifesto* of 1924: "Surrealism does not allow those who are addicted to it to leave off when they please. Everything goes to show that it acts on the mind in the manner of narcotics: like these it creates a need of a certain kind and it may drive a man to some terrible revolts... The imagery of Surrealism is like that opium-induced imagery which a man need not call up in his mind, for it comes to him, as Baudelaire put it, 'spontaneously and despotically, and he cannot dismiss it, for his willpower fails and can no longer govern his faculties.'" Breton here is referring to the imagery of poets, for at that time, in 1924, he saw Surrealism wholly in terms of literature and in this famous manifesto ignored the painters. Apart from a mention of Picabia and Duchamp, his only reference to the visual arts concerned the collage technique, and only in its Cubist version: "The means available to Surrealism require to be extended. Anything will serve to obtain certain associations with the desirable suddenness. The pasted papers (*papiers collés*) of Picasso and Braque have the same value as the introduction of a commonplace into a literary development in the most polished style. It is even permitted to call *poem* what one obtains by as random an assemblage as possible of headings and scraps of headings cut out of the newspapers" (*ibid.*).

André Breton's failure, in the *Surrealist Manifesto* of 1924, to make any mention of Max Ernst, André Masson and Joan Miró is all the more surprising since he saw them regularly. Presumably he was still unaware of the possibilities of Surrealism in painting, for they were not obvious at the time. It was not until abstraction had modified the traditional relation with reality and Dada had destroyed the notion of masterpiece that Surrealist subject painting became possible. Looking back on these days, Breton later wrote: "From 1918 to 1921, in avant-garde painting, one may say that things had come to a standstill, there was an absolute crisis of the model. The old model, taken from the outer world, had expired. The model that was to follow, taken from the inner world, had not yet been discovered" (André Breton, *Genèse et perspective artistique du surréalisme*, 1941). Surrealist painting could not come into existence until a pictorial technique had been discovered which gave access to this "inner model."

In their consistent emphasis on the unconscious mind, the Surrealists stood directly opposed—even more than the Dadaists had been—to the spirit and techniques associated with a scientific, materialistic, pragmatic outlook, which Breton in his Manifesto implicitly condemned with this insidious question: "Cannot the dream be applied to the resolution of the fundamental questions of life?" Because he was a poet, Breton, in 1924, had not yet realized the full importance of painters, of image-makers, in an age when imagery was coming to prevail over all other forms of communication. But it was not long before he did realize it.

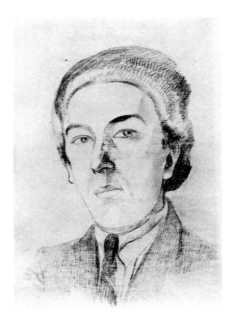

Robert Delaunay (1885-1941):
Portrait of André Breton, 1922.
Pencil and charcoal.

In the collages of Max Ernst, on the contrary, it is reality that becomes uncanny and the visible world that appears abstract. No voluntary intention enters into his choice of picture elements, he lets himself be guided by the unforeseeable workings of chance, and the resulting surprises give him an insight into the unknown side of his own individuality. As Werner Spies writes: "The meeting between Max Ernst and Dada was for him an unprecedented release. He thereby discovered ways of falling back from direct artistic procedures, and this in his eyes was a positive regression. From now on he avoided any direct structuration. The virgin canvas and the blank sheet on which the hand's mark was to be inscribed did not cease to set problems for him. So far as possible he avoided whatever is meant by style, skill and predicates of artistic activity... His collages aimed largely at destroying the visual habits created by the experience of the previous generation. His refusal of the blank paper and the virgin canvas was a revolt against anything imposed by the exigence of others. In defiance of all that can be learnt, he played the simulated dilettante... This insight of his, exploited systematically and reinforced artificially, resulted in a manner of working which rested largely on quotation and interpretation."

For the Surrealist painters, the image became the meeting place *par excellence* of the known and the unknown. Max Ernst, with his experience of collage, had already discovered it to be the first automatic technique giving access to the unconscious; it revealed the possibility of obtaining "a dictated record of the mind, in the absence of any control exercised by reason, over and above any aesthetic or moral preoccupation." Max Ernst's collages were fundamentally different in their import from those of the Berlin Dadaists. The latter were out to produce a visual shock, a dynamic set of contrasts soliciting a reorganization of the faculties of perception; they stressed the gaps between reality and its representation and denounced the present with a mechanical logic which played on the formal indifference of photography, a totally de-individualized technique of representation.

From the time of his first Paris exhibition (Au Sans Pareil Gallery, May 1921) Max Ernst made friends with the French poets. In August 1922, with the help of Paul Eluard, he settled in Paris. His painting took the direction of his collages, and in a setting imbued with the space and spirit of Metaphysical Painting he conjured up one intriguing image after another. Oil painting, with its colours and lights, enabled him to give a more individualized expression to his collage subjects, and to make them even more uncanny. After exhibiting at the Salon des Indépendants in 1923, he took ship for Indochina accompanied by Eluard. He was back in Paris in the autumn of 1924, just in time for the publication of Breton's *Surrealist Manifesto*, and thereafter he moved away from the influence of Chirico.

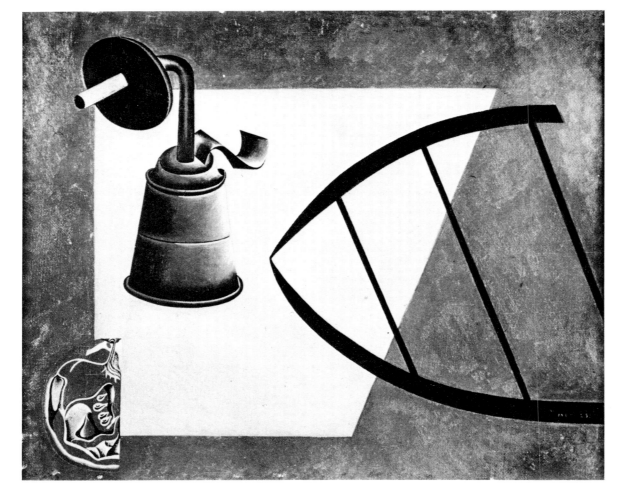

Joan Miró (1893): The Carbide Lamp, 1922-1923. Oil.

Announcement in La Révolution Surréaliste, ▷
No. 1, 1 December 1924: The whole world is talking
about the Surrealist Manifesto — Soluble Fish
by André Breton — What is Surrealism?

"The ball of thread unrolled by the cats dressed as harlequin of smoke twisting my vitals and piercing them during the period of famine which gave birth to the hallucinations recorded in this picture fine growth of fish in a poppy field noted on the snow of a paper palpitating like the breast of a bird in contact with a woman's sex in the form of a spider with legs of aluminium which returns in the evening to my house at 45 Rue Blomet," and so on. This text by Miró about his *Harlequin's Carnival* (1924) proves that he too had entered the domain of strange enchantments. Born in Barcelona in 1893, he showed as a boy an eager curiosity about the life of nature and growing things; already he was fascinated by organic forms and the infinitely small. Parallel to his commercial studies, he dabbled in the fine arts. Then, after an illness, he spent a long convalescence in 1911 in his parents' country house at Montroig, in Catalonia. From then on he devoted himself to painting and this Catalan village became his first and favourite subject. Back in Barcelona he enrolled in the art school of Francisco Gali, a private, anti-academic studio where students even learnt to draw by touch. Soon afterwards he discovered Cubism and was fascinated by it, while continuing to use the Fauve palette. In 1918 he had his first one-man show, at the Dalmau Gallery, Barcelona, a showplace of avant-garde art. He was then practising a coloured Cubism, but at Montroig, where he often stayed, he began moving towards a more meditative and poetic style of his own. The minute delineation of his surroundings attenuated the brightness of his colours: "Happiness of lingering in the landscape till one understands a blade of grass. Why disdain it? This blade of grass is as beautiful as the mountain tree," he wrote on a postcard of 1918. This closeness to nature led him to break with traditional space, which could no longer accommodate the singularity of his perceptions. "What interests me most is the calligraphy of a tree or of roof tiles, leaf by leaf, branch by branch, blade of grass by blade of grass," he wrote to his friend E.C. Ricart.

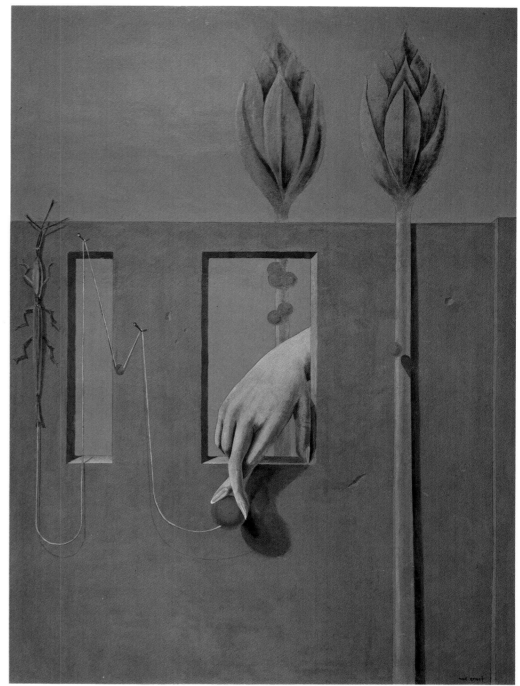

Max Ernst (1891-1976): At the First Clear Word, 1923. Oil.

Miró made his first trip to Paris in the spring of 1919, and the following year he settled there. He at once made friends with Picasso. He lived at 45 Rue Blomet, but every summer he went back to Montroig and the Catalan landscape he loved. His first one-man show in Paris (Galerie La Licorne, 1921) was prefaced by Maurice Raynal. That same year he began *The Farm*, a key work to which he often referred back. His detailed delineation of this Catalan farm gave him an opportunity to carry realism to the limit, while opening up many other possibilities of development. He carried precision beyond appearances and thus discovered the importance of signs. "The reality of *The Farm*," writes Jacques Dupin, his biographer and commentator, "is at the heart of all Miró's poetic œuvre. Everything that floats up and onto the surface of the canvas comes from the earth, and *The Farm* is the direct precedent, the very figure of the earth in Miró's world. It remained for him to rise by one degree, to have the necessary strength and patience and boldness to carry through the magical transformation from the real, from the real alone, the reality that desire awakens and fecundates."

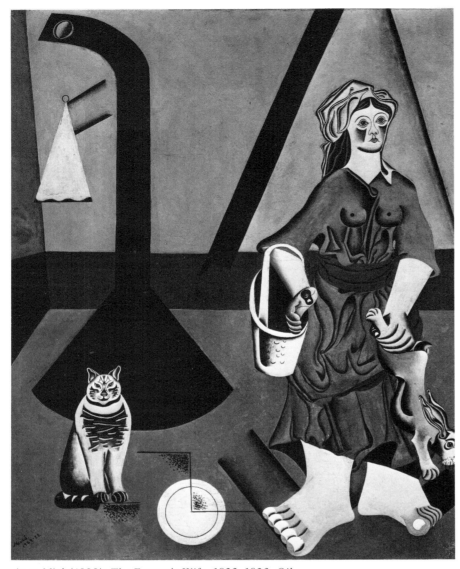

Joan Miró (1893): The Farmer's Wife, 1922-1923. Oil.

This new reality germinates in *The Tilled Field* through the signs summarizing and condensing his poetic emotion, but signs wholly imbued with the substance and texture of nature. The connection with nature was soon to be broken off by a radical breakthrough on the level of light and space. But, a thorough Spaniard, Miró was still intent on maintaining contact with reality; hence his insistence on objects whose outward appearance he emphasizes. From now on he organized his canvases in terms of carefully delineated details, as in *The Farmer's Wife*, where the formal purism of the stylization reinforces the detachment from visual reality.

In 1924 Miró discovered the work of Paul Klee, at the very time when his (Miró's) friendship with André Masson—who had a studio next door to his own—became important for him. For a long time Miró had continued to work on the basis of natural appearances. Now he transcended them by sheer force of imagination. He transfigured nature in order to "express precisely all the golden sparks of our soul." In the late summer of 1924 he wrote from Montroig: "I succeed in escaping into the absolute of nature and my landscapes have nothing to do with external reality... I know that I am following dangerous paths, and I confess that I am often panic-stricken, the panic of a traveller in unexplored territory. Then I react, thanks to the discipline and severity with which I work, and confidence and optimism return to give me my momentum." With *The Harlequin's Carnival* (1924) he achieved the complete transposition of metaphor into painting.

During the winter of 1923-1924 he cemented his friendship with his neighbour, the young painter André Masson. Born in 1896, Masson had been indelibly marked by the horrors of the war, which he experienced in the trenches, and memories of it haunted his mind. After a journey undertaken to soothe his shattered nerves, Masson settled in Paris and came under the influence of André Derain. He was attracted by Cubism, however, and became in fact so forthright a Cubist that D.H. Kahnweiler sponsored his first one-man show early in 1924. Miró said of him: "Masson has always been a great reader and was full of ideas. He numbered among his friends practically all the young poets of the day. Through Masson I met them... they interested me more than the painters I had met in Paris. I was entranced by the new ideas they expressed and above all by the poetry they discussed. I would stuff myself full of it all night."

Working at night as proof corrector in the plant where the *Journal Officiel* was printed, Masson took to drugs and alcohol in an attempt to experience that "unsettling of all the senses" preached by Rimbaud. In the winter of 1923-1924 he met André Breton and made his first automatic drawings, while in his painting he still used more symbolic forms, in a state of metamorphosis. Having passed through a Cubist phase, Miró and Masson were aware of the autonomy of the picture space and its material and formal requirements, and this brought them close to the abstract painters. But it was not until the experience of automatism had eased the rigour of their compositions that they were able to break free completely. For the time being they were more attracted to a biomorphic figuration, already visible in Max Ernst. Now, in 1924, came Breton's *Surrealist Manifesto* denouncing realism, calling for an effort of imagination and focusing attention on the psychic world of dreams. "I believe in the future resolution of these two states, dream and reality, into a sort of absolute reality, a *super-reality*, if one may call it so. This is the conquest I am setting out on, certain of never reaching it but too heedless of my death not to bear up somewhat under the joys of such a possession" (André Breton). The pursuit of that conquest meant that appearances had to be transcended. "The case against the realist attitude now needs to be got up, after the case against the materialist attitude. The latter, more poetic in fact than the other, implies on the part of man a pride of monstrous proportions, but also a new and more complete downfall. It is to be seen, above all, as a happy reaction against several ridiculous tendencies of spiritualism. Finally it is not incompatible with a certain elevation of mind" (Breton). This distrust of reality leads down the path to self-revelation; it further reveals that poetry is always elsewhere, that it must be won the hard way. "For all the misfortunes that we have inherited, it must be acknowledged that we are still left with the greatest freedom of mind. It is up to us not to misuse it. To reduce imagination to slavery, even in the name of what is vulgarly called happiness, means shrinking from whatever may be found of supreme justice within oneself. Imagination alone gives some inkling of what may be, and that is enough to remove this terrible taboo; enough, too, for me to surrender myself to imagination without any fear of going wrong" (Breton). Surrealism was a call to absolute freedom, the freedom to cultivate individual difference.

At the Weimar Congress of the Constructivists in 1922, Tzara, and with him the Paris Dadaists, broke with the German Dadaists; and at the Paris Congress that same year (International Congress for the Determination of Directives and the Defence of the Modern Spirit) Breton and Tzara angrily parted company. This was the break-up of the Dada movement: it ended to make way for Surrealism. Breton later wrote (in *Cahiers d'Art*, 1934): "Dada cannot be said to have served any other purpose but to keep us in the state of perfect receptivity in which we are at present, and from which we are now going to set out in full lucidity towards what beckons us on."

While Dada in its utter nihilism repudiated the past, Breton on the contrary looked back to it for the sources of Surrealism: all those who had celebrated the marvellous and the imaginative. When he paid a visit to Freud in Vienna in 1921, he was eager to seek out a scientific and rational approach to the sphere of the irrational. The meeting itself was a failure; the two men were unable to reach an understanding. Breton nevertheless continued to use and develop the Freudian method of free associations, for he found it a fruitful source of new poetic effects. Already in 1919, with Philippe Soupault, he had practised automatic writing. In 1922 he decided on a fresh exploration of reality through hypnotic trances. In *Les Pas perdus* (1924) he wrote: "It is known, up to a certain point, what my friends and I mean by Surrealism. This word, which is not of our coining and which we might equally well have abandoned to the vaguest critical vocabulary, is employed by us with a precise meaning. By it we have agreed to designate a certain psychic automatism which corresponds well to the dream state, a state which today it is very difficult to delimit." The word Surrealism had in fact been taken over from Apollinaire, who had coined it and used it in his programme notes for the ballet *Parade* in 1917, which he had seen as "the starting point of a series of manifestations of that new spirit which... bids fair to modify the arts and manners in universal gladness. For common sense requires them to be at least on a par with scientific and technical progress."

The *Surrealist Manifesto* of 1924 gave Breton an opportunity of clarifying a certain number of points, of specifying what Surrealism meant for him and his group: "It would be quite unfair to deny us the right to use the word Surrealism in the very special sense that we attach to it, for it is clear that before us this word had failed to gain currency. I define it then once and for all: Surrealism, masculine noun. Pure psychic automatism by which it is proposed to express verbally, in writing or in any other way, the actual workings of the mind. A dictated record of the mind, in the absence of any control exercised by reason, over and above any aesthetic or moral preoccupation." For Breton the essential point, as explained by Georges Hugnet, was to lay the basis for more constructive experimentation: "For

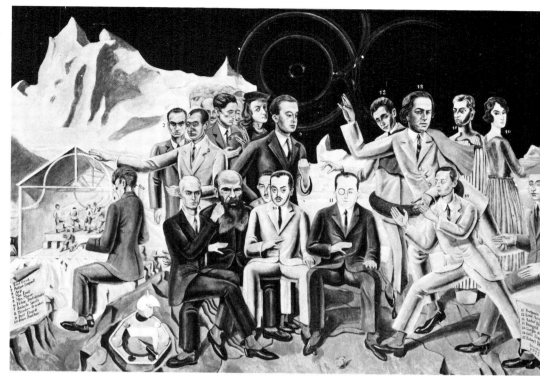

Max Ernst (1891-1976): All Friends Together, December 1922. Oil.

Dada the adjective *modern* was a pejorative word. Dada had always fought against the modern spirit. Breton's intention was clear. Faced by the rising tide of obscurity, he wished to create light. He wished to investigate the manoeuvres of Dada. Dada was at the end of its run. It had gone down like a ship in distress. A reorientation was necessary" (Georges Hugnet, in *Cahiers d'Art*, No. 7, 1932).

Surrealism, in 1924, extended as yet only to literature: then, in the course of a sharp struggle, painting was to take it over. With Dada out of the way, Constructivists and Surrealists now stood opposed to each other; the first, resolute advocates of objectivity, the second resolute advocates of pure subjectivity.

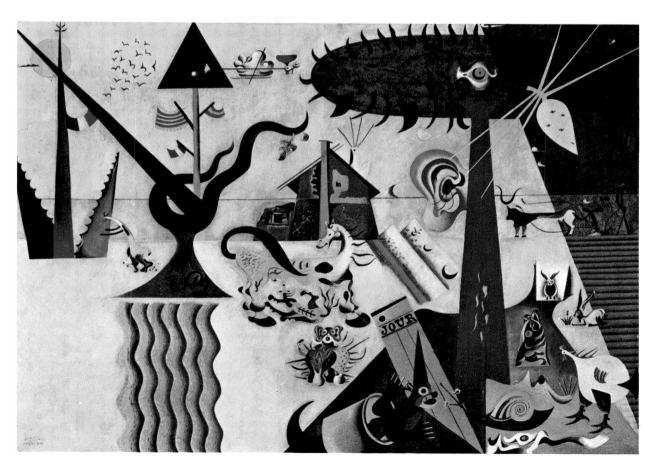

Joan Miró (1893):
The Tilled Field, 1923-1924. Oil.

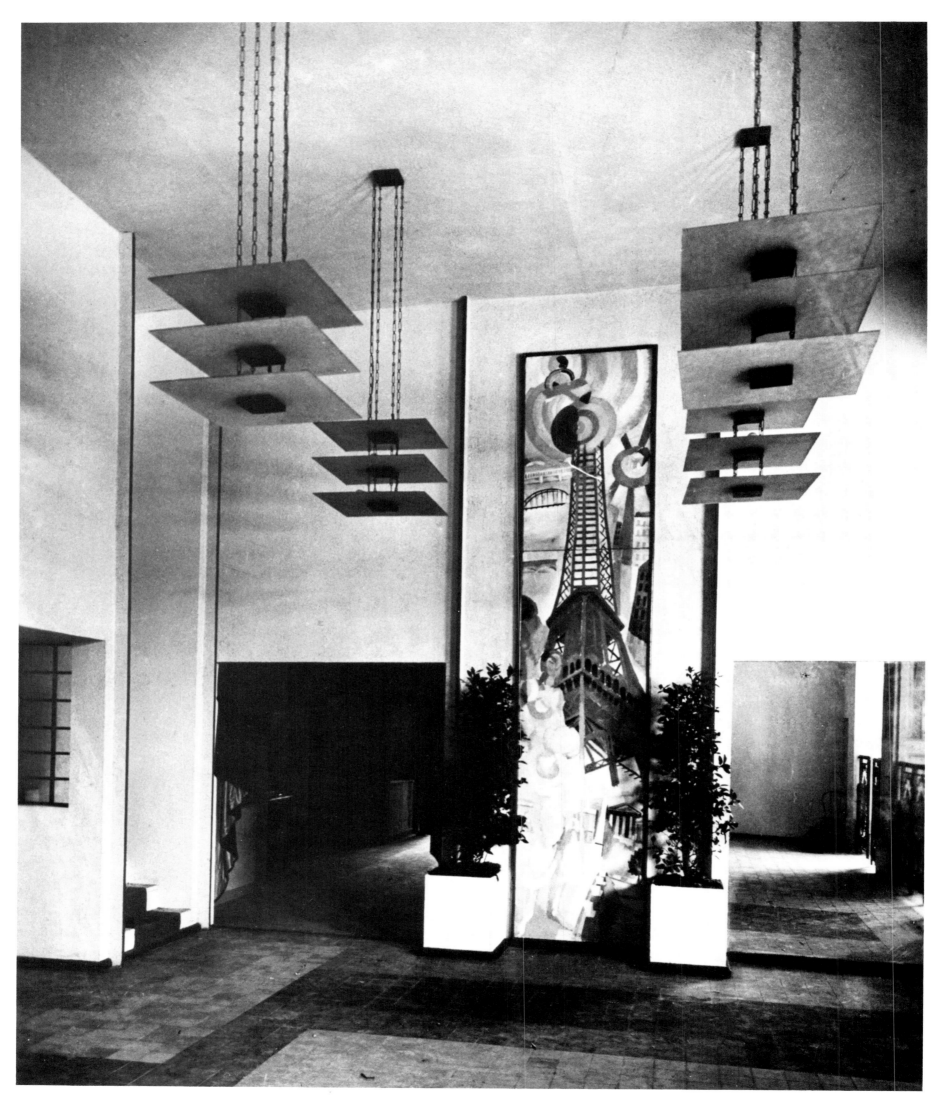

Robert Mallet-Stevens (1886-1945): Hall of a French Embassy, project shown at the Exhibition of Decorative Arts, Paris, 1925.

Art for Life's Sake

1925-1929

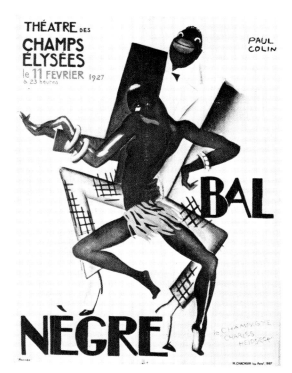

Paul Colin (1892): Poster for the Revue Nègre at the Théâtre des Champs-Elysées, Paris, 1927.

Paris reconquered its position as the capital of the world. "It was like being on holiday," was the way Raymond Radiguet summed up the atmosphere of those "wild years." And it was true that people were coming to Paris, or coming back to Paris, from all over; in Paris, more than anywhere else, freedom, facility, pleasures were on offer. The post-war world grew intoxicated with the illusion of its recovered power, with the feeling that life must be pleasant at any price: in the deceptive images of night life people strove to forget yesterday's sufferings and today's failures. They sought to break free from the real by dazing themselves with colours, rhythms and dreams.

The 1920s marked a reprise and an intensifying of the myths of the Belle Epoque which had been believed to be dead and buried. In Montmartre, in Montparnasse especially, painters, poets and models, collectors, rich and worldly tourists met in a mad whirl of bohemian life. The years around 1925 produced a style called "Art Deco" which blended the conquests of geometrism with the resurgent aspects of Art Nouveau. Luxury was still flaunted with satisfaction, but it was henceforth subject to incessant changes in taste. It was hard to escape the temptations of fashion, which advertising posters and the press helped to circulate, while the quest for the sensational and spectacular stimulated fashion's ceaseless renewal.

Jazz rhythm americanized the French public, which was no longer shocked by the geometrism of Russian or German artists. It was the hour of eclecticism: Russian and Swedish ballets, the Revue Nègre. Joseph Delteil recalled that time: "It was all the rage, that Revue Nègre. 'All Paris,' and all of Paris, flocked every evening to see it at the Théâtre des Champs Elysées. Not only the general public, but the young literary generation, the great performers, the avant-garde headed by Cocteau, who went to see it five or six times running, Crevel who bought a season ticket for a month, Fernand Léger, etc. It has to be said that that show teemed with stars, first among them, of course, Josephine Baker, a devil of a Negress, but also Sidney Bechet and Louis Douglas, with tremendous sets by Cavarrubras and a bill-sticker of genius, Paul Colin. Moreover, spectacle as a genre was coming into its own. That conjunction of the 'charms' of old Africa and the modern spirit was one of the crossroads of 1925, a meeting place" (Joseph Delteil, *La Deltheillerie*, 1968).

Paris, the rendezvous of Art Deco

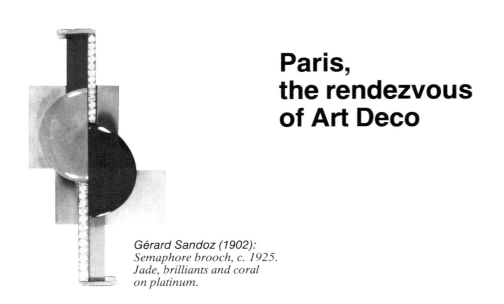

*Gérard Sandoz (1902):
Semaphore brooch, c. 1925.
Jade, brilliants and coral
on platinum.*

Fleeing the pervading Puritanism of their country, American artists came in large numbers to Paris, where they played a leading role in the night life: money flowed freely, and encouraged whatever was daring. Every day movement and rhythm grew more hectic, the light more dazzling, the forms and colours more strident. Novelty meant a certain affirmation of freedom, merited only by daring everything and more. To be modern meant to shock, to provoke, to be always different... Advertising struck the keynote. It kept changing the décor of the city while sensitizing the public to the discoveries of the avant-garde; turned towards the future, it was ruled by the demands of novelty at any price. In the name of information and communication it sought for the most telling effects, forms that were schematized and anonymous, but also aggressive and startling; it meant to deliver its "truths" like blows. Carlu, Cassandre, Colin, Loupot outdid each other in graphic inventions.

The fashion designers did not remain idle; dressmakers exploited the novelty and modernity which promoted consumption. Dresses grew shorter, hugged the shape of the body; décor and accessories were geometrized; everywhere movement and contrasts prevailed. Advertising and fashion brilliantly proved that aestheticism was compatible with commerce; everything was mixed up together; distinctions were blurred, borderlines erased. The fine arts themselves were caught up in the demands of fashion. Dealers and collectors multiplied; the snobbery of modernity attracted a fashionable public to painting, and a number of artists let themselves be tempted by decorative expression. The School of Paris was once more riding high: Van Dongen, Foujita, Kisling became the minstrels of the modern woman; Erté gave a lead to fashion, and seduction became an article of trade. Consumption reigned supreme; it permitted escape; it renewed pleasure and desire; it flattered and dulled the senses. For many, art went with luxury; creation was confused with novelty.

A great manifestation made it possible for people to take stock of things: the Exhibition of Decorative Arts in Paris confirmed in the public eye the triumph of Art Deco taste. Today it enables us to record what distinguishes the production of decorators from that of creators. The necessity for that exhibition had already been felt in 1906; it had been planned for 1916, for 1921, for 1922. Only in 1925 did it become a reality, with international dimensions. The goal defined in 1915 was twofold: "Let us make haste in the face of the foreign threat, the foreigners are way ahead of us..." Hence the need to restore its place to France, which "for centuries... has imposed its taste on the world; today we only know how to glory in the talent our ancestors possessed." In addition, it was necessary "through the collaboration of the artist, the industrialist, and the artisan, to assemble an international exhibition of all the decorative arts: architecture, the art of wood, stone, metal, ceramics, glass, paper, fabrics, etc. in all their forms, whether applied to useful objects or to works destined for purely sumptuous ends: exterior and interior decoration of public and private buildings, furniture, personal adornment" (in R. Guidot, *Art et Industrie, Tradition et Avant-garde*, catalogue *Paris-Moscou*, Centre Pompidou, Paris 1979).

But the proposal of Francis Jourdain which would have opened to the French public the field of veritable problems of design was rejected. "I had suggested to the governing body the idea of presenting the most usual objects, so-called articles picked up at a bazaar, which, on this occasion, would have owed the beauty of their stark forms to the collaboration of engineers, industrialists, and artists less concerned about décors arbitrarily added on in excess than about the imperatives of necessity, common sense, and reason. My proposal did not seem worthy of any reply" *(ibid.)*.

As it turned out, the 1925 exhibition furnished above all the occasion for displaying luxury products, so-called prestige manufacturing. The functionalists were much annoyed, and denounced that bastard art, a mélange of Art Nouveau and geometrism which flirted with Cubism; they dubbed it "geometrized noodle style." The problem of form-function was eliminated in favour of decorative modes that weakened the boldness of the rhythms and colours of modernity by the refinement of materials and technical skills. The resulting eclectic objects sought to charm by their performance: the Art Deco style was fundamentally opposed to the international style created by the Esprit Nouveau, the Bauhaus, and the Russian artists. Effect was preferred to quality, and inferior imitators were consecrated while the public moved away from the true creators whose demands were always disconcerting, never flattering, and therefore difficult to market. Luxury industry triumphed over art: this mentality was denounced by Le Corbusier in *L'Art décoratif d'aujourd'hui* (1925): "Since we are in crisis today there is no more urgent task than to force ourselves to readapt to our functions, in all fields of endeavour... To seek the human scale, the human function, is to define human needs... Human object-limbs are type objects answering type needs: chairs for sitting, tables for working, a device to give light, machines for writing (yes indeed!), cabinets for filing... Extensions of our limbs, they are adapted to human functions, which are type functions. Type needs, type functions; therefore, type objects, type pieces of furniture."

Because they established false imperatives—consumption leading to desire and pleasure, as well as to the taste for luxury—the laws of commerce made the integration of art into production impossible, with a few exceptions. Above all they challenged that social and educational function to which those creators aspired who were apt to consider the production of objects of daily use as the final end of creativity because they found in it a social justification.

Le Corbusier, for his part, made his position known in a polemical text and by his participation in the 1925 Exhibition of Decorative Arts in putting up the Esprit Nouveau Pavilion. He stressed the social function of art and opposed the riotous spread of decoration so as to bring the object down to the size and needs of man. In *L'Art décoratif d'aujourd'hui* he wrote: "If our minds are different, our skeletons are similar, our muscles are located in the same places and carry out the same functions: dimensions and mechanisms are thus a fixed quantity. The problem is therefore set up for whoever finds an ingenious solution, reliable and inexpensive. Responsive to the harmony that establishes calm, we shall recognize the object which is in harmony with our limbs... Here decorative art leads to the stage completed by the art of the engineer. The engineer's art covers a vast range of human activity. If its branches at one extreme are deployed in pure calculus and mechanical invention, those at the other extreme lead to *Architecture.*"

ngen's studio in the Villa Saïd, Paris, about 1920.

Georges Lepape (1887-1971):
Cover design for Vogue, Paris, 1925.

Phantom I Landaulette, motor-car built by Rolls Royce, 1925-1929.

The 1925 style

Cover of L'Illustration,
special number devoted to the
Exhibition of Decorative Arts, Paris, 1925.

That primacy of the architect's activity was achieved by Le Corbusier in the *Pavillon de L'Esprit Nouveau*, which adopted the title of the periodical which he and Ozenfant edited. It was dominated by the purist aesthetic, which Ozenfant in fact summed up in an article in *Cahiers d'Art* (Nos. 4-5, 1927): "Purism is not an aesthetic but the purification of plastic language... Having become conscious of what he has to say, the artist *imagines* in terms of technical aids: that is the technical phase. To compose well means to find ways of explaining that imagination as forcefully and briefly as possible: it must then be asked whether traffic is possible over the bridge which has been built, whether that construction has universal interest: works of art must answer to that notion of universality like all the works of humanity: that has been too often forgotten. It is good to have reliable methods."

Whereas painting and sculpture abandoned all effort at representation, the whole of architectural output remained dominated by representational aims. The Exhibition of Decorative Arts provided the opportunity to erect showpiece-buildings reestablishing direct relations with the lavish ornamentation of Art Nouveau. These constructions generally were distinguishable from the art of 1900 only in that they opposed the contrast of elementary geometric forms to the sinuous unrolling of the spiral, and that they replaced cast iron with concrete. Architecture would have seemed only a simple "matter of taste" if the realizations of Mallet-Stevens and above all the Esprit Nouveau Pavilion and the Soviet Pavilion had not obviously denied the idea. In that context they even took on the appearance of manifestoes.

Having come to Paris to arrange the Soviet exhibition, Rodchenko reacted in a highly significant way. In his letters from France, later published in the first issue of *Novi Lef* in 1927, he compared with great lucidity the situations in Eastern and Western Europe: "Yesterday, while watching the public in the act of dancing a fox-trot, I said to myself that it would be a good thing at that moment to be in the East and not in the West. But it is necessary to teach the West how to organize work, and to work in the East... Everything Europe has created is usable; it only needs to be washed, cleaned and given an aim." And he also denounced the attachment to folklore which he found everywhere, and especially in Russian emigré circles. The ensemble of artistic production only sharpened his disappointment: "I also visited the Salon des Indépendants. What insignificance and what

dearth of talent. The French are really gasping for breath. Thousands of canvases, and all are paltry and quite simply provincial; I hadn't after all expected that. After Picasso, Braque and Léger there is really nothing, nothing but a vacuum." Rodchenko's reaction to the production of objects was more ambiguous; if he appreciated the technology and creative potential of the Westerners, he also attacked their thirst for consumption: "There are millions of objects here; they make you dizzy: it would be good to be able to buy whole carloads of them and carry them home to our country. So many different things are manufactured here that all those who can't buy all of them look poor. Now I understand the capitalists who never possess enough, since objects are the opium of life. One must be either communist or capitalist. There is no third way" (in G. Karginov, *Rodchenko*, 1977).

The participation of the USSR in the Paris international exposition of 1925 threw light on its achievements in the sector of production. The Soviet Pavilion was designed by Konstantine Melnikov (1890-1974), while Rodchenko was the creator of the Workers' Club. In the pavilion itself or at the exhibition in the Grand Palais, a selection of architectural projects, a collection of ceramics and chinaware, and finally a sample of photographic and film production were on display. The representation of the USSR, carried out with particular care, was one of the first which enabled it to show its development, and was chosen to fulfil a clearly defined programme: "The pavilion must express the idea people are to have of the USSR... it must be original and distinguish itself by its character of present-day European architecture... We must give an idea of our new Soviet way of life: set against the luxury and riches of other countries the freshness and originality of the artistic creation of our revolutionary epoch" (*Documents et Matériaux de l'Architecture soviétique, 1920-1925*, in A. Kopp, *Ville et Révolution*, 1967). And the Commissar went one better in the publications of the catalogue: "The Paris exposition is close to our hearts. It is an exhibition of industrial art. Here is a term which often appeared in the pages of our art reviews after the October Revolution. It was in fact our revolution which put the accent on this idea that art must, before everything, incarnate real life; that it must construct reality and that true beauty consists in the adaptation of the object to its destined purpose."

The architectural feat of Melnikov's pavilion was remarkable; it utilized wood to the limits of the possibilities of the day, and thereby demonstrated the ways opened by the "culture of materials." The pavilion appeared not as a palace but as an application of functional elements; communication, the interrelation of the different sections, the necessities of circulation, justified the great walls of glass and the diagonal staircase—everything that scandalized a large number of commentators: the rigour and the daring of this construction thereby made it a model of its kind and a sort of manifesto of the new architecture which made Russian builders known to Westerners.

The press reactions were lively. If, for some, "Russia breaks up everything and ends only by making its staircase inconvenient, a glass cage in which we glimpse emptiness and disorder" (J. Hiriart, in *Vient de paraître*, special issue on the 1925 Paris exhibition), others, like Albert Gleizes, already seized all its importance. "Architects," he wrote, "had the wonderful surprise of seeing resuscitated by a great architect's skill and authority, something which, hastily put up by carpenters, had never seemed to them anything but a stop-gap determined by makeshift devices." For his part, Melnikov, in an interview he gave to Félix Fénéon for the *Bulletin de la vie artistique* (1925), made his intentions quite clear: "Why give a false air of eternity to a moment destined to be ephemeral? My building does not need to last as long as the Soviets... In short, contrasting colours, simple lines, free circulation of air and light; this pavilion ... bears some resemblance to the country I have just left."

s the construction of the Workers' Club by Rodchen... ...on of Decorative Arts gave this artist the opportunity ... synthesis of the experiments and theories developed by prod...vism within the Vkhutemas group in Moscow. Rodchenko here attained a functionalism very close to that preached by the Bauhaus. In his conception of the library he laid emphasis on the position of the furniture in the room space, on the economical use of materials and on the educational function of the place, going so far as the use of colours which accentuated its character of intellectual stimulation as well as of repose. M.L. Ginsburg, leader of the Constructivists, summarized the new architectural spirit in an article which appeared in *L'Amour de l'Art* (1925): "Our new architecture ... aims its research at a more direct observation of the things of its time; it has its roots in the new economic and social principles of our life. In the first place, it utilizes all the discoveries of contemporary technology, and seeks to obtain by the simplest means, by the most direct and constructivist methods and procedures, the maximum of artistic expression."

▷ *Raoul Dufy (1877-1953): Harvest Scene, blue-on-white design printed on Tournon linen, 1920.*

▽ *Pavilion of the Bon Marché department store at the Exhibition of Decorative Arts, Paris, 1925.*

Le Corbusier, whose Esprit Nouveau Pavilion made an equal impact, was more able than anyone to grasp all the novelty and importance of these achievements, since they joined the root of his own preoccupations. "No more eruptions, no high-pitched personal cases. The fullness of our resources urges us towards the general, towards the appreciation of the clear fact. To individualism, the product of fever, we prefer the banal, the common; the rule rather than the exception. The common, the rule, the common rule appear to us as strategic bases of the advance towards progress and towards the beautiful." (Le Corbusier, *Urbanisme*, 1925). With the *Pavillon de l'Esprit Nouveau*, Le Corbusier sought to present his conception of a modern dwelling. Its construction, he wrote, was: "a veritable epic: no money, no ground, and prohibition by the directorate of the exhibition to carry out the programme which had been drawn up. That programme was: To repudiate decorative art. To affirm that architecture extends from the smallest movable object of use to the house, the street, the city and yet beyond. To show that by selection (series and standardization), industry creates pure objects. To affirm the value of the pure work of art. To show the radical transformations and the new freedoms brought by reinforced cement or steel into the conception of city dwelling. To show that an apartment can be standardized in order

▷ *Alexander Rodchenko (1891-1956): Workers Club,*
Exhibition of Decorative Arts, Paris, 1925.

▽ *Le Corbusier (1887-1965) and Pierre Jeanneret (1896-1967):*
Pavilion of L'Esprit Nouveau, Exhibition of Decorative Arts, Paris, 1925.

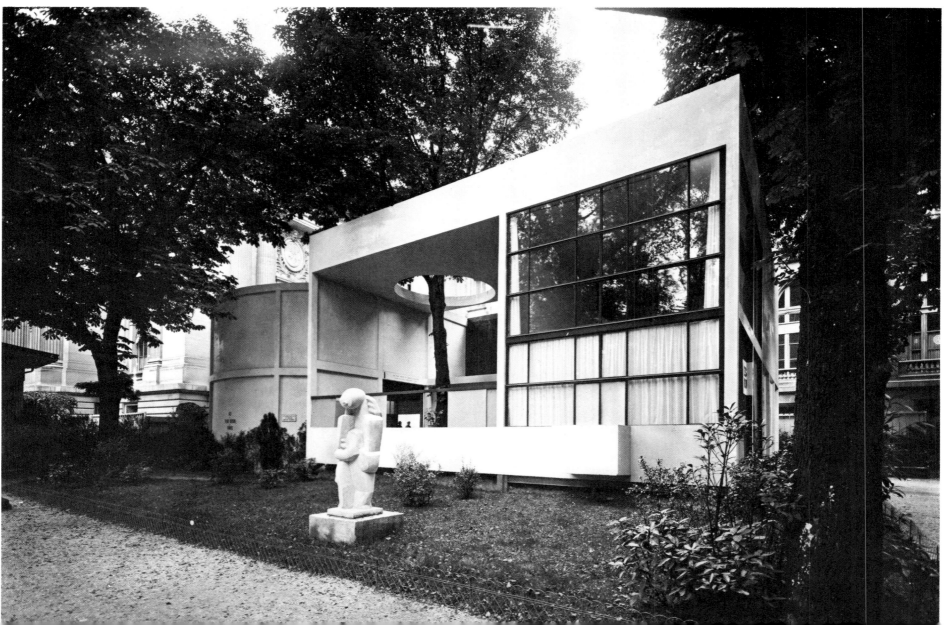

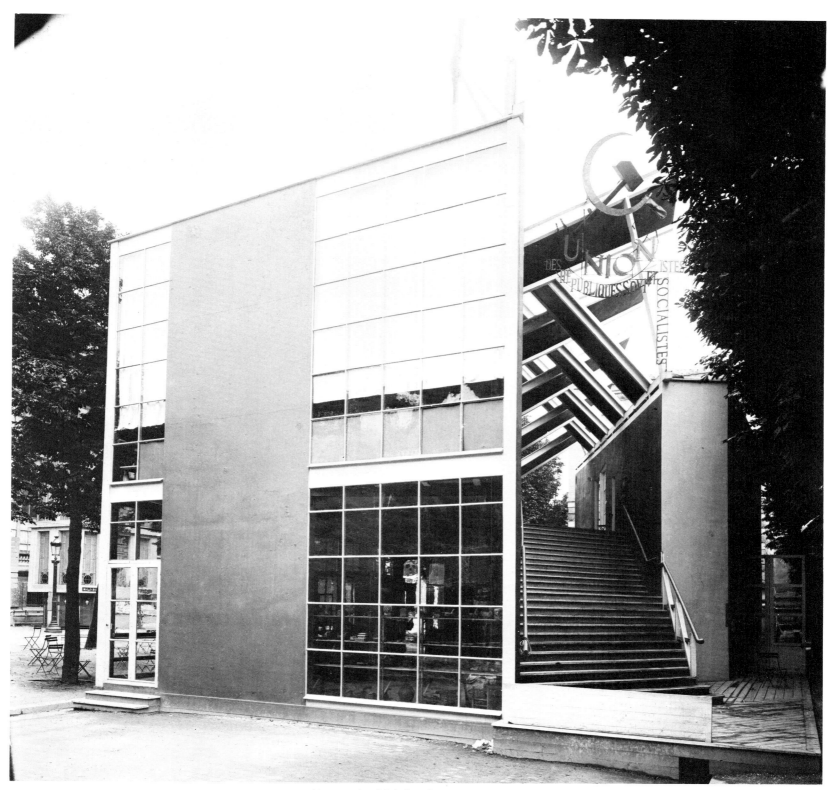

Konstantine Melnikov (1890-1974): Pavilion of the USSR, Exhibition of Decorative Arts, Paris, 1925.

Repudiating "decorative art"

to satisfy the needs of the 'mass' man. The practical, habitable cell, beautiful and comfortable, a veritable machine for living, agglomerates into a huge colony, in height and breadth. *The pavilion will thus be a 'cell' of villa-buildings constructed entirely as if it were 15 metres above ground.* Hanging gardens and apartments" (in Le Corbusier and Pierre Jeanneret, *Œuvre complète, 1910-1929*). Even if the hostility of the organizers went so far as to dissuade the international jury from bestowing the highest awards upon him, this achievement by Le Corbusier was epoch-making, and he was quite aware of it. "A new term has replaced the word *furniture*: that expression embodied accumulated traditions and outdated usages. The new word is the *equipment* of the house. Equipment, by analysis of the problem, means to classify the diverse elements necessary for domestic use. Replacing the

innumerable pieces of furniture decked out with various forms and names, standard *cabinets* are built into the walls or supported on the wall, positioned in each place in the apartment where a specific daily function is performed ... nor are they made of wood, but of metal, in workshops where up until now furniture was built " *(ibid.)*. Le Corbusier succeeded in showing that art is incompatible with decoration; if one leads to consciousness, the other contents itself with distraction.

To be sure, the French artists did not avow themselves beaten by the snares of commerce and fashion; in 1930 they reacted by founding the Union des Artistes Modernes (U.A.M.) which brought the functionalist artists together, and in his inaugural manifesto Louis Chéronnet said: "Modern art is a truly social art, a pure art, accessible to all and not an imitation made for the vanity of a few."

Functional art versus spectacular art

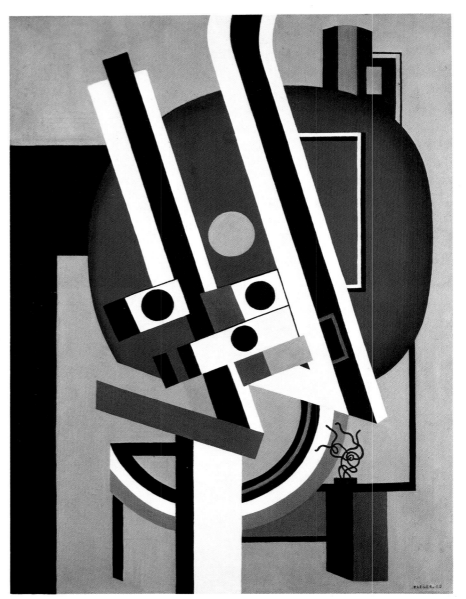

Fernand Léger (1881-1955): Composition, 1925. Oil.

Sonia and Robert Delaunay, as well as Fernand Léger, who had inspired by their creations the grammar of forms and colours which spread through the city, were ill served by their imitators: Art Deco had taken over their stylistic effects without ever managing to recapture their spirit. At the 1925 exhibition they were tolerated, and appeared as if on the fringe. Léger presented ornamental paintings for the project for the French Embassy constructed by Robert Mallet-Stevens and for the Esprit Nouveau Pavilion by Le Corbusier. He was busy with the invention of a monumental art. The white walls of modern architecture called for another kind of painting; in this context Léger created his most abstract compositions. He had understood the importance of geometric form, its "visual and psychological influence. The billboard shatters the landscape, the electric meter on the wall kills the calendar" (*The Aesthetics of the Machine*, 1923). He was also attracted by the pure tone which "implies frankness and sincerity." Referring to his experiences in 1949 Léger said: "Around that time, modern painting was also constantly evolving. It had escaped from the subject, even from the object, and a resurgent abstract period had come into being. Total escape—which achieved the liberation of colour—this was what happened. Before that date, a colour was still linked to a sky, a tree, a familiar object. Now it was free, a blue and a red had value in themselves; you could use them at will" (Fernand Léger, in *Art d'Aujourd'hui*, 1949). The desire to integrate painting into architecture led him to make a distinction in his production between the art object and ornamental art: "The *art object* (painting, sculpture, machine, object), a strict value in itself, the product of concentration and intensity, anti-decorative, the opposite of a wall. Coordination of all possible plastic means, grouping of contrasting elements, multiplication in variety, radiance, light, fine adjustment, intensity-life; the whole locked up inside a frame, isolated, personified. *Ornamental art*, dependent on an architecture, strictly relative value (almost tradition) conforming to the necessities of place, respecting live surfaces and acting only to destroy dead surfaces. (Realization in abstract flat coloured surfaces, with the volumes rendered by architectural and sculptural masses.)" (Florent Fels, *Propos d'artistes*, 1925). In the same statement Léger also revealed his aim: "To distract man from his enormous and often disagreeable effort, envelop him, make him live in a new and dominant plastic order."

The reactions of the public were diverse, often conflicting, but the fact was there: colour had overcome construction. "The fixed, habitable rectangle becomes an elastic rectangle. I say elastic because every applied colour, even as a nuance, possesses a mobile action. Visual distances become relative. The rectangle disappears, attacked in its edges and in its depth. Free colour had found its use. The modern individual thereby finds himself in an entirely renovated vital mechanism. The psychological action is automatically set going. An inner evolution proceeds slowly and unconsciously" (Fernand Léger, in *Art d'Aujourd'hui*, 1949).

In 1924 Léger was already keeping his distance with regard to production by the artisan, whose workmanship he extolled for its quality but whom he refused to consider as an artist. "The artisan is everything? No. I think that above him there are some men, very few, who are capable of raising him in their plastic conception to a height which dominates the foreground of the Beautiful. Such men must be able to consider the work of the artisan and that of nature as a raw material; to order it, to absorb it" (Fernand Léger, in *Bulletin de l'Effort Moderne*, 1924).

Even more than Léger, Sonia and Robert Delaunay gave the modern world its rhythms and colours. The impetus of Robert's earlier, pre-war work subsequently seemed to be slowed by material difficulties. A sociable man, Delaunay needed a public, he needed friends; and his closest friends had fallen in the war. Mallet-Stevens' commission to decorate the hall of the French Embassy at the 1925 Exhibi-

tion of Decorative Arts enabled him to carry out a monumental picture: *City of Paris*, but the Exhibition committee sentenced him to paint a light veil in gouache over the feminine nudities deemed to be offensive! It was only at the Paris World's Fair of 1937 that he found the genuine possibility of employing his creative power in an architectural context. His wife Sonia, on the other hand, set out to apply their previous experiments to fashion and dressmaking. By substituting for traditional ornamentation geometrical designs with dynamic lines and contrasting colours, she created a new art of fabrics; her creations were adopted by the world of fashion design and influenced the décor of life. Thanks to her, the art of the avant-garde, by way of fashion, invaded everyday life and changed the taste of a whole generation. Although Sonia Delaunay thus amply earned a living for two, she soon gave up bringing out her "simultaneous fabrics" in order to be able to paint again. In 1938, in a text he intended to devote to her, Robert showed what their investigations had in common but also emphasized what constituted the essence of Sonia's originality. "Abandoning decorative themes known and reissued for ten years, elements of nature interpreted and distorted with a view to their use in fabric design, she started a wholly new art that was no longer an art of interpretation but one of creation. As much as we find it *old-fashioned* to represent on a dress a Louis XVI hoop or a Chinese landscape, or stylized fruits or wildflowers, so do we find it logical and truly human to start with architectonic and organic elements which are part of the life of today, elements that are simpler and more real, more in touch with modern life" (in *Les Cahiers inédits de Robert Delaunay*, 1957). And he went on: "A dress or a coat, for her, is a portion of space, ordered, conceived, and, through matter and dimensions, forming an organized whole according to laws that become a standardization of her art." In this text Robert further showed all that the new world owed to Sonia's invention: it was she who shaped the silhouette and style of the modern woman, but also she who defined the taste of the modern woman and created her décor.

Sonia Delaunay (1885-1979): Group of Women, 1921. Watercolour and gouache.

Whatever ambiguity there may have been in the attitude of Matisse and Picasso between 1919 and 1924, and in the context of a general return to order, was dispelled during their evolution between 1925 and 1929. Their paintings then became the delight of collectors and connoisseurs, and brought them many honours: publications, international exhibitions, and even official distinctions; but in fact it was rather through a misunderstanding. The criticism of their work had never been so superficial. Monographs that were otherwise very full generally resumed in a few lines this new crucial phase, all the importance and significance of which we can better grasp in the light of the evolution of art today. For what Matisse and Picasso were then bringing into play was the distance between the real and its representation.

During the twenties, and in the context of the prevailing abstraction, to come back to the subject seemed to signify a retreat; only an attentive reading of the artists' statements and a critical analysis of their production shows that such was not at all the case. In coming back to the utilization of the figurative "sign," Matisse and Picasso were re-evaluating the possibilities of the picture; newly questioning the visual, whose translation they deemed indissociable from plastic reality. To paint and to redefine the qualitative norms of painting was also to refuse the impoverishment of style to which the cheap imitators of their previous discoveries—Fauve or Cubist—had condemned themselves. It also meant opposing the decorative effects called for by fashion and prevailing taste but impugned by their humanist conscience. Matisse and Picasso forbade themselves just as much to submit their pictorial investigation to the "political" requirements of communication and function as to bow to Dadaist nihilism, which would have negated what was the direct origin of their vocation as painters. They thrust fiercely aside everything that might limit their new field of investigation: the image as the condition of mimesis.

This new exploration of the visible was anchored in the expression of their individual subjectivity: it enabled them to invent other plastic signs which, in a more complex way than those of the surrealist painters, placed directly in evidence the distance and the relations between the signifier and the signified. To be convinced of that, one has only to observe how often the themes of the window, the mirror, or the "painting within the painting" are repeated and revivified. This doubling of the image directly concretized their interrogation of painting, whose specific nature they perceived in returning simultaneously to the insistent use of drawing and of the third dimension. Now, each time Matisse and Picasso renewed their exploration of space, they came back to the practice of sculpture. In spite of appearances, Matisse was making a total reassessment of his resources, the very ones which guaranteed him international success. Copenhagen, in fact, had devoted a highly important retrospective to him in 1924, and in 1927 he received the Carnegie Prize. The Bernheim-Jeune Gallery in Paris showed his work regularly, and he exhibited in Berlin as well as in London, New York, Pittsburgh, Brussels...

In spite of this fame he stated to Florent Fels in 1929: "Methods do not have the immense importance which is attributed to them, and I do not find myself at all committed by what I have done. Even admitting that there exists some richness in certain pictures of mine, I should not hesitate to leave off painting if my highest expression were to find some other outlet" (F. Fels, *Henri Matisse*, 1929). This attitude brings out the tension that existed between his experience of the real and the means of rendering it.

As a result of his celebrity Matisse gave many interviews, and a reading of them enables us to better define the problems which obsessed him. Thus, in 1925, he stressed in his conversations with Jacques Guenne his awareness of the gap between the real and pictorial representation: "It was with slowness that I came to discover the

secret of my art. It consists in a meditation on nature, in the expression of a dream always inspired by reality. With greater perseverance and regularity I learned to push each study in a certain direction. Little by little the idea asserted itself that painting is a mode of expression and that one may express the same thing in several ways. *Accuracy is not truth...* For my part, each time I find myself in front of my canvas it seems to me that it is the first time I am painting" (in *L'Art Vivant*, 1925).

Despite this confession, no one seemed to perceive that Matisse was forever starting over. Aware that no answer was final, he embarked each time on a "new adventure," because his previous manner of seeing and of doing things could no longer satisfy him. Going deeper in his understanding of the world, he defined new means of expression meant precisely to enable him to go beyond the visible.

Matisse, the truth of his own emotion

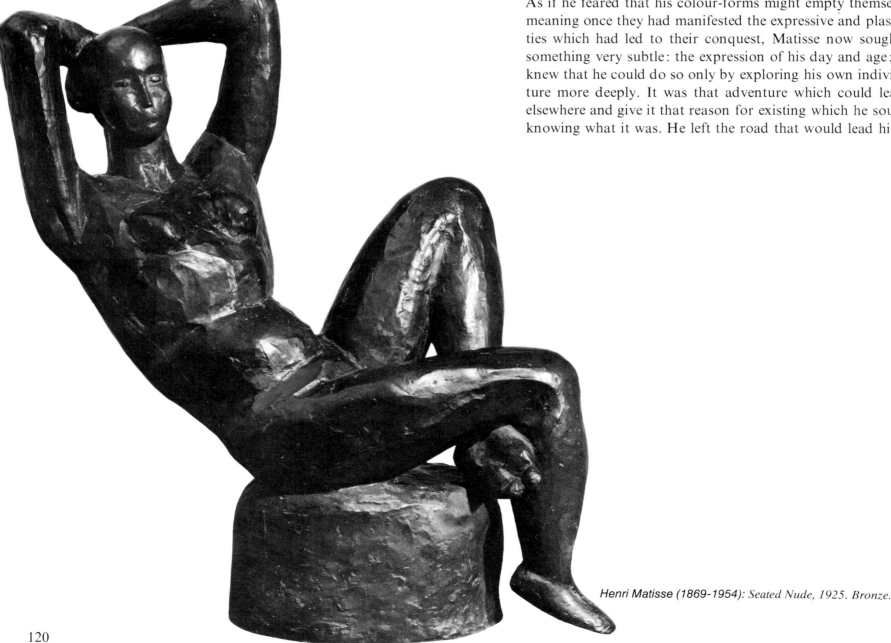

Henri Matisse (1869-1954): Seated Nude, 1925. Bronze.

Hence the importance which he placed on the study: "Yes, I copy nature, and I even try to put the passing hours into my pictures. This one was painted in the morning, that one at the end of the afternoon: one with a model and the other without a model" *(ibid.)*. The presence or absence of a model disclosed his new relation to painting, about which he would theorize only later on, in 1935: "I decided then to discard verisimilitude. It did not interest me to copy an object. Why should I paint the outside of an apple, however exactly? What possible interest could there be in copying an object which nature provides in unlimited quantities and which one can always conceive more beautiful? What is significant is the relation of the object to the artist, to his personality, and his power to arrange his sensations and emotions... Today, it seems to me that we live in a period of fermentation, which promises to produce important and durable works. But, if I am not mistaken, only plastic form has a true value, and I have always believed that a large part of the beauty of a picture arises from the struggle which an artist wages with his limited medium" (in *The Studio*, 1935).

Matisse thus said clearly that his purpose was guided by the necessity of seeing and saying differently, of going beyond the norms of the known and of the already stated; in short, of going further in the expression of painting and of the real. In a talk recorded in 1936 by Tériade, in the ninth issue of *Minotaure*, he explained his views on the question: "When the methods have become so refined, so thinned out, that their power of expression grows exhausted, one must come back to the essential principles that human language has shaped. They are the principles which then 'come to the surface,' which come back to life, which give us life..., the courage to rediscover purity of means." As if he feared that his colour-forms might empty themselves of their meaning once they had manifested the expressive and plastic possibilities which had led to their conquest, Matisse now sought to render something very subtle: the expression of his day and age; but he also knew that he could do so only by exploring his own individual adventure more deeply. It was that adventure which could lead his work elsewhere and give it that reason for existing which he sought without knowing what it was. He left the road that would lead him to known

Henri Matisse (1869-1954): Odalisque in Red, c. 1921. Oil.

results. "Our senses have a developmental age that does not spring from their immediate surroundings but from a moment of civilization. We are born with the sensibility of an epoch of civilization... The arts possess a development that does not come from the individual alone, but also from a whole acquired force: the civilization that precedes us... We are not masters of what we produce. It is forced upon us" *(ibid.)*. The consciousness of belonging to a given age made him more demanding with regard to his intuition: "The reaction of one stage of development is as important as the subject. For that reaction comes from me and not from the subject. It is from my interpretation that I react continuously until my work is in agreement with me. Like someone who shapes his sentence, works over it again, rediscovers it. At each stage I have an equilibrium, a conclusion. At the next sitting, if I find a weakness in the whole of my work, I reintroduce myself into my picture through that weakness. I re-enter by the breach and re-imagine everything... At the last stage the painter finds himself liberated, and his emotion exists entirely in his work. He himself, in any case, is unburdened of it" *(ibid.)*.

Such a quest for wholeness bespeaks his rejection of any simplifying intervention. If he renewed his consciousness of the real, he rejected, like Cézanne, any dissociation between perception and the means of expressing it. Translating the third dimension again became a major problem: how to convey depth on a flat surface, synthesize real space, perceptible and in plane projection? How to conceptualize an instant so as to give it duration, if not by starting from the truth of one's own emotion and keeping watch over the quality of its plastic solution? When shadow invades the face, Matisse negates it by the colour of the background; when the line becomes too synthetic he contrasts it by values. Nothing can exist outside a global relation. Drawing gives a new impetus to painting; the spreading of paint on a surface demands an exploration in sculpture. The subject stays the same, but each time the means undergo new experiments subject to a requirement that rejects any aestheticizing solution. "I paint Odalisques in order to do nudes. But how can I do a nude without its being artificial?" (Tériade, *Visite à Henri Matisse*, in *L'Intransigeant*, 1929). There is the sole question. It simultaneously implicates the man and the work. The answer cannot be conceived theoretically; it is arrived at by experiment. "The painter discharges his emotion by painting, but not without seeing his conception go through a certain analytical phase. The analysis takes place in the painter. When synthesis is immediate it is schematic, without density; and the expression becomes poorer" *(ibid.)*. The plastic sign is no longer given; it is conquered; Matisse was now seeking concentration and stability before taking a new leap.

Georges Rouault
(1871-1958):
*The Dance
of Death, 1926.
Lithograph for
Baudelaire's*
Les Fleurs du Mal.

The changing face of realism

In a vehement outburst in 1925 George Grosz denounced an existing situation whereby the interests of certain artists coincided with those of the bourgeoisie, diverting art from its proper ends and distracting modern man from his reality. "Art today is dependent on the middle class and will die along with it. Without wishing it, perhaps, the artist is just a factory turning out banknotes and shares used by the rich exploiter and snobbish aesthete to invest his money in a more or less lucrative way and appear before society as the protector of a culture which resembles him. There are many for whom art is also a kind of flight far from this world of the 'rabble' towards a better planet, the moon of their imagination, a pure paradise with neither political parties nor civil war" (George Grosz, *Die Kunst ist in Gefahr*, 1925).

This attack was certainly not without foundation: the economic recovery fostered the development of the art business; galleries, exhibitions and publications multiplied and artificially democratized artistic creation. Speculation and publicity occupied a dominant position in this exposure, where the "sensibility" of painters became a marketable product. History shows that many adapted themselves to the exigencies of this demand, at the risk of destroying themselves, as has been proved with the passage of time. Painting then often became a diverting and decorative product, holding the spectator's interest less by what it signified than by the sentimentality of the anecdote for which it provided a setting.

The success of the Douanier Rousseau made naive art fashionable; in his wake Louis Vivin, Séraphine Louis, André Bauchant, Camille Bombois and many other naives charmed the public.

In a parallel but deeper register there developed a neo-realist movement oriented towards the return to tradition and to the earth. Dunoyer de Segonzac, Dufresne, La Patellière, Gromaire, Waroquier and Vlaminck, with their widely differing temperaments, were its important French representatives. They were opposed to Cubism, which they considered an ill-fated experiment imported from abroad, and to

abstraction. Segonzac is speaking: "I said one day to a Cubist: if you replaced your discs by elements of feeling and of life, you would have greater force and intensity," and again: "This school, artificial and of foreign origin, has tried in vain to make people believe that it was carrying on the movement inspired by Cézanne. At the cost of clever publicity it was able to throw people off the track only in those countries without a deep and genuine pictorial tradition. Like all schools created on the outside of life, it was fated to rapidly wear itself out" (quoted in Bernard Dorival, *Les Etapes de la Peinture française contemporaine*, vol. III, 1943). Instead of the new vision and construction the neo-realists preferred binding themselves to craftsmanship, to a sense of decorum, to the legacies of tradition. It was during the period when the School of Paris, the foreign artists of Montparnasse, were sharing among themselves the posthumous glory of Modigliani by devising the triumph of a new mannerism: Van Dongen, Foujita, Pascin, Kisling delighted in depictions of the modern woman. Chaim Soutine (1893-1943) alone remained consumed by a passion which no pleasure could cloy. Haunted by his subjectivity he projected onto his canvas visions romantic, to be sure, but with a truth of sensation so violent it convulsed the images and order of painting. "Rent to the innermost depths of his being by the drama around him, which he expresses in bloodstained harmonies, sticky with tissue fluids, tossing in a mass of bruises," wrote Elie Faure, in the first biography of Soutine (1929). Soutine projected his pain and his tragedy on all things, especially the most abject, as if he "had feared to come out of himself in activity and joy, as if he had wanted to solicit the meanest objects to approve his despair" *(ibid.)*.

George Grosz (1893-1959): *The Butcher, 1928. Watercolour.*

Chaim Soutine (1893-1943): Flayed Ox, 1926. Oil.

We might find another sign of this crisis in figurative painting in the work of Rouault and Chagall. Both artists slackened their production considerably in order to devote themselves essentially to engraving; an art of communication, a more intimate space for expression which, by virtue of its multiplication and its format, lacked just that final object of decorating drawing-rooms. As Chagall was once more settling in Paris, during the summer of 1923, he received from Vollard the commission to illustrate Gogol's *Dead Souls*. The 1920s were among the happiest moments of his career. "After the turmoil of the Russian Revolution, Paris seemed to him like an earthly paradise, with her atmosphere, her serenity, her cultured refinements, her tradition of courtesy, her light, her colours. Hitherto he had gone through life like a leaf in a storm; now, in Paris, he realized that his love for Bella had given new meaning to his life, new inspiration to his art" (Lionello Venturi, *Chagall*, 1956). By this translation of his subjectivity into images he felt close to the Surrealists, who, however, criticized the mystical tonality of this inspiration. Not until 1941 did

Breton, in *Genèse et perspective artistiques du surréalisme*, grant Chagall his full esteem: "There has been nothing more resolutely magical than these works, whose wonderful prismatic colours bear away and transfigure modern tormentedness, while yet keeping the old simplicity in the expression of what proclaims the pleasure principle in nature: flowers and the manifestations of love." Still more than his painting, his illustrations to Gogol had a subjective dimension, reaching deep into his memories and the folklore of his childhood.

The technique of engraving was also one of the avenues by which Rouault expressed his moral and religious thought. The drawings and etchings which illustrated his masterly work *Miserere*, also commissioned by Vollard, represented for him the field of activity in which he freed himself from the weight of the war and its social ills; it was there he was able to give suffering a human and spiritual meaning. If he strove after quality of craftsmanship, he did not want to be deceived by the parade of fashion, nor to let himself be diverted by the demand for touching images. There he gave meaning to life. In a prefatory letter to the monograph devoted to him by Georges Charensol (*Georges Rouault, l'homme et l'œuvre*, 1926), the painter wrote: "Do not speak of me except to exalt art; do not present me as the raging firebrand of revolt and negation; what I have done is nothing, do not give me so much importance. A cry in the night. A ineffectual sob. A strangled laugh. In the world, every day thousands upon thousands of the needy who are better than I am, die at their task. I am the silent friend of those who toil in the deep-worn groove, I am the ivy of eternal wretchedness that clings to the leprous wall behind which rebellious humanity hides its vices and its virtues."

Marc Chagall (1887): Sobakevich, etching for Gogol's Dead Souls, *1924-1925.*

Christian Schad (1894): Self-Portrait with Model, 1927. Oil.

ambiguity, because the French public appreciated him for his criticism of Germany. However, Pierre Mac Orlan, in his preface to Grosz's Paris exhibition, wrote: "Grosz has found the language necessary for the flowering of his vision. By cutting out a photograph and bringing to it his extraordinary understanding of the fantastic and of homicidal squalor, he struggles to reach his goal directly. He sees things and men in transparency; he blends the noble elements of revolution with the basic odours of the life of the people, in which blood is heated to street temperature... Only a man possessing great purity of thought may, at certain moments, conceive this exasperation of passions and attitudes. Grosz is the great poet of life in revolt."

Grosz was much less satisfied by what he saw in Paris: "In reality, French cultural production is financed, as in our country, by the needs and interests of the bourgeoisie. The Parisian artists are as little aware of that as their German colleagues. They lead a studio existence, bricked in with all kinds of formal problems, but they no longer can or wish to exert any fundamental influence on events" (*Pariser Eindrücke*, in *Europa Almanach*, 1925).

The previous year, in 1923, summoned before the court for the circulation of obscene images, Grosz had shown how strongly he felt the obligation to reform moral standards: "In my view, even by, and precisely thanks to, the representation of the ugliest things in this work, which can be said to shock a certain number of people, a great educational labour is achieved." A new movement was then to assert itself in Germany: the New Objectivity (Neue Sachlichkeit), characterizing the work of those bent on rendering everyday reality, often without dogmatic bias. In 1925 the critic Hartlaub organized an exhibition at the Kunsthalle in Mannheim: *The New Objectivity, German Painting Since Expressionism*, and it was to this show that the new movement owed its echo among the population and its recognition by the critics. Among the most well-known exhibiting painters were Beckmann, Dix, Grosz, Scholz and Schad. In the catalogue preface Hartlaub drew a distinction between the artists of the right wing, to whom he more specifically applied the concept of "new objectivity," and those of the left, whom he called "verists." "What we are show-

The New Objectivity

If Rouault, as a Christian, acknowledged the vices of humanity, the German painters savagely exposed them. In Berlin, realism took on another dimension, artistic and theoretical. The Dadaists had now settled their score with romantic and expressionistic sentimentalism; photomontage had given them a technique which led back to the real in a critical context. More marked than the French by the disasters of the war and its aftermath, the German artists had a deep consciousness of their social responsibility, which led them to political commitment. The fact is proved by Grosz's statements in the article quoted above: "Expressionistic anarchism must come to an end. Today, owing to the force of circumstances, painters delight in it, for they don't see what is happening; they have no contact with working people. A time will come when the artist will no longer be that bohemian and bombastic anarchist but a healthy man working in clarity, in collectivist society. As long as that collectivist goal has not been reached by the working masses, the intellectual will be tossed between unbelief and cynicism. It is only after the victory of the working class that art will leave the narrow bed where it lies today becoming anaemic, quartered within the life of two hundred families... Then and only then will the monopoly of capital over spiritual things come to an end" (George Grosz, *Die Kunst ist in Gefahr*, 1925).

George Grosz exhibited in 1924 in Paris, where he had already acquired a certain reputation, but in fact his reception rested on an

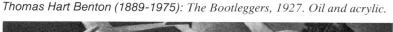
Thomas Hart Benton (1889-1975): The Bootleggers, 1927. Oil and acrylic.

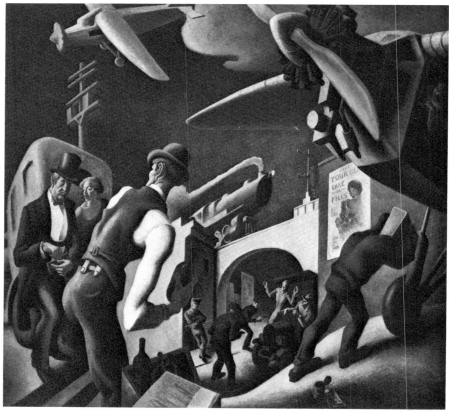

ing bears the mark, in itself purely external, of the objectivity by means of which artists express themselves. Two groups here express themselves without constraint. One—it might almost be called a 'left' wing—digs out what is objective in the world of existing facts, and projects the experienced event with its own rhythm and degree of warmth. The other is directed more towards the search for the object in its timeless value; in order to give artistic reality to the eternal laws of existence. If the artists of the first group have been called 'verists,' the others might almost be called classicists... What we are showing is simply that art still exists and that once again it is tending towards the original; that it is struggling for its right to what is new, to what is original; that it is alive, despite a cultural situation that seems hostile to art as rarely any century has been." Grosz would go still further

dreams too pretentious by far and brought it back into the world, but it has killed the truth that was in this world, and has literally become the painting of whitewashed tombs."

In the United States realism scored a similar success, but without the critical dimension accorded it by the Germans. The regionalists and genre painters argued from modern life more than they genuinely explored it. Strongly influenced by photography, they often took their subjects from it; for many it was a matter of rehashing the recipes of academicism seasoned according to the taste of the day, with that moralistic flavour characteristic of the prohibition era.

The populism of Thomas Hart Benton (1889-1975) was more political; nationalistic and isolationist, this Missouri painter had a reactionary attitude in his aesthetics and in his subject matter. He

Otto Dix (1891-1969): The Big City, 1927-1928. Triptych, mixed media.

when he wrote in 1925: "The verist holds a mirror in front of his contemporary to let him see his mug. I drew and painted in order to contradict, and I sought by my labours to convince the world that it is ugly, sick, and a liar."

In his *Big City* triptych of 1927-1928, Otto Dix showed "the imagining of the big city as the symbol of an anti-paradise which with sparkling colours allows an illusion of earthly felicity to shimmer on the surface, while behind its facade dwell emptiness, squalor and disappointment" (Eberhard Roters, in the catalogue *Paris/Berlin*, Centre Georges Pompidou, Paris 1977). Here Otto Dix made a synthesis of his work during the twenties at the same time as he paid his debt to the tradition of German painting by going back to the form of the religious triptych. In the central panel he exposed middle-class pleasures, against which he set, on the left, the excluded, and on the right, the victims.

The New Objectivity provided an alibi for many provincial artists, and was not long in being attacked when its extravagances became fashionable, a state of affairs denounced by Ernst Bloch in 1937: "It is true that the New Objectivity has sometimes torn art away from

wished to safeguard his country against foreign assaults and against contemporary amorality; his antimodernism was determined and his naivety was a disguise. He had charm for many of his fellow citizens attached to the past and to the traditions of the heroic era of conquest. "The fact that our painting could be talked about in the language of the people, whether or not it resembled it, was for us the proof that we had succeeded in removing our art from the hothouse atmosphere created by an imported aesthetic that had no meaning for our country."

The name of this artist emerges from among a host of painters who have remained anonymous. In the United States, as in France, art was menaced from within by a reactionary spirit which rejected the discovery of other horizons but which, without meaning to, would enable succeeding generations to look with different eyes on the past of their own region. By affirming that the art of the regionalist "symbolized from an aesthetic point of view what concerned the majority of Americans, that is, America itself," Benton paved the way, for example, for that unforgettable look which the American photographers of the thirties were to take at their country.

Pablo Picasso (1881-1973): Guitar, 1926. Dishcloth, newspaper, string, pencil and ink.

Picasso and Surrealism

With his *Three Dancers* Picasso made a new break in his development. Like the *Demoiselles d'Avignon*, this large figure composition marked a turning point, opening a yet unexplored domain to the artist: that of space, colour and movement.

Between 1907 and 1914 Picasso had been essentially engaged in the pursuit of optical equivalents. Now on the contrary he wished to consider the pictorial locus as the site of an activity yielding a meaning; as the field of inquiries instigated by representation. By surrendering its control, the Ego subject transformed the conditions of expression: language was no longer that which made translation possible, but an experience in which the unconscious forced its way into meaning. Metaphor replaced metonymy. It is interesting to note the coincidence between this affirmation of the ego by Picasso and the first evidences of surrealism. Going beyond the traditional relation between subject and object, Picasso began a hunt for truth which enabled him to understand how he was personally and totally implicated in the production of signs. The *Three Dancers* and the *Guitar* are the two poles defining the field of this new exploration of the individual unconscious. From the biographical standpoint, this quest is situated around the time when the bonds of love were breaking between Picasso and his wife Olga, and at the moment when the passing of his friend Ramon Pichot (to whom he dedicated the *Three Dancers*) brought a reminder of death into his consciousness.

Travelling to Monte Carlo, where Diaghilev's Ballets Russes were giving a series of performances in 1925, Picasso and Olga were forced to recognize a new failure in their attempt at reconciliation. It was as if love had turned to hatred. In the *Three Dancers*, Picasso vented his inward violence: stability gave way to convulsion, balance to movement, harmony to harshness. Movement invades the painting; forms shift and break up as they recede in depth, dislocated in their momentum; symmetry is shattered by diagonal tension; the intensity and coldness of the coloured flat tints cause the surface of the painting to fly into fragments. The classical order, illusion and harmony that previously charmed the painter are turned to ridicule, the better to expose their falsehood in a cry that bursts from within and opens new horizons. Bluntly, Picasso turned again to the researches and problems of the avant-garde, just when the Surrealists had need of his example.

Picasso knew André Breton—he had done a drypoint portrait of him in 1923—but it needed Breton's manifesto *Le Surréalisme et la Peinture*, published in July 1925 in the periodical *La Révolution Surréaliste* (an issue illustrated with five paintings by Picasso), to make clear the role conferred by the poet on the painter; Breton, moreover, awarded Picasso a second certificate of surrealism by inviting him to take part in the first group exhibition of Surrealist painting, at the Galerie Pierre, Paris, in November 1925.

Even if events in the life of Picasso at this time remain in obscurity, the break marked by the *Three Dancers* reverberated throughout the whole of his work, and testifies to a growing anguish released by plastic expression. Now, as it happened, Breton, in *Le Surréalisme et la Peinture*, opened up a new lyrical field, that of the "purely interior model," which Picasso was also just discovering. The convergence was all the more astonishing in that the revolution Picasso achieved working in isolation with his *Three Dancers* had already been perceived by Breton; furthermore, the scarcely finished painting was reproduced in the July 1925 issue of *La Révolution Surréaliste*. In his text, Breton refers to Picasso as a "searchlight" having already explored that road on which "no one before him had dared to see."

Picasso could not help feeling encouraged to go further on the path he had chosen. The *Guitar* which he cunningly put together in 1926 is the most significant work in his transition from Cubism to Surrealism. In this assemblage, made up of a dishcloth, newspaper and string, and which, according to Sir Roland Penrose, he had thought of setting with razor blades "so that people would cut their fingers picking it up," the justification was no longer visual in nature, but proceeded from within. His aggressiveness could not have been more in evidence.

In this laying bare of the inner man, and especially in the forms derived from it, can be seen a new relation to Negro or archaic art. From 1905 to 1914, this influence, in aesthetic terms, was confined to the discovery of non-European forms of expression which fostered liberation from the attachment to the visual, and the affirmation of the autonomy of rhythms and forms. Around 1925, on the contrary, Picasso and the Surrealists were fascinated by the power and magic of exotic signs. It was at the time when Breton was preaching "integral primitivism," which started a cultural revolution by leading back to the primordial inquiry into the nature and meaning of the real.

But when Picasso made a second leap he was able to count on another way of circulating his work, thanks above all to Christian Zervos, one of his staunchest admirers, who started a new review, *Cahiers d'Art*, in Paris in January 1926. Zervos also applied himself to the periodical publication of a descriptive catalogue of Picasso's complete work. Even before bringing out the first volume in 1932 he regularly published in his review illustrated accounts of that artist he so admired. The public thus had at its disposal a scientific equipment and a global knowledge that radically transformed its relation to Picasso's ongoing work. Henceforth it was enabled to appreciate the importance of the work not only by reference to the paintings which it was shown, but far more so by situating the pictures it saw in exhibitions within the general context of artistic production, the memory of which was preserved in book form. Picasso's liberty was thereby strengthened: he felt freer to invent and search in no longer having to resort to proofs of what he had already done; from then on he found himself encouraged in a creative discontinuity justified by his ceaseless striving to develop further.

Quality for Picasso henceforth no longer depended on a plastic effect but on the truth of his desire. Thus he was able to say to Tériade in 1932: "When you look at things closely, all you have is your ego. You have your ego fixed in your belly like a sun with a thousand rays. The rest is nothing."

One cannot help acknow-
ledging Picasso's immense
responsibility. A failure of will
on the part of this one man,
and the matter that concerns
us would at the very least have
hung fire and might never
have been realized at all. His
admirable perseverance is a
precious enough pledge for us
to do without an appeal to
any other authority. What lies
at the end of that anguishing
journey? Will we ever know?

André Breton, *Le Surréalisme et la Peinture*,
1928

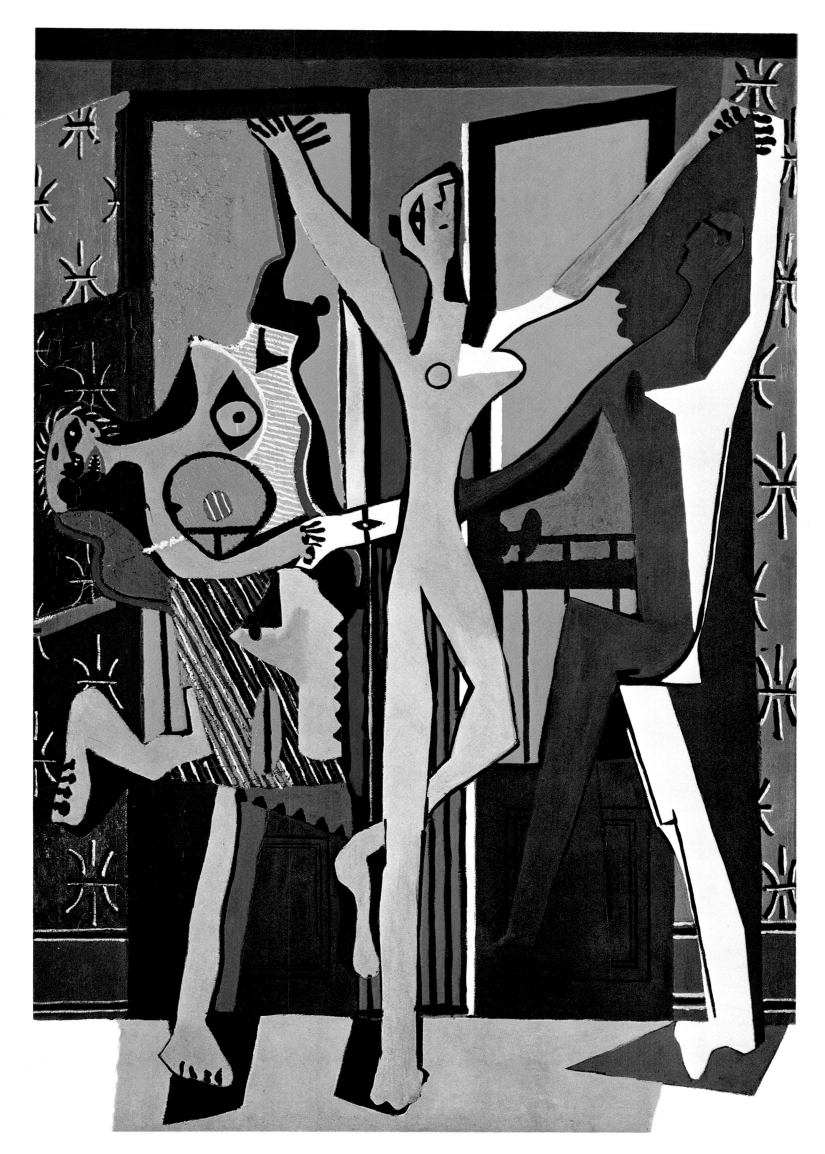

Pablo Picasso (1881-1973):
The Three Dancers, 1925. Oil.

Left to right: Giorgio de Chirico (1888-1978): The Ghost, 1918. Oil. ● Hans Arp (1887-1966): Figurine, 1915. Wood relief. ● Cover of the catalogue of the first group exhibition of Surrealist painting, Galerie Pierre, Paris, November 1925. ● André Masson (1896): Armour, 1925. Pen and ink. ● Giorgio de Chirico (1888-1978): I'll Be There... The Glass Dog, 1914. Oil. ● Joan Miró (1893): The Harlequin's Carnival, 1924-1925. Oil.

Surrealism and painting

In his *Surrealist Manifesto* of 1924, André Breton had not (or almost had not) referred to painting. The question as to whether there was such a thing as a surrealist art was not long in being asked. At the end of 1924 it cropped up in the first issue of *La Révolution Surréaliste*, which, notwithstanding, included illustrations by Chirico, Max Ernst and, above all, automatic drawings by André Masson. Max Morise insinuated in his article *Les Yeux enchantés* that Surrealism and painting were incompatible: "It is more than likely that the sequence of images, the flight of ideas, are a fundamental condition of any surrealist manifestation. The flow of thought cannot be considered from a static point of view. Now if it is in the time dimension that we examine a written text, a painting and a sculpture are perceived only in space, and their different areas appear simultaneously. It does not seem that any painter has yet been able to give an account of a series of images..." Morise went on: "The fact remains nonetheless that to paint a canvas you must begin at one corner, continue somewhere else, then elsewhere again, a procedure that leaves much room for the arbitrary, for taste, and tends to lead astray what has been dictated by thought." A bit further on, Morise admits to a discriminatory conception of nominalism: "In that kind of waking dream which characterizes the surrealist state of mind, our thought is revealed to us under the appearances, among others, of words, of plastic images. A word is soon written, and it is not far from the idea of a star to the word 'star,' to the symbolic sign attributed to it by the writing: STAR. I am thinking of Picasso's stage set for *Mercure* which represented night; not a star in the sky; only the written word flashed there several times." Picasso had thus gone a long way in bringing the relation signifier-signified to a crisis, and in the context of pictorial practice by annexing even the image of the word. But Morise, who had not perceived it, went on to show still greater blindness towards the expressiveness of the line and the drive of gesture, whereas a drawing by Masson on the following page proved the opposite: "The properly pictorial expression is not so favoured if we allow that whereas vocabulary is an instrument combining the advantages of being almost unlimited and constantly available—the word becoming one, so to speak, with the thought—,the marks of the brush on the canvas, on the contrary, translate intellectual images only in a mediate way, and do not carry their representa-

tion within themselves" *(ibid.)*. By confessing to a consciousness of images as merely illustrative, Morise betrayed his incapacity to understand the art of his time (which proved precisely the opposite of what he said) and above all to accept that surrealist version of plastic art, of which Masson and Miró had already many examples.

In issue No. 3 of April 1925 of *La Révolution Surréaliste*, Pierre Naville, co-editor of the review together with Benjamin Péret, went further in the column *Beaux-Arts*: "The only taste I know is distaste. Masters, master blackmailers, daub your canvases. There is no longer anyone who is unaware that there is no such thing as *surrealist painting*. Neither the strokes of the pencil governed by chance movements, nor the image retracing the figures of a dream, nor imaginative fantasies can qualify as such; that is well understood. But there are *sights seen*. Memory and the pleasure of the eyes: therein lies the whole of aesthetics." But in his inability to perceive painting except as image he had overstepped the mark, and the answer was not long in coming: the following issue (No. 4, 15 July 1925) opened with an article by Breton, who by a veritable takeover had assumed the editorship of the review (which now for the first time featured illustrations by Miró). Breton showed clearly that he meant to put his house in order: "Undoubtedly it was a little hasty to decree that spontaneity should be given every licence, or that one should let oneself be carried along by events, or that the world could only be intimidated by making harsh demands upon it. Each of these conceptions, prevailing in turn, has had the effect of robbing us of the original merits of the surrealist *cause* and of inspiring in us a regrettable detachment from it... Even if the breadth of the surrealist movement were to suffer, I feel it is indispensable to open the columns of this review only to men who are not in search of a literary alibi." And he returned directly to the argument of Morise by concluding: "In the sky one star more or less doesn't matter" (André Breton, *Pourquoi je prends la direction de la Révolution surréaliste*).

In the same issue he replied precisely to the question of the existence of surrealist painting by publishing the first part of his essay *Le Surréalisme et la Peinture*, which he continued in issues 6 and 7 of 1926 and 9-10 of 1927. This text was unexpected. Breton did not reply to the arguments of Morise and Naville by a theory of surrealist art; in that case he would have entitled his article "Surrealist Paint-

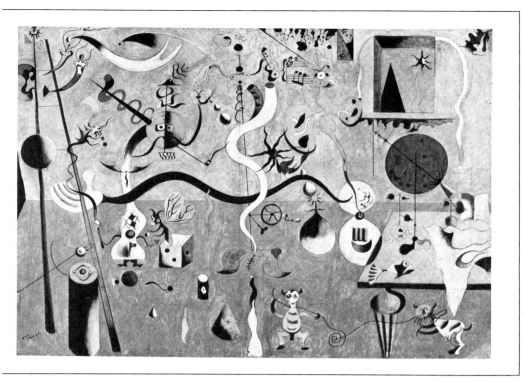

Thus, contrary to all expectations, surrealist art appeared on the scene, disconcerted the critics by bringing elements into play which baffled the laws of form and aesthetics, and took by surprise the poets who in fact had expected only images. That at least is what Breton admitted in the first part of *Le Surréalisme et la Peinture* (published in *La Révolution Surréaliste*, No. 4): "So it is that I cannot consider a painting otherwise than as a window, about which my first concern is to find out on what *it opens*, in other words, whether, from where I am standing, the 'view is beautiful,' and I love nothing so much as what stretches away before me *as far as the eye can reach.* I enjoy, within a frame, a sight beyond all measure. What am I doing there, why am I staring so long at that person, to what lasting temptation am I exposed? But it seems that it is a man who is making me this offer! I do not refuse to follow him where he wishes to lead me. Only afterwards do I decide whether I have done the right thing by taking him for a guide, and whether the adventure into which I have been tempted by him was worthy of me." Breton could give no better proof that his critical motivations were of a personal order and that painting interested him only by its image-forming possibilities; it was lucky for him he had a powerful instinct. He confirmed his attitude, moreover, in referring to the relation between image and language. "The need of determining visual images, whether or not those images have an existence prior to being defined, has found expression at all times, and has resulted in the formation of a veritable language which seems no less artificial to me than the other, and over whose origin it would be fruitless for me to linger. At the most I owe it to myself to consider the present state of that language, in the same way as the present state of poetic language, and to recall that it is necessary to what first called it into existence" *(ibid.)*. And again, when he asserted that the model must be "purely interior" he clearly shows that the objective is not art but an expansion of the real.

Max Ernst (1891-1976): Two Children Are Threatened by a Nightingale, 1924. Oil with wood construction.

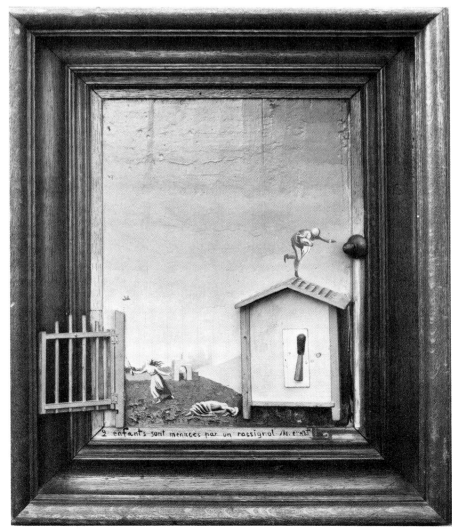

ing." But he made known his almost visceral attachment to art. He gave the basis for it in the conclusion of his essay (when he once more took up the articles from *La Révolution Surréaliste*, after having expanded them), in the 1928 edition of *Le Surréalisme et la Peinture*: "All that I love, all that I think and feel, makes me incline towards a particular philosophy of immanence by which the surreal is contained in reality itself, and is neither above or outside it. And vice versa, for the container would also be the contained. It is a way of saying how much I reject with all my strength those attempts which, in painting as in writing, may strictly result in the removal of thought from life, as well as in placing life under the aegis of thought."

If in this text Breton no longer refers to painting as a "lamentable expedient," no more does he make of it an end in itself; painting represents one means among others of expressing a pre-existent super-reality. Besides, he is more interested in artists than in art: hence his plan to open a surrealist gallery. Issue No. 6 of *La Révolution Surréaliste*, of 1 March 1926, announced the opening for 10 March at 16, Rue Jacques-Callot, in the 6th arrondissement of Paris. But, very curiously, no reference is to be found there to two art shows of 1925 in which the surrealist poets also took an active part: the exhibition of sixteen paintings and fifteen drawings by Miró (from 12 to 27 June), and that of surrealist painting (from 14 to 25 November), the title of which, as it happened, reversed the terms of the title Breton had given his essay. Both shows were held in the Pierre Gallery, 13, Rue Bonaparte; the second, which opened on 13 November at midnight, attracted a large crowd. In addition to Man Ray, Masson, Miró, Ernst, paintings were shown by Arp, Roy, and also Chirico, Paul Klee and Picasso. Even criticism that was generally receptive to the avant-garde failed to grasp all the importance of the event, and Maurice Raynal, for example, wrote: "In any case, the fact remains that surrealist painting cannot go very far because it is conceived outside any concern for style, composition, architecture and modelling. Pleasant knick-knacks, the fashions of a day, already tainted with an unbearable intellectual and graphic jargon, surrealist painting makes one thing of embossed leather and copperware, of the miniature photograph, of the wood-carving, of point-lace and in general of all the works of amateurs and young ladies." The catalogue was prefaced by a poem by Breton and Desnos based on the titles of the paintings.

JOAN MIRÓ

Sun of prey prisoner of my head
Remove the hill, remove the forest.
The sky is bluer than ever.
The dragon-flies of the grapes
give it precise forms
that I sweep away with a gesture.

Clouds of the first day,
Unfeeling clouds sanctioned by nothing,
Their seeds burn
In the straw fires of my gaze.

In the end, to clothe oneself with a dawn
The sky will have to be as pure as the night.

Paul Eluard, *Voir*, 1948

Joan Miró (1893): *Figures, 1925. Oil.*

Still more peremptorily, Breton acknowledged that he was a critic of "moods" when he wrote in *La Révolution Surréaliste* of 1927 (No. 9-10): "I only listen, of course, to that inner voice of mine which backs certain men's names only to stifle others more effectively: the same voice that tells me that this is safe and that is dangerous, which causes me to find a justification not in this rather than that, but in the very opposition of this and that." It was starting with this issue, moreover, that he spoke of Max Ernst and André Masson, and it was in the book which expanded his thoughts that he spoke of Miró and other artists.

It is illusory to try to define "surrealist painting" when Breton, independently of any critical system, set himself up as the sole authority issuing the patent of surreality. His changes of mood deeply affected the history of Surrealism and of painting: admissions and exclusions were multiplied without its being possible to pin down artistic reasons for them. Breton paid more attention to the subject and to the creator's attitude than to the finished work; his first text appeared as a

rehabilitation of the fantastic and the imaginary, whereas the surrealist painters and sculptors were to fulfil themselves, if not by opposing him, at least unbeknownst to him. That was the case with Masson, Miró and Ernst, who, without its being recognized, invented the techniques making possible a genuine surrealist art, that is to say, giving access to "integral primitivism." If Max Ernst, by his use of collage, had already found the means to summon up the "dream image," Miró and Masson revealed the possibilities and results of pictorial automatism, otherwise known as automatic writing, "the instrument of self-discovery."

Contrary to Cubism, Surrealism had no style, it represented rather a state of mind. In its first phase, lasting from 1924 to 1928, literary men had all the more difficulty in speaking of the work of the painters in that they understood it little or badly. They expected an iconography of the imaginary, while the painters were perfecting an abstract technique of automatism in which the symbolic referent was marginal if not non-existent.

After *Harlequin's Carnival*, exhibited at the 1925 group show at the Galerie Pierre, which summarized his latest experiments (they would reappear in the works he completed at Montroig the following summers), Miró concentrated during the winter in Paris on a much more abstract and spontaneous expression, which freed him from the architectural rigour of Cubism. In what might at first be taken for the enlargement of a detail of previous paintings, he laid bare the work of painting itself: the glide of the brush, the running of the colours, the texture of the pigments, the play of gesture or of sign becoming pictograms of previously unknown biomorphic forms charged with that eroticism which the surrealist writers had made available as a subject. Miró worked freely, directly on the canvas, abandoning himself to the immediate expression of the impulses of his being. His painting became the scene of an instant projection, the field for the metamorphosis of the self into painting.

By working in this way, Miró reversed the traditional practice of painting which started from drawing, from an image around which the rest of the work was organized. Miró, on the contrary, started from the void and gave it shape until, little by little, he took possession of it. Michel Leiris stresses the point by referring, when speaking of him, to the experience of the Tibetan monks: "Today it seems indeed that before writing, painting, sculpting or composing anything whatever of value, one must get used to an exercise analogous to that practised by certain Tibetan ascetics with the object of acquiring... the understanding of emptiness. That technique is roughly as follows: one looks at a garden, for example, and one examines all its details (studying each of them in its most infinitesimal particulars), until one has a memory of sufficient precision and intensity to continue seeing it with the same distinctness even with closed eyes. Once the perfect possession of this image has been acquired, one subjects it to a strange treatment. It consists in removing one by one all the elements composing the garden, without allowing the image to lose any of its force [... until] ultimate absence enables the mind really to see and contemplate the void." Then one reconstructs and removes, at a faster and faster pace, until one has "acquired the complete understanding of the physical void, the first step in the understanding of the true void, that understanding of the moral and metaphysical void which is not, as one might be tempted to think, the negative idea of nothingness, but the positive understanding of that term, at once identical and opposite to nothingness,... the absolute" (in *Documents* No. 5, October 1929).

In the same article, Leiris refers to "those immense canvases which seemed to have been not so much painted as besmirched, confused like wrecked buildings, seductive like discoloured walls on which generations of billstickers, in alliance with centuries of drizzle, have inscribed mysterious poems, long stains with suspicious outlines, doubtful like those alluvial deposits coming from no one knows where, sands washed down by rivers whose courses are ever-changing, subject as they are to the movement of wind and rain."

Alongside this experience of emptiness, Miró did not break off relations with nature. In his sketchbooks he noted his stealthy impressions, chance encounters, hallucinated images induced by hunger or fatigue. "How did I think up my drawings and my ideas for paintings? Well, I'd come home to my Paris studio in Rue Blomet at night, I'd go to bed, and sometimes I hadn't had any supper. I saw things, and I jotted them down in a notebook. I saw shapes in the chinks in the walls, and shapes on the ceiling, mainly on the ceiling..." (Joan Miró, *Catalan Notebooks*, 1977). Carried out at the prompting of the unconscious, bound up with the expression of subjectivity and especially of the libido, this painting released signs of a profound erotic suggestiveness which the artist asserted by a line that grew more confident in proportion as he recognized them. Robert Motherwell has grasped this aspect of the work perfectly: "Miró is filled with sexuality, warm, abandoned, clean-cut, beautiful and above all intense—his pictures breathe eroticism, but with the freedom and grace of the Indian love-manuals. His greatness as a man lies in true sexual liberation and true heterosexuality; he has no guilt, no shame, no fear of sex; nothing sexual is repressed or described circumspectly" (Robert Motherwell, *The Significance of Miró*, in *Art News*, May 1959).

Miró had thus found the technique which enabled him to confess the totality of his being, to bring to the light of day that dim world of desires, doubts, pleasures and giddiness. "Rather than setting out to paint something, I begin painting and as I paint the picture begins to assert itself, or suggest itself under my brush. The form becomes a sign for a woman or a bird as I work. The first stage is free, unconscious" (quoted in James Johnson Sweeney, *Joan Miró: Comment and Interview, Partisan Review*, 1948).

If, until 1927, Masson still remained bound in his painting to cubist construction, in his drawings he had engaged since 1924 in a genuine experiment of automatic writing. He used the pen as a psychic medium; the line spoke by itself in its lyricism before there sprang from its tracery some biomorphic signs, some states of metamorphosis which the painter seized upon in order to accentuate them. Masson let himself be carried away by his gesture, his impulse, by his

André Masson (1896): Fish Drawn on the Sand, 1927. Oil and sand relief.

respiration, and thereby laid the groundwork for American gestural painting, which he would influence directly when the Second World War forced him to emigrate to the United States. Like a seismograph, his hand recorded his impulses, his contradictions. Later, in *Métamorphose de l'Artiste* (1956), he wrote: "First surrealist drawings. All in pen and India ink. They are characterized in their spontaneity by unforeseen associations. It is not a question of incongruous confrontations of objects, nor of collages belonging to the realm of humour, but of apparitions of beings falling a prey from all sides to the horrors of change. Metamorphoses in their pure state, removed from conventional *images* of the fable, the myth, or folklore." This last statement brings out what the surrealist painters discovered under the dictation of the unconscious: the renouncing of stereotyped images, the expressiveness of a line which gets its meaning from the very character of the course it takes, a way of slipping the signifier directly into what is signified. It was only in *Genèse et perspective artistiques du surréalisme*, dated 1941, that Breton acknowledged the relations existing between the automatism of the painter and that of the poets. "André Masson, at the very beginning of his road, encountered *automatism*. By means of it the painter's hand veritably sprouts wings; it is no longer that which traces the forms of objects but indeed that which, taken by its own movement and by that movement alone, describes the unintended figures in which, experience shows, those forms are called forth to be re-embodied. The essential discovery of Surrealism, in effect, is that without preconceived intention, the pen which rushes to write, or the pencil which rushes to draw, *spins* an infinitely precious substance, all of which is perhaps not coin of the realm, but which, at least, appears charged with everything emotional that the poet or painter is then concealing."

Sand pictures and frottage

Masson's painting still resisted the impulses of this freedom—the thickness of paint carried by the brush (and the necessity of reloading it) curbed the spontaneity of that flow—until he found a different technique from oils: the use of sand. This material had already been used by the Cubists in their research into textural collage during the synthetic period. Masson discovered its possibilities for automatism by "writing" with glue on a prepared base and spreading sand over the whole of the surface in paintings of marine subjects. The canvas, once placed upright, and no longer retaining the sand except along the lines of glue, enabled him to invent a kind of drip technique (in two stages) which filled him with enthusiasm. *Fish Drawn on the Sand* represents one of the first applications of this method; Masson enhanced the line of sand with touches of paint that reinforced its signification while charging it with violence. He applied himself to this practice, which gave him a new freedom with a more permanent base, creating at the same time a space different from that of drawing. Referring to this composition later he wrote: "By an entirely intuitive movement, on an unprimed canvas, the successive sweeps of glue will receive a rain of sand. These slight reliefs call for signification: a few swarthy features, a spot of heavenly blue above, a bloodstained trace below. Similarly, space takes on a meaning: here, a sandy beach without beginning or end" *(ibid.)*. The imagery Masson introduces in his conclusion still holds him back, but we already have the foreshadowing of that "all over" space of Pollock. And for Masson, depth again became a dominating concern; he expressed it by various and contradictory means. He knew the reassuring unity of perspective to be lost forever: "We are in the trough of a metamorphosis (on a world scale) and feel no more *spatial security* than we would in the eye of a hurricane or within the spiral of a gigantic maelstrom" *(ibid.)*.

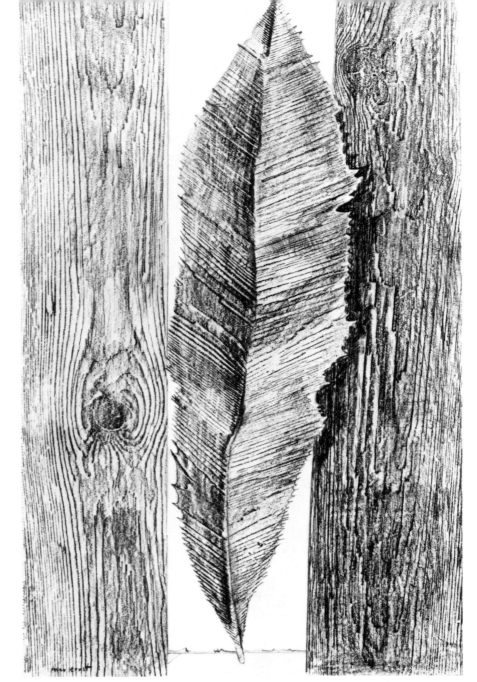

Max Ernst (1891-1976): Leaf Customs, from Histoire Naturelle, *sheet 18, 1925. Frottage, pencil, watercolour and gouache.*

In *Le Surréalisme et la Peinture*, published in 1928, Breton did not speak of the importance of these technical inventions, and even seemed to mistrust them: "There is perhaps in Joan Miró only one desire, that of letting himself go in order to paint with that pure automatism which I, for my part, have never ceased to call for, but whose deep value and justification I fear that Miró by himself has too casually examined. It is true that in that sense, perhaps, he might pass for the most 'surrealist' of us all. But we are far here from that 'chemistry' of the intelligence." By 1941, in *Genèse et perspective artistiques du surréalisme*, he had radically revised his opinion, coming out in favour of automatism and against what had fascinated him in Chirico and would soon captivate him in Dali and Magritte: the *trompe-l'œil* image. "There is a great risk of departing from Surrealism if automatism ceases at least to travel its road *underground*. A work can be considered as Surrealist only in so far as the artist has tried to enter the total psycho-physical field (of which the field of consciousness is but a small part). Freud has shown that at this 'abyssal' depth reigns the absence of contradiction, the mobility of emotional investments due to repression, the absence of time and the replacement of external reality by psychological reality subject to the pleasure principle alone. Automatism leads to this region by a straight line. The other route by which Surrealism can arrive there, the fixing of dream images in *trompe-l'œil* (and there lies its weakness) has been shown by experience to be less certain, fraught with risks of going astray."

Even when referring to Max Ernst in 1928, Breton, although much drawn to this painter's art, spoke less of his pictorial inventions than of the fascination of his images. "So it is that Max Ernst has now begun to delve into the substance of objects, giving it complete freedom to determine anew their shading, shape and attitude. Under his brush come into being sunflower women, higher animals fixed in the ground by roots, immense forests towards which we are swept by a savage desire" (André Breton, *Le Surréalisme et la Peinture*, 1928). Now as it happens, it was during the summer of 1925 that Max Ernst discovered the technique of rubbing (frottage) which permitted him to break out of a temporary absence of inspiration. The practice brought him close to automatic writing, in possessing at least its instantaneity of revelation. Ernst had just read Leonardo da Vinci's *Treatise on Painting*, and the page on which the author recommends stimulating the imagination by looking at a wall covered with stains. Ernst himself has related his discovery:

My curiosity aroused, I marvel and am led to inquire indiscriminately, using for this the same means, into all sorts of materials that happen to come into my field of vision: leaves and their veining, the ragged edges of sackcloth, the brush-marks on a "modern painting"...
I emphasize the fact that, through a series of suggestions and transmutations arising spontaneously—in the way things do in hypnagogic visions—the drawings thus obtained increasingly lose the character of the original material (wood, for example) and assume the aspect of images of an unhoped-for precision, of a kind likely to disclose the initial cause of the obsession or to produce some semblance of that cause.

<div align="right">Max Ernst, "Beyond Painting,"
in Cahiers d'Art, No. 6-7, Paris, 1936</div>

Max Ernst (1891-1976): Bird, 1925. Frottage.

Max Ernst (1891-1976): Vision Induced by the Nocturnal Aspect of the Porte Saint-Denis, 1927. Oil.

Max Ernst, by discovering this "objective chance," found himself finally in possession of an automatic technique which would free him from the perspective and theatrical space of Chirico. From then on he never abandoned the frottage technique. In his article in *Cahiers d'Art* he goes on to say: "Based as it is on nothing but the intensification of the irritability of one's mental faculties by suitable technical means, ruling out any conscious mental guidance (of reason, taste or moralizing) and reducing to the utmost the active share of the man who has hitherto been called 'the maker' of the work, the frottage procedure subsequently revealed itself as the true equivalent of what was already known as *automatic writing*. It is as a spectator that the maker is present, indifferent or eager, at the birth of his work and observes phases of its growth... The role of the painter is to focus on and *project what is seen within him*." With Surrealism the traditional role of the painter was reversed; the gaze was turned not outwards but inwards. Rimbaud had already proclaimed that the poet became a clairvoyant by a long, immense and reasoned derangement of all the senses, as Ernst once more recalled. It was at the end of the same year, 1925, that he found the possibility of integrating the frottage technique into painting, in *100,000 Doves*. Indiscriminately, he covered his canvas with paint which he then scraped, after having placed it on a rough surface, or, on the contrary, he picked out the trace of the ground-imprint by using a rag soaked in colours; *Forests* or *Vision Induced by the Nocturnal Aspect of the Porte Saint-Denis* were directly inspired by this practice.

In the same text Ernst raised this possibility: "And by adapting frottage to the technical means of painting (for example: grattage of colours on a ground prepared with colours and placed over an uneven surface), even though the frottage procedure had at first seemed applicable only to drawing, and by trying more and more to restrict my own active participation in the making of the picture, in order to increase thereby the active share of the hallucinatory faculties of the mind, I contrived to look on *like a spectator* at the birth of all my works... A blind swimmer, I have made myself a seer. *I have seen*. And I was surprised to find myself in love with what I *saw*, wishing to identify myself with it."

Joan Miró (1893): *Spanish Dancer*, 1928. Collage: sandpaper, rope, nails, linoleum.

The assemblage

The first results obtained from the new technique were a sequence of thirty-four frottages, which Ernst published in book form under the title *Histoire Naturelle* (Edition Jeanne Bucher, Paris, 1926).

The book was prefaced by Hans Arp with a long automatic poem inspired by the frottages. Arp settled in Paris at the time of the first group exhibition of surrealist painting (1925), in which he took part. He lived first in an atelier close to that of Ernst, 22, Rue de Tourlaque (where Miró also came to live); then, in 1926, he moved to Meudon, in the suburbs, where he remained until his death. He had already participated in all the Dada exhibitions and publications without being influenced by anyone whatever. He continued to work on his assemblages of biomorphic forms, changing the means of producing them but not their spirit. But his dreamlike figures, created by chance,

won a wider audience, and the Parisian Surrealists arrived at equivalent formal solutions when they cast off the spatial scaffolding of Cubism. Those forms which evolved freely in space, defying the laws of gravity, those unique and ambiguous figures replied exactly to the question Breton had put in his *Surrealist Manifesto* of 1924: "Cannot the dream be applied to the basic understanding of life?" Arp also anticipated what the poet expressed in his *Second Surrealist Manifesto* (1929), by not trying "essentially to produce works of art, but to cast light on the undisclosed yet discoverable part of our being, where all beauty, all love, all virtue which we scarcely know glows with intensity." Arp took part in surrealist activities. In a text printed in No. 7 of *La Révolution Surréaliste* (15 June 1926), he put in poetic form the nature which his assemblages had made material: "Leaves never grow on trees; like the bird's-eye view of a mountain they have no perspective. The observer is always in a false position before a leaf. As to branches, trunks and roots, I declare that they are the lies of the bald-headed, like a lion who ferociously sniffs at a succulent young married couple, the lime-tree grows tamely on the plain laid with flooring."

In the conclusion to *Le Surréalisme et la Peinture* (1928), Breton addressed a resounding tribute to Arp's poetics: "The carpenters who under Arp's direction get almost what they want from wood, from which are made flutes and frightful whatnots, make themselves accomplices of today's great crime of outrage-to-reality. We walk on sand in which each of our feet leaves a hole that is already no longer the size of that foot; there are empty objects separated by full gaps, secret moulds out of which come worn-out masks of glass."

If the free association of the elements of his assemblages, the contrast and fullness of his flat coloured tints, offered a different possibility of automatism, Arp however did not deny the influence which Surrealism had on him. "Surrealism sustained me, but it did not change me; it perhaps heightened the poetic, associative side of

Hans Arp (1887-1966): *Bottle and Bird or Winged Configuration*, 1925. Painted wood relief.

my work." In fact, until he took up three-dimensional sculpture in earnest in 1930, Arp remained essentially a Dadaist creating in accordance with the "laws of chance."

The assemblage in the hands of Miró and Picasso had another resonance, less "arbitrarily plastic." That was especially true of Miró's *Spanish Dancer* of 1928, the three-dimensional equivalent of his paintings. Collage here is substitution for plastic materials: the string replaces the line; the square or the nails replace the sign sym-

With the *Spanish Dancers* Miró had perhaps only been sending up Miró, but in his subversive humour he discovered another possibility of surrealist automatism, which brought him very close to the death of painting by forever purging him of those marvellous effects of *trompe-l'œil* which the Surrealists continued to relish.

There was nothing of Cubism in the collages which Picasso was doing at this time. They were, on the contrary, very close to that inspiration by association which was eminently surrealist, even if the

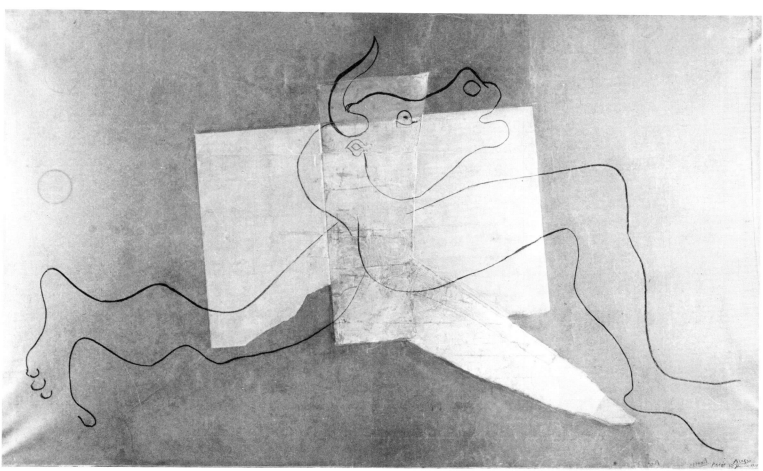

Pablo Picasso (1881-1973): Minotaur, 1 January 1928. Charcoal and pasted paper.

bols; the different papers are a substitute for the texture of the work. The object that is found seems naturally to take the place of the elements pictorially sought. It is as if Miró, in a supreme effort, were trying to wipe out what still constituted the charm of his painting; he then gives the impression of having even come to distrust his own equipment as a painter. His object paintings—he produced effectively three very different versions of that *Spanish Dancer* (1928)—show his taste for incongruous things, cast aside by men or by nature, which he collected and heaped up until the chance of a new encounter forced him to utilize them in assemblages that would soon take on the dimension of sculptures.

In *La Peinture au Défi* ("Painting in Defiance," 1930) Aragon brought out perfectly the close connection between painting and the assemblages which forced Miró to leave the flat surface of the wall. "It is hard to say whether the collages of Miró are imitations of his painting or whether his painting did not rather imitate in advance the effect of the collage as Miró gradually came to practise it. I rather incline to the latter interpretation." Not only did this type of assemblage stimulate the imagination; above all it condemned "realism" by bringing the elements of the real directly into the picture.

Spanish painter had never really been part of the surrealist group. His *Minotaur* called forth the illustration of a myth of which the Surrealists were very fond during the thirties, but nothing yet made it possible to foresee this subject on the day of its discovery, 1 January 1928. Picasso saw one of his essential themes appear there; extracted from his legend, the Minotaur became for him the figure of violence and tragedy, the monster bearing within himself all the sexual desires, and whose passion and endless race could not fail to arouse feeling. The assemblage, combined with the automatism of the movement of handwriting, fostered the sudden recognition of an essential figure of mythology.

In a few months, the Surrealists, and with them all the artists of the twentieth century, had set forth the chief means of making a new exploration, that of the internal dimension. Automatic writing, frottage and associative assemblages were not long in taking over the art of sculpture. The work was no longer the place of reproduction; it became the moment of revelation, challenge and confession, crucible of the transmutation of subject into object. Through these techniques, which uncovered instinctual activity, the artist's gaze escaped the tyranny of the eye, which aimed only to possess the visible.

The Bauhaus in Dessau

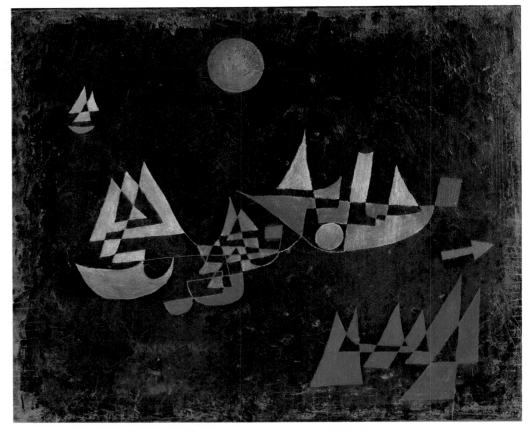

Paul Klee (1879-1940): *Departure of the Ships, 1927. Oil.*

The removal of the Bauhaus from Weimar to Dessau took place under the most favourable auspices. On 22 June 1925 the permit for the construction of the building designed by Gropius was granted; the majority of teachers and students followed their director, who appointed as professors former pupils who had just completed their studies, and among whom were Josef Albers, Herbert Bayer, Marcel Breuer. That same year appeared the first of the series of Bauhaus Books: *Internationale Architektur* by Gropius. Accredited in the spring of 1926 under the name Hochschule der Gestaltung (School of Design), the Bauhaus could count on a large subsidy from the City of Dessau. On the 4th and 5th of December the new buildings were solemnly inaugurated, and in his address Gropius declared: "Thanks to the steadfastness of professors and students, the Bauhaus continues its road, and we can note with satisfaction today that the ideas of the Bauhaus have brought forth a movement which extends well beyond our frontiers, and which reflects the structures of modern life. One man could not have created this movement by himself. It was born of the intellectual clarity and the ardour of teachers and students. The more we succeed in making our task truly collective, the easier it will be for us, starting from this collective spiritual nucleus, to establish the relationship between industry, handicrafts, science, and the powers that grant permission for development." This was not just a teacher handing out high marks: the Bauhaus became a meeting-point for all Europe and a research centre with which everyone reckoned; its regular activity as a publisher extended and deepened its influence.

The construction of the new school enabled Gropius to involve his students very actively in an architectural programme and its realization, and thereby to orient several of his disciples towards the art of building, to the extent of making it a privileged field. It may thus have been in answer to the requirements of the situation and to students' expectations that Gropius, early in 1927, opened a division of architecture which he placed under the direction of Hannes Meyer (1889-1954). This new discipline made it possible to step up research on functionalism and prefabrication according to the programme defined by Gropius himself in 1926: "Each thing is determined by its essence; to be conceived so that it functions correctly its essence must be studied thoroughly, for it must perfectly serve its purpose, that is, perform its practical functions, be durable, cheap, well made."

Josef Albers (1888-1976): *Fugue, 1925. Frosted glass, red glazing, partly cut out, partly painted in oils.*

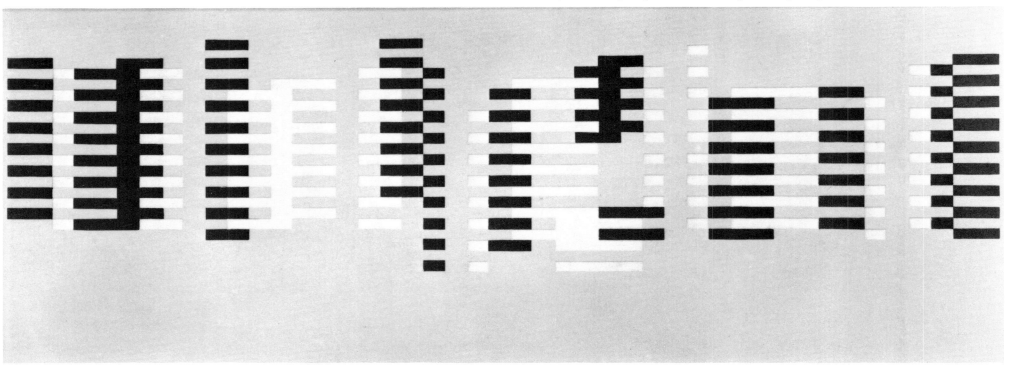

This conception of an economy of the work can be found as much in the creative activity of the teachers as in their course syllabuses; for Josef Albers it was even decisive, as he defined his aims in the *Bauhaus-Prospekt* of 1929: "1. Acquisition of general knowledge: practical knowledge of working materials and of the work; specifics: initiation into current research on construction and form. Accent placed on energy (from active to passive) and size (from volume to point), on movement (statics/dynamics) and expression (light measurement, colour, material). 2. Apprenticeship in the meaning of economy and responsibilities, in discipline and critical sense, through free invention and discovery with a professional object in view." Albers inclined to an impersonal, or at any rate, rational creation. In his work itself, developing the notion of economy, he played with the negative, which, by avoiding waste, imposed another understanding of form and its psychology. By the repetition of simple elements, colours, or fundamental values, he constructed spaces for analysis that enabled him to seize the essence of the elements used; the serial and systematic character of his creation was entirely new. At the time when he was laying the foundations of optical art, he discovered the physiological phenomena connected with the reading of forms and colours, which henceforth defined his creative field.

Paul Klee and Wassily Kandinsky did not remain indifferent to the objectivism and formalism which reigned supreme at Dessau. They pursued their inquiry into the deep significance of the constituent elements of painting, purifying their resources to the extent of transforming them into a few stereotyped signs formulated with an economy that, far from curbing their imagination, on the contrary exalted it. Their courses left them room to theorize and try out this vocabulary of the elemental. In the posthumous work *Das Bildnerische Denken*, which gathered the essential part of this work and of his theory as a teacher, Klee imparts his thoughts which fully illustrate his preoccupations at the end of the twenties: "We want to be exact, without being one-sided. That is a feat of strength, but one that must not deter us. Knowledge, as far as possible, is precision. But the imaginary, for its part, remains indispensable." And he continues with this personal definition of functionalism: "We are seeking not form but function. There again we wish to adhere to the greatest possible precision. The functioning of a machine is one thing, the functioning of life is something else, something better. Life creates and reproduces itself. Now when has a worn-out machine brought forth its young?... Following the principle that 'the work is related to its inherent law like the Creation to the Creator,' the work grows in its own way proceeding by general, universal laws. But it is not itself the rule; it is not universal in advance... As a projection, a phenomenon, it is a finite thing with a beginning and limits. But it resembles the infinite law in that, even in its finitude, it preserves something imponderable. Art as the emission of phenomena, projection from an original, supra-dimensional depth, symbol of the Creation. Second sight. Mystery. All of which does not prevent the carrying on of precision research."

In the same text, Klee criticized formalism: "Formalism is form without function. Today we see all kinds of exact forms around us. Willy-nilly, the eye gulps down squares, triangles, circles and all kinds of manufactured forms. They arouse the admiration of the horde of the uninitiated: the formalists. The living form is just the opposite." For in Klee's view the creator is he who guesses what creation is, he who "knows how to make things enter the flux of existence and is himself mobilized to render them visible. They retain the trace of his movement and it is the magic of life... The search for functional foundations is unceasing, it is never interrupted, and yet even today it runs against many limits—God be praised, perhaps! For confronted by mystery, baffled analysis breaks down. But the mystery is penetrated by participating in the creation of forms."

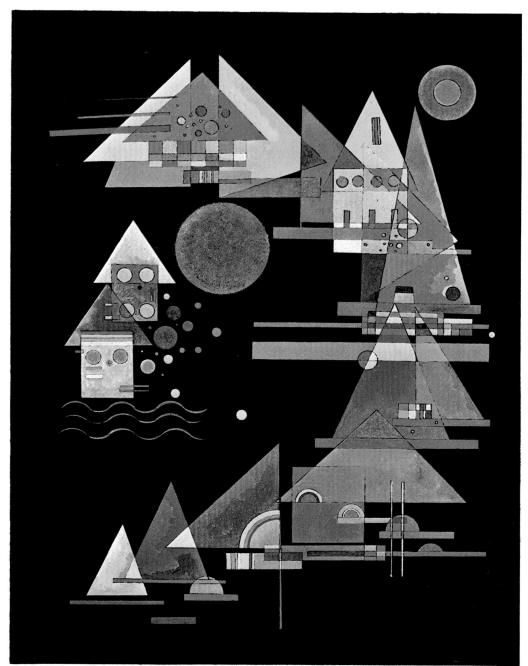

Wassily Kandinsky (1866-1944): Arched Points (No. 407), 1927. Oil.

Kandinsky shared this view. In the introduction to his book *Punkt und Linie zu Fläche* (Point and Line to Plane, 1926), he wrote: "The researches which must form the basis of this new science—the science of art—have two aims and derive from two imperatives: (1) from the simple desire to know, arising spontaneously from a need to be familiar with pure science, without any practical aim; and (2) from the necessity for a balance of creative forces schematically classified into two components, intuition and computation: 'applied' science."

The spirit of the Bauhaus changed in 1928 with the departure of Gropius, leading to that of Bayer, Breuer and Moholy-Nagy. Hannes Meyer replaced Gropius as director and gave the school a still more functionalist orientation, also introducing new fields of training: photography, sculpture, psychology. The Bauhaus at that time numbered 166 students, and the Friends of the Bauhaus, 460 members. Klee and Kandinsky remained on the staff, even though politics bulked larger in the school's activity.

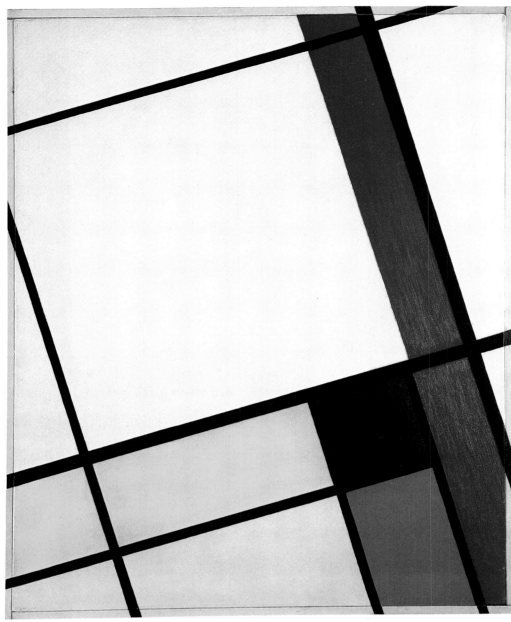

César Domela (1900): Neo-Plastic Composition No. 50, 1926. Oil.

The triumph
of geometric abstraction

While Surrealism remained an essentially Parisian movement, Constructivism now had an international audience. More and more artists became converted to the practice of a logical art, of which the effects of form and composition were taken over by the world of fashion. The development of Kupka is significant in that regard. After having been one of the pioneers of lyrical abstraction, he came progressively to a characteristic starkness, attesting to the intensity of his non-objective approach, which he summarized in the review *Abstraction-Création* (1932): "What is the kernel of my attitude? It is to stick to the path I took after my escape from traditional painting based on the forms of nature. In addition, I refuse to believe that to tell the truth is not 'art,' and to conclude that art must necessarily be a lie... Also to make an abstraction of *trompe l'œil*, atmosphere and every lie of the third dimension. I have since spent my time in proving the possibility of creating freely. Geometric planes, attention to boundaries only. Possibilities for traditional painting analysed to yield new forms and situations."

The same held true for César Domela. Born in Amsterdam in 1900, he produced his first abstract works in Berlin. In Paris in 1924 he came under the influence of Mondrian and joined the De Stijl group, the new plastic art appearing as "natural" expression to many painters of that generation. Abstraction had even made an entry in force into the museum, thanks in particular to the director of the Hanover Museum, Alexander Dorner, the first to acquire a Mondrian for a museum. In 1927 he commissioned El Lissitzky to install the Abstract Painters' Room, opened the following year. On permanent display here, in a revolutionary setting, was a representative group of Constructivist creations.

The time had come to extend the influence of these purist laboratory researches and above all to envision their entry into every-day life where they would find their true meaning. Henrik Stazewski (1894), a Polish Constructivist, summed up the meaning and importance of this abstraction in the review *Praesens* in 1926: "The new plastic art sees in abstraction a way of expressing the universal elements which go to form the contemporary collective style. Individualism as free interpretation of nature, escaping control, is not suitable to represent the style of the contemporary era. The need for an aesthetic based on the principle of collectivist construction neither denies nor diminishes individuality, but leads only to the most universal values, common to all men." And he continued prophetically: "Constructivism does not tend to the creation of a style set up as an unchangeable standard, based on forms discovered and accepted once and for all; on the contrary, it faces the problem of construction, which can and must undergo continual transformations and improvements, under the influence of always new and ever more complex needs dictated by general development."

And so, just when the Russian Constructivists were forced to cease all creative activity, their ideas flourished in Western Europe, where their theories acquired a new impetus. It was in March 1927 that Malevich arrived in Warsaw, where he was triumphantly welcomed by Kobro and Strzeminski; he exhibited his works at the Hotel Polonia, and the meeting with him marked the official founding of the Polish movement, which was to create many important works. A few days later, Malevich was in Germany; he travelled to the Bauhaus in Dessau, where he met in succession Gropius, Hannes Meyer, Kandinsky, Moholy-Nagy, and even Mies Van der Rohe; but relations were difficult. Malevich had given up painting since his *White Square on a White Ground*, and his conception of architectonics was completely foreign to the functionalism of the German artists. In the notes taken by the Polish poet Peiper, who served as Malevich's interpreter, we can get an idea of the gulf which separated his conceptions from those of the Germans. Peiper makes this reference to their discussion: "Malevich distinguishes between architecture and architectonics: the first has a strictly utilitarian object; the second is strictly artistic. Architectonics produces works in which it is solely a question of the artistic relation of spatial forms; it does not take into consideration that someone is going to live inside its work... Gropius, who, unlike Malevich, is an architect by profession, sets himself another goal. For him, the manner of constructing depends, with the highest degree of precision, on the function of the building; the reality of the building is derived from the reality of the construction, and the technique of construction determines the form of the building. However, Malevich would be pleased if constructors erected buildings following his plastic models" (Peiper, "At the Bauhaus," in *Zwrotnica*, 1927).

Once he had returned to the USSR, Malevich was no longer allowed to leave it. In 1929, a final and modest exhibition was devoted to him at the Tretiakov Gallery in Moscow. The catalogue reproduced only one Cubo-Futurist painting of 1911, *The Haymakers*, a choice which revealed the rise to power of the socialist realists. The

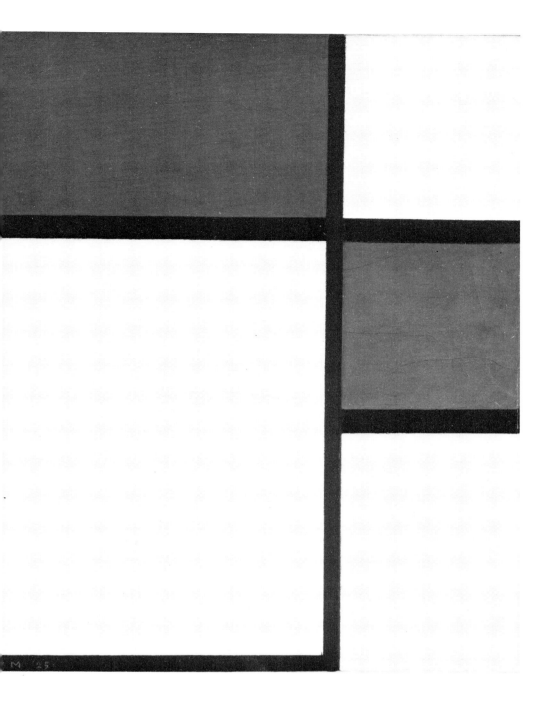

architecture. It is quite possible that this revival of the plane led artists to the abstraction of the natural appearance..." It is there that he locates the reversal of old and new practices: "Composition after the fashion of natural appearances therefore had to be left out of painting in order for painting to be truly new. By a sustained effort, the group arrived at composition which was based exclusively on the *balance of pure relations* born of *pure intuition* from the union of deepened sensibility and superior intelligence. Although these relations are formed in nature and in our mind in accordance with the same basic and universal laws, *in our day* the work of art manifests itself differently from nature, because in the work of art today we must try to express of nature only what is essential, and of man only what is universal. Individual expression, proceeding from our own nature, is already making its appearance there. So *do new laws make a path for themselves.*"

Such exacting standards make it easier to understand the quarrel that had just occurred between Van Doesburg and Mondrian, and which led the latter to cease contributing to the review *De Stijl*. In his "Manifesto of Elementarism," published in *De Stijl* in 1926, Van Doesburg argued the case for the 45-degree line (he had used it since 1924), which, being more dynamic, would suit the spirit of modern man better than the horizontal-vertical opposition of Neo-Plasticism. Mondrian could not bear this attack—he vowed an almost visceral hatred to anything that recalled nature, as we shall see—and in the same article of *Cahiers d'Art* he replied directly: "The new composition is based on *permanent, contrasting and neutralizing oppositions.* The line is straight, and always, in the right angle formed by its two principal oppositions, the plastic expression of what is constant. And the size relations are always based on this main positional relationship. The new plastic art is thus an 'equivalent' of nature, and the work of art no longer has any visual resemblance to natural appearance."

◁ *Piet Mondrian (1872-1944): Composition, 1925. Oil.*

▽ *Frank Kupka (1871-1957): Untitled, c. 1928. Gouache.*

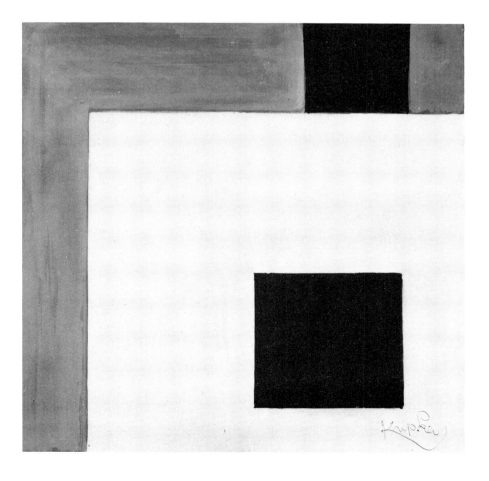

short preface by A. Fedorov-Davydov was significant. Denouncing what seemed to him the creative dead-end of the twenties, he concluded: "Some turned definitively towards a so-called 'production art,' finding in it an escape from the dead-end of abstraction. Others kept to abstraction and 'sank into themselves,' after having made up the absence of real content with deep-seated emotions. But, although subjectively removed from the positive basic tendencies of the new art of industrialism, objectively they promoted its birth through their works. K.S. Malevich belongs to this latter category... He is a subjectivist and philosophical dreamer. But that does not prevent his works from having an objective value all their own. His suprematist painting has already made business in textiles and a whole range of other branches of the decorative arts!" The USSR could not give its revolutionaries a better burial!

To become a model for textile design or ceramics was just what Mondrian refused to do. In an article entitled "The New Plastic Expression in Painting" which appeared in *Cahiers d'Art* in September 1926, he took his bearings while at the same time tracing the history of De Stijl: "Soon, however, it became a painting much less 'pictorial' and more 'architectural or constructive.' Pure colour appeared, perhaps because some artists also concerned themselves with interiors, not in the sense of decoration, but in a more or less constructive fashion by planes of pure colours. This concern with interiors was perhaps the origin of the Neo-Plastic art of colour in

For Mondrian, the enemy was the disorder of nature, the enemy was romanticism. Never did he formulate his conception better than in the text, still famous, which he published in 1926: *The Home, the Street, the City*. There he made clear his need to go outside the painting to fulfil himself in the three dimensions of the real and in the setting of everyday life, while at the same time irrevocably condemning everything which could divert the new man from his quest for another absolute. "As long as man is ruled by his fleeting individuality instead of cultivating his true being which is universal, he neither seeks nor can he find anything but his own self. Consequently the home becomes the place where that fleeting individuality is nurtured, and the plastic expression of the home is the reflection of that petty preoccupation. The exteriorization of that concentration on oneself has been until now almost fatal for the entire age.

"In order for our material environment to be one of pure beauty, and therefore healthy and practical, it must no longer be the reflection of the egoistic feelings of our petty personality; it must no longer even be at all lyrical in expression, but on the contrary purely plastic.

"We desire, therefore, a new aesthetics based on the pure relations of pure lines and colours, because only pure relations, pure elements of construction, can arrive at pure beauty." That was the programme Mondian sought to put into effect in different town-planning projects and in the organization of his own studio, the most typical example of his quest for the achievement of truth: "This means that interior and exterior are completely equivalent, and thus form a unity. The exterior is then an image of the interior, the two together reflecting each other in all exterior reality" (Mondrian, *Natural Reality and Abstract Reality*, 1919-1920).

Mondrian, who was to be so plundered by cheap imitators, especially after his death, and by persons who observed none of his rigorous requirements, proved repeatedly that he would have liked to express himself outside painting, to which however he was condemned by the general economic conditions of his time. He longed to express himself in everyday living-space, which would have enabled him to come to grips with the question *how*, that is, the relation between the elements in the direct approach to reality. For, he said: "It is not enough to place next to each other a red, a blue, a yellow, a grey... it must also be the right red, the right blue, the right grey. Right in itself and right in relation to the other. Everything lies in the how: how the elements are placed and how the colours of the different elements behave. And the action of the colour itself depends on the structure of the rooms; the distribution of light plays an important role in the determination of the colour" *(ibid.)*.

He goes still further in this awareness of relations when he writes: "Yes, all things make up a whole; each part receives its visual value from the whole, and the whole receives it from the parts. Everything is composed through relation and reciprocity. Colour exists only through the *other* colour; size is defined by the *other* size; opposition exists only by reference to another opposing position. That is why I say that relation is the main thing" *(ibid.)*. Mondrian knew that this projection of the interior towards the exterior which leads to the environment could as yet be achieved only at the level of the home or dwelling-place rather than of architecture, for: "Personally," he said, "I do not see at present the possibility of attaining perfect plastic expression by following the organism of what one wishes to build and in thinking only of its utility. Our intuition, still overburdened by the past, does not seem developed enough for that purpose" (Mondrian, *The Home, the Street, the City*).

Mondrian was convinced that he could achieve equilibrium only by wrenching free of the "disorder of nature." That was the idea he affirmed in *The Home, the Street, the City*: "Denaturalization being one of the essential stages in human progress, it is therefore of the highest importance in Neo-Plastic art... To denaturalize is to abstract. Through abstraction one obtains pure abstract expression. To denaturalize is to explore more deeply. Denaturalization goes on consciously and unconsciously. An instance of the latter way can be found in the progress of fashion; do we not in fact see the cut of garments not only become more streamlined but go counter to the natural shape?" And he concludes on a peremptory note: "And man? In himself nothing, he will be but a part of the whole; and it is then that, having shed the vanity of his small and petty individuality, he will be happy in the Eden he has created!" When Mies van der Rohe took over the direction of the Bauhaus in 1930 he proved to share certain ideas of Mondrian concerning exterior and interior space by taking up the problems of construction and town-planning together in the same class in architecture.

Whereas Mondrian had to be satisfied with prototypes, it is to three creators, Hans Arp, Sophie Taeuber and Theo van Doesburg that we owe the most astonishing architectural achievement of modernism: the Aubette, a dance hall and entertainment centre at Strasbourg. It was even called "the Sistine Chapel of Modern Times." This realization, unfortunately destroyed, remains the most remarkable in concrete art. In 1926 Sophie Taeuber was contacted by the promoter Paul Horn, whom she in turn put in touch with Van Doesburg, who took charge of the building and disposition of rooms, leaving complete freedom to each of his co-workers. Inaugurated in 1928, the Aubette was greeted by total incomprehension, which hastened its dilapidation. We have its record preserved in the preliminary sketches and mock-ups. It was in the dance-hall-cinema, the largest room of the centre, that Van Doesburg applied the theory of the diagonal which, by opposing the right angles of the architectural elements, introduced a new kinetic dimension. Sophie Taeuber also took a very active part in this realization, conceiving several arrangements of space; in the passageway, for example, she emphasized the function of place by composing the flagstone paving of long rectangular bands which underscored the architectural proportions, while in the tea-room she worked out several right-angle compositions, separated by vertical bands with designs in relief. Hans Arp's contribution was less important. In an issue of *De Stijl* (No. 87-89, 1928) devoted to the Aubette, Van Doesburg showed this necessity of the oblique. In his article *Elementarism and its Origin* he says in particular: "The fundamental polarity of natural structure is conditioned in all that surrounds us by the horizontal and vertical positions. The entire mechanics of everyday life is based on the system of right angles. The vital functions (standing, walking, lying down, moving, sitting, etc.), that is, everything which has to do with architectural structure, is equally based on that system." But, for Van Doesburg, "a confluence of primordial values ends in a chronic decadence" from which modern man must free himself. "He builds a new world on the ruins of the old, and pits the orthogonal system against obliqueness. The oblique dimension not only destroys the old orthogonal means of expression, but at the same time brings into being a new optics and phonetics. These elementary changes have their equivalents in relativity, in the new research into matter and the attitude towards the unlimited intelligence of the human being and his creative effort. Opposed to religious dogmas and absolutism, the elementarist experiences life as a perpetual transformation, and spiritual activity as a phenomenon of contrast. The elementarist tries to unify into a new form of expression the two principal factors of our creative activity, namely, repose and movement, time and space" *(ibid.)*.

Mondrian had answered Van Doesburg in advance in *The Home, the Street, the City*: "The naturalist and frivolous expression of the slanting line cannot be denied. Furthermore, this unbalanced expression is not destroyed by the contrasting position of another line.

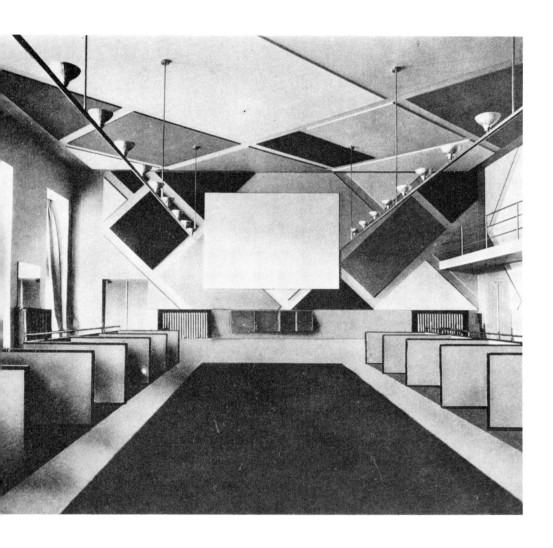

Although that, even so, may produce an impression of stability, the plastic expression remains one of perpetual movement, thus of natural appearance."

In this effort at bringing the painting out of its frame so as to achieve a total ordering of space, Schwitters' experiment was highly original. Although in his painting Schwitters let himself be captivated by an ever-increasingly geometric arrangement, in his *Merzbau*, the habitable sculpture on which he started work in 1923, he remained more lyrical. He referred to it as follows in *Merz 21* (1931): "The name KdE (Cathedral of Erotic Misery) is a simple appellation. It has nothing to do with the content, but that is a fate which it shares with all appellations... One might say that the KdE is the statement in a pure form, with a few exceptions, of everything in my life, important or not, during these past seven years; but into which has slipped a certain literary shape." And he added, "The literary content is Dadaist."

So there we have a curious meeting-ground, and one of the last, between Dada and Constructivism. Instead of feeling drawn to the Surrealists, Schwitters moved towards the future group called Abstraction-Création. The *Merzbau*, destroyed in 1943 during the bombing of Hanover, appears as an outgrowth which became the prototype of the contemporary conception of the environment. Schwitters even had the idea of a total spectacle, an environment of sound that would complement this assemblage and serve as décor for a sort of "happening" before its time. In this total *Merz*, this "all-over" Merz *(Gesamtkunstmerz)*, he sought to "fold all the branches of art in the embrace of a single unity."

The invention of the environment

△ *Theo van Doesburg (1883-1931): Interior of the Aubette dance hall and amusement centre, Strasbourg, 1928.*

◁ *Kurt Schwitters (1887-1948): Merz Construction* (Merzbau) *in the artist's home, Hanover, c. 1923-1933.*

▽ *Piet Mondrian (1872-1944): Set design for Michel Seuphor's play* L'éphémère est éternel, *1926.*

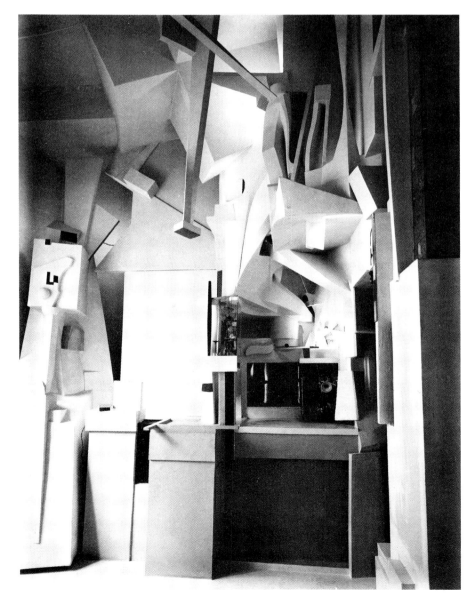

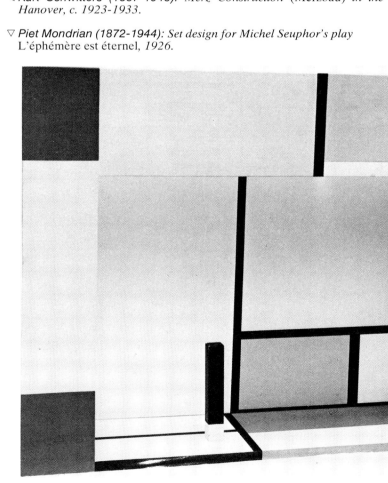

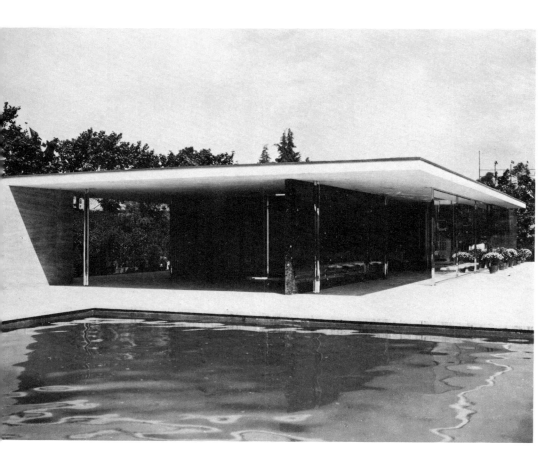

Functional architecture

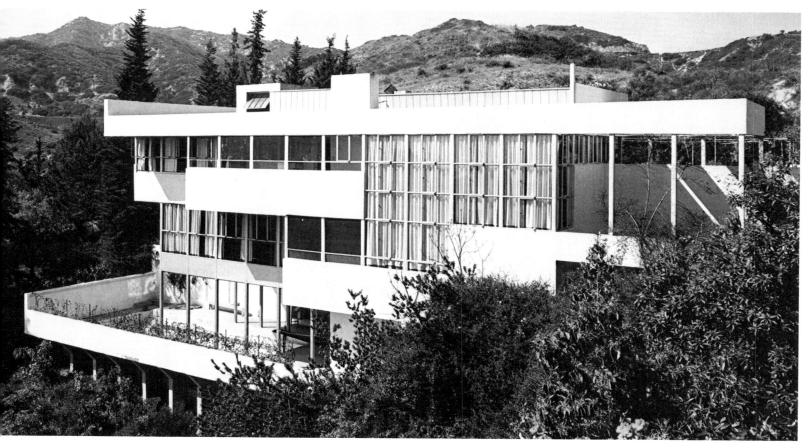

△◁ *Ludwig Mies van der Rohe (1886-1969): German Pavilion at the Barcelona World's Fair, 1929.*

△ *Hans Scharoun (1893): One-family house built for the International Werkbund Exhibition, Stuttgart, 1927.*

◁ *Richard Neutra (1892): Lovell House, Griffith Park, Los Angeles, 1927-1929.*

▷ *Le Corbusier (1887-1965): Villa Savoye at Poissy, near Paris, 1929-1931. East corner.*

In 1927 two events brought architecture onto the front page: the international competition for the League of Nations building in Geneva and the International Werkbund Exhibition in Stuttgart, two public events in which the same protagonists figured, for architecture had become an international affair.

The League of Nations, whose role has already been mentioned, set out to build an architectural complex bringing together its various activities and its numerous services, and an international competition was opened for the erection of this monumental block. Among the 337 projects submitted, that of Le Corbusier (in collaboration with Pierre Jeanneret) attracted particular attention by the intelligence of its programme and the boldness of its plastic solutions. Whereas many of the participants had considered only the idea of a palatial building and had given it every form from Greek temple to Russian Orthodox church, Le Corbusier found an opportunity to develop his functionalist theories by a more thorough study of the needs of different departments and the problem of internal traffic. He divided the functions of the centre into three parts: a General Secretariat, a Grand Palace of the General Assembly and Committees, and a Great Assembly Hall. The rationality of the course he proposed was the more convincing in that he knew how to integrate the block of buildings wonderfully into the natural surroundings and to exploit the meagreness of the available building ground. The Great Assembly Hall, with 2,600 seats and an almost parabolically curved ceiling, would have represented the "architectural monument" of the thirties. The project missed adoption by a single vote, under pressure above all from Aristide Briand and political circles. The jury finally decided to award nine first prizes *ex aequo* and the execution of the work was placed in the hands of the authors of four projects, who drew inspiration from Le Corbusier's principles of organization, but emptied them of their meaning.

Le Corbusier's functionalism was not limited to an intelligent understanding of the consumer's needs. The Villa Savoye which he built in 1929-1931 at Poissy, near Paris, illustrates the innovations brought about by his grasp of the use of materials, of the function of a dwelling and of its relationship to nature, an understanding which he summarized in five points in 1926, in a famous text that became the charter of modern architecture. "1. *The stilts* (free-standing supports)... Reinforced cement gives us the stilts. The house is in the air, far from the ground; the garden passes under the house, the garden is on top of the house as well, on the roof. 2. *The roof-gardens...* Technical reasons, reasons of economy, reasons of comfort and sentimental reasons lead us to adopt the roof-terrace. 3. *The open plan...* Reinforced concrete in the house brings the open plan! The floors are no longer placed one on top of the other on partitions. They are open. Great economy of the structural cube, strict exploitation of every centimetre. Great financial economy. Comfortable rationalism of the new plan! 4. *The extended window...* Reinforced cement revolutionizes the window. The windows can run from one end of the facade to the other. The window is the *standard mechanical element* of the house... 5. *The open facade.* The supporting posts set back from the facade, inside the house. The floor is cantilevered outwards. The facades are no longer more than light membranes of insulating walls or windows..." (Le Corbusier and Pierre Jeanneret, *Les cinq points d'une architecture nouvelle*, 1926). The Villa Savoye represents the perfect illustration of this manifesto by carrying out the ambitious design of integrating interior space into an exterior space expanded to the dimensions of the "four horizons."

The scandalous elimination of modern architecture by the League of Nations jury spurred Hélène de Mandrot to call together many young architects, chosen with the advice of Le Corbusier and Sigfried Giedion, at the Château de la Sarraz, near Lausanne, from 26 to 28 June 1928. On this occasion there was formed the CIAM (First International Congresses of Modern Architecture) which, through the subjects of its meetings, its documentation and its theory, played henceforth an important role in the development of the art of building.

It would be wrong to limit the comprehension of the architecture of that time to the use of new materials. Like the painters and sculptors, the architects tied the "culture of materials" to the definition of a

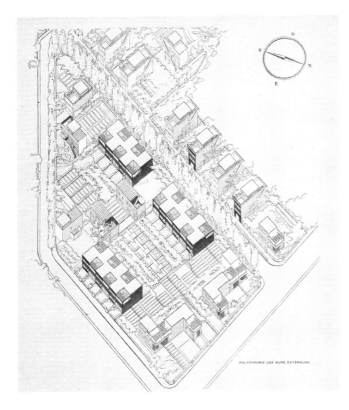

Le Corbusier (1887-1965):
*Plan of the housing
development at Pessac,
near Bordeaux, 1925.*

utilitarian, functional, industrial and economic programme; to a new ethic of man to enable him to live the life of the present. It was no longer a matter of creating masterpieces of facades, but of endowing man with a space describing his daily existence. This form-function identity went far beyond the Cubistic modernism which the unthinking spectator had in mind. J.J.P. Oud, in a lecture in 1921, printed as an article in *De Stijl* in 1927, had already exposed this false interpretation: "The architecture rationally based on the new conditions of life will be at the opposite pole from architecture today. Without falling into sterile rationalism, it will be essentially utilitarian, but with a utilitarianism embodied in higher aspirations. Radically opposed to productions of form and colour devoid of technique and resulting from a moment of inspiration, such as we are familiar with, it will create, in a technical and almost impersonal manner, works that are perfectly adapted to the purpose assigned them, with clearly defined forms and pure proportions."

A text by Hannes Meyer appearing in 1928 in *Bauhaus* No. 4 summed up the basic conception of these new constructors: "To build is a biological process. To build is not an aesthetic process. The new dwelling becomes essentially a machine for living and also a biological device answering material and spiritual needs. The modern era places new materials at the disposal of new architecture... We organize these materials into an architectural whole on the principles of economy. The individual form, the structure, the colour of the material and the texture of the surface are thus automatically determined by life." And Meyer goes on to demonstrate his faith in the construction of a new man: "Neither concern for well-being nor concern for prestige should be among the guiding principles in architecture. Well-being hangs on the heart of the man and not on the walls of the room..."

Because all men belonging to the same historical moment reach out towards similar horizons, all the functionalist builders were equally conscious of the material and its economy, as well as of the "educational" role they had to fulfil: thus this architecture took on an international character, as shown by comparison of documents. The integration of nature rested equally on new foundations; it answered to the needs of physical and moral hygiene, and went against traditional architecture, which proceeded essentially by utilizing a local raw material.

But the new ideas were hard to get accepted. Even in the United States, although many architects were fascinated by the theory of functions as defined by Frank Lloyd Wright, its circulation, except in the building of a few private houses, remained no less arduous.

Richard Neutra, born in Vienna in 1892, came under Wright's influence after having been trained by Loos and Mendelsohn. Emigrating to the United States in 1923, he learned American methods of construction and settled in Los Angeles in 1926. Lovell House (1927-1929) was the first practical application he achieved. In it he combined American technological know-how with European ideas on habitat. Like Wright, he sought integration with nature and here for the first time used a steel framework. Afterwards he had recourse to prefabricated metal door-frames, permitting the use of large glass panels.

As for Mies van der Rohe, ever since his designs for a brick country house in 1923 he had appeared as one of the boldest and most innovative builders. But he gave the full measure of his architectonic sensibility and his feeling for building material only with the erection of the German Pavilion at the International Exhibition of Barcelona in 1929. Using plane sections as points of convergence between matter and structure, he developed the interior arrangement far beyond the walls, which he replaced by large surfaces entirely in glass.

Nowhere did the situation seem as favourable for architecture as in Germany. The Weimar Republic emerged strengthened from the monetary reform of 1924; billions flowed into the country thanks to the Dawes plan, and the social expenditures of the great centres considerably increased. By imposing taxes on old housing, and by expropriation, the cities acquired great tracts of land for building, which they had the means of financing. The new architects were conscious of their social responsibilities; they shared the opinion of Ernst May when he said: "A centre of dwellings, of whatever type, which caters only for the living conditions of a wealthy elite, has no business to exist," but on the contrary "the poorest of the poor must have his fate bettered."

As director of the Deutscher Werkbund, Mies van der Rohe was the driving force behind the most brilliant demonstration of the new architecture, organizing through the Werkbund the International Housing Exhibition in Stuttgart in 1927, out of which grew the experimental Weissenhof settlement. This exhibit set forth the economic facts of rationalization and at the same time demonstrated the reality and the requirements of the new housing for the people. Since the end of the war and in the face of the necessities of reconstruction, this problem had been in the limelight. Many experiments had just been tried (in Bordeaux, Berlin, Hanover, Rotterdam); it became urgent to bring them together for comparison and to demonstrate convincingly the merits of the designs of international functionalist architects. Mies van der Rohe invited them to participate in the Stuttgart exhibition by submitting one or two constructions, and also in the parallel exhibit of photographs, mock-ups and designs; seventeen took part, of whom twelve were Germans.

In his final programme, Mies van der Rohe specified: "However important may be its technical and economic aspects, the problem of modern housing is first of all a problem of architecture. Rationalization and standardization are not the whole problem; they are means which one should be careful not to mistake for ends. The problem of new housing is a problem of a state of mind; the battle for new housing is only one aspect of the great combat for new forms of life."

The great importance of this exhibition is that it led to the execution of projects financed by the city of Stuttgart. Here is the information made available about it in France, thanks to an article in *Cahiers d'Art* (No. 7-8, 1927): "The city of Stuttgart, desiring to build a model garden-city, appealed eight months ago to the 'Ring' group of German architects. The request was for delivery in six months of sixty villas conceived along the most modern lines, both from the technical and artistic point of view, the widest latitude being given in the choice of construction methods and interior fittings, also to be designed by the architect."

In an article in *Architecture Vivante* (1928), Sigfried Giedion gives an exact analysis of this exhibition and stresses its innovations. "The exhibition has effectively revealed the integration of architecture into daily life. It has, in our view, an extraordinary importance, for it has allowed the new architecture to escape from the asepticized atmosphere of the avant-garde laboratory in order to penetrate the consciousness of a wide public. The new architecture, it is true, can afford less than any other discipline to do without the active cooperation of the masses. But it is no less true that it is not the masses who create new architectonic problems. The awakened consciousness shuts itself up in a negative attitude. But the new forms make their way nonetheless in the unconscious."

The overall plan was established by Mies van der Rohe, who then left complete freedom to each architect. He himself crowned the ensemble by a light, airy building of several floors, with a steel skeleton and volumes divisible according to the wishes of the tenant. "Construction by skeletal framework is the best adapted to our needs," he said. "It makes it possible to rationalize the construction and to divide the interior with complete freedom."

Gropius was more dogmatic. For him "the architect's task today is that of an organizer who must face all the biological, social, technical and plastic problems and make a synthesis of them in an autonomous unity." He took advantage of Weissenhof to try out the system of prefabrication by dry mounting of individual detached houses. Oud, for his part, worked with terraced houses, and Le Corbusier presented the execution of two previous projects: the Citrohan house of 1922 and another with two flats, the prototype of the "machine for living." All agreed with the Dutchman Mart Stam, who declared: "The best home will be the one that has been treated as a perfect object of use."

By displaying the requirements of a social, economic and aesthetic order, the Stuttgart exhibition of 1927 lifted architecture out of the

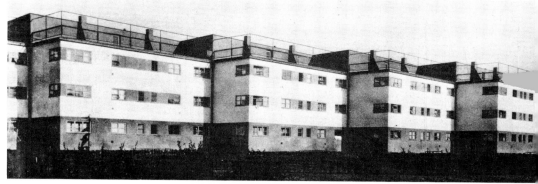

Ernst May (1886-1970): Low-cost housing estate in Frankfurt am Main, 1928.

ruts of regionalism and traditionalism. It was a landmark in being the first—and also the last—exhibition devoted exclusively to modern architecture.

During the same period a still more important experiment was being tried out in Frankfurt. In 1925 the mayor, a social-democrat, entrusted Ernst May with responsibility for the city's town-planning, the running of an office for the planning of industrial estates, and the model study of housing; he also left him great decision-making power. It was in this context that Ernst May, with many collaborators, built the settlements of Römerstadt (1927-1928) and Westhausen (1929-1930).

For economic reasons, studies were pursued further in programming, standardization and prefabrication on the level of structure and interior fittings. Thanks to the economies thus achieved, it seemed possible to enhance the standing and comfort of each dwelling: bathroom, fitted kitchen, running water, central heating were the most conspicuous conquests. Römerstadt was the first industrial estate in all of Germany to be completely electrified. As a corollary, even new social solutions were put forward: kindergarten, community centre, communal laundry, cold storage, collective radio antenna, etc. The choice of the roof-terrace made Frankfurt "the Mecca of modern

Ernst May (1886-1970): Römerstadt housing estate, Frankfurt am Main, 1927-1928.

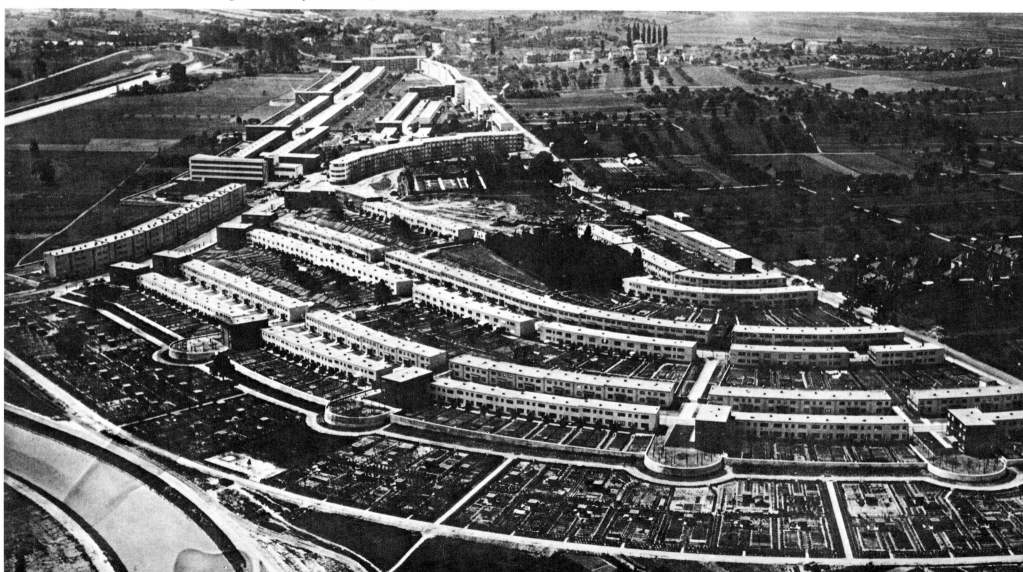

cities." But such programming obviously implies a rigorous definition of human requirements: light, air, sun and comfort must be paid for by a strict distribution of individual living space. Thus, in Frankfurt, a family of four had a habitable floorspace of 58 square metres; that of the kitchen was limited to 5.97 square metres, thanks to an in-depth study of domestic ergonomics. Functional design aimed here at adapting the body to its milieu; the furniture, built into the walls, served only the customary practical functions and was arranged according to a minimal-motion study. The interior design of the sleeping car or the automobile represented for these theoreticians a success which served as a model for their imagination of the family cell. Everything was normalized, standardized, functionalized. Ernst May wrote: "In the future man will no longer have just any dwelling at his disposal; it will be possible instead to establish a vital minimum for specific categories of people, classified according to their numbers and economic capacity, and the best solution will be determined to secure for each person his 'housing ration'" (*Minimal Housing*, in *Das Neue Frankfurt*, No. 11, November 1929). This abstract definition of human needs harks back to the conclusion of Mondrian we have already quoted: "And man? In himself nothing, he will be but a part of the whole; and it is then that, having shed the vanity of his small and petty individuality, he will be happy in the Eden he has created" (in *The Home, the Street, the City*).

In an attempt to respond to the needs of society, Ernst May also built in 1928 at Frankfurt the first provisional settlement for the homeless, a complex housing 300 families. Cheap and temporary, this prefabricated construction gave each family a living space of 32 square metres; individual bathrooms and kitchens were replaced by communal installations. Speaking of it, May defined the concept of "minimum existence." But the economic recession soon turned practice against the idealism of theory. The provisional housing estate became permanent, and politicians exploited it as a model for a minimum wage. In attempting to alleviate the misery of the most deprived, May thus was fated to raise the walls of their prison.

"Housing for minimum existence" was precisely the theme of the CIAM congress organized in Frankfurt in 1929. The experience of the new towns had not yet had time to betray the dream of the idealists; but the following year, at the Congress of Brussels, their condemnation was final, and in his concluding report Karel Teige unmasked the illusion of trying to improve "the fate of the poorest of the poor."

Developer of one of the districts of Frankfurt, Ferdinand Kramer summarized for the 1929 CIAM congress the social concepts of the

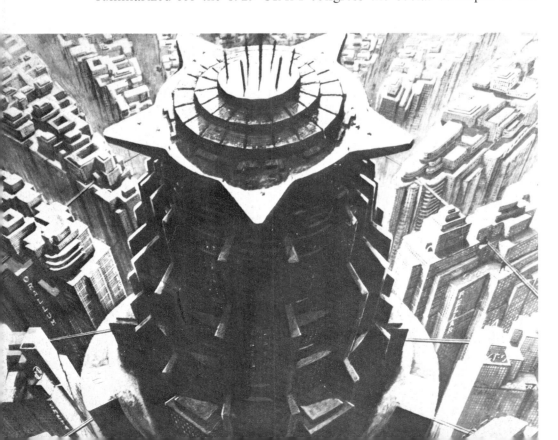

The condemnation of Utopia

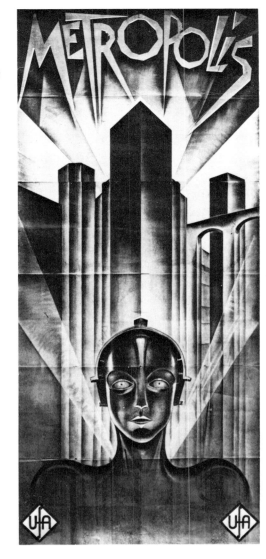

▷ *Poster for the Fritz Lang film* Metropolis, *1926.*

▽ *Still from the Fritz Lang film* Metropolis, *1926.*

German builders: "The degree of rationality of an architecture is determined by the relation between the aim pursued and the means utilized to achieve it. It is only from the intention that the cost can be estimated... Consequently, the idea is making more and more headway that if it is desired to establish a rational architecture, a house must be built to last for a single generation. The possibility will thus be left open for an innovation in the domain of construction and for a natural evolution whose tendency is approximately known today... An essential condition for applying the rational principles set forth above is the construction of a large group of dwellings. Only in this way can a rational administration of lighting, heating and hot water be set up. The objection that such an agglomeration would amount to shutting up a whole stratum of the population in barracks is not pertinent, for only such an architecture can give free rein to individual initiative for interior furnishings" (Ferdinand Kramer, *Housing for the Vital Minimum*, 1929).

But too many elements, especially of a political and economic order, escaped the notice of the supporters of this programmed rationality. Current events demonstrated their lack of realism. The flats of Praunheim and Römerstadt were already beyond the means even of those with jobs by the time they were completed. For Germany did not withstand the world economic crisis of 1929, and the solutions advocated for construction (prefabrication and industrial standardization) had as their primary effect an increase in unemployment. This was fully demonstrated by Christian Borngraeber in "The Social Claims of the New Architecture": "Rationalization in architecture has led to the elimination of entire craft-guilds, notably roofers and joiners. The result will be an increase in the number of the unemployed. Some 90% of new residential houses have flat roofs. The main roofers' union complained, in a letter to the magistracy, of the catastrophic social and economic consequences of this type of architecture. In midsummer, 40% of roofers and 75% of workers in slate-quarries were jobless. Flat roofs had been adopted as an economic measure,

but it had not been considered that thousands of square metres of slate roofs might have been put up simply with the unemployment benefits paid to two-thirds of the roofing trade" (in *Paris-Berlin*, exhibition catalogue, Centre Georges Pompidou, Paris, 1978). And the same was true of all the other trades and even the "production stations" organized by the municipalities to give work to the unemployed, but administered with the same rationalist ideas; they increased the effects of the crisis by extending it to sectors of the economy that were still little affected.

In parallel there was Ernst May's idea of creating satellite towns around the old city: "The ideal residence for the city-dweller in love with nature," following the slogan for Römerstadt, considerably increased the "communications" budget of the cities while straining the budget of each family by creating a new heading: transportation. The failure was complete, to the point where "the worker can no longer permit himself the heavy consumption of heat entailed by central heating," and Nazi propaganda did not wait to speculate on the disaster of this experiment in urban socialism.

At the end of 1930 Ernst May and Hannes Meyer emigrated to the USSR in the hope that a Marxist economy would enable them to carry out their social programme. The "culture of the habitat" having failed, jerry-can suburbs and shantytowns multiplied on the outskirts of the large German cities, before the Nazis salvaged certain functionalist programmes, turning them round so as to better subjugate the people. For functionalist theories presupposed the clearing away of inner aspirations in order to establish a community space, a goal towards which tended every totalitarian power, Fascist or Stalinist. The ultimate objective of the Constructivists was abandoned, but their experiments were recovered for use.

Frankfurt supplanted the garden city that devoured all the worker's leisure activities by a hygienic and collective space, the multiplication of public spaces to the detriment of volume with individual character. Thus the privacy of the room was replaced by the development of the lounge, placed under the eye of the mistress of the house, where the radio also throned; and we know what its role would be in regimenting the masses! Thus the family living space was already making room for the garden and communal lines of communication, and thus human functions began to divide into work, recreation, rest. The egalitarian urge opened the door to totalitarianism, which made its power secure in the streets, on the public squares and in the stadiums, those vast collective spaces where it is easy to keep watch over the crowd and manipulate it. The city would be functional or it would not be at all, thought the functionalists. They were blinded by rationalism; they forgot, in their desire for a new man, to take into account the right to individuality and above all the contingencies of real life. Dreaming only of the future, they carved out, defined, projected their utopias without recognizing that in life the beautiful and the useful do not necessarily coincide, and that the "normative" is more enslaving than liberating. By conceiving the city as space for production, consumption, traffic and amusement, they facilitated the baleful trilogy of Nuremberg: "Space, rhythm and light."

In their wish to create a paradise for humanity, they forgot man and nature, or at least ignored them. Already significant were these words of Mondrian: "The truly modern artist sees the metropolis as the giving of form to life in the abstract; it is closer to him than nature and it inspires in him the same feeling of beauty. For, in the large city, nature is already under constraint, ordered by the human spirit. The proportions and rhythm of the surface and line in architecture speak more directly to the artist than nature's whims; it is the place where from now on the mathematical artistic temperament of the future will develop, the place from which the New Style will come" (in *De Stijl*, I). The end of the twenties proved that the realization of the dream betrayed the utopia. It was in the politicians' interest not to recognize the fact, the better to pervert the goals which the artists set themselves.

The Russian builders were treated no better. Although the same problems were debated in Moscow within the Association of Contemporary Architects between 1925 and 1932, the achievements were rare which made it possible to define a new setting for life and which fostered the birth of a modern man.

Only a few private initiatives still allowed the new architecture to express itself. It was as difficult to induce firms to commission works as it was to imagine another's needs and reality. The fiction, the dream of the future could be pursued only in the imagination, the scale model, or in the art of illusion in the fullest sense, the cinema. *Metropolis* (1926), an expressionist film about the future, catalysed precisely the dreams without giving rise to social or political consequences.

William Van Alen (1882-1954): Spire of the Chrysler Building, New York, 1928-1930, seen between the RCA Victor Tower (left) and one of the towers of the Waldorf Astoria (right).

To many artists at the end of the twenties, painters, sculptors or architects, the stage appeared as the ideal locus for a synthesis of the arts: a constructible and habitable place where sound as well as human movement could provide a different ultimate end for experiments with light, space and dynamism. Under the impetus of those artists, the traditional Italian-style stage-picture turned into a slower-moving, many-sided space culminating in theatre-in-the-round.

This quest for a modern space was busily pursued in the theatrical activities of the Bauhaus. For Lothar Schreyer, the theatrical work was but another form of the work of art testifying to the "unity of life by the multiplicity of the living." And shortly afterwards, Oskar Schlemmer gave in his Diary (1929) an excellent definition of the Constructivist effort in theatre: "The recipe followed by the Bauhaus theatre is very simple: as few prejudices as possible; approach the world as if it had just been created; don't brood things to death, but let them develop, cautiously but freely. Be simple, not poor ('simplicity is rather too grand a word!'), better to be over-simple than finicky or pompous; don't be sentimantal but witty, which is to say all and say nothing! Again, start out from the elementary, what does that mean? Start from the point, the line, the simple plane, start from the simple composition of surfaces; start from the body, start from the simple colours, red, blue, yellow and black, white, grey, start from textures, experience the different textures of glass, metal, wood, etc., and fully assimilate them. Start from space, from its laws and mystery, and let oneself be 'bewitched' again. Everything is said and nothing is said, so long as these words and ideas have not been experienced and become pregnant with meaning."

Schlemmer was in charge of the theatrical department of the Bauhaus, where he staged epoch-making performances by using the actor, dancer or mime in a space built with the aid of all the resources of light and materials furnished by contemporary technology. "The question," he further wrote in 1929 in his Diary, "is above all to see if

The theatre as a synthesis of the arts

△ Walter Gropius (1883-1969): *Project for a Total Theatre, 1927. View of the interior.*

▷ Oskar Schlemmer (1888-1943): *Stick Dance, 1927.*

the event called dance can be produced starting from the elements of space, form, colour. They turn into that event when the words and concepts space-form-colour and all their various manifestations such as cube, sphere, pyramid... have become sensations and, so to speak, flesh and blood: constituent and indissoluble parts of the sentient universe and corporeal consciousness, putting forth their magical force in a real and continuous manner." For Schlemmer, the theatrical workplace was the experimental frame making it possible to recognize the space occupied by man; to bring out his rhythm. In his experiments with the limits of the body and its rhythm in space Schlemmer foreshadowed what would become the subject of contemporary dance in the seventies: the representation of body reality.

Even if they pursued different ends, the experiments of Meyerhold in Russia and Piscator in Germany showed a very similar orientation. Using artificial lighting, projections of colours and images, or even films, they completely "denaturalized" the place of theatrical representation, emphasizing the specific characteristics of stage space. The theory of alienation-effect grew out of the complexity of the theatrical workplace, and produced a new relation between actor and spectator, which Piscator expressed in the *Red Revolution Revue* in 1924, when he introduced film sequences, touching off a provocative explosion of the traditional stage. His object was not to tell a story but to explain events, and he brought into the theatre those techniques which properly belonged to the film: montages, close-ups and travelling shots.

Piscator's political programme was unambiguous: the subordination of every intent to the revolutionary objective, with accent placed deliberately on the class struggle and the means of propagating it. But to make his activity more effective, Piscator freed the stage from all its conventions. Reflecting the spirit of the Dada photomontages, he shattered the traditional unity of time, place and action. His way of using stereotypes and symbols, of acting intensely by making play with close-ups to reveal the essential, of making space as dialectical as speech, won him a large popular audience. His ideas were adopted by numerous "agitprop" theatrical companies originating in workers' theatre groups, partly amateur, which toured all over Germany and revived improvisation, using current events to make their political discourse more convincing.

In an article in 1920 (in *Der Gegner*, 1920-1921, No. 4), Piscator stressed the relations which he maintained with the art of his time, and which enabled him to work together with men as artistically and politically revolutionary as Grosz and Heartfield. "The style, to be mastered as much by the actors as by the author, must be entirely concrete (analogous as a whole to the style of a manifesto by Lenin or Chicherin, which has a sure-fire emotional effectiveness, if only by its simple and clear rhythm, admitting of no mistake). Whatever is said must be said without vain affectation, without having recourse to 'experience' or 'Expressionism,' without any contortions; it must be said in conformity with the revolutionary will... That excludes *a priori* all Neo-romantic, Expressionist or other styles and problems springing from the individual and anarchistic claims of the bourgeois artist. Of course, one must not neglect to utilize the latest technical and stylistic artistic resources, to the actual extent that they serve the aims already stated, and not just any personal version of an artistic revolution achieved through formal studies."

In the USSR a similar search for popular theatre had developed from the pageantry celebrating the revolution; often it utilized the resources of still flourishing regional folklores. All these forms of theatre renovated the space of the stage, but they also gave a new meaning to stage movements by breaking with realist imitation, for example by reintroducing the wearing of masks.

This insistence on the effectiveness of communication is significant of the consciousness many artists had of the final aim of their work. It involved the educational and pedagogical concerns of the largest number of them, whatever their background. Art again found the need for a certain conditionality, but outside any problem of taste or style.

The worker Prissypkin, who yearns for a cultured life and repudiates his social background, marries a hairdresser's daughter. The "red wedding" ends with a fire in which everyone perishes except Prissypkin, who is frozen in the water hosed in by the firemen. Fifty years later, in 1979, he is found in the cellar, preserved in a block of ice, and the Institute of Human Resurrections decides to bring him back to life. In the cold, rational, algebraic world in which he is loosed, everyone looks upon him with disgust, and his only consolation is to find, climbing out of his collar, a bug, the only vestige of the past that is left to him. Shut up with his dear bug in the Zoo, he becomes its main attraction.

Theme of *The Bug*, a play by Mayakovsky
staged by Meyerhold at the Moscow State
Theatre, 12 February 1929

Oskar Schlemmer (1888-1943): Metal Dance, 1929.

Liberating sculpture from the mass

Brancusi in his Paris studio with the Golden Bird, *1922. Photograph by the artist.*

There was no surer sign of the incomprehension met by contemporary artists in the circulation of their work than the court battle between Brancusi and the United States Customs. In 1926, the Brummer Gallery in New York organized Brancusi's first big one-man show from 17 November to 15 December: thirty-seven sculptures, five pedestals, a painting and twenty-five drawings. The U.S. Customs seized the *Golden Bird*, finished the same year. Brancusi had declared it as a "work of art" worth 600 dollars; the Customs rejected its description as art and demanded for this "piece of metal" 210 dollars in duty. The artist sued and the trial lasted two years. The question whether the *Golden Bird* was a work of art gave rise to debates over the definition of art and beauty, and led the artist to provide explanations of his artistic intentions. Influential witnesses came to his aid: the sculptor Jacob Epstein, the art critic Henry MacBride, William Henry Fox, the director of the Brooklyn Museum, the photographer Edward Steichen.

It was easily proved that Brancusi was a professional sculptor. The debate became trickier when an answer had to be given to the question: "But is the *Bird*, properly speaking, a work of art?" For Steichen, it was an artistic work by virtue of form and balance; if the form was born of the sculptor's vision, the balance lay in the dimensions. Epstein stressed the pleasure which that form suggested to him, while William Fox spoke of the quality of emotion it stimulated in him. The experts representing the Customs Department, two traditionalist sculptors, refused to call the *Bird* a work of art.

On 30 November 1928 in Paris Brancusi finally received the court's conclusions: "The *Bird* is doubtless not a work of art of imitative character, but, in belonging to a 'new trend' it is no less distinguished by its harmonious and symmetrical lines which render it pleasant to look at and highly ornamental." It was besides "the work of a professional sculptor whose 'abstract' method must be accepted, by reason of its having spread throughout the whole world." The law thus granted freedom of the city to abstract art by stressing the importance of subjective and emotional qualities, just at the time when Brancusi's approach was already outstripped by the researches of the extreme avant-garde.

In quest of perfection, Brancusi applied himself to a few themes, seeking to purify to the maximum the form of their expression so as to place that form in harmony with his spirituality. Every detail which might harm the whole was gradually eliminated, enabling him to attain a language of great symbolic clarity. By the polish and perfection of his workmanship, archaic forms were revitalized, losing their temporal character to exalt only the elemental and absolute sentiment of life, which radiated from a core to the ultimate inflections of the volume. But the theme of the *Bird*, more especially, allowed Brancusi to break away from classical equilibrium to rediscover that leap into space which characterized contemporary sculpture. The polishing of the materials further strengthened the dynamism of the mass; by reflecting the light it opened out directly into a dialogue with its surroundings.

It was in this search for lightness and the expression of a universal rhythm that Brancusi found common ground with the younger generations. But was not the theme of flight in partial contradiction with the heaviness of the traditional materials which Brancusi continued to employ? As a matter of fact, the idea of flight ("it was flight," he said "that occupied me all my life") translated the need to express perfect mobility, the desire to escape the weight of the world.

By very different means, Jacques Lipchitz (1891-1973), who had received the classical training of a sculptor, expressed the same needs for space and depth. After his Cubist phase, during which, for the first time in 1916 in *Man with a Guitar*, he had made a "tunnel" through a dense solid volume (and the importance of this "hole" which transformed spatial tension would not go unnoticed by the young English sculptors, Moore and Hepworth), he returned in 1924 to transparent structures in bronze which freed him from the solid mass.

The series of small bronzes which he modelled from 1925 onwards enabled Lipchitz to make a fresh start on his spatial experiment. Eliminating every effect of volume, he played with convex and concave surfaces that filled space in a lyrical and dynamic way. His subjects, the characters of the *Commedia dell'Arte*, encouraged fantasy; but it was more particularly the instruments carried by the figures

Jacques Lipchitz (1891-1973): Musical Instruments, 1925. Bronze.

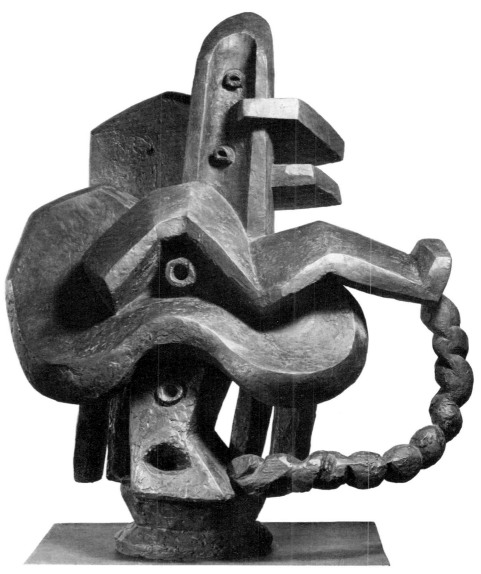

(guitar, violin or lyre) which allowed him to make previously untried spatial experiments, by the incorporation of metal grating or lattice-work, bringing another (total) opening up of space. Not only did Lipchitz reject the closed and dense character of traditional sculpture, but also, by giving the impression of assembling (rather than modelling or sculpting; in other words by bringing together dissimilar flat elements), he directly heralded the experiments in wrought and welded metal that Picasso and Gonzalez would carry out, and which were already being tried by Gargallo. In fact, Lipchitz utilized all his skills and the resources of the metal-casting trade to succeed in creating pieces of such lightness that they could not have been made using any other technique than that of metal founding. Here he introduced a completely different use of space, and, in his later, more lyrical work, he still remembered the transparency and soaring movement thus mastered, which would finally free him from the burden of Cubist construction.

Settled in Paris since 1923, Pevsner applied himself regularly from then on to sculpture. His experience as a painter gave him a different awareness of space, and he sought to escape from Euclidean depth. In his youth he had been fascinated by the impression of the infinite conveyed by Russian icons; and it was this notion of the "limitless" which he tried to express in his painting and sculpture, relying essentially on the resources of light and transparency. He rediscovered this subjective dimension in incurved planes, in the dynamism of profiles or volume-edges serving as a passage between the opposites obtained by the positive-negative play of light and shadow, of the full and the empty. Through radiance or rupture, he tried to suggest the infinite in life. Pevsner remained attached to that constructive concept which he had defined together with his brother Gabo, but he used it as a spring-board to go beyond what could be defined. Each of his works appears

as a free construct of the imagination which resorbs masses in the tension of lines of force; these would later be transformed into developable surfaces.

Katarzyna Kobro was equally fascinated by space. Born in Poland in 1898, she came under the influence of Archipenko before becoming one of the most rigorous Constructivist sculptors. As early as 1925 she took possession of the void as a fundamental dimension of sculpture. The traditional term "sculpture" loses its meaning when applied to her creations, since Kobro not only completely destroyed volume, but also blurred the spatial position of the metallic bands which defined her spaces by painting them in primary colours. Her objects thus presented profiles that were always different. As the companion of Strzeminski she played a fundamental role in the development of Constructivism in Poland. In an essay signed by her and Strzeminski (*Space Composition. Calculations of Space-Time Rhythm*, written 1929, published in Lodz, 1931), Kobro clearly showed her feeling for space: "Each sculpture contains within its bounds a well defined part of space. That is why we can say that sculpture encloses space. The boundary of the sculpture is the demarcation line which clearly separates the space situated outside the sculpture from the space contained within the sculpture. We may thus consider that this limit determines either the interior space or the exterior space. The essential characteristic feature of sculpture lies in the fact that it is not the shaping of the interior space alone. We may just as well consider that its surface, its boundary, confers a form upon exterior space, a form in accord with that of the volume. Each sculpture poses, in this way or another, the most important problem: the relation of the space contained in the sculpture to the space located outside the sculpture." So clear-cut an expression of this fundamental problem would have been unthinkable twenty years before.

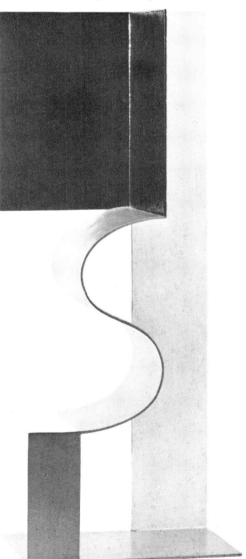

Katarzyna Kobro (1898-1951): Space Composition 6, 1931. Painted metal.

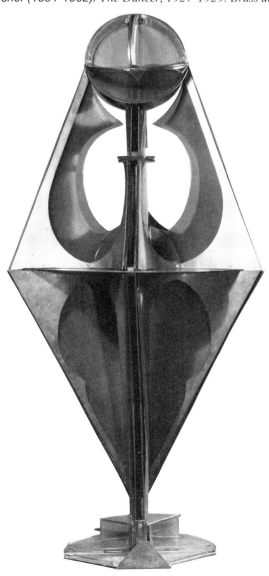

Antoine Pevsner (1884-1962): The Dancer, 1927-1929. Brass and celluloid.

151

Photography

A new art of propaganda

*Laszlo Moholy-Nagy (1895-1946):
Jealousy, 1927. Photoplastic.*

With the invention of photomontage, the Dadaists stressed the effect produced by photography and displayed its different operational characteristics. They had radically severed the mimetic connection with appearances which photography had maintained since its invention; they had set its constructive faculties free, but had also revealed its technical potentialities. After that, the practice of photomontage would develop along two main lines, formal and political. With scientific and technical developments asserting themselves as the reality of our age, Constructivists of all tendencies subjected the mechanical nature of photography to their creative power. They discovered another field of experiment belonging directly to the domain of communication. Moholy-Nagy summed it up in two characteristic statements: "The reality of our century is technology: the invention, construction and maintenance of machines. For us today, to use machines means to act" (in *MA*, Vienna, 1922). And again: "Compared to the process of creation, problems of execution are important only so far as the technique adopted—whether manual or mechanical—must be mastered" (in *Abstract of an Artist*, New York, 1947).

In Germany John Heartfield quickly grasped the potential political power of photomontage. From his first photographic collages he had shown that this technique gave him an efficient means of struggling against bourgeois art and culture, forms of expression which seemed to him obstacles on the road to the self-assertion of the proletariat. Thereafter he estimated his artistic production according to its efficiency, that is, its contribution to organizing the struggle against capitalist power structures. He wanted his works to lead not to contemplation but to action. The montage allowed him to analyse and dismantle social reality in order to change it. It stimulated perception by questioning the homogeneity and harmonious totality of traditional illusionism in order to stress the contradiction of its relations. In an important speech delivered in Moscow in 1931 (and published in 1936 in the monograph devoted to him by the Ogis publishing house in Moscow), Heartfield outlined his scheme: "Photography is a mechanical device; photomontage is a piece of work done with the product of photography. That entire process forms one whole. The expression 'shoot a film' is reactionary; we must say 'mount a film,' that is, construct it, create it... If I assemble documents and juxtapose them with intelligence and skill, the effect of agitation and propaganda on the masses will be enormous. And it is that which is most important for us. It is the very basis of our work. There lies our task, which is to act on the masses in the strongest, the best, the most intense way possible. If we succed, we shall have brought a true art into being. We must utilize all the resources of photography down to the last detail to show the masses the class enemy in his true colours." And he con-

cluded: "Photomontage has always been a weapon in the hands of revolutionary artists, and it will remain so."

Such a speech, delivered in Moscow, was addressed to an experienced public, since the Russians, very early on, had also used the resources of photomontage, which they called "factography." El Lissitzky, for example, conscious of its power of "representation," declared: "Art is no longer a mirror of the people's consciousness, but the organizer of it... there being no mode of representation as wholly comprehensible by the masses as photography," while Gustav Kluzis stressed the bond between photomontage and industrial culture: "Photomontage: a new art *of agitation*... A new demand is making itself felt, that of an art in the form of a technique attaining the level, in respect of its resources and internal chemistry, of socialist industry."

If before the First World War publicity and politics had never met, during the war on the contrary all the countries involved seized control of publicity to promote war loans and recruitment, or simply to reassure the people and give them ideological comfort. Once the habit had been acquired, after the armistice the main political parties employed publicists, who found in that capacity an additional reason to become integrated into the life of society. Thus the publications of Heartfield, who worked regularly for the German communist party, scored such a success that they gave Hitler cause for concern. The latter declared as early as 1925: "I was always extremely interested in propaganda. I saw in it an instrument which, precisely, the Marxist social organizations used with masterly skill... I very soon understood that the judicious use of propaganda is a veritable art, which was and has remained practically unknown to the bourgeois parties." Hence, from then on, the intensive use of colours and symbols in Nazi propaganda. It reached the point where the philosopher Ernst Bloch observed in 1933: "When two individuals do the same thing they don't carry it out in the same way. What, then, is the result when one wishes to imitate the other in order to deceive? So today, when the Nazi cannot as yet show his true face, nor what he wants to accomplish, he adopts a disguise. The Nazis steal. The first thing they stole was the colour red..."

When in 1934 Walter Benjamin defined the author as a producer, he was making a synthesis of what had really taken place in Germany and the USSR: "The goal of factography is social change. It is an operative task, not one of information. The producer-author works in solidarity with the proletariat."

It was essentially within the framework of the Moscow periodical *Novi Lef* and under pressure from Mayakovsky and Rodchenko that this concept of factography was defined, an occupation of partly artistic, partly scientific, but also journalistic nature, utilizing facts to analyse what they conceal and bring them into the dialectic of critical thought. Rodchenko saw in the use of photography the most natural means of integrating art into production. In 1922 he became interested in photography, which just then was making considerable strides in the USSR owing to the necessity for information and for the creation of effective propaganda material. In 1923 Rodchenko composed his first photomontage to illustrate Mayakovsky's poem *Pro Eto* (About This), and from this time on the two artists began a long partnership as publicists: they called themselves "publicity constructors." Within two years they produced over fifty posters and a hundred advertisements. It was the lack of possibilities in industrial production and general scarcity that drove the Russian Constructivists into publicity activities, those least compatible with their utilitarian conception of art. But they found in publicity work a real field for developing their pedagogical ideas; all subjects seemed good to them to awaken revolutionary aspirations in a country where illiteracy was still widespread.

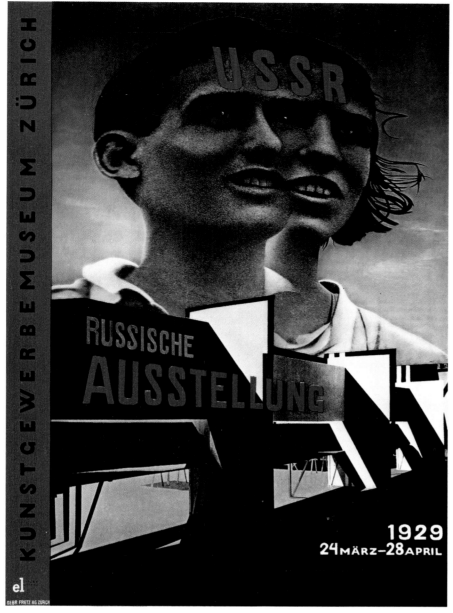

In the review *Kino-fot*, launched by Alexei Gan in 1922, the latter developed the Constructivist theory of the cinema-eye *(Kinochestvo)*: the mechanical eye registers reality more exactly than the human eye, by analysing it from a new point of view. This phenomenon was also noted by Mayakovsky, when in speaking of the cinema he said: "For you the cinema is a show. For me it is almost a vision of the world. The film transmits movement. The film makes literature over again. The film explodes aesthetics. The film is courage. The film is a sports-lover. The film circulates ideas."

Rodchenko occupies an important place in the illustration of these ideas, since he was responsible for most of the cover designs of *Lef* and *Kino-fot*. In 1927 he carried out his first assignment as a reporter and when the Lef group was dissolved he became a professional photographer. Photography still represented a profession in which he could put his Constructivist ideas into practice; he exploited the autonomy and specificity of mechanical resources, stressing the guidance of the eye, depth of field, rigour of composition. In an article in 1928 entitled *The Roads of Contemporary Photography* (in *Novi Lef*, No. 9), he defined his programme: "We must seek (and, do not fear, we shall find!) the new aesthetic, the enthusiasm and the pathos which will enable us to express the new Soviet facts by means of photography in an artistic language. A snapshot of a reconstructed factory is not for us simply the picture of a building, but the share of pride and pleasure caused in us by the industrialization of the land of the Soviets, and we must find the means of perpetuating that sentiment. Our duty is to experiment until we succeed."

However it was not long before Rodchenko became a target for the attacks of traditionalist artists, who once more took over the organization of Russian culture; they denounced his conception as "formalist, an aesthetic in imitation of the West." From 1930 on, barred from teaching, he could act only through photography, and even there his subjects were often imposed on him: books on sport, the circus, parades, or special numbers of magazines devoted to the building of the Soviet Union. Starting in 1929, the avant-garde in the USSR was irrevocably condemned. Mayakovsky was the victim of the same discrimination; in that regard his last exhibition is significant. Covering twenty years of activity of the greatest poet of the revolution (on the literary front he had been at the centre of the transformation of an art of sublimation into one of production), it was held in February 1930 and given only three rooms in the Writers' Club in Moscow. There Mayakovsky met with a popular success, but administrative difficulties were deliberately heaped in his path. He had been seeking less a political poetry than the affirmation of a total concept in which the social combat would be organically integrated in the choice of language and the rhythm of its respiration. He had wanted to bring art to the masses and create a society where all would participate in artistic action. The enforced silence he saw threatening him could not help but contribute to his suicide. His poem *At the Top of My Voice* remains his testament.

Socialist realism triumphed in all sectors. Leaning on tradition, flattering its consumers, it set out to present "the life of our times, the life of the Red Army, of workers, peasants, heroes of the revolution and labour" (Manifesto of the Federation of Artists of Revolutionary Russia, 1928).

John Heartfield (1891-1968): Communist election poster, 1928. Photomontage.

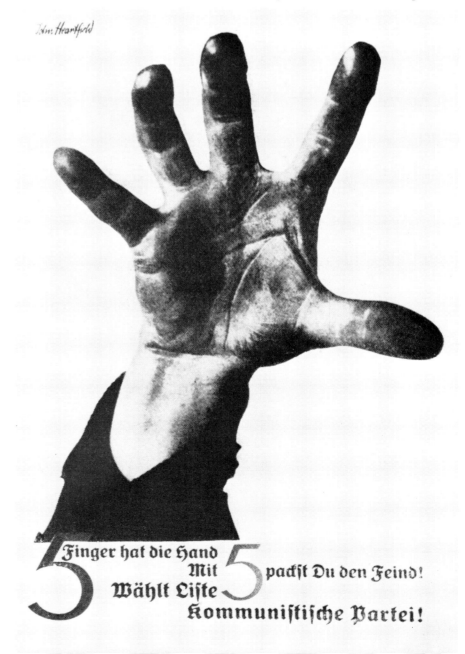

Edward Weston (1886-1958): Artichoke, halved, 1930. Photograph.

ing of the film and improvement in optics—transformed the craft of the photographer. He could work much more rapidly, in conditions of minimum lighting, and above all he could take pictures without being seen. Weston had already given up the "artistic soft focus" of his first phase when he travelled to Mexico, where he came to a different awareness of the real. He noted in his *Daybook*: "The camera must be used for recording life, for rendering the very substance and quintessence of the thing itself... I shall let no chance pass to record interesting abstractions, but I feel definite in my belief that the approach to photography is through realism." And he added: "Unless I pull a technically fine print from a technically fine negative, the emotional or intellectual value of the photograph is for me almost negated." We can see that this definition of realism or photorealism is the opposite of that given by the Russian or German Constructivists. It locates the "true" in the external model, of which the film is but the mirror, and in the eye of the photographer, who merely tries without cheating to restore what he perceives.

A similar attitude led Charles Sheeler to reverse the traditional relations between painting and photography. If the photographer heretofore had often tried to recreate the effects of painting, Sheeler

Photographic realism

Whether to see things as they are or as one would like to see them—or rather as those who commission works would like to have them seen—has always been a serious problem which artists of every age have had to face. But when, during the 1920s, photography took on a privileged position in the press, photographers began to worry about the use editors intended to make of their negatives; their liberty was directly threatened from the moment the "documentary" image began to fill gaps in printed news and their production became incorporated into the media system. In the United States, before 1914, under the impetus of Lewis Wickes Hine and Jacob A. Riis, sociological photography had shown itself as an efficient political weapon; that was why the lords of the press were determined thenceforth to control its effects, and those who did not submit to their laws risked being sacked. The position of many photographers was in fact very precarious, as these bitter extracts from the *Daybook* of Edward Weston bear witness: "This Sunday morning, June 26, 1927. I've been very unlucky. Chandler lost a 5-dollar bill I gave him to pay the grocery. That money came from the sale of a print which brought in 10 dollars... just enough to hold out for a week."

Those who let themselves be converted into newspaper photographers took the star role. The progress made in technology—lightness and manoeuvrability of the cameras, size of the negative, sensitiz-

Ansel Adams (1902): Monolith, The Face of Half Dome, Yosemite National Park, 1926. Photograph.

did exactly the opposite. His oils recaptured the effects obtained by photography in a kind of hyperrealism before its time. But because his pictorial practice was not studied or erected into a theory, his work as a photographer appears much purer and more significant. In other words, his painting holds the interest only in proportion as it illustrates his photographic vision in colours. Sheeler was a creator essentially by his practice of the "pure photo," by the revelation of the intrinsic properties of his resources and of the transmitting medium. That practice, discovering new forms, modified the relationship to the world, displaced knowledge, exploited the acquisitions won by a technological civilization.

In this kind of expression nature rediscovered its rights, since it once more provided ideas and subjects. A "realist" chapter is bound to begin each time there is a sweeping change in man's consciousness of nature, and especially in the distance between the observer and the observed. At the end of the twenties the problem was to see, outside all sentimentalism, utilitarianism or functionalism, a "reality" more than ever determined by the technique and the industry that reflected it. It was impossible here to dissociate the means of representation from the content. Photography, from then on, became incorporated

into daily life to the point where, by being too much seen, it was no longer looked at. The fact was emphasized by Gisèle Freund, a French photographer of German birth, trained precisely in the context of these years, who reflected and wrote a great deal about the conditions of her art. "It [photography] is the typical means of expression of a society founded on a civilization of technicians, conscious of the aims it has set for itself, rationalist in spirit and based on a hierarchy of professions. At the same time photography has become a first-rate tool for this society. Its power of exactly reproducing external reality, a power inherent in its technique, lends it a documentary character and makes it appear as the most faithful and impartial process of reproduction of social life" (Gisèle Freund, *Photographie et société*, 1974).

But Gisèle Freund also warned against the artificialness of that impartiality: "For photography," she said, "although strictly bound to nature, has only a factitious objectivity. The lens, that supposedly impartial eye, permits all possible distortions of reality... The importance of photography thus lies not only in the fact that it is a creation, but above all in the fact that it is one of the most effective means of shaping our ideas and influencing our behaviour."

Charles Sheeler (1883-1965): Funnel, 1927. Photograph.

Charles Sheeler (1883-1965): Upper Deck, 1929. Oil.

Poster for "Film and Photo,"
International Exhibition
of the Deutscher Werkbund,
Stuttgart, 1929.

August Sander (1876-1964):
The Businessman and
Democratic Party Parliamentarian,
Cologne, 1928. Photograph.

Such an "objective" photography developed in Germany through the work of artists like August Sander (1876-1964) and Albert Renger-Patzsch (1897-1966) just when the New Objectivity was asserting itself in painting. Sander appeared as the most ruthless of documentarists while seeming to look the other way. In relentlessly fixing his models on film he gave a new look to what was already known. Through the physiognomy and the attitude of his characters, he sought to reflect their occupations, their work, and also their place in the social hierarchy. His scheme to compile a veritable encyclopaedia of twentieth-century man comprised forty-five volumes of twelve photos each. Only the introductory volume, *Antlitz der Zeit* (Face of Our Time), was published, in 1929. In the preface, the novelist Alfred Döblin described these straight photographs as a "sociology without text." "In the same way," he said, "that there exists a comparative anatomy which makes it possible to get an idea of the nature and history of bodily organs, so this photographer practises comparative photography, attaining thereby to a scientific viewpoint far superior to that of photographers who lose themselves in detail." Sander's work would appear suspect to the Nazis, who withdrew the album from sale, and it was only by a miracle that he was able to save the negatives destined for the remaining publications.

This return to resemblance could not fail to sound an alarm for a theoretician like Bertolt Brecht, who reacted by denouncing photographic mimicry. "The situation," he said, "becomes complicated because less than ever does the simple fact of portraying reality tell us anything about that reality." If he distrusted photography, however, he recognized its possibilities, as is shown by an unfinished text (Ber-

Photography as art... **Art as photography**

tolt Brecht, *On Realism*, 1937-1941): "Photography must leave behind the era when the artist never sought anything but to show, sempiternally, all the beautiful things that could be done with a camera; especially when he wished only to prove that one could do with a camera what could be done equally well with a brush." He condemned those who stated: "a chair is a chair." As a convinced Marxist, he aimed at a "transformation of the world, which is no longer inhabitable," and, noting that a "photo of the Krupp factories or the AEG doesn't reveal very much about those institutions," he affirmed that political awakening could not be located in the image of the factory. "Reality, strictly speaking, has slipped into the functional. The reification of human relations, the factory, for example, no longer reveals what is ultimate in them. Thus it is necessary, in fact, to construct something, something artificial, manufactured" (quoted in Walter Benjamin, *A Short History of Photography*). This realization thus led Brecht to move away from resemblance: "Artists have almost always discouraged those who wished to set up as a criterion the resemblance between their images of reality and reality itself," he remarked, and finally gave realism the following definition: "The work of the artist is not just evidence of beauty concerning a real object... it is not a beautiful testimony about the beauty of the object; it is precisely and before anything else an account of what the object is, an explanation of the object. The work of art explains the reality to which it gives form; it gives an account of and transposes the experiences which the artist has had in life; it teaches how to see the things of the world clearly. Artists of different periods naturally see things differently. Their vision does not depend only on each of their personalities, but also on the knowledge of things possessed by them and their time. Our time demands that we consider things in their process of development, as things in transformation which are influenced by other things and other processes. We find this way of seeing things in our science as well as in our art." And he concluded: "What matters above all is to teach sound thinking: thinking that questions things and events to extract from them the aspect that changes and that can be changed" (Bertolt Brecht, *On Realism*, 1937-1941).

In 1929 two events paid tribute to the importance of photography: the exhibition at the Folkwang Museum in Essen, and the display *Film und Foto*, organized by the Deutscher Werkbund (German Arts and Crafts Society) in Stuttgart, the veritable sanctioning of a new way of seeing. Presented in Essen in January, the exhibition *Photography of the Present* was afterwards shown in Hanover, Berlin, Dresden, Vienna and London. It enabled the writer Wilhelm Kästner to make a distinction between pictorial and photographic realism: "As with painting, here too one might speak of *Neue Sachlichkeit* (New Objectivity), except that the relation between the photo and the painted picture is reversed by comparison with what formery happened, in so far as the new objectivity in painting seeks a greater photographic accuracy in the *pictorial* reproduction of the object. In photography, this objectivity is expressed in the *strict* reproduction of the object, in its exact development, in virtual isolation from the environment and background, in a multiple, searching illumination that eliminates shadows to the greatest possible degree or uses them merely as outlines of pictorial elements; and above all in the preference for clearly perceptible solid objects with a formal structure easier to apprehend than that of the painting" (in *Fotographische Rundschau*, 1929).

◁ *Florence Henri (1893):*
Marseilles, 1930. Photograph.

Albert Renger-Patzsch (1897-1966):

△ *Cable Railway, 1928. Photograph.*

▷ *Untitled, 1928. Photograph.*

The "Film and Photo" exhibition in Stuttgart in 1929 brought together more than a thousand photographs. It established the reputation of Moholy-Nagy, El Lissitzky, Rodchenko, Steichen, Weston, Man Ray, Renger-Patzsch, Sander and others, several of whom helped to organize the show.

The exhibition was afterwards shown in Berlin and Vienna. Its originator, Gustav Stolz, introduced it as follows: "Photography today has reached a turning-point. Formerly it was thought that artistic effects could be obtained by removing, with the aid of many retouches, everything which gave photography its distinctive character, namely, precision, sharpness, clarity, truth to nature... Things are different with the photography of today. It uses only the technical resources offered by the camera to carry out its work. And thereby it obtains effects denied to the hand of man. An incredible truthfulness to nature from the material point of view, an extremely rapid seizure of the most outstanding moments of a movement, represent its most characteristic successes. The improvement in technical equipment also makes it possible gradually to get away from the frontal, panoramic shot. The camera comes right up to the object, takes it from the side, from above, from below, thereby bringing out entirely new aspects of what it photographs."

The well-known German typographer Jan Tschichold also took part in organizing this exhibit, and he stressed the role which photography henceforth played in news, communications and publicity. In his manual published in 1928, *Die neue Typographie*, he devoted a chapter to the use of photography, and wrote in particular: "Today with the help of photographs we can express many things better and faster than by the inconvenient channel of the spoken word or of writing. The photographic negative thus takes its place alongside the letters and lines of the typographer's type-case as a modern but distinct element of typographical structures."

Renger-Patzsch showed in his work how photography made it possible to recognize and bring out a subject. He illustrated what had been already advocated by Moholy-Nagy in 1925 when he said in his book *Malerei-Fotografie-Film*: "The camera can improve, not to say complement, the optical instrument which our eye is for us. This principle has already been applied in certain scientific experiments such as the study of movements (walking, jumping, galloping) and of mineralogical, zoological and botanical forms (enlargement, microscopic shots) as well as other studies in natural sciences; but these experiments remained isolated and the relations between them were not observed. Until the present, we have utilized the potential of the camera only in a secondary sense. That is clearly apparent in photographs which are described as 'defective'—views with a single plane, views from beneath, sidelong views, that already startle us even when they are due to chance."

In the French group, besides Man Ray (and Atget, whom Breton had extolled in 1926 in *La Révolution Surréaliste*, now discovered at last), were the newcomers Kertesz, Florence Henri, Berenice Abbott. In an article illustrated with photomontages, photographs and photograms ("Photography, What it is, What it Shall Be," in *Cahiers d'Art*, No. 4, 1929), Moholy-Nagy wrote: "Invented a hundred years ago, photography has only just been discovered... The first attempts are somewhat primitive, often even crude, and, by reason of their very sincerity, always rudimentary. But we possess verifiable ideas which will serve as a guide to the progress needed. (1) Photography is a light-image which must correspond to a deep sentiment of the inner life (photogram). (2) Photography is the documentary conception of the external world, such as it is given us by the sense of sight (photography by camera obscura)... One imagines appearing here the first symptoms of the relativity of learning; a sublimation, an intellectualization of the media of creative power."

In an article on photographic realism (*Cahiers d'Art*, 1935) Man Ray pointed to a phenomenon already made fully observable by the *Film und Foto* exhibition: the social impact of photography, "that force acting by immediate necessity of the social contact, upon which it [photography] depends. As with the spoken word, the demand of diffusion and attention photography makes upon the mass public brooks no delay... We must therefore accept that a photograph, by reason of its current social dependence, is made for the moment; and alongside that requirement, the personality of the cameraman becomes of secondary importance... If full confidence had not existed in the automatism of that eye functioning with a social conscience which physiology itself imposed, its force would have petered out in weaknesses. But when it was left unfettered the results, with a few exceptions, entirely justified the confidence it enjoyed."

With that thought, Man Ray takes us into the domain which Walter Benjamin sought to re-examine from the theoretical standpoint. Benjamin foresaw the political impact of photography, with its possibilities for reproduction that brought about a shift in the traditional relationships between art and society. In his essay, *A Short History of Photography*, he wrote: "To be sure, it is typical that discussions continued over the aesthetics of *photography as an art*, whereas scarcely any notice was taken of a much larger problem: the reality of *art as photography*. And yet the effect of photographic reproductions of works of art has much more importance for the function of art than the more or less artistic spirit of a photography for which the experience lived through has become *booty for the camera*." Benjamin grasped at that time the importance of having the images, whatever their origin, carried by media. He added: "Everything changes, however, if we pass from photography as art to art as photography. Everyone may observe how an image, but especially a plastic work, and in the highest degree a piece of architecture, is captured better on a photograph than in reality. There is a temptation to attribute this fact to a simple decline of the artistic sense, to a capitulation by our contemporaries. But we cannot help observing that at about the same time as the techniques of reproduction were being born, a change occurred in the way great works were apprehended. No longer could they be considered as the productions of individuals; they became collective products, so powerful that, in order to be assimilated, they had at first precisely to be reduced. In the last analysis, the methods of reproduction are a technique of reduction and afford man a degree of control over works of art without which he would no longer be master of them."

This denaturalizing or "de-realizing" effected by the media began in the 1930s, thanks to the conquests of the cinema and the success of illustrated weeklies. Thenceforth nothing would be as before, and the importance of photography as a product continued to grow at the same time that art was becoming more closely dependent on the process of photographic production or reproduction.

Once more the question may be asked: What is the real? The subject conveyed by the image, or the image in its specific technical character? The image, being at once the work and the representation of the work, involves the spectator in a new relationship of communication.

But the American artists represented in force at the 1929 Stuttgart exhibition did not have such theoretical worries. In Edward Weston's footsteps, they stayed in close touch with the subject of photography; their sensitivity, their vision, found expression essentially in subject choice, centring of the image, and specific technical features. Weston, moreover, affirmed that the photographer must picture the final image completely in his mind even before snapping the shutter. By the sharpness of his prints, he led the eye to remember all the details, as if each negative had been the sum total of a long optical promenade.

Man Ray (1890-1976): Still from the film L'Etoile de Mer, *1928.*

The collective name chosen in 1932 by the young photographers who admired him is significant: Group f. 64, adopting the technical sign for the smallest lens opening, that which produces the greatest sharpness of image.

Among these young artists was Ansel Adams (1902), who became a photographer after meeting Paul Strand in 1930. Through scientific verification of all technical data he soon reached a level of skill enabling him to catch the subtlest variations of substance and light. A nature-lover, he extolled in his work the most beautiful landscapes of the United States in a language that found its poetry in its rigour and integrity.

But already Carl Linfert was warning against a formalism that, becoming fashionable, brought forth a new fetishism. Giving his views on the exhibition *Das Lichtbild* (Essen, 1931), he wrote, in fact: "Photographs rarely express anything concerning what they transmit to us. But what we are offered holds our attention like a fetish. Ever since Renger-Patzsch, in fact, photographs have become something frightening... The mania for watching things and photographing them has grown to such proportions that everything is collected but nothing finally is perceived... The object itself, whatever the rigour with which the camera fixes it, becomes more mute than ever."

Man Ray (1890-1976): Dormeuse, 1929. Solarized print.

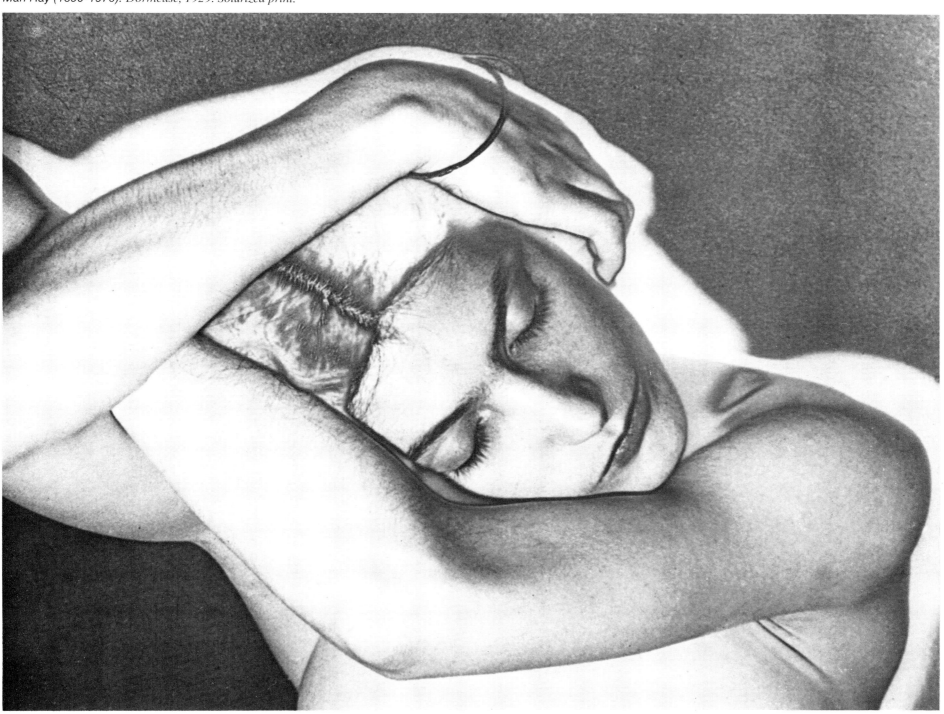

Son sourire, le feu, tombera sous forme de gelée noire et de rouille blanche sur les flancs de la montagne.

Max Ernst (1891-1976): Title page of his collage novel La Femme 100 Têtes *("The Hundred Headless Woman"), Paris, 1929, with one of the collage illustrations.*

The Second Surrealist Manifesto

In an essay entitled "Surrealism—Latest Snapshot of the European Intelligence" (in *Literarische Welt*, February 1929), Walter Benjamin declared: "Since Bakunin, Europe has not known a radical idea of liberty. The Surrealists possess one." But he also emphasized that the Surrealists could not avoid the inexorable choice "between anarchist grousing and revolutionary discipline." It was a clear statement of the problem that faced André Breton and his friends, and led to the drafting of the *Second Surrealist Manifesto*, published in Paris in the last issue of the review *La Révolution Surréaliste* (15 December 1929).

The year 1929 marked a turning-point in the development of the Surrealist movement, and this change of direction was basically due to political circumstances. The crisis broke over a meeting convened by Breton to examine "the recent fate of Leon Trotsky," who had just been exiled from the USSR by Stalin (January 1929). Breton contemplated a common action to support Trotsky, the admired revolutionary leader. In a provocative letter the poet asked the addressees to define their ideological position. The invitation was sent out to the Surrealists and to all intellecutals of the left. The meeting was scheduled for 11 March at the Bar du Château in Paris; the absentees were numerous, and many others replied in a mocking or rude tone. It was a failure. Just as the Paris Congress of 1922 had put an end to Dada, so the meeting over Trotsky split Surrealism.

In the *Second Surrealist Manifesto* Breton, defining the movement in relation to the revolution and politics, came straight to the point: "Despite the different individual approaches of each of those who claimed, or claim, affiliation with it, all must finally agree that Surrealism tended to nothing so much as to precipitate, from the moral and intellectual viewpoint, a *crisis of conscience* of the gravest and most general kind, and that only the obtaining or failure to obtain this result could decide its historical success or failure." The question, in fact, was whether the Surrealist revolution could remain purely internal or whether, if it continued as a spiritual movement, it could adapt itself to a political activity. "Everything inclines us to believe that there exists a certain spiritual point from which life and death, the real and the imaginary, the past and the future, the communicable and incommunicable, the high and the low, cease to be perceived as contraries. Now it would be vain to seek any other motive in Surrealist activity than the hope of finding that point."

This 1929 manifesto, which had little to do with art, was above all the occasion for settling scores: it pitted against each other attitudes that had become contradictory. For Breton, Surrealism had to end in a radical transformation of all sectors of "alienated life," a critique of labour, the family, morals, sexuality, etc. Could that transformation be achieved outside a critique of economic and political conditions? That was the question being asked.

Since 1925 and the Moroccan insurrection against French rule, the Surrealists had been drawn into relations with the French communists and contributing to their publications. However, in the pamphlet *Légitime Défense* (September 1926), Breton replied forcefully to Pierre Naville, who belonged to the Party. "There is not one of us who does not wish for the transfer of power from the hands of the bourgeoisie to those of the proletariat. Meanwhile it is no less necessary, in our view, that the experiences of the inner life should continue, and do so, of course, without outside regulation, even Marxist." Shortly afterwards, in November 1926, Breton excommunicated Antonin Artaud and Philippe Soupault, who had committed the other "crime" of considering their artistic activity as an end in itself.

To refuse to follow what Naville called the only revolutionary path, Marxism, and at the same time to reject the practice of art, was to walk a tightrope; the more so in that both in the political arena (rise of Fascism, eclipse of liberty) and on the artistic scene (the Surrealist gallery and review), pressures were ever increasing. There was a risk of trapping Surrealism in the vice of culture and preventing it from resolving the dichotomy between art and reality, precisely the breach it had set out to heal. In a lecture delivered in Brussels in 1934, Breton showed that he was fully aware of this double difficulty. "In reality, we are faced with two problems: one is the problem of knowledge, which at the outset of the twentieth century in fact made the relations between the conscious and the unconscious the business of the day... The other problem we face is that of the social action to adopt, action that, in our view, has its own method in dialectical materialism, action to which we cannot remain indifferent in so far as once more we hold the liberation of man to be the condition *sine qua non* of the *liberation of the spirit*, and that the only hope for the liberation of man lies in the proletarian revolution" (André Breton, *Qu'est-ce que le Surréalisme?*) But between the *Second Surrealist Manifesto* (1929) and this lecture (1934), Aragon, the loyal companion, had converted to Communism.

The 1929 manifesto was also a reaction touched off by temper or at least by circumstances, as Breton himself acknowledged in 1946 in the foreword to a new edition of it: "It was just around 1930 that the keen-minded were waking up to the impending, ineluctable return of worldwide catastrophe. In addition to the resulting bewilderment, I will not deny that for me there was another anxiety: how to steer out of the more and more imperious current the skiff that a few of us had built with our own hands to paddle against that very stream?" However, in that *Second Manifesto*, he made his position clear: "The problem of social action, I deliberately come back to it and I insist upon it, is but one of the forms of the more general problem which Surrealism obliged itself to raise: *that of human expression in all its forms.* Whoever speaks of expression speaks, to begin with, of language. It should not be astonishing, therefore, to see Surrealism placing itself first of all solely on the level of language, and on its return from whatever foray, coming back there as if for the pleasure of occupying a conquered country." This crisis thinned the ranks of the Surrealists; Ernst remained on his guard, Masson was excluded, Miró moved away, Man Ray came back, and, among the new members

appeared Tanguy, Magritte and, above all, Dali. In the *Second Manifesto* Breton spoke little of automatism and somewhat of the illustration of dreams; and it was this aspect which the newcomers would turn into images. All three, in fact, escaped the problems raised by twentieth-century painting through developing an abstract poetics in a realist imagery.

The son of a Breton sailor, Yves Tanguy was born in Paris in 1900. During his youth he spent his holidays in the family home at Locronan, and the seascape of northern Brittany left a deep impression on him. Following the family tradition he went to the naval officers' training school; at Lunéville, during his military service, he became friends with Jacques Prévert, with whom he came back to Paris in 1922, deeply disillusioned with military life. In 1923 Tanguy had seen in the window of the Paris dealer Paul Guillaume a painting by Chirico; it gave him the shock that would determine his choice to become a painter. His readings of the *Chants de Maldoror* and of *La Révolution Surréaliste* drew him to Breton; in June 1926 one of his paintings was reproduced in *La Révolution Surréaliste*. Tanguy's theatrical conception of the third dimension, brought out by an emphatic horizon-line, created a strange, indefinite space between earth and sky, from which details and figures emerged, handled in a more literal manner. Gradually these forms became more enigmatic and not without resemblances to those of Miró or Arp. But Tanguy put stronger emphasis on their volume. In them he rediscovered his memory of the rocks, plants and sea animals of his childhood days in Brittany. In these landscapes, halfway between the desert and the bottom of the sea, reigned a profound silence—deepened by the lengthening of the shadows—and a strange solitude, through which dimly flitted a few mysterious creatures.

Referring to him in *Le Surréalisme et la Peinture* (1928) Breton said: "I long to rejoin Yves Tanguy in the place he has discovered... The verbs of sense, to see, to hear, to touch, to taste, to feel, must not be conjugated like the others. To this necessity correspond the astonishing participles: already seen, already heard, never seen, etc. To see, to hear, is nothing. To recognize (or not to recognize) is everything. Between what I recognize and what I do not recognize there is myself. And what I do not recognize I would continue not to recognize."

△ *Yves Tanguy (1900-1955): Death Lying in Wait for its Family, 1927. Oil.*

◁ *Salvador Dali (1904): Illumined Pleasures, 1929. Oil and collage.*

161

Joan Miró (1893): Dutch Interior II, 1928. Oil.

The question
of representation

Breton, we see from the tone of his text, is at ease in speaking of Tanguy's work, for its imagery allows him to resort directly to metaphor to bring it to mind. He was to feel even more at ease with Magritte and Dali, whose expressions are still more centred on the staging of what they present. Magritte especially, in showing the distance between words, things, and images, asserts, according to Herbert Read, "the independence of the poetic idea in painting."

That is also Breton's observation in the short passage he devotes to Magritte in *Genèse et perspective artistiques du surréalisme* (1941): "Then again, Magritte's non-automatic but, on the contrary, fully deliberate approach, became from that moment on a mainstay of Surrealism. Alone in his tendency, he tackled painting in the spirit of the 'lessons of things' and, from that angle, systematically put the visual image on trial, taking pleasure in pointing out its weaknesses and observing the dependent nature of its figures of thought and speech. A unique undertaking, of the utmost rigour, on the borderline between the physical and mental, bringing into play all the resources of a mind exacting enough to conceive of each painting as the place for solving a new problem."

Born in 1898 at Lessines in Belgium, René Magritte studied at the Academy of Fine Arts of Brussels. Afterwards he earned his liveli-

hood by making drawings for advertisements or wall-paper prints; he formed a friendship with the painter Victor Servranckx, who drew him into a kind of synthetic Cubism. In 1925 he published, together with E.L.T. Mesens, a composer and an artist connected with Dada, the first and last issue of a Dadaist review, *Oesophage*. But from 1922 Magritte was especially dominated by the memory of Chirico, and that influence showed strongly in the works he exhibited at the Le Centaure gallery in Brussels in 1927 before leaving for Paris, where he met Breton and Eluard. It was the period during which he discovered his themes, his space and his technique; he would never change them: strangeness of surroundings, levitating objects, transparency, picture-within-a-picture, elimination of all relations of scale, transmutation of substances, etc.

In his book *Dada and Surrealist Art* (Abrams, New York, 1968) William Rubin has accurately summed up Magritte's contribution: "Using the ambiguous picture-within-a-picture, Magritte drew attention to his definition of painting as something other than the objective reality it represents. A realistically descriptive style like his runs the risk of having the painted image understood merely as a substitute for the object itself. Magritte rightly insisted, however, that his art goes beyond the creation of illusions of objects in combinations that might in principle exist on the same plane of reality as combined Ready-mades... For Magritte the art of painting consisted in representing images. But though the image is made up of illusions of obects... the conversion of these *objects* into the state of *images* transforms their meaning."

In considering the art of painting as "the art of describing thought that lends itself to being made visible and thereby to calling forth the mystery of experience," Magritte is close to Man Ray and his use of photography. For Man Ray too was alert to that critical practice of reporting the relations which exist between an object, its designator, and its representation. Magritte emphasized the gap particularly by his choice of titles. "The titles of my pictures accompany them in the same way as names correspond to objects, without either illustrating or explaining them," he said.

This illustration of the distance between signifier and signified, which Magritte was the first Surrealist to introduce into painting, has

René Magritte (1898-1967): Threatening Weather, 1928. Oil.

earned him a large posterity in the art of today, when many artists are examining precisely the questions posed by representation. In Magritte's work the image itself arouses suspicion and resists all one-sided interpretation. Magritte translates speech into gaze, turns the field of the visible inside out, and does so to a far greater degree than Dali.

It was not until 1966 that Magritte found in reading *Les Mots et les Choses* (Words and Things) by Michel Foucault a philosophy inquiring into the problems that he had been dealing with since 1928. He wrote to the author on 23 May 1966: "The words resemblance and similitude enable you to suggest forcefully the presence—completely strange—of the world and ourselves. However, I believe that those two words are scarcely differentiated; dictionaries are hardly enlightening as to what distinguishes them from each other. To me, for example, peas have relations of similitude among themselves, both visible (their colour, their form, their size) and invisible (their nature, their flavour, their weight). It is the same for the false and the genuine, etc. Resemblance does not exist among Things: they have, or do not have, similitudes... But painting brings in a difficulty: here it is thought which sees and which can be visibly described... Is the invisible then sometimes visible? Yes, on condition that the thought shall be exclusively composed of visible figures. In that regard it is obvious that a painted image, which is by its nature intangible, conceals nothing, whereas the visible that can be touched inevitably conceals another visible, if we trust our experience" (René Magritte, *Ecrits complets*, 1979).

Dali chose a much more spectacular path by making a case for the systematic description of paranoid insanity. Born in 1904 in Figueras, in Spain, he attended the School of Fine Arts in Madrid before becoming interested in different avant-garde movements, and especially in the painting of Chirico. In 1928 he went to Paris, where he met Picasso and, during a second journey a little later, Miró and the Surrealists. His pictures of the year 1929 cast their spell over the Surrealist writers; Breton wrote the preface to Dali's Paris exhibition in the autumn of 1929 at the Goemans Gallery.

Dali, who was versed in Freud's work, had a method: he called it the paranoiac-critical method, "a spontaneous method of irrational knowledge based on the systematic and critical objectification of the phenomena of delirium." It prompted Breton to say that for the first time "the windows of the mind were thrown wide open."

Dali was very close to the associative techniques and automatic methods advocated in Breton's *Surrealist Manifesto* of 1924, but in his insistence on paranoia, a mental disturbance characterized by delusions and hallucinations, he touched especially the interests of Jacques Lacan, who in 1932 published *De la psychose paranoïaque dans ses rapports avec la personnalité* (On Paranoid Psychosis in its Relations with Personality). "The only difference between me and a lunatic," said Dali, "is that I am not crazy." By this he emphasized that he could enter into the paranoid state at will. In 1930, in his article *L'Ane Pourri*, he said: "I believe the moment is at hand when, by an active paranoid thought-process it will be possible... to systematize confusion and to contribute to the complete discrediting of the world of reality."

His works of that period were the most forceful, the most disturbing; that "convulsive beauty" extolled by Breton was nourished by an aggressive sexual drive which showed up in Dali's answer to a survey carried out by the Yugoslav Surrealists on desire, *Surrealism Here and Now*, Belgrade, June 1932: "I have hidden desires, secrets from myself, since I am constantly discovering them in myself; I think that *secret desires represent true growth, and, further, the true spiritual culture which can be no other than that of desires.* No desire is guilty, the fault lies only in repressing them. All my desires are (to use current

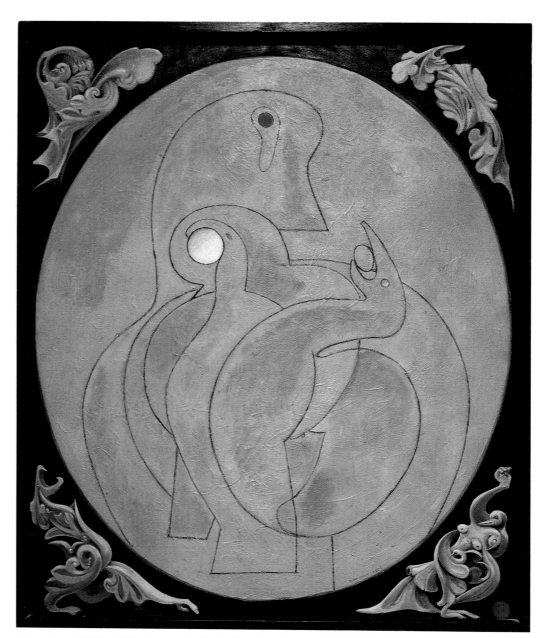

Max Ernst (1891-1976): Inside the Sight: The Egg, 1929. Oil.

terminology) vile, infamous, lewd, etc... To arouse the greatest number of desires, build up the pleasure principle (the most legitimate aspiration of man) against the reality principle. The consequence of poor methods is the contrary of that, to strengthen the reality principle against the pleasure principle. Result: moral degradation. Sade alone seems to me a perfect instructor for the unbridled desires of youth."

Dali thus appeared as the agitator most likely to succeed in this total liberation of the inner man; his methods were forceful, his symbolism easily identifiable, his technique attractive in its traditional artificiality. In *La Conquête de l'Irrationnel* (The Conquest of the Irrational) Dali explained: "My whole ambition, in pictorial terms, consists in materializing with the most imperialist frenzy of precision, the images of concrete irrationality. Let the imaginative world, the world of concrete irrationality, be of the same firmness, the same persuasive density, knowable and communicable, as the external world of phenomenal reality..."

In surrendering to the illusionism of provocation, Dali was not long in being caught in his own trap, the more so in that his images, rejecting the expressivity of the language of painting, soon began to respond to a growing consumer demand by a public that found in him at last a contemporary artist who posed no problems other than those they felt able to recognize immediately.

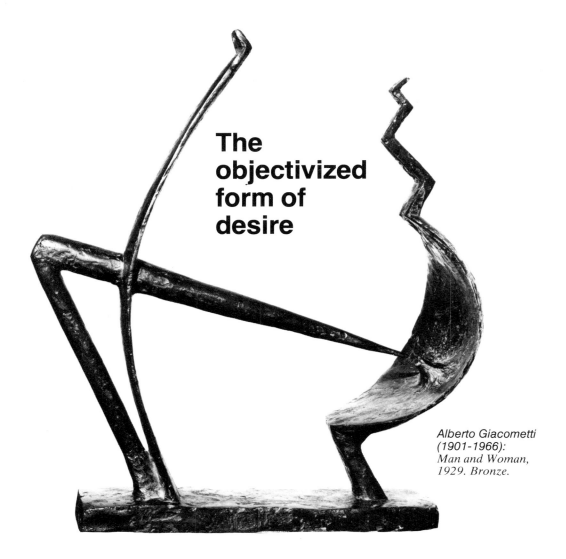

The objectivized form of desire

Alberto Giacometti
(1901-1966):
Man and Woman,
1929. Bronze.

It was about the time of the publication of the *Second Manifesto* (1929) that Surrealism found in Alberto Giacometti its first sculptor, in the fullest sense of the term. When Giacometti formally joined the movement during the winter of 1929-1930 he gave rein to the expression of a latent sexual violence that could not fail to attract Breton. "There was," wrote Jacques Dupin (*Giacometti*, 1962), "an instinct of cruelty in Giacometti, a need for destruction that conditioned his creative activity. From his earliest childhood he was haunted by the obsession of sexual murder." It was through his friendship with André Masson and Michel Leiris that Giacometti had been led the previous year to discover Surrealism.

Born in 1901 at Stampa in eastern Switzerland, in the Italian part of the Grisons, Alberto Giacometti belonged to a family of artists fully informed about the avant-garde; his uncle Augusto had even had contacts with Dada in Zurich. Giacometti painted while still very young, before he began in 1920 to devote himself to sculpture, his destined medium of expression. In 1922, after training in Geneva and travelling in Italy, he went to Paris, where he worked for three years in Bourdelle's studio in the Grande Chaumière academy. The range of his knowledge of art history was exceptional: he had a passion for Egyptian, Etruscan and African art; he was thoroughly familiar with Italy, with the arts of antiquity and with the Renaissance masters, but he also knew at first hand the work of the foremost contemporary sculptors, Archipenko, Brancusi, Laurens, Lipchitz. Giacometti was haunted by the real and its representation; in 1925, becoming aware of the limits of representational art, he decided to start all over from scratch, feeling himself incapable of grasping nature and its appearances, in the totality of his model and the truth of a relation which, in his own words, "changes every day." Much later he related the experience of a sudden death he had witnessed in 1921, and one cannot help thinking that it had a determining effect in his decision to give up the portrayal of appearances. For as a matter of fact, an unexpected event proved to him that, as regards volume, nothing distinguishes a living body from a dead one.

When Giacometti broke with the delineation of the real, it was therefore with the idea of expressing everything that form refused to yield in its submission to a living model, and of experimenting with the expressive possibilities that depended on the autonomy of its component parts. Hence the attention he paid both to the invention emerging from certain contemporary works, particularly by Laurens and Lipchitz—they revealed to him the importance of volume developing for its own sake within the specific features of its space—and also to the non-European arts that translated realities and fundamental concepts the meaning of which could not be satisfactorily brought out by the translation of gesture. Gradually, Giacometti freed himself from the tutelage of nature to develop ever more schematic forms, forms symbolic as well, which began to put questions to him in their mystery. Negro and South Sea arts often served him as a reference; his interest in them coincided with that shown by the Surrealists. In 1929, during the first public exhibits of Giacometti's work, Michel Leiris significantly recognized this common approach: "I like Giacometti's sculpture because everything he does is like the petrification of one of those crises, living with the intensity of an adventure swiftly caught and instantly congealed. There is, however, nothing of death in this sculpture; on the contrary everything in it, as in true fetishes that one wants to worship (true fetishes, that is to say, those that resemble us and are the objective form of our desires), is prodigiously alive" (Michel Leiris, *Alberto Giacometti, Documents*, 1929).

In the following year, 1930, a *Miro/Arp/Giacometti* exhibition was held at the Galerie Pierre in Paris. It placed Giacometti at the centre of the Surrealist movement, and it was against this background that he shortly began the creation of his celebrated object-sculptures. In a letter to Pierre Matisse in 1948, he explains how the works he produced during this period enabled him to express his inner feelings. " I was no longer interested," he wrote, "in the external form of people, but in what I felt about them in my emotional life. (Throughout all my previous years, the Academy period, I had been aware of a disagreeable contrast between living and working—each one acting as an obstacle to the other. I could find no solution to the problem. The fact that, at certain fixed hours, I had to produce a reproduction of some figure, and, what is more, a figure about which I had no special feelings, seemed to me a basically spurious, an inane activity, wasting precious hours of life.) It became no longer a question of producing an object with some external resemblance, but of living, and carrying out only what had touched my emotions, or what I wanted to do."

It was a sexual impulse of a similar nature which moved Picasso towards Surrealism, and at the same time drove him towards a new period of sculpture. First of all, in his painting, Picasso moved gradually in the direction of assemblage compositions. These were primarily biomorphic and went well beyond the dislocative nature of Cubist expression. His works also involved utilization of a space in a way which directly invited their three-dimensional interpretation. The anatomy of his bathers was laid aggressively open, to the point where they became mere bone structures not unrelated to the "objects" which Giacometti was creating at the same period. Though surrealistic in appearance, this symbolic iconography had the major effect of introducing into the artist's work that expressionist dimension which culminated in *Guernica* (1937).

In 1929, by way of Surrealism, sculpture entered a new phase in the making of "symbolically functioning" objects. For this, the African and South Sea island arts were scrutinized afresh. Over and above their formal aspects, their disturbing, sensual magic was rediscovered, stemming from their fetishistic, religious use in binding, liberating or fecundating rites. Taking the psychic reality of this art as their starting point, Giacometti and Picasso reverted to the function of the symbol and its power of collective expression.

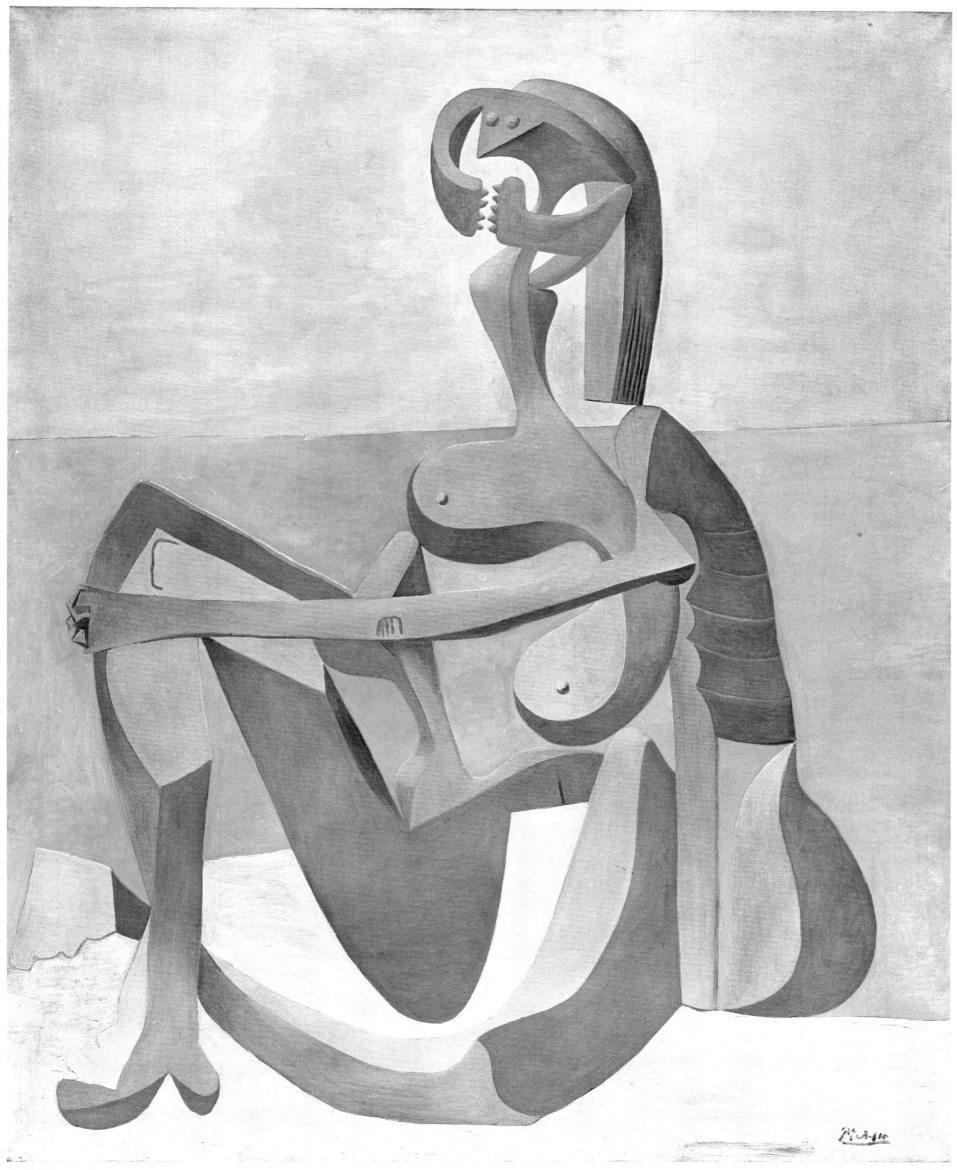

Pablo Picasso (1881-1973): Seated Bather, January 1930. Oil.

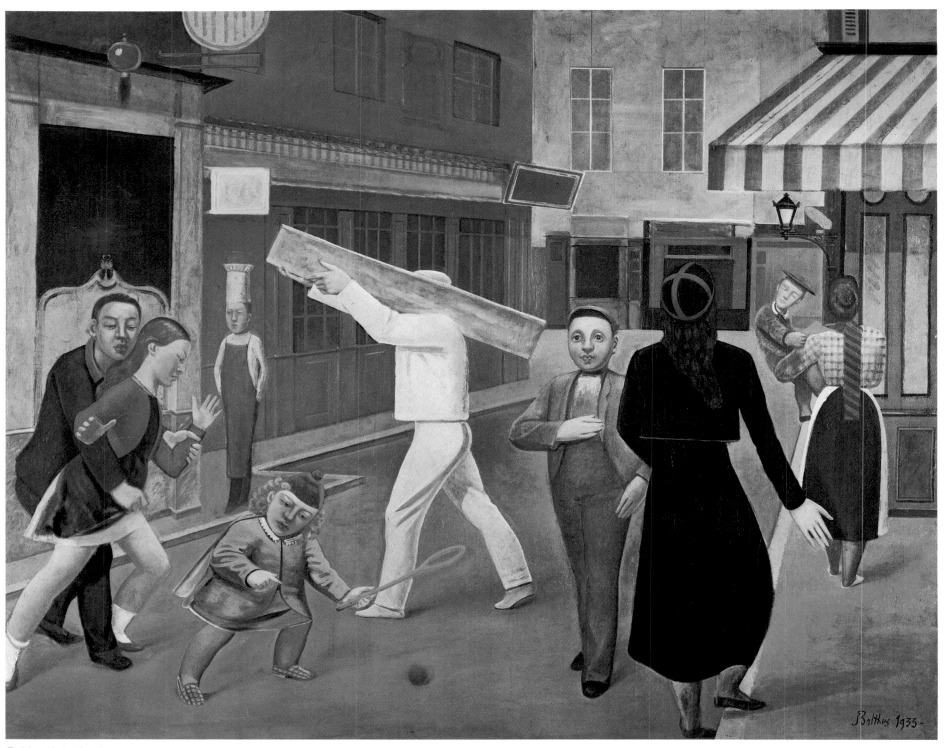

Balthus (1912): The Street, 1933. Oil.

The Time
of
Trial

1930-1936

THE year 1930 marked the end of the period of the "mad years," those years of infatuation for modernism, in respect of style, but most of all in respect of ideas. When the economic crisis cast its long shadow over other areas of human activity, it exposed plainly the hollowness of the evolutionary and scientific dreams: for the world of art it was to have the severest of consequences. It struck home on the day-to-day material life of the artists. The art market was heavily depressed by the scarcity of convertible assets, so hindering the spread of what was considered a sort of "spiritual solace." Many galleries closed and none made any sales. Even famous names saw their market value depreciate at a dizzy rate.

So every artist had to face up to an agonizing re-appraisal of his values; their dreams of "futuria" seemed to be damned for ever. But it was also a fact that this economic and political crisis arose at a time when the field of creativity was going through a crisis of its own, a time when it seemed that everything had already been done, if the same trend was to continue.

The effect of the economic situation was to disturb the avant-garde movement, undermining confidence in evolutionary theories and betraying the headlong advance of the movement which, up till then, had seemed inevitable. On an artistic level, the search for a national identity, the political alibi of all the nationalist political parties, leaned in favour of a return to tradition, to art of a regional nature, to the exemplification of recognized values. Even so, the more creative minds avoided this backward step and outlined the problematics of a fresh advance. This took the form of a general critique of society, by postulating the pointlessness of producing art, if such production did not, at the same time, represent an individual way of life.

Paradoxically, this crisis took place at the very moment when art was beginning to reach out to a wider audience among the people. This was the result of its being featured in specialized periodicals, and in daily papers or weekly magazines. It also figured in the activity of museums, widening their scope by frequent demonstrations of contemporary movements, thematic exhibitions, and retrospectives of living artists. But it was essentially those artists who had worked out the most revolutionary theories on the uses of art who were the first to be rejected in the very areas where they could best have applied their principles. Ideas on the ordering of society had not reached maturity in the minds of political and economic leaders. Apart from those rare personages who had somehow managed to integrate themselves in the

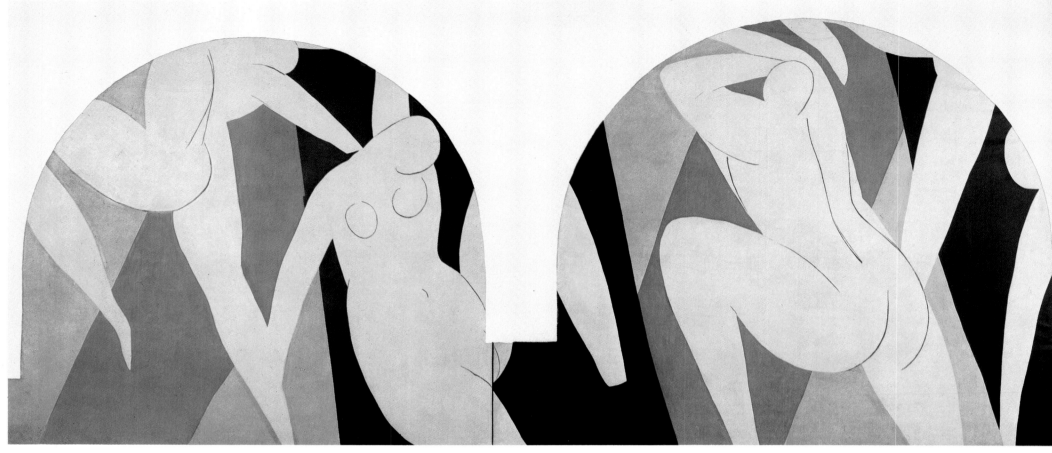

Henri Matisse (1869-1954): The Dance (first version), 1931-1932. Oil.

industrial production scene, or who had established the effectiveness of their impact on the media, artists had no choice but to re-assess their value to society in an atmosphere of hostility. They had to prove that the value of a work does not have to be quantified, that creativity has more secondary effects than immediate, but that these are possibly the more durable ones. Art and fashion went separate ways. All the theories had to be re-examined in a hardening environment, within a situation which deteriorated from year to year.

Despite all this, it was a period destined to prove fertile in every area. It was as if men and women were forced by the harshness of reality to re-examine their personal identity, by denouncing whatever it was that crushed them or menaced their freedom.

Matisse was a perfect example of the crisis situation which reigned in art around 1930. In analysing the "Matisse method," Marcelin Pleynet rightly acknowledges: "What must be recognized here is the consciousness that, sooner or later, Matisse will draw upon the successful results of his mastery and knowledge. And on each occasion, in one way or another, he will be forced into a confrontation between his know-how in the field of painting on the one hand, and on the other, his complete lack of knowledge in a related field and another discipline. This interplay of knowledge and ignorance is 'methodically' subjugated to the results of knowledge, thereby confirming their revolutionary nature" (Marcelin Pleynet, *L'enseignement de la peinture*, 1971).

It was precisely in 1929 that Matisse returned to a persistent, definitive method in his drawing and, above all, in his sculpture. And all this happened at a time of disruption in his life, involving a trip to Tahiti and the United States and ending in the commission for the celebrated mural for the Barnes Foundation. The execution of *The Dance* was to open up for Matisse, in a conclusive manner, new frontiers of the possible in his painting practice, by opening his eyes to a fresh type of relationship between form and colour.

Matisse relied for support on "the courage of rediscovery of purity of method." In the field of drawing he broke away from the aim of filling up the page, in order to re-invigorate the dash of his line. This approach was to be synthesized in his illustrations for Mallarmé's poems, a work commissioned from Matisse in 1930 by Albert Skira. "Etchings made with a continuous stroke," was Matisse's own comment on this work, "with a thin line and complete absence of hatching, leaving the printed page almost as white as it was before going into the press. The drawing fills the page without the use of a margin, giving an even lighter effect. For unlike the usual practice, the drawing is not massed towards the centre, but is distributed over the whole surface of the page."

An article published by Matisse in *Le Point* (No. 21, July 1939) gave the artist the opportunity to explain in detail the role he assigned to drawing, which he had described as "the purest, direct translation of my feelings." "I have always held," he wrote, "that drawing is not just an exercise in a special kind of skill, but primarily a means of expressing intimate feelings and of describing states of mind. But the means are simplified in order to give greater simplicity and spontaneity to the expression, which should address itself without encumbrance to the mind of the spectator" (Henri Matisse, *Notes d'un peintre sur son dessin*).

We find the same effectual purity in his sculpture. In this, from 1927 on, he sought, for the first time, smooth modelling, free from divisive effects from the light source. His sculpture *Le Tiaré*, produced after returning from his Tahiti trip, is a condensation of his experience of the third dimension. The sculpture speaks volumes in its continuous elaboration of a rhythm which is refined, yet at the same time solidly contrasting, from the set of the shoulders to the top of the hair, in a movement which is uninterrupted, but at the same time completely re-devised, so that the image of the woman becomes metamorphosed into an exotic bloom.

Matisse had been awarded the Carnegie Prize at Pittsburgh in 1927: in 1930 he was invited to sit on the jury. On his way to the United States via the South Seas, entranced by the quality of the light in Tahiti, he made a short stop there.

During a visit to the Barnes Foundation at Merion, Pennsylvania, he was invited by Dr Barnes to decorate the main hall of the Museum.

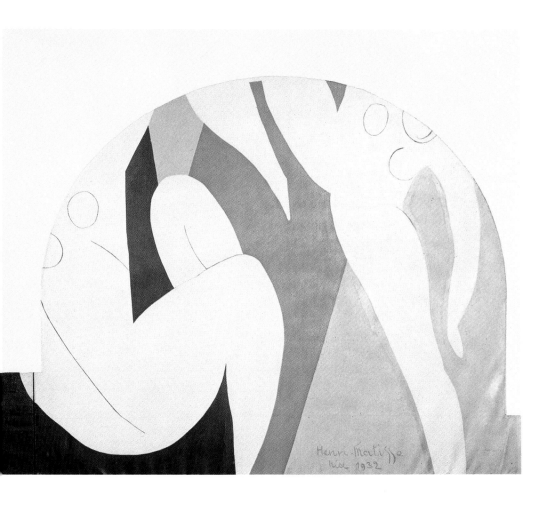

This was the first time Matisse had had to face mural painting of a monumental nature, that is, the integration of a painting into existing real space. The problems this posed excited him, and he drew a bold conclusion. "One day," he announced, "I believe that changing habits will force the easel painting out of existence. There will be only murals."

That experience was to have a transfiguring effect on the whole of his later production. In a letter addressed to the Soviet critic Alexander Romm in 1934, he explained the whole layout and concept of the Merion decoration. "It consists," he wrote, "of a panel measuring

Matisse discovers colour-form

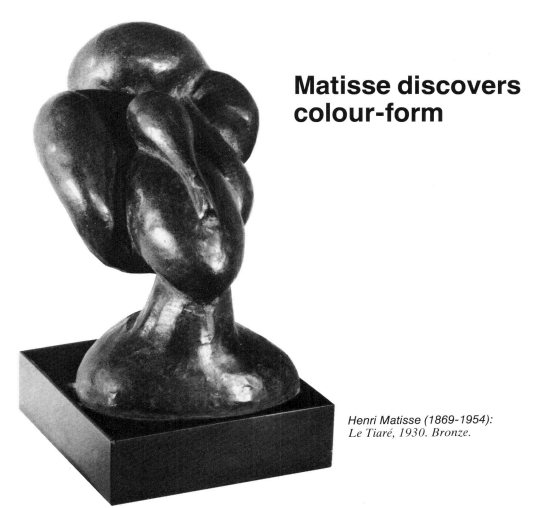

Henri Matisse (1869-1954):
Le Tiaré, 1930. Bronze.

13 metres by 3 metres 50, located above three doors, glazed throughout and 6 metres in height... the painting forms a kind of facade above the three doors—like the pediment of a cathedral porch—a facade which rests in shadow, yet must at the same time maintain the luminosity of the whole as a continuation of the wide wall surface pierced by these three great bays of light... These panels are painted in flat colours and the painting of the areas between the doors continues into the decoration of the dark areas, giving a unity of surface from ground level to the top of the vault, that is, 6 metres plus 3 metres 50 = 9 metres 50. In conjunction with the pendentives resting on these black surfaces, this gives the illusion of a monumental support to the vault. The whole musical harmony of the work is provided by the other colours, rose-pink, blue and the uniform pearl grey of the nudes... As the result of a dimensional error in the two pendentives, which I had reckoned as having a width of 50 centimetres at the base, instead of one metre, I had to start again on my first panel, after its completion at the end of a year's work... The second is not a straightforward replica of the first. Because of the difference in the pendentives, having to suit heavier architectural masses than their counterpart, I had to alter my composition. I even produced a work of a different character: the first had a warlike theme, the second is Dionysiac. And the colours used, although the same, became different, because the difference in the quantity used produced a change in the quality. When colours are used in complete freedom, the effect is that their quality is affected by the relationship of their quantities."

There are, then, two versions of *The Dance*. The first was purchased in 1937 by the City of Paris Museum of Modern Art, the second was set up in Merion, in 1933, by the artist himself.

Matisse felt deeply the distinction between an easel painting and a mural. To achieve the unifying simplicity demanded by the architectural dimension, he devised a manner of working which renewed his familiarity with the form-colour equation, whilst at the same time freeing him from sensitivity to gesture and performance, or, in other words, to painterly effect. He used a method employing gouache cutouts. This technique enabled him to reconcile the basic quantity/quality relationship and once again put him at the head of the avant-garde.

The Dance was executed at Nice over a period of two years. Recalling this long labour in a discussion with Raymond Escholier (in *Matisse, ce vivant*, 1956), the artist confided some of his feelings when faced with the necessity of starting the whole task afresh to fit the dimensions of the support structure. "It is perhaps important," he said, "to point out that the composition of the panel was the product of a direct face-to-face confrontation between the artist and 52 square metres of surface, which the artist had to carry as an entity in his mind. It was not a case of the modern method of copying a composition onto a surface so many times enlarged, 'as requested,' by some transfer technique."

Matisse was then past sixty years of age. In order to get the problem of drawing and painting in perspective, relative to the quantity/quality relationship, whilst working at those dimensions, Matisse devised a novel technique. He got his assistants to colour sheets of paper, which he then cut up and pinned to the wall, or had them pinned there by his assistants. In this way he could move them about or cut them up until he found the ideal condition. By so doing he gave a completely new angle to the traditional relationship between drawing and painting. Up till then, the practice in Western painting had been to fill with paint the area determined by the drawn line, until Cézanne had established their individual identity by declaring: "Drawing and painting are not two distinct processes. As you paint, you are also drawing: the more the colours are brought into harmony, the more the drawing takes final shape. When the colour reaches its greatest richness, the form reaches its plenitude."

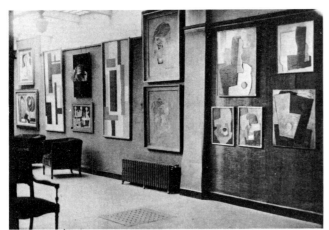

View of the Cercle et Carré Exhibition, Paris, March 1930. ● *Cover of the review* Cercle et Carré, *No. 3, 30 June 1930.* ● *Members of the Cercle et Carré group, Paris, 1929.*

From "Cercle et Carré" to "Abstraction-Création"

The centre of gravity of abstract art moved slowly from east to west, and in 1929 Paris became the meeting-place of its main protagonists. Impelled by the rising tide of Nazism, those still left in Germany were not slow to join them. The position of the abstract artists became very difficult. The Surrealists had taken their place as the latest talking-point of the avant-garde movement and they saw their hopes of finding a place in contemporary output dying. They looked all set to become the first victims of the economic recession already making itself felt. This situation roused them to regroup their forces, the better to defend themselves; to re-examine the final purpose of their efforts and to emphasize the special attributes of their group.

The situation was saved by a painter newly-arrived in Paris, named Joaquín Torrés-García (1874-1949). Born in Montevideo, Torrés-García acted as a catalyst to the group. When he first met Van Doesburg in 1928 he had already been affected by abstraction, though without entirely abandoning some figurative reference in his work. In the November of the same year as this meeting, Torrés-García exhibited alongside Jean Hélion and a number of other painters who had been rejected by the Salon d'Automne. Intrigued by his work, Van Doesburg invited him to his studio and showed him the productions of Neo-Plasticism and the De Stijl group. Shortly after this, whilst visiting an exhibition by Vordemberge-Gildewart, Torrés-García met the Dutch painter-critic Michel Seuphor. The Dutchman introduced him to the art of Mondrian and gave the two painters the opportunity of meeting.

Torrés-García and Seuphor formed a lasting friendship and became ambitious to found a group entitled Cercle et Carré (Circle and Square). They gathered a number of friends round them and an ever-increasing volume of participants began to take part in their discussions. Among them were Vantongerloo, the Italian Futurist Russolo, Mondrian, Arp, Sophie Taeuber: it was not long before the group, centred in Paris, could count eighty members. Finally, it was decided to publish a magazine, and the first issue of *Cercle et Carré* appeared on 15 March 1930. On 28 April an exhibition was organized in Gallery 23, Rue La Boétie.

The purpose of *Cercle et Carré* was to defend, advertise and raise the prestige of abstract art. In the group's programme of declaration, Seuphor wrote: "Once it is activated within us, a strictly controlled sensitivity will become one shape of healthy thought, or of our moral equilibrium. By achieving, within a work, a unification between this sensitivity and the structural principle of the work, we shall arrive at what I will call its architecture. We shall thus have put our finger on the overall role of the artist. This is: to establish, on the foundations of a structure that is simple, severe and unadorned in every part, and within a basis of unconcealed narrow unity with this structure, an architecture which, using the technical means available to its period, expresses in a clear language that which is truly immanent and immutable, and which, in its particular individual organization reflects the splendid order of the Universe" (*Cercle et Carré*, No. 1, 15 March 1930). But Torrés-García added a rider to this. "To induce order," he

Ben Nicholson (1894): White Relief, 1936. Oil on carved wood. ● *Jean Hélion (1904): Composition, 1932. Oil.* ● *Jean Gorin (1899): Neo-Plastic Composition No. 29, 1931. Oil.*

stated, "would certainly be an achievement. But it is not enough. What is needed is to *create an order.*"

The career of *Cercle et Carré* was a brief one. During the summer of 1930, Torrés-García left Paris, leaving with Seuphor the responsibility for keeping the paper alive. But Seuphor fell ill whilst preparing the fourth, and last, issue of the magazine. When Torrés-García returned, in May 1931, the situation had undergone considerable change. Van Doesburg was dead, and a new group, Abstraction-Création, had been formed. This was an altogether wider grouping, associating all the Constructivist trends.

Van Doesburg had been excluded from *Cercle et Carré* and in 1930 launched another magazine, *Art Concret*. In its one and only issue he took exception to the term "abstract," calling it negative, because it was linked to the evolution of a painting in its progression away from a reference point outside itself. He opposed "abstract" with the more positive term "concrete."

Though the terminology may be new, the theory was not. It was simply a confirmation of what the more daring artists had been practising for a dozen years. Abstraction-Création was to be a longer-lasting movement, because it was less partisan. It was launched on 15 February 1931, and four years later had no less than 400 members. The group established an annual review which ran to five issues.

The platform on which the members based their ideas was too wide a one for them to adopt a fighting stance. But through its members and their wide dispersal, the association took on an international character. So even though it proved unable to mount any major demonstration, the group gained an expanding audience. Thus at Lodz, in Poland, thanks to the efforts of Stazewski, Kobro, Hiller and Strzeminski (possibly the most minimalist of the artists of the period), two rooms at the local museum were allocated to the display of abstract art. This was in 1932, and to this day the Lodz showing remains one of the most moving and significant statements of abstract art.

A little later, interest in abstraction reached British shores. The collector Douglas Cooper and the critic Herbert Read both supported the avant-garde movement, and especially the young sculptors Henry Moore (1898) and Barbara Hepworth (1903-1975), and the painters Ben Nicholson (1894), John Piper (1903), Paul Nash (1889-1946) and Edward Wadsworth (1889-1949). The work of Mondrian had exerted a profound influence on creative art in Britain. It is particularly noticeable in Marlow Moss (1890-1958), who had been a disciple of Mondrian since 1929, and in Nicholson, who visited Mondrian in 1934. In 1935 the British group launched a review, entitled *Axis*. This was destined to play a particularly important role at the time of the arrival in London of artists fleeing from Hitler's Germany, such as Gropius, Moholy Nagy, Breuer, Gabo.

As far as the United States was concerned, more than thirty American artists associated themselves with the Abstraction-Création group. Abstract painting had, in any case, been regularly displayed in the Société Anonyme exhibitions mounted by Katherine S. Dreier and in the Gallatin Collection, which had been opened to the public in 1927 under the title of the Gallery of Living Art (its adviser was the Frenchman, Jean Hélion). We should also note that the first major exhibition devoted to abstraction, *Cubism and Abstract Art*, was to take place in 1936 in the Museum of Modern Art, New York. This museum had been opened with funds donated by Mrs John D. Rockefeller with the aims of "introducing America to living art forms and identifying her with them, and preserving the intellectual and artistic patrimony of Europe." The exhibition was organized by the critic, Alfred H. Barr, Jr.

In its affirmation of the autonomous nature of art, Abstraction-Création was above all attacking a renascent academicism, which favoured a return to sentimentalism and over-refinement. In 1931, in

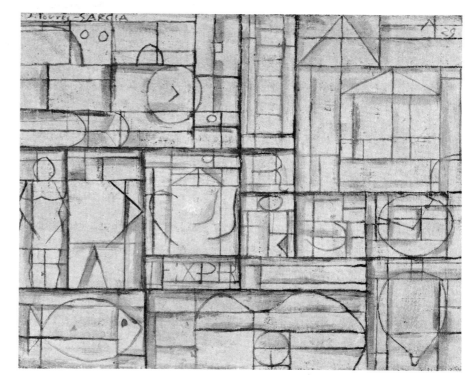

Joaquín Torrés-García (1874-1949): Composition, 1929. Oil.

Cahiers d'Art, Christian Zervos launched a major inquiry. In issues 7 and 8 of 1931 he asked artists and writers to give readers their observations on this art which had been accused of: "(1) being wilfully inexpressive and cerebral to an excessive degree, and hence of being in conflict with the very nature of true art, which should concern itself essentially with the sensual and emotive; (2) having wilfully substituted for emotions deriving from the depths of the unconscious an exercise in the use of pure tone and geometric design which was more or less subtle and adroit, but always objective; (3) having restricted the range of possibilities open to painting and sculpture to such an extent as to reduce art to a simple interplay of colours within forms of a very restrictive plastic rationale: such were at best suitable for posters or advertising brochures, but not at all for the sort of work prevailing in the world of art; (4) having, through its technical severity and total denudation of the subject, brought art into a dead end, thereby destroying all possibility of its further development."

Arp's reply to this attack was full of humour:

Man likes what is vain and lifeless. He cannot understand that painting may be something else besides a landscape prepared with oil and vinegar, that sculpture may be something else besides a woman's thigh made out of marble or bronze. Any living transformation of art seems to him as hateful as the eternal metamorphoses of life... I love nature, but not the substitutes for it. Illusionist art is a substitute for nature.

For his part, Mondrian asserted: "The nature of plastic expression depends on the period: it is the product of that period. So the mentality of each age demands its individual plasticism." For him, it was not a question of perfecting plastic expression but the work itself, so that Beauty might become a reality in actual life. He is well aware of the existence of an impasse here, but it still seems to him a long way off, and he forewarns us in these words: "Up till now every form of plastic expression has been able to be developed, to be continued in the direction of a pure plasticism. But once this has been brought into being, there is no longer any way ahead in art. But will art always be needed? Is it anything more than just a poor artifice, to make up for the lack of beauty in life itself? Once Beauty has been brought into being in life... and that should be more or less possible in the future, in view of the advance in the progress of mankind which we can confirm, assuming our view is not a too superficial one... then it will be completely natural for life itself to fling art into the abyss; an abyss which, in our own time, art is already skirting."

It is significant, in this connection, to read the different texts figuring in the first publication of *Abstraction-Création* (1932). Jean Gorin, for example, wrote: "The collective movement of the new plasticism uses means of expression which are completely universal, mathematical and scientific. It is impersonal art carried to its limit. Everybody uses the same elements, the straight line and the rectangular plane of pure colour or of non-colour: the use of the right angle is a constant condition. By the creation and qualitative perfection of pure plastic relationships the work can achieve a cosmic unity. It is complete art, allowing the expression of the whole of our being, both material and spiritual, both individual and universal, in a state of constant equilibrium. It is the rational, collective art of the new age of the machine." Born in 1899, Jean Gorin was influenced by Cubism, before meeting Mondrian in 1927. He was then developing purist compositions and later executed very original spatial constructions of an entirely neoplastic severity.

Jean Hélion wrote: "What is the right domain of painting, if the whole idea of painting has not been entirely sold out? Blue, black, red, white, yellow, grey, colours, optical energies which can be applied and organized like the terms of a mathematical function, so that this function outlines a progression which can be as infinite as possible. Constituent parts, never complete forms; these relationships of energy, of numbers, of forces, but not of objects... to create a machine to comb through appearances and, if there are any at the end of it, ideas." Born in 1904, Jean Hélion entered into friendly association with Theo Van Doesburg at a very early age. He contributed to *Art Concret*, then to *Abstraction-Création*. Then, around 1940, the political situation induced him to revert to a greater social involvement with a more immediate message.

There was no let-up in the expansion of the international following of the Bauhaus. But after the architect Hannes Meyer had taken over the running of the institution from Gropius, there was a change in its general outlook. Paradoxically, working against a pedagogical background which always took additional account of productive capacity and design problems, Kandinsky and Klee found a greater autonomy in the management of painting workshops which, at that time, were operating independently. Systematic application of the theory of the utility shape enabled the Bauhaus to earn a good income. This amounted to 32,000 marks in 1929.

But political tension in Germany continued to mount. If Hannes Meyer oriented the Bauhaus more and more towards the left, in Dessau the right-wing faction gathered strength. Meyer was eventually dismissed without notice and left for Moscow with a dozen students. Mies van der Rohe took over the management of the Bauhaus. From 1931 onwards, he strengthened the staff engaged in technical instruction, to the detriment of the exclusively creative subjects. This decides Klee to leave, making his way to the Düsseldorf Academy. Then, on 30 September 1932, closure of the Bauhaus was ordered by the National Socialist Party, which had obtained a majority in the Dessau City Council.

Mies van der Rohe made an effort to save the school by turning it into a private institution. Backed up by Albers, Kandinsky, Peterhans and others, he moved to a disused telephone works in Berlin: he still had 168 students, 33 of these being foreigners. But on 11 April 1933 the Berlin school was surrounded by police and troops and thirty-two students were summonsed. On 20 July the institution was dissolved, the majority of the members being forced to flee the country to evade persecution. A regular diaspora developed, travelling across Europe and eventually reaching the USA, which in this way became opened up to functionalist theories and, above all, to their pedagogy. Albers arrived in the United States in 1933, followed by Gropius, Breuer and Moholy-Nagy in 1937 and Mies van der Rohe in 1938. It was thanks to their teaching that the influence of the Bauhaus soon spread throughout the world.

After a number of typically Constructivist experiments, Klee returned to a more fantastic form of art. The motivation behind this is to be found in his posthumously published book, *Das bildnerische Denken* (1956). "The creative power," he wrote, "will not submit to any labelling. In the final analysis, it remains a mystery which defies description. Nevertheless, it is by no means a mystery which is beyond our grasp and incapable of stirring us to our very roots. In fact, we are ourselves charged with this same power down to the very last atom of our being. We cannot define what it is, but, to a varying degree, we can get close to its source. It is our duty to make this power manifest in every way, to expose it in its operations, in exactly the same way as it is exposed in ourselves."

Klee had long had an interest in the drawings of children and in primitive art, as well as in the arts of Africa, the South Seas and New Guinea. Now he became concerned by the expression of a different relationship between the symbol and the object symbolized. "In this respect," he wrote, "there is a case for defining the scope of the means of plastic expression in the *notional* sense and of displaying the strictest economy in their use. Spiritual order is better affirmed in this way than by an abundance of means of expression. Avoid a massive use of

Sophie Taeuber-Arp (1889-1943): Triptych, 1933. Oil.

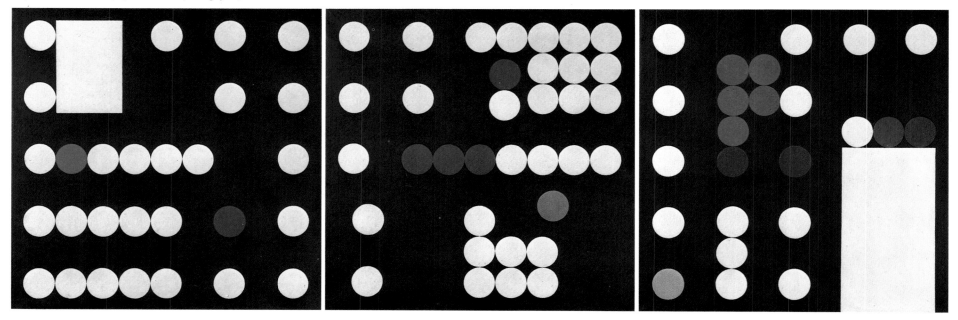

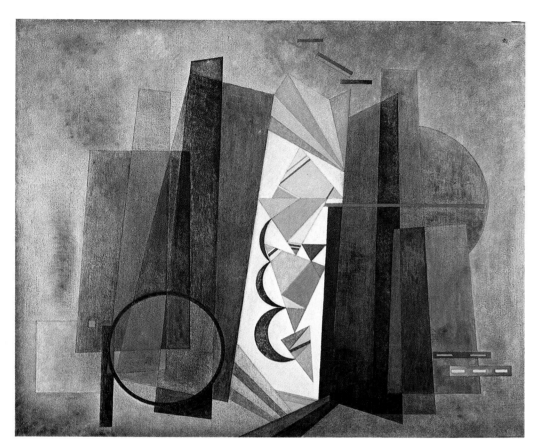

Wassily Kandinsky (1866-1944): Development in Brown, 1933. Oil.

The break-up of the Bauhaus

material resources (wood, metal and glass etc.), to the benefit of notional resources (line, tone, colour—none of which is a tangible *object*). Of course, notional means of expression are not without a material embodiment, or else it would not be possible to 'write'... Basically, *writing and drawing* are identical processes' *(ibid.)*.

Persecuted by the Nazis, Paul Klee returned to Switzerland, settling in Berne. It was here that he met, for the first time, Daniel Henry Kahnweiler, who has left us this priceless account of his methods: "Klee," he stated, "was that rare being among painters, in that he was left-handed—or, at least, he was so in his art. He wrote with his right hand. His work, so impulsive in its bizarre poetry, could persuade you to believe in a world of fantasy... his art, which seemed to recognize neither laws nor taboos, was, in fact, the outcome of extraordinarily methodical considerations... Klee's methodical character was likewise shown in the minutely detailed catalogue he prepared of his works. You have to realize that when Klee started any work, he had no preconceived notion of a title. About once a month, he assembled all his completed works, in order to set about 'christening' them. It was then that he gave them their titles" (D. H. Kahnweiler, *Paul Klee, curieux homme*, catalogue of the Klee exhibition, Musée Cantini, Marseilles, 1967).

Kandinsky, on the other hand, remained linked to the Bauhaus until his last days in Berlin. He did not take refuge in France until 1933. As a result of participation in numerous demonstrations, he already had some following there. In his reply to the survey of abstract art carried out by *Cahiers d'Art* (No. 7-8, 1931), he made his own position clear. Above all, like Klee, he emphasized the importance he attached to intuitive insight. He started by turning back his own question on Zervos, by asking: "Could the supporters of painting prove that the subject, in painting, is just as indispensable as the colour and form (in a restricted sense), without which it would not be

possible for the painting to be conceived?" He then gives his opinion as to what constitutes a work of art. "Some of our 'abstract' paintings currently being shown are endowed with artistic life in the best sense of the word: they have the throb and radiance of life and act upon a man's inmost being through the intermediary of the eye. *And this, in a manner which is exclusively 'pictural' in its appeal.*"

Finally, Kandinsky emphasizes the essential role played by the use of colour, and by the overwhelming effect it has on all rational order in the person concerned. "As far as intellectual work is concerned," he wrote, "we are entitled to the affirmation that, in the history of art, there have been periods in which the collaboration of the reason (i.e. intellectual effort) has played a role which has been not only important, but decisive... Furthermore, we can maintain with equal legitimacy that up till now, intellectual effort on its own, that is, without the support of the intuitive element, has never given rise to works of any vitality... The number of attempts I have made to carry on in a manner which is exclusively subject to 'reason' from start to finish, have never reached a satisfactory conclusion. As one example, I drew the projection of an image on a surface, in accordance with mathematically calculated proportions. But the colour was already having such a profound modifying effect on the proportions that it was impossible to rely upon 'mathematics' alone... Further, in colour considered on its own, 'mathematical' mathematics and 'pictorial' mathematics occupy two totally different fields. If, to an apple, you add an ever-increasing number of further apples, then the apples increase in quantity and you can count them. But if, to some yellow, you continue to add more yellow, the yellowness does not increase, but is reduced (what we have at the beginning and what we had remaining at the end cannot be counted)."

Paul Klee (1879-1940): Open Book, 1930. Gouache over white lacquer.

Naum Gabo (1890-1977): Project for the Palace of the Soviets in Moscow, 1931.

When the State asserts its power and authority

Once the dream of man's moral and social transfiguration through the quality and character of artistic creation had faded into nothingness, the consequences were graver in the field of architecture than in any other. This was owing to the downward drag of the economic situation. During the 1930s, innovative builders lost the confidence of public authorities and of their promoters, who destroyed the credibility of their theories and social programmes and brought them into ridicule.

Even so, the logic and economic sense behind the innovative shapes and materials of the previous decade had gained support. It was, in fact, during the thirties that modernism came into being on a city-wide scale, through the introduction of the results of artistic research in the planning of multiple entities. But this transformation was brought about more by the economic situation than by any creative urge. Indeed, this development generally took place without the presence of those very people who had introduced its major components, and who would, therefore, best be fitted to set it on its true course.

New ideas recovered most quickly in the field of residential building. In the face of the economic crisis, the idea arose of corporate ownership of blocks of flats. And in the course of building these, it was economic considerations that rapidly brought about the replacement of all the traditional techniques used in major construction works by the use of reinforced concrete, and standardization became the order of the day. But it was above all in the interests of comfort, hygiene and pleasurable design that constructivist proposals were revived. This change showed in such matters as the enlargement of windows (leading, in its turn, to the introduction of roller blinds), the construction of loggia type balconies in place of platforms enclosed in wrought iron, the enlargement and fitting out of kitchens, the introduction of bathrooms into every flat, the multiplication of shared services, such as a common washroom, garage and so on. Bit by bit, modernism gathered strength. It was manifested in an irreversible slide towards a form of collectivism, although the process acted, in fact, against the interests of those who had started it off, who saw themselves condemned to the position of mere theorists, in view of the small amount of work which was offered to them.

The competition for the construction of a Palace of the Soviets in Moscow was the last huge project giving rise to a confrontation between major architects, ranging from Gabo to Ginsburg, from Perret to Mendelsohn, and from Gropius to Le Corbusier. But the prize was awarded, in the end, to a low quality submission. The competition coincided with a moment when numerous architects had gone to the USSR in the hope of finding a collectivism which would be more sympathetic to carrying out their popular housing programmes. But these hopes were soon dashed, for reaction was also gathering momentum in the Soviet Union. Paradoxically, both Le Corbusier and then André Lurçat were attacked on all fronts. In the USSR they were criticized for their bourgeois tendencies, whilst in France they were reproached for being bolshevist! (The political plans as well as the avant-garde concepts of André Lurçat had, incidentally, become embodied in the École Karl-Marx at Villejuif, founded in 1933.) It was, in fact, not till after the Second World War that the idea of social housing was to become a credible one.

Alvar Aalto (1898-1976): Paimio Sanatorium, Finland, 1929-1933.

Le Corbusier (1887-1965): Swiss Pavilion at the Cité Universitaire, Paris, 1930-1932. South side.

Nevertheless, Le Corbusier was given the opportunity of two major commissions. These were for a Salvation Army Hostel in Paris (1929-1933), and for the Swiss Pavilion of the Cité Universitaire, also in Paris (1930-1932). In the design he made a bold approach to fenestration by blending the windows into the plane of the facade. It was here that the concept of the window embrasure gave way to that of the transparent facade. But Le Corbusier was soon to realize the thermal problems this created, as well as those of lack of privacy, since it puts the occupant virtually in the street. The remedy found by the architect was that of the sun visor, which was to open up new possibilities for sculptural effects in the design of living space.

The concept of the Swiss Pavilion of the Cité Universitaire departs from the rigorous concepts of Le Corbusier's early designs. In it, he even introduced a shaped wall composed of dressed stone, so bringing the idea of the curved plane into contemporary building. Likewise he played upon the contrast between materials and forms, so adding a fresh dimension to his design, by loading its functionalism with actual plastic qualities. But it was rarely that his creative genius was able to express itself in an economically viable context of this nature. Hence, his architectural development took place mainly in the form of projects and scale models. In any case, most avant-garde building designers found themselves similarly in exile, as far as their theories were concerned. Like Mies van der Rohe, who, in 1931, seized the opportunity to display his revolutionary Bachelor's Country Home in the middle of the main hall of the Bauhaus exhibition in Berlin. It summarized the results of the architect's researches into design and space. But it was also the time when the Brownshirts were stalking the city streets. Soon, for Mies van der Rohe, as for most of his Bauhaus colleagues, there would be no way out but emigration. Modern architecture died in Germany, once the Nazis came to power.

The name of Alvar Aalto (1898-1976) began to become known around 1930. It was about this time that the North European countries began to give a new drive to contemporary architecture, as displayed in the Stockholm Exhibition, organized by Gunnard Asplund in 1930. In Sweden and neighbouring countries, the constructivist spirit grafted itself onto a well-established and continuing tradition of craftsmanship. This facilitated the humanization of housing and living conditions by a lively usage of materials (especially wood), and through a very strong feeling for the integration of housing with the natural environment. By his sense of space, and above all through his feeling for work in wood, Aalto added a new dimension to the most revolutionary theories.

The modern designers continued their clashes of opinion and search for a common language within the confines of the CIAM. What they were looking for was some form of standardized presentation. The organization held its fourth Congress during the summer of 1933, and a series of proposals was studied, all with the aim of improving the physical and psychological conditions of the urban population. The discussion was dominated by Le Corbusier, whose proposals were reiterated and expanded in the celebrated *Athens Charter* of 1933. This emphasized the architects' consciousness of the need to progress from the design of the house to the design of the whole town.

Despite the temporary successes of the left in France and Spain, the dreams of "futuria" and the functionalist Utopia fell apart. But these dreams were taken up again directly by the totalitarian powers and turned back upon the very people they had been intended to liberate. They realized that to maintain their hold over the masses they would need the use of style and symbol. In a direct corruption of the ideas of the urban Constructivists, they used the width of the boulevards, in a semi-religious form of ritual, to organize Fascist ceremonial. They made use of methods of prefabrication to house the crowds, and of programming techniques to make the idea of the Defence of the West a part of the "New Order." Acting in the name of Science and Reason, the Nazis founded their whole aesthetic structure upon a hierarchy which made plain to people in a direct manner the obedience which the individual owed to his leader. The various forms of totalitarianism gave their political theory an aesthetic flavour and made a fetish of techniques aimed at deluding the masses they have access to culture and forms of expression, whilst at the same time accusing live art of degeneracy, because it remained free and individualized.

Marcello Piacentini (1881-1960): Students' Hostel, Rome University, 1934.

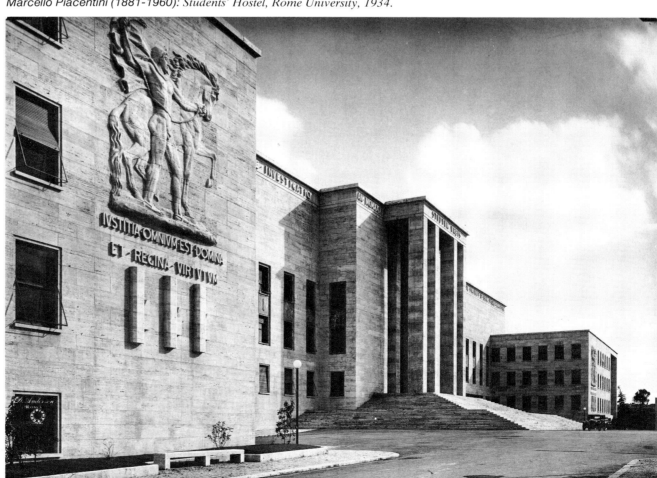

The necessity for another realism

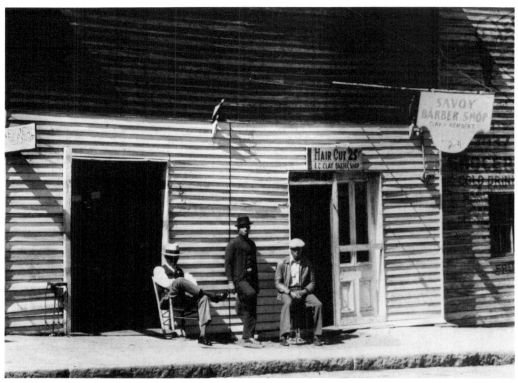

Walker Evans (1903-1975): Barber Shop in a Southern Town of the United States, 1936. Photograph.

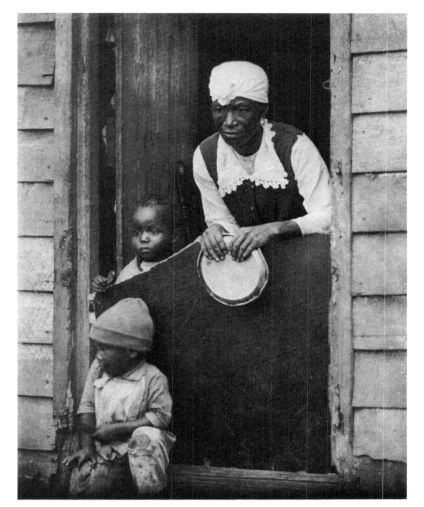

Doris Ulmann (1882-1934): Black Woman with Pie Pan and Two Children in a Doorway, c. 1925-1934. Photograph.

The 1930s were marked by such an expansion of visual appeal that the dimension of communication often took precedence over that of expression: or, at least, it was the determining factor in the choice of the medium employed. Even the painters were not spared the side-effects. The man in the street became subject to a constant bombard-ment of visual impact, by way of photographs, the cinema, and adver-tising images. The audacity of these continuously pushed out the fron-tiers of the acceptable—for what is provocatively new is quickly enough transformed into a criterion of normality. This is because the multiplicity of impressions made gives rise to familiarity, and hence to the standard which the latest fashion must surpass, in its turn, if it wishes to be noticed.

The existence of an illustrated press necessitated pictorial report-ing, producing a kind of instant recall, an experience of the event by proxy. And in spite of the distance the mechanical process placed between the actuality and its photographic image, the spectator (in the words of Walter Benjamin), was forced to seek, "in a semblance of reality, that tiny spark of the chance event, of the here and now, by means of which the actuality sets ablaze, so to speak, the character of the image." And it was paradoxical that it was against a background of political activity by the Roosevelt government that reportage dis-covered its artistic and social dimension. The aim of this activity was twofold. It was intended, partly, to assist artists by giving them work, and at the same time, to show the misery into which a third of the United States had been plunged by the depression, putting some thir-ty-four million souls in a state of need. Between 1935 and 1942, some 270,000 pictures were taken by the best photographers, under the direction of Roy Stryker, Director of the F.S.A. (Farm Security Administration). The only intention behind them was to expose the true facts and the extent of the misery. They became the most un-forgettable testimonies of an era of despair and, at the same time, of a vanishing civilization.

The advertising trade, which grew in both its nature and the forms it took, had a direct effect on the development of the taste of the period. Alongside this, it aroused an awareness of the problems and experiments of the avant-garde movement. Everyone engaged in graphic presentation used shock tactics, both as far as the ideas in-volved were concerned, also in the images used, and their style.

Because of the general success of the advertising image in impos-ing itself on the public by the means at its disposal, modern man is increasingly subject to conditioning by the various channels of com-munication and the media. The advertising trade was quick to pick up the latest discoveries of photography: effects created by film stock manipulation, image re-centering, serial effects and so on, but above all, its way of isolating the subject, the more to enhance the impact of its presence. In 1929, Wilhelm Kästner, in his résumé of the Essen exhibition, *Fotografie der Gegenwart*, wrote as follows: "Here is the explanation why there are no longer any admirers of landscape, or few of them any longer, while on the other hand there is a domination of the simplest objects, especially of everyday objects, preferably mass-produced and (unlike still life) all heaped together. This is a characteristic of the transition from a free pictorial, purely artistic creativity, in the sense given to it by painting, to applied photography, as a department of the advertising trade."

Though he may not have used photography, Cassandre made a direct use of its effects. He achieved the originality of his advertising designs by separating his subject from its utilitarian background, in order to strengthen its individual, independent existence in form and colour. This is where graphic art came into its own. In its pursuit of moderation and clarity it defined a further purpose: the achievement of impact. From now on, the mass media were to exert an increasingly powerful effect in the conditioning of the public, an influence so strong that "photographic effects" began to find their way back into painting, where the classical models were in a state of crisis.

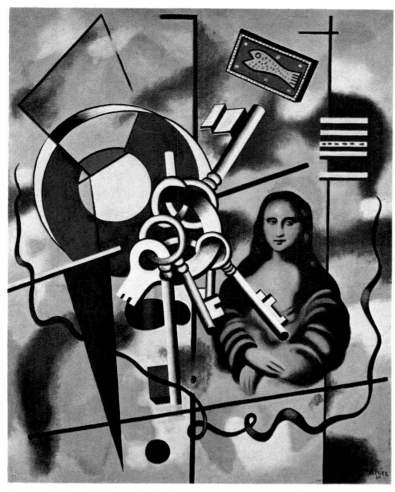

Fernand Léger (1881-1955): The Mona Lisa with Keys, 1930. Oil.

everything it was possible to achieve in the matter of plastic escapism has been achieved, the point where the very object which constituted the replacement value for the subject, as far as the masters of Cubism were concerned, has been reached, then the object itself disappears. So we find ourselves face to face with an art which is one hundred per cent art for art's sake. This necessary condition of freedom has now... become stagnant. It looks as if reaction plus the possibility of creative continuity in the face of the abstract will develop by way of a return to the subject. That seems natural enough to me."

Léger's *Mona Lisa with Keys* was painted a year before the painter travelled to New York. The modernity and contrasts of the city fired him with enthusiasm. This was the moment when American painters, too, had been forced into an amplification of the contrasts in their images, if they wished to compete with architectural and advertising effects. This was the sort of thing Ben Shahn was doing, for example. He himself practised photography and did not scorn to use the poster designers' methods. And as he was directly inspired by the political and social events of his time (such as the Sacco-Vanzetti case), he sought the maximum impact for his images in the creation of a "new realism," which was different, but not so very distinct from that of Léger. Shahn's painting had a political and moralizing flavour. So he made use of different means to serve a "new objectivity" which, in this quest for style, achieved a denunciatory potential which went beyond the description of the actual.

One of the most significant examples was that of Léger. In his *Mona Lisa with Keys*, he was playing at one and the same time with the new photographic effects (the representation of the keys and the tin of sardines), and a classical model, the Mona Lisa. (It was not the picture itself that he reproduced, but a female portrait closely resembling it.) That Léger was perfectly aware of the visual impact of this contrast was shown by his writing about the painting. "One day I had painted on a canvas a bunch of keys, my own bunch. I did not know what to put by its side. I needed something that would form a complete contrast to the keys. So when I had completed my work, I went out. I had hardly taken more than a few paces, then imagine what I saw in a shop window! It was a postcard of the Mona Lisa. It struck me at once. That was the very thing I needed: what could have made a greater contrast with the keys? So I put the Mona Lisa in my picture. Afterwards, I added a tin of sardines, making a very sharp contrast. The picture is one that I shall keep, not sell." And he added: "From the point of view of contrasting objects, I have executed the most 'risqué' of pictures. For, as far as I am concerned, the Mona Lisa is an object, like any other. As far as I am concerned, the painting is a creative success, in spite of the enormity of this difficulty."

Thus, in a very direct sense, Léger introduced the iconography of the Pop Art of the 1960s. In a text which was published posthumously, *Le problème de la liberté en art*, he gave the reasons for this inevitable return to the depiction of an object, such as he had himself felt, and to which American artists were also to return after all the explosion of action painting had died down. "If the acknowledgment should be made," wrote Léger, "that abstract art, the final expression of that freedom, has arrived at its zenith, at the point where

Ben Shahn (1898-1969): Sacco and Vanzetti: In the Courtroom Cage, 1931-1932. Gouache.

Sacco and Vanzetti in the prisoners' dock during their trial for murder at Braintree, ▷
Massachusetts, 1921. Photograph.

Max Ernst (1891-1976):
Loplop Introduces
Members of the
Surrealist Group, 1931.
Cut and pasted photographs,
pencil, and pencil
frottage.

particular by Raoul Hausmann, who with Moholy-Nagy proved one of the most lucid experimenters in this new medium. In an essay on it (*Formdialektik der Fotografie*, in *A bis Z*, Cologne, May 1932), Hausmann pointed out the divergences that exist between the human eye and the camera eye: "A new conception of photographic optics is also called upon to play an important part in the transformation of social knowledge. But only a careful choice of contradictory pairs (inner form and outer form, light and dark) is capable of transforming photography from an imitative or at most documentary technique into a creative medium of expression... It is still assumed that the human eye sees with the same precision all objects in their spatial recession, one behind the other, and that the precision of the camera lens is limited to certain zones. In reality the human eye, in the process of seeing, follows a sequence of viewpoints *(Blickpunkte)* round which all the rest is blurred, and the apparent precision of the different parts of space is only arrived at afterwards by the conscious mind, that is to say by the imagination *(Vorstellung)*."

Hausmann went on to explain that modern photography should emphasize these contradictions with our habits of seeing: "In order to produce an optically correct photograph, one, that is, which takes account of these laws of vision, it is necessary to reinforce the essential oppositions." He thus makes it clear already that the artist should, by the intelligent practice of his craft, avoid the evident sides of the "cliché" which, if too much insisted on, run the risk of producing images which, though all too readily taken for truth, are merely mirages. As Hausmann saw it, the photographer is in fact engaged in an unremitting struggle with his medium, whose whole tendency is to substitute itself for the real. Already in the 1930s direct experience was beginning to be replaced by photographic memory.

Hausmann at that time had just taken part in the First International Exhibition of Photomontage, organized by César Domela in Berlin in 1931. He took the opportunity, in his inaugural lecture, to emphasize the wide range of possibilities offered by the photomontage technique, which many people imagined was already outmoded. "The initial form of photomontage consisted in shattering the surface by multiplying the points of view and in interweaving several levels of imagery whose complexity far exceeded that of Futurist painting. Since then the photomontage has undergone a certain evolution which may be described as constructive... It is safe to say that the photomontage, like photography and the silent film, still has much to con-

Edward Hopper (1882-1967), on the other hand, remained attached to the descriptive form, which he practised in a bare, laconic style. For him, this was the vehicle through which he translated feelings of isolation and alienation he shared with many Americans. In these apparently commonplace images, stripped of all compromise, he shows a warm sympathy for the people and objects in his works. They make common cause with the gripping objectivity of the photographs of the Farm Security Administration.

Thanks to technical improvements and the ever-increasing demands made upon it by the press and advertising, photography enjoyed an immense vogue. Its attraction for both artists and public was such that in 1934 Rodchenko could say: "Photography has all the rights and all the merits necessary for us to take it up as the art of our time." It offered a fresh and unlimited field of creativity. This was recognized by all the painters who turned to photography, and in

Edward Hopper (1882-1967):
Early Sunday Morning, 1930. Oil.

Cassandre (1901-1968):
"L'Atlantique," 1931. Poster.

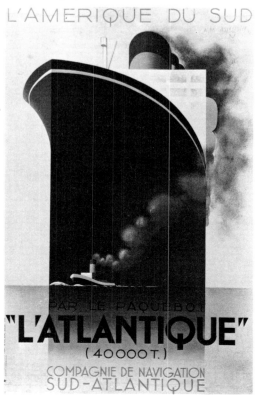

Man Ray (1890-1976): Observatory Time, The Lovers, 1932-1934. Oil.

tribute in unforeseeable ways to the education of our eye, to our knowledge of optical, psychological and social structures. And it will do so thanks to the clarity and accuracy of its means, in which content and form, meaning and statement, are interconnected and inseparable" (in *A bis Z*, Cologne, May 1931). And indeed the photomontage was becoming more diversified, more subtle; it had reached the point of making the viewer see the invisible, another visible, or even renewing the visible.

Max Ernst was combining collage and montage to create his whimsical series of pictures centring on Loplop, Superior of the Birds, an imaginary figure with anthropomorphic forms. From 1929 to 1934 Ernst pursued his dialogue with this Alter Ego who cast his strange shadow over the everyday world. Even more than Ernst's famous collage novels of this period (*La Femme 100 Têtes*, 1929; *Rêve d'une petite fille qui voulut entrer au Carmel*, 1930; *Une Semaine de Bonté*, 1934), the long series of Loplop pictures enabled him to work out a synthesis of the combined possibilities of collage and automatic writing. In his preface to the catalogue of the exhibition *What is Surrealism?*, organized at the Zurich Kunsthaus in 1934, he wrote: "The joy one takes in any successful metamorphosis answers, not to any mere aesthetic desire for distraction, but rather to the age-old need of the mind to free itself from the illusory and boring paradise of unchanging memories and to seek out a new field of experience, an incomparably wider field where the frontiers between the inner world, as it is agreed to call it, and the outside world (according to the classic philosophical conception) become more and more blurred and, in all likelihood, will disappear completely when more precise methods than automatic writing will have been discovered." And collage and photomontage were those very methods.

Raoul Hausmann (1886-1971): Magnifying Lens, 1931. Photograph.

The collages of Herbert Bayer stand midway between Surrealism and Constructivism. An Austrian artist, trained at the Weimar Bauhaus in the early twenties, he later taught at the Dessau Bauhaus (1925-1928), in the workshop of printing and advertising design. Bayer, in the best of his work, succeeded in creating an imagery which displaces and renews the mind's awareness of reality, opening up unexpected byways of vision and imagination. His experience as a typographer and graphic designer enabled him to create visual shocks of considerable impact, while the subjects he chose bring him into relation with the world of the Surrealists.

It was just at this time that Man Ray contrived to introduce into painting his rich experience as a photographer—his expertise in the enlargement of details, his resourceful creation of textural effects with coarse-grained paper, his infinite range of variations in lighting. Much of this experience went into his large oil painting entitled *Observatory Time, The Lovers*, an arresting image of an enormous, disembodied pair of lips, not only looming on the horizon but apparently filling the sky and dwarfing the landscape.

The idea for this singular painting came to him from some photographs he had made, magnified details of the human face and body. "One of these enlargements of a pair of lips haunted me like a dream remembered. I decided to paint the subject on a scale of superhuman proportions." He worked on the painting off and on for two years (1932-1934) in Paris. During this time he would go for daily walks in the Luxembourg Gardens, not far from his studio at Rue Val-de-Grâce 8. From there he could see the dome of the Observatoire, and this impression is recorded in the picture, in the domed observatory visible on the horizon of the crepuscular landscape. The shape of the lips suggests the entwined bodies of two lovers. Man Ray set great store by this painting, and it represented the spirit of his work in all the more important exhibitions devoted to Surrealism in the 1930s and later.

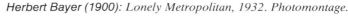

Herbert Bayer (1900): Lonely Metropolitan, 1932. Photomontage.

Henry Moore (1898): Composition, 1931. Cumberland alabaster.

The affirmation
of biomorphic forms

It was in 1930 that Hans Arp revealed his powers as a sculptor, and from then on the novelty and quality of his works never ceased to cast a spell over his contemporaries. In spite of an apparent analogy between his forms and those of Brancusi, the two men were actually following up two opposite lines of research. Brancusi started from the real and in the process of exhausting its possibilities arrived at abstraction. Arp did the reverse. Starting from an abstract form, he worked his way back to nature by following the prompting of his intuition, outside any convention or tradition. Arp arrived at three-dimensional expression just as he was moving away from the Surrealists and linking up with the Abstraction-Création movement. True, his large earlier reliefs set on pedestals had already shown his powers of free expression in space, but the crisis he went through in the winter of 1929-1930 brought out these powers to the full. Disconcerted by the deterioration of his Dada collages over the years, he began questioning the "finished" character which he had hitherto given his forms. His "torn papers"—an angry tearing up and random resticking of his collages—were his response to the anguish of seeing his earlier works go to pieces. Then he gradually reverted to sculpture in the round which he had not practised since 1914; he was attracted to it by its solidity and permanence. After some trial works in an expressionist vein (which he destroyed), he fell back on the shapes of his reliefs which he gradually "thickened up." The first autonomous volumes date from 1930. He worked in wood before realizing that modelling offered greater freedom. *Three Disagreeable Objects on a Figure* is one of his first successes. Here he materialized in space some shapes remarkable for their biomorphic character and abstract tension— novel, too, in that each volume is independent of the others. This idea

of a sculpture in several parts was also developed by Giacometti (with whom Arp was then friendly, buying one of his works in 1931); it also became a key feature of Henry Moore's work.

Arp's forms, in their free growth, offer some surprising similarities to those painted by Miró and Tanguy. By preferring modelling to cutting, Arp was led to invent automatic sculpture. As he said in 1934: "I let myself be borne along by the work in the making. I trust myself to it unthinkingly. The forms arise shapely or strange, hostile, unaccountable, mute or slumbering. They arise on their own. All I seem to do is move my hands about. These lights and shadows come to us by 'chance,' we should welcome them with surprise and gratitude. The 'chance' for example that guides our fingers when we tear some paper. The figures that then appear give us access to mysteries, reveal the underlying paths of life" (Hans Arp, *Jours effeuillés*, 1966). Unlike Brancusi, Arp does not rely on a stimulus or an inviting piece of material. All he needs is some matter permitting him to capture the vital flux: this his hands arrest and shape in an effort which crystallizes life. Clay and plaster proved to be best suited to his impromptu insights into form and metamorphosis; and while some of his works were later executed in stone, only a few of these were actually carved by Arp himself.

Beginning with the divided forms of his wood collages, he gradually attained to complete freedom in the handling of volumes in space. Such were the *concretions* that appeared in 1934: they mark the fruition of this research. Developing freely from a core of energy, these forms engross space in their cavities and thus renew the relations between the solid and the void. They seem to arise from their own necessities of formal development. Hitherto only Picasso and Matisse had achieved such organic fluidity. "Concretion," said Arp, "is something that grows." Born of the pressure of the hand on pliant material, they represented for him "the clotting of earth and heavenly bodies." He could smoothe them with a caress or compress them with a determined gesture.

Arp's participation in the discussions of the Abstraction-Création group was re-echoed in 1942 in the claim he laid to the term *concrete*: "We do not want to copy nature. We do not want to reproduce, we want to produce. We want to produce as a plant produces fruit, and not reproduce. We want to produce directly and not through a go-between. As there is not the slightest trace of abstraction in this art, we call it concrete art. The works of concrete art should not be signed by their makers. These paintings and sculptures, these objects, should remain anonymous in the great workshop of nature, like the clouds, mountains and seas, like animals and men" *(ibid.)*.

Progressively moving away from the strict patterning of Cubist space, the sculptor Henri Laurens followed up a similar line of research, working in a vein of highly personal lyricism. After 1930 he turned away from the fragmented and discontinuous space of his previous work and set himself to developing volumes made up indeed of contrasting masses, but rich in articulations and passages that underscore the fluidity and dynamism of the whole and accentuate its unity. Though he returned to a space "limited by forms," Laurens did not in fact revert to traditional sculpture; new and personal is the movement he gives his figures, through a subtle displacement of the centre of gravity and a sensitive anchoring of the core of equilibrium within the visual instability. Laurens in the 1930s seems very close to Matisse, their development running parallel. In 1935, in an essay published in *Cahiers d'Art*, Laurens touched on the need he felt for this new lyricism: "But the fact that we are aware now of this atrophy of the instinctive faculties, of impulses, of the deeper feeling for things, raises the hope that we may soon get over this error by setting ourselves to re-educate these atrophied forces. It will then be seen that everything vital in life, whether near us or remote from us, visible or

conjecturable, as soon as touched on by a new individual, transforms undiscernible harmonies into perceptible harmonies." Herein he found the élan that enabled him to pass on from small-scale work to monumental compositions.

It was also in the 1930s that Henry Moore made his name as a sculptor of international stature. Born in Yorkshire in 1898, he was stimulated not only by the new departures of contemporary art but also by the achievements of classical and archaic art. Gradually overcoming the influence of the latter, of the Pre-Columbian art of Mexico in particular, he renewed his vision of nature, just as his work was becoming more abstract, by making a collection of found objects: stones, shells, bones, etc. From them he gained an understanding of essential principles—equilibrium, rhythm, growth, harmony, contrast. He pondered on these objects, which retain in their very mass the organic imprint of life. Though he seemed to move away from visual appearances, he was actually deepening his grasp of reality. "Pebbles and rocks show nature's way of working stone," he said in 1934. "Smooth, sea-worn pebbles show the wearing away, rubbed treatment of stone and principles of asymmetry."

In 1932 Moore used a stone with a hole in it for the starting point of a sculpture on the theme "Mother and Child," one of his favourite subjects. As with Laurens and Lipchitz, movement is obtained by inclined axes and asymmetrical masses. But his eagerness in collecting the waste products of nature links him up directly with the biomorphic forms of Arp, Miró and Tanguy. While striving to make volumes live in space, he nevertheless remained attached to mass. Moore generally works by tackling directly the stone or wood which he wants to charge with a human presence. His interest in the expressiveness of forms leads him to a gradual stripping away of non-essentials and an ever firmer hold on space, until he is able to integrate the void into the form in an organic whole, after the example of shells, which "show nature's hard but hollow form... and have a wonderful completeness of single shape." As Moore has wisely said: "All good art has contained both abstract and surrealist elements, just as it has contained both classical and romantic elements—order and surprise, intellect and imagination, conscious and unconscious. Both sides of the artist's personality must play their part... My sculpture is becoming less representational, less an outward visual copy, and so what some people would call more abstract; but only because I believe that in this way I can present the human psychological content of my work with the greatest directness and intensity" (*The Sculptor Speaks*, article in *The Listener*, 18 August 1937).

◁ *Henri Laurens (1885-1954): The Streamer, 1931. Bronze.*

▷ *Hans Arp (1887-1966): Torso, 1932. White marble.*

▽ *Hans Arp (1887-1966): Three Disagreeable Objects on a Figure, 1930. Bronze.*

Before coming to the attention of sculptors as a new and challenging medium, metal had already imposed itself as a prime material of modern architecture and furniture. Once it was taken up by sculptors, it began to modify their art in unforeseen ways. The Spanish tradition of course had already produced some sculptures in iron, and Julio Gonzalez, a goldsmith before becoming a sculptor, had done some repoussé work in metal in 1914.

From 1926 on, this evolution was speeded up. The Paris review *Cahiers d'Art* of September 1926 reproduced an astonishing African genie of the Ebro war, an assemblage of iron. Then, in No. 7-8 of the same review, there appeared an article on Pablo Gargallo (1881-1934). Living in Paris and working in a modernistic Cubist spirit, this Spanish artist created some figures in iron which draw on all the resources of wrought, welded, hammered and cut-out metal. For Tériade, the author of the article, iron represented "a laying bare of the heart of sculpture." He wrote: "Gargallo has favoured the realization of his purpose by adopting new materials, humbler ones perhaps than those in common use, but more flexible ones lending themselves naturally, as if by the effect of their own laws, to the extreme differentiation of planes which he aimed at."

Iron was the medium that would permit the total liberation of the volume-mass advocated by Kobro: "The use of the limiting limit offers the advantage of bringing to the fore for the first time the conception of sculpture as an ordering not of the material but of a definite part of space. The use of the limiting limit has had this secondary effect: that, in determining a sculpture, whose volume is only partially occupied by form and matter, it makes us understand that the formation of the space in which it stands is the most important thing, and that the quality of the material which goes to fill the different parts of these spaces is only a secondary problem" (Strzeminski and Kobro, *La Composition de l'Espace...*, 1931).

In the use of iron as a medium for sculpture, one of the leading roles was played by Julio Gonzalez (1876-1942), first by executing the metal assemblages designed by his friend Picasso, then by the gathering power and stature of his own work. Born in Barcelona, he learned the craft of metal-working as a child from his father, who owned a small workshop. In 1918, though already known as a sculptor in Paris, he set himself to acquire a more thorough technical experience by taking a job as an apprentice welder in the workshops of the big French plant Soudure Autogène Française. Family circumstances forced him to give up sculpture for a few years, and when he returned to it in 1927 he began working in a spirit akin to that of Gargallo. He renewed his friendship with Picasso, who had been his bosom friend in younger days, and from the autumn of 1928 they began working together in metal. The transformations due to their collaboration are only too evident. Picasso, buoyed up by his eager curiosity, probed into and tested all the possibilities contained in this new medium of expression; and by associating Gonzalez with the actual execution of his own projects, he revealed to his friend some unexpected potentialities.

Picasso's first piece of sculpture in iron, one of the so-called *Wire Constructions*, dates from this autumn of 1928. After visiting Picasso's studio and seeing them, Kahnweiler described them as "line drawings in space." They mark in fact the introduction into sculpture of the "cage" (a motif often recurring in Giacometti's work, as in his famous *Suspended Ball* of 1930);

Sculpture in metal

that is, a volume expressed not in the mass, but in the singling out of its contours cutting through space. In an article on "Picasso's Projects for a Monument" (*Cahiers d'Art*, 1929) Christian Zervos wrote: "One might be tempted to suppose that these combinations worked out by Picasso are the immediate creations of today. This would be to overlook those marvellous interpretations of planes which he has been making for several years past, and which in sculpture were to lead him on to his interpretations of mass and space. These perforations of the mass constitute the innumerable appearances of the monument, by creating successive displacements of the parts."

The *Seated Bather* of January 1930 shows that, in his painting, Picasso had also arrived at this new conception of a totally penetrable figure. These years around 1930 moreover stand out as one of the most fruitful and inventive in his long career. His return to sculpture was but one further token of the creative élan inspired by his love for Marie-Thérèse Walter, from 1927 on. The first signs of this return to the third dimension can be detected in the heavily shaded drawings of that same year. The ever freer handling of a variety of volumes led him straight back to the assemblage. But the assemblages of this period are more dynamic than, and wholly different in spirit from, the ones he had made in 1912-1914; they are not so much constructed as contrived, in the surrealist manner. Being able now to make them in metal, Picasso entirely renewed the terms of the problem of solids and voids in sculpture, while at the same time renewing the expressive resources of sculpture. He did not produce many of these welded assemblages, but each one of them is a work of particular significance. Such is *Woman's Head* of 1931, made up of two skimmers together with some nails and mattress springs: it is the perfect embodiment of the "found object." Picasso brought off the feat of achieving unity in this uncanny head, on the basis of incongruous elements which in the process lose neither their specific qualities nor their primal differences. No drawing could have given any inkling of the strange encounter of these fortuitously discovered elements, which henceforth ensured the autonomy of his pictorial output with respect to his graphic work.

The use of iron marked a new stage in the evolution of modern sculpture by opening up a new approach to the problem of equilibrium, a problem hitherto posed almost entirely in terms of mass. The use of iron freed sculpture from the pedestal—as most effectively demonstrated by Calder— and even enabled it to expand horizontally in dynamic equilibriums which contrast strikingly with the vertical hieraticism of traditional sculpture.

But most of all iron disclosed the internal structure of volumes, whereas sculptors in the past had been bound by their medium to concentrate on the external features of the mass. This revelation of the framework displaced the classic notions of "finish," while at the same time it integrated the work into space in a direct and telling way. For a form made up of different elements is no longer a form which invites the void to penetrate its gaps and openings; such a form, on the contrary, is constituted on the basis of a core of space which the metal envelops and develops and prolongs into an environment which overflows its real dimensions.

In the specific case of Julio Gonzalez' sculptures, they amplify the expressive power of volumes by laying bare the process of their elaboration. The progressive transformation

of the iron, as it is heated, wrought and hammered into shape on the anvil, remains visible in each of the parts. And because the assemblage of iron is the result of an addition—in contradistinction to direct cutting, which is a subtraction—it gives the artist an unexpected and exhilarating freedom, a sense of exploring as yet untried resources.

Born directly in the space of their making, and inspired by the chance encounters and accidents occurring in the course of execution, these assemblages are close kin to the creations of surrealist automatism in other media. But because its originality depends so much on chance discoveries made during the elaboration, this sculpture in iron also served to renew the data of mimesis. Being no longer subject to the representation of the signified, the material henceforth makes itself

felt in a metaphorical way. The fixity of the representation is emphasized by the introduction of a contradiction: every element may go to signify another, and this discovery was to be pregnant with consequences. With iron, the gesture became one of the verities of sculpture, and the mass became transparent by disclosing what it consists of rather than what limits it.

From the time of his arrival in Paris in 1926, Calder began making wire sculptures and eventually went on to sheet metal. In 1929 he produced his first moving sculptures: "Why must art be static?... The next step is sculpture in motion." With wire he contrived the dozens of figures and animals that went to form his famous miniature circus (now in the Whitney Museum, New York): the performances he gave with them, both in Europe and the United States, remain a vivid memory to those who saw them.

Calder, a native of Philadelphia, spent several years in Paris, and the visit he paid there, in 1930, to Mondrian's studio at 26 Rue du Départ, in Montparnasse, was decisive for his evolution: "This one visit gave me a shock that started things... I was particularly im-

pressed by some rectangles of color Mondrian had tacked on his wall in a pattern after his nature. I told him I would like to make them oscillate—he objected."

Calder joined the Abstraction-Création group, which included Mondrian, Van Doesburg and Arp, and under this stimulus went on to produce some abstract wire constructions which were exhibited in Paris at the Galerie Percier in April-May 1931; the catalogue was prefaced by Fernand Léger. These stationary constructions were later dubbed "stabiles" by Hans Arp. The following winter Calder began making abstract sculptures with moving parts. These were first exhibited at the Galerie Vignon, Paris, in February 1932: "I asked Marcel Duchamp what sort of a name I could give these things and he at once produced 'mobile.' In addition to something that moves, in French it also means motive." Instinctively, by discovering natural and artificial movement, Calder endowed sculpture with a new dimension and renewed the conditions of equilibrium by setting it free of weight.

With his plaster and metal construction called *Suspended Ball* (1930) Giacometti touched simultaneously on the problems of the "cage" and the "mobile," but here the object and its movement are connoted rather in symbolic and psychoanalytical terms. Like Picasso, he had seen the necessity of achieving transparency. "For me," he said, "the figures were never a compact mass, but were like a transparent construction." Transparency was necessary to convey the mysteries within, all that eludes the eye—inner life and emotion. His subjectivity and memory led him on to constructions as powerful on the expressive level as they were bold on the technical level: among them are some of the first sculptures calling for spectator participation. For Giacometti these constructions were more important as projects—occurring to him ready made—than in their realization, which seemed to him a secondary matter. "I was to see them carried out, but the realization itself was irritating. The model having been made in plaster, it was essential for them to be carried out by a cabinetmaker (I would retouch them afterwards if necessary) in order for me to see them shape up like a projection."

These constructions, with their dramatic implications, set the direction taken by "surrealist objects," for they sprang into being like an uncontrollable response, their component elements being endowed with a metaphorical power never yet seen in sculpture. In them Giacometti exteriorized his existential anguish, taking violence and cruelty as his subject, and freed himself from the obsessive presence of death by signifying it directly through the use of bones from actual skeletons. He condensed his obsessions in a space peculiarly his own

◁◁ *Julio Gonzalez (1876-1942):*
The Angel, 1930-1932. Iron.

◁ *Alexander Calder (1898-1976):*
Helicoidal Mobile, c. 1932.
Painted metal and wire.

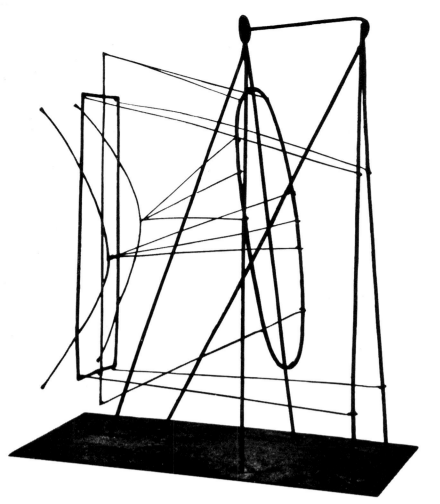

Pablo Picasso (1881-1973): Wire Construction, 1930.

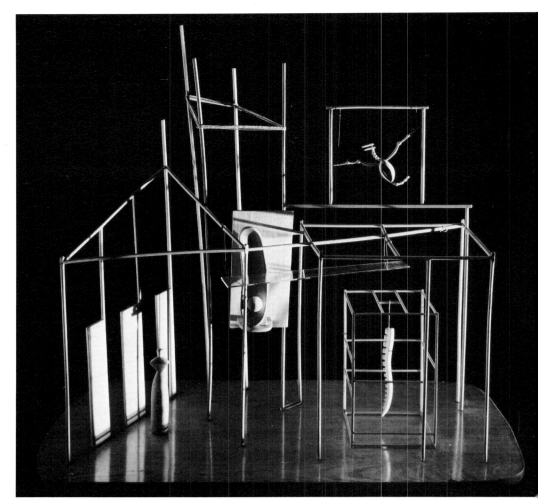

Alberto Giacometti (1901-1966): The Palace at Four A.M., 1932-1933. Wood, glass, wire and string.

in its tensions and foreshortenings. His *Palace at Four A.M.* (1932) sums up the conquests and themes of his Surrealist period. Here, in an architecture reminiscent of a Meyerhold set, he elaborated a mystery which he explained in some notes published in *Minotaure* (December 1933): "For years I have only made sculptures which presented themselves to my mind in a completely finished state. I have confined myself to reproducing them in space without making any changes in them, without asking myself what they might mean. Once the object is constructed, I have a tendency to find in it, transformed and displaced, certain images, impressions and facts which have moved me deeply (often without my realizing it), certain forms which I feel to be very close to me, though I am incapable of identifying them, which makes them all the more perplexing to me." In the summer of 1934 he suddenly started working again directly from the model: "Once more I could see the bodies which attracted me in reality and the abstract forms which seemed to me truthful in sculpture, but I wanted to do the first without losing the second." By then his Surrealist period was over—to Breton's disappointment: in the *Dictionnaire abrégé du Surréalisme*, published in conjunction with the International Surrealist

Exhibition of 1938 at the Galerie Beaux-Arts, Paris, Breton, under the entry "Giacometti," tersely and dismissively described him as "Former Surrealist sculptor."

No matter; Giacometti's free-lying bronze *Woman with her Throat Cut* (1932) is one of the most fascinating Surrealist objects and an important sculpture in its own right. It was the first piece to develop lengthwise, and Giacometti drew and photographed it from above as it lay splayed out on the floor of his studio. Here again he emphasized the metaphorical importance of the crustacean shapes that go to make up the work. Like Picasso and Henry Moore, Giacometti in the thirties showed a certain obsession with skeletal forms. The drawings Picasso published in *Minotaure* are akin to Giacometti's sculptures. Ideas for sculptures that were never carried out, these drawings were directly inspired by the analysis of human bones, the living imprint of their structure and their biomorphic expressiveness. Dealing with such themes as the Minotaur, the Crucifixion and Bullfighting, themes which were to find an unforgettable fusion in *Guernica* (1937), these disquieting bone drawings oriented Picasso towards the expression of violence, sacrifice, death. More than any other subject, it was they

Alberto Giacometti (1901-1966): Woman with her Throat Cut, 1932. Bronze.

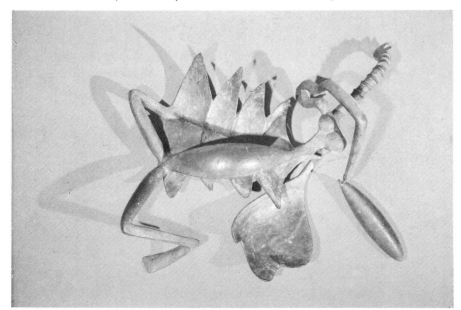

Henry Moore (1898): Reclining Figure, 1933. Pen and ink, chalk, charcoal and wash.

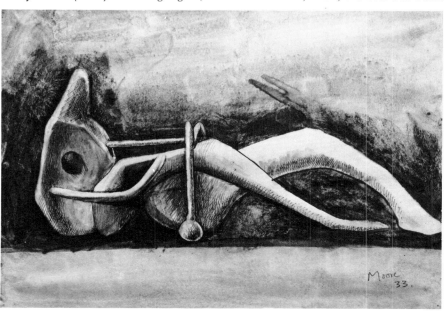

that prompted Breton (in *Minotaure*, No. 1, June 1933) to state, in his highly wrought prose, what the artist had brought to art and what the poet expects of art: "Because it alone can really suggest man's power of acting upon the world in order to shape it as he sees fit (in this respect fully revolutionary), I single out in this production of his the ever continued striving to confront all that exists with all that may exist, to conjure up from the never seen all that may urge the already seen to make itself less foolishly seen... And while it may be taken for granted that the great enigma and permanent cause of man's conflict with the world lies in the impossibility of justifying everything by logic, can one call upon the artist and scientist to account for the ways chosen for its satisfaction by the imperious human need to fashion *against* external things other external things in which all the resistance of the inner man shall at once be broken down and included? Picasso, to my mind, is only so great because he has thus put himself constantly in a state of defence against external things, including those which he has extracted from himself; because he has never held those things to be anything but *moments* of intercession between himself and the world. Indifferent to all that to artists generally is an object of delectation and vanity, Picasso has sought out the perishable and the ephemeral for their own sake."

Henry Moore too has been keenly interested in the shapes offered by bones, because, as he has said, "bones have marvellous structural strength and hard tenseness of form, subtle transition of one shape into the next and great variety in section." They have enabled him to create some of his most dramatic, tautly rendered figures.

Giacometti and Picasso were the creators of what has come to be known as the Surrealist object. They also have the distinction of according to form an importance which the Surrealists denied it, concerned as the latter were almost exclusively with eye-fooling and mind-fooling imagery. Three-dimensional collages of found objects chosen for their own sake were justified by Dali as "representations susceptible of being provoked as fulfilments of unconscious actions... The incarnation of desires whose manner of being objectified is by substitution and metaphor, their symbolic realization constitutes a process based on the *perversion of the sexual*, which resembles in all aspects the process of poetry-making" (Salvador Dali, *Objets surréalistes*, in *Le Surréalisme au service de la Révolution*, December 1931).

As early as 1924 André Breton had suggested the realization of "certain objects which can only be approached in dreams." But it was the eye-fooling illusionism practised by Tanguy, Dali and Magritte in the 1930s which led inevitably to the appearance of real objects "with a symbolic function." A further extension of the techniques of collage and photomontage, these phantasmal constructions served to subvert and discredit the real and the functional by irrupting in their specific field. From 1931 on Dali multiplied his "symbolically functioning objects"; they might be described as "assisted Readymades," to apply Duchamp's expression to them. (Meanwhile Giacometti published a set of drawing of his constructions called *Mute and Movable Objects*, in *Le Surréalisme au service de la Révolution*, December 1931.) Dali acknowledged that his objects left "no opening for formal preoccupations. They depend solely on the amorous imagination of each person and are extra-plastic." This was the period in which Miró made his first found objects, from which stemmed his work as a sculptor which only assumed its true dimensions after the Second World War; the period too in which Man Ray multiplied his ironic constructions, a further offshoot of the Dada spirit.

Such was the proliferation of these objects, in the inventive hands of the Surrealists, that it was decided to bring them together in a public showing. Hence the Surrealist Exhibition of Objects at the Galerie Charles Ratton, Paris, in 1936. Calder, the American inventor of the mobile, was also represented in this show.

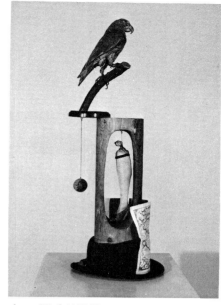

Hans Bellmer (1902-1975):
The Machine-Gunneress in a State of Grace, 1937.
Wood and metal construction.

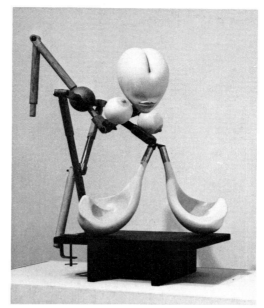

Joan Miró (1893):
Poetic Object, 1936.
Assemblage.

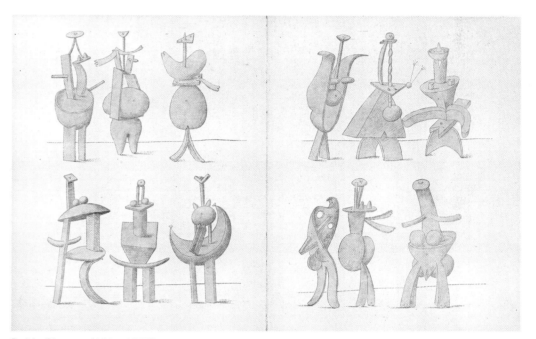

Pablo Picasso (1881-1973): Anatomies, 1933. Charcoal.

Salvador Dali (1904):
Retrospective Bust of a Woman, 1933.
Bronze and other materials.

Hans Arp (1887-1966):
Maimed and Stateless, 1936.
Newspaper sculpture.

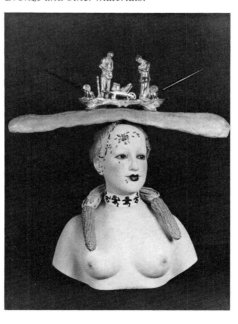

Art and politics

Diego Rivera (1886-1957):
*Nazi Culture, 1933. Detail
of a large mural painting
(destroyed).*

In spite of the first Popular Front government in France (1935-1937), the international situation remained tense. Fascism seemed to be raising its head on all sides, so brutal and menacing that no one could any longer believe in the hoped-for revolution of man and society for which so many European artists had worked and striven in the 1920s. In the darkening mood of individuals and countries, Expressionism returned to the fore, denouncing and prophesying in powerful tones. Thus Max Beckmann, exiled from his native Germany, painted his large triptychs, which stand out as an unforgettable indictment of a world sinking into madness and cruelty.

With such shadows hanging over daily life, the time was past for aesthetic and formalist debates. Even descriptive realism had had its day, it simply had not the power to bear effective witness. Brecht, also banished from his own country, saw this clearly: "In the face of the continual challenges offered by a constantly changing social environment it is no use keeping to old and conventional forms, that too is mere formalism," he said in a famous debate over Expressionism. And with his usual lucidity he defined the terms of a new realism:

John Heartfield (1891-1968):
*Madrid 1936.
Photomontage, 1936.*

"One cannot write the truth just like that. It is absolutely necessary to write to *someone*, to someone who can do something about it... The truth has to be weighed, sifted out by him who speaks it and weighed by him who hears it. For us writers it is much more important to know to whom we speak the truth, and who has spoken it to us... The most important thing of all is for right thought to be taught. By right thought I mean thought that questions things and events in order to single out from them what is changing and what can be changed" (Bertolt Brecht, *Schriften 2, Zur Literatur und Kunst; Politik und Gesellschaft*, 1933-1938).

Many artists raised similar questions and forced their art to become a political act, or at least reflected on the painter's activity and its political and social implications. This was the line of thought summed up by the French painter Edouard Pignon when he looked back on the 1930s: "In France there was widespread unemployment and this was a source of great anxiety to all... We were inevitably thrown into this context, sensitized to this climate of feeling. We wanted to discuss all these ideas that were in the air, follow up some form of social and political thought. And for this to react on painting and from there for painting to try and express these ideas, there was but one step to take" (Edouard Pignon, *La Quête de la Réalité*, 1966).

With terror on the rise and censorship with it, painters and writers sprang to the defence of peace and freedom, in the few countries where they were still able to speak out. In France Georges Bataille and Aragon were among the writers who took the lead. In 1936, at the Maison de la Culture in Paris, Aragon was the moderator of a great debate on the necessity, and the appropriate ways and means, of a return to realism in the arts. The more relevant statements of position were published in a revealing book, "The Quarrel over Realism" (*La Querelle du Réalisme*, Paris, 1936). Echoing Brecht, Aragon—a Surrealist turned Communist—exhorted painters to follow the Marxist line of socialist realism: "In a word, this realism will either be a socialist realism or painting will cease to exist, it will cease to have any dignity left... Believe me, the time has come for you painters to speak out like men. You need not decorate any more palaces of the great with lifeless arabesques. It is up to you to go to work with other men, to be their equals in the world to come. Bear this in mind... If, to use a famous phrase, it is for the writers now to be the engineers of the mind, do you think your own destiny should be anything less?" (Louis Aragon, in *La Querelle du Réalisme*, 1936). Mere demagogy perhaps to reduce the conquests of modern art to "arabesques decorating the palaces of the great," but the tone speaks volumes for the bewilderment and cross-purposes of the period.

Mexico was then the only country whose leading artists had enlisted in the service of the revolution: Orozco, Rivera and Siqueiros were covering the walls of official buildings with vast allegories celebrating the virtues of social change and modernity, in a dramatic, expressionistic style. Treating each painting as a manifesto, they succeeded equally well in giving an identity to their country by revitalizing the art and styles of the Pre-Columbian past, and by thus creating a genuinely popular, genuinely modern art.

In the United States, when Franklin D. Roosevelt became president in January 1933 and launched the New Deal to counter the depression, government action was taken in all sectors of national life. Even artists were mobilized and put to work under the Federal Art Project, the first programme of socialized art, modelled on the system of government patronage developed in Mexico; indeed Siqueiros, Rivera and Orozco were personally invited to share with American artists their experience of mural painting and collective work. Not only were public buildings in the United States decorated with murals (over 2,000 of them between 1935 and 1939), but dingy walls and blind façades in city neighbourhoods were also painted.

In the ruthless political strife of Europe in the 1930s, the photomontages of John Heartfield proved to be an effective weapon. With his knack of condensing and heightening the most complex ideas, Heartfield denounced the Nazis and Fascists with withering irony. His analysis was all the more lucid and forceful for being politically oriented. He was a committed artist, but one who never forfeited his creative freedom. Like so many of the younger men at that time, Heartfield threw in his lot with communism, which seemed to him the only bulwark against the blight of Hitlerism. A large exhibition of his photomontages was held at Stuttgart in 1929, as part of the international Werkbund exhibition of "Film und Foto." In 1933 he left Germany for Prague, and from there, in 1938, fled to London, where in 1939 he held his exhibition "One Man's War Against Hitler."

Heartfield raised the problem of realism in terms of language and content. He utilized new forms for as yet unexplored purposes and his montages are implacable in their incisive, hard-hitting satire. The carrying power of this form of realism was brought home to Aragon, and in 1935, when with communist support the left-wing Popular Front ministry was about to be formed, he invited Heartfield, then living in Prague, to exhibit his work at the Maison de la Culture in Paris. At that exhibition Aragon gave an important lecture (2 May 1935) on the art of photomontage: "There was a time when Heartfield arranged his scraps of photographs for the pleasure of achieving surprise effects. Then, under his fingers, they began to *mean something*. Very soon the poetic *taboo* gave way to the social *taboo*; or, more exactly, under the pressure of events, in the struggle in which the artist found himself caught up, these two taboos merged, and *the only poetry left was the poetry of Revolution*. Burning years in which, with the Revolution countered here, triumphant there, two men arose in the same way at the highest point of art, in Russia Mayakovsky, in Germany Heartfield."

Summing up Heartfield's achievement to date, Aragon concluded: "John Heartfield *now knows how to salute beauty*. He knows how to create these images which are the very beauty of our time, because they are the very cry of the masses, the translation of the struggle of the masses against the brown-shirted executioner... He knows how to create these real images of our life and our struggle... Because he speaks for the enormous host of the oppressed all over the world, and does so without for a moment lowering the magnificent tone of his voice, without humbling the majestic poetry of his colossal imagination. *Without lessening the quality of his work*. Master of a technique which he has invented himself, unfettered in the expression of his mind, using as his palette all the aspects of the real world and shaking up appearances to suit his purpose, he has no other guide but dialectical materialism, no guide but the reality of the historical movement, which he translates into black and white with the frenzy of a fighter" (Louis Aragon, *John Heartfield et la beauté révolutionnaire*, Paris, 1935).

Max Beckmann (1884-1950): Departure (triptych), 1932-1933. Oil.

Pablo Picasso
(1881-1973):
Portrait of Dora Maar, 1937.
Oil and Ripolin.

Dreams
and
Deceits

1937-1939

O<small>NE</small> of the most active and forward-looking groups was Abstraction-Création, formed in Paris but made up of artists from many countries. Equally international in make-up was the Surrealist movement. These two, representing the very incarnation of avant-garde art in the 1930s, were firmly and indeed implacably opposed to the return to tradition prescribed and exacted by the totalitarian regimes in Germany and Italy. The free exercise of art, already impossible in Russia, also became impossible over an ever larger area of Western Europe, and those artists, and they were many, who valued their creative freedom, had to leave Germany (after 1933), then Austria and Czechoslovakia (after 1938), then even France (after 1940). A few remained in Paris (notably Picasso and Kandinsky), where they were able to work on in seclusion but could not exhibit. Some fled to Switzerland (Balthus, Arp). Many took refuge in England (Kokoschka, Heartfield, Schwitters), many more in the United States (Léger, Ernst, Mondrian, Tanguy, Dali, Chagall, Masson).

Hitler, the new master of Europe, was profoundly disturbed by modern art, which he described and publicly branded as "degenerate art" *(entartete Kunst)*, and which he did his best to root out and destroy. Under the impact of his subjection of Europe, the creative forces of modern Western art seemed to have been set adrift. Yet in fact the international solidarity of the artists themselves had never been greater, and the large dispersion of those forces towards the American continent had, in the result, a liberating and revivifying effect, of whom the first beneficiaries were the younger artists of the United States. Duchamp and Picabia had brought a stimulating breath of fresh air into the American art world during the First World War. During the Second, it was the Surrealists, regrouped in New York and active as ever, who were to exert a profound influence on contemporary American painting.

In the threatened Europe of the thirties the atmosphere was not propitious for uncommitted art. Artists left their ivory towers and sought a social justification for their activity. The prevailing mood is reflected in the questions which the Paris art magazine *Cahiers d'Art* (No. 1-4) put to a number of artists in 1939: "Does the creative act feel the influence of outside events, when these events consist in nothing less than the annihilation of the forms of civilization?... Can the work of art exist outside historical time?... Does the artist depend in any way on the social and religious problems faced by the community during the period in which he is working?"

Georges Rouault (1871-1958): Christ, 1938. Oil.

Miró replied: "There are no more ivory towers. Withdrawal and aloofness can no longer be indulged." Masson replied: "The only justification for a work of art, for a poem, for a discovery in the field of biology or psychoanalysis, lies in the extent to which it contributes to the enlargement of man, to the transmutation of all values, to the denunciation of social, moral and religious hypocrisy and thereby to the denunciation of the dominant class."

The social and political unrest of the thirties was felt by most artists, and so strongly that there was a movement away from abstract art, which was felt to be irrelevant to the problems of the day. Significant is the attack launched against it by Brecht: "So you paint for example something indefinite in red. At the sight of this indefinite red thing, some weep because it reminds them of a rose, others because it reminds them of a child mutilated by bombs in an air raid and running with blood. You have done your job: to arouse feelings by line

and colour... We communists see things differently from the exploiters and the tame spirits in their service. But our other way of seeing is concerned with things. With things, not with the eyes that see them. If we wish to teach others to see things differently, we must teach them about things. And what we want is not so much to make people see things 'differently,' but to make people see them in a definite way" (Bertolt Brecht, *Schriften 2, Zur Literatur und Kunst, Politik und Gesellschaft*, 1935-1939).

Picasso shared this view and because he did his art gained a new momentum. He for one had never given way to the temptations of abstraction, though at the same time he had never ignored the problem involved in it. In the thirties he gradually moved on from Surrealism to Expressionism, and in this context gave a new dimension to the Cubist aesthetic. The point was no longer to see, but to make others see and feel in a definite way through the truth and forcefulness of the artist's reaction to the tragic events of his time. Those of the Spanish Civil War, which broke out in July 1936, were naturally to touch Picasso most closely. Before that, in the summer of 1934, he had made a long journey through Spain, to Madrid, Toledo and Barcelona. By the end of 1934 his marriage with Olga had broken up. In 1935 his companion Marie-Thérèse gave birth to a little girl, Maia. Soon he was to meet a young woman painter and photographer, Dora Maar, herself an active Surrealist and a person of strong political views who helped to focus the concerns and anxieties stirring within him. Early in 1936 a large Picasso exhibition was organized in Barcelona by a group of left-wing artists headed by the architect José Luis Sert: it was opened by a lecture on Picasso's work given by Paul Eluard, entitled *Je parle de ce qui est bien* (I speak of what is good). (Picasso's close friendship with Eluard was to make him more and more a politically committed artist.) After Barcelona, the exhibition went on to Madrid, where it aroused the enthusiasm of the young poets Lorca, Alberti and Bergamin, and Picasso was there associated with the triumph of the Frente Popular. Then, in July 1936, General Franco and his followers revolted against this left-wing coalition and the Spanish Civil War began. As a tribute to the country's greatest artist, Picasso was named honorary director of the Prado by the Loyalist government.

On 17 December 1936, in the French communist paper *L'Humanité*, Paul Eluard published a poem on the Spanish Civil War, *Novembre 1936*, which profoundly stirred the European conscience:

> **Look at the builders of ruins at work**
> **They are rich patient tidy dark and foolish**
> **But they do their best to be alone on earth**
> **They stand at man's side and heap rubbish upon him**
> **They bow brainless palaces down to ground level.**

A friend of both Eluard and Picasso has written: "Leaving behind the 'inner model' of Surrealism, Eluard entered into the anti-fascist solidarity, in spite of what separated him from the communists, at a time when the first of the Moscow purge trials had begun. Eluard was prompted not only by poetic but by political reasons. Picasso followed his friend's poetry all the more closely since he himself was often the subject of it. He was very much struck by this poem *Novembre 1936*, which proved that the highest artistic form was compatible with a historical and political theme" (Pierre Daix, *La Vie de Peintre de Pablo Picasso*, 1977). From now on in his art Picasso was to "speak of what is," of what touched him, of what was happening around him, giving an intense and prophetic interpretation of contemporary events heralding even more tragic ones to come.

While many artists in the Europe of the 1930s saw all too clearly what lay ahead, few of them were able to give pictorial expression to the looming tragedy. Two who did, Rouault and Chagall, were mysti-

cal painters. At the big exhibition "Masters of Independent Art" held at the Petit Palais, Paris, in 1937, a whole room was set aside for Rouault. A consummate master of the painter's craft, Rouault was an artist who went beyond painting in his powerful expression of human emotion, of the human spirit, of human aspirations to which the suffering of Christ has given a meaning. He conveyed something of this in the letters he addressed in December 1936 and March 1937 to the *Revue de Belles-Lettres* (Nos. 2 and 4): "This alleged ugliness of mine is one stage, one moment of my researches. Perhaps I have been too objective. Such and such a thing befell me, I was there. But I am not one of those cautious, over-clever people who never go wrong... However, 'any revolt may be directed towards love.' As to my most hideous grotesques, even though I may seem to have painted their poor crucified faces with vitriol, I have done so without any pre-conceived or literary intention... As I have penetrated more and better to the heart of my pictorial passion, I have felt the form become more sober and severe, the exertion to be made more controlled and spare" (Georges Rouault, *Sur l'Art et la Vie*, 1971).

Because he was a Jew and a Russian émigré, Chagall felt even more disturbed by the rise of the Nazis and the spread of racial persecution. Since 1922 he had lived in France. In the spring of 1931 he made his first trip to Palestine, the cradle of his religion; in 1935 he made a trip to Vilna in eastern Poland, not far from his native Vitebsk. He was now ready to revitalize the Biblical message in con-temporary art. The anguish of the period enabled him to give its true dimension to the sacrifice of Christ and to remind us "that while the essentially poetic art of Chagall embodies a *religious* quality, in the exact sense of the word, that quality, stemming from the universal principle of love binding all things together, does not with him imply any established dogma or creed and depends less on the subject than on his way of expressing it and the grace with which he imbues his picture" (Jean Leymarie, catalogue preface of the exhibition "Marc Chagall and the Bible," Geneva, 1962). His poetry was that of a seer and the revelation of the human essence conveyed by the Bible found a new actuality in the glowing colours of Chagall's painting at a time of anxiety and crisis.

Not even Bonnard's happy temperament could quite escape from the gathering storm clouds. While he refused to cut himself off from the joys of nature, he made the most of the moments of light whose glow stepped up the stridence of his colours and lent them a note of discord. As a pantheist he continued to hope for a renewal of the world and could never bring himself to look at things from a sociolog-ical point of view. Many painters of his generation were marked by a nostalgia for the "golden age," encouraged in this by the success of the great Paris exhibition of 1934, "Painters of Reality," at which the Le Nain brothers and Georges de La Tour were revealed. But around a few elder men like Jean Lurçat and Marcel Gromaire, a new genera-tion of French artists—Fougeron, Gruber, Pignon, Tal Coat—was already inventing a figuration that was much more expressionistic, both in its forms and subject matter, for it was directly concerned with rendering the conditions of daily life and the impact of events.

Looking back many years later on the debates of this period over the issue of an art for the people, one of these artists implicitly admit-ted that they achieved little: "I failed to realize in my own mind that the *people* meant me myself... And yet I had started life as a miner before becoming a painter, at the price of dogged efforts, and I knew better than anyone what were the ideas of the working class of that day about art" (Edouard Pignon, *La Quête de la Réalité*, 1966).

And in order to distinguish itself from "poetic reality," the only figurative painting still practised by this new generation, roused and stimulated by Picasso's *Guernica* (1937), continually widened the scope of allegorical, symbolic and expressionistic effects.

Pierre Bonnard (1867-1947): The Gulf of Saint-Tropez, 1937. Oil.

...no more ivory towers

Marc Chagall (1887): The White Crucifixion, 1938. Oil.

The Paris World's Fair of 1937: Pavilions of the USSR and Germany.

The Paris World's Fair of 1937 marked only a brief pause in the deepening uneasiness of the Western democracies before the growing power and pretensions of the dictators. On the neutral ground of the Fair itself the protagonists faced and vied with each other, ideologically, technologically and artistically. The architecture of the different pavilions was particularly significant in this respect. All three of the totalitarian régimes, Germany, Italy and Russia, regarded the Fair as a show-window for their self-advertising displays. Their buildings and their sculptures were "virile," art in the view of these governments being no more and no less than a psychological weapon for winning over the "hearts" and "minds" of the masses and imposing their ideals of brute force and irresistible power. All three of these régimes looked back for inspiration to Roman imperial architecture (or to what they took to be such), which to them offered the only possible model for the "regenerate art" they had in view.

The Arts and Techniques exhibition at the World's Fair, however, had some interesting things to show in the way of monumental art; its exhibits also raised openly, for the first time, the problem of commis-

sioned art with a specifically social purpose. Needless to say, there was no question here of applying the programme suggested by Léger in response to a newspaper inquiry about his views on the Paris World's Fair: "How I would conceive an international exhibition in 1937? Well, here is my suggestion. I see Paris all white, by that I mean all the façades scraped and cleaned, using for that purpose all the unemployed... A luminous, translucent atmosphere: Greece on the banks of the Seine! Why not? Think of the psychological effect on the crowds of such cleanliness and light" (Fernand Léger, "Reply to an inquiry: What would you do if you had to organize the 1937 World's Fair?", in *Vu*, Paris, 1935).

The programme actually carried out for the Fair did nevertheless involve many commissions given to artists for monumental works which they had been dreaming about for years. For the Popular Front government of 1935-1937, like the New Deal in the United States, drew up a cultural project for aiding artists and a bill was passed in the French Parliament providing for artistic collaboration in all buildings erected by the State. This went some way towards satisfying the

Raoul Dufy (1877-1953): Sketch for his mural decoration in the Palace of Electricity at the Paris World's Fair of 1937.

Paris 1937,
the World's Fair

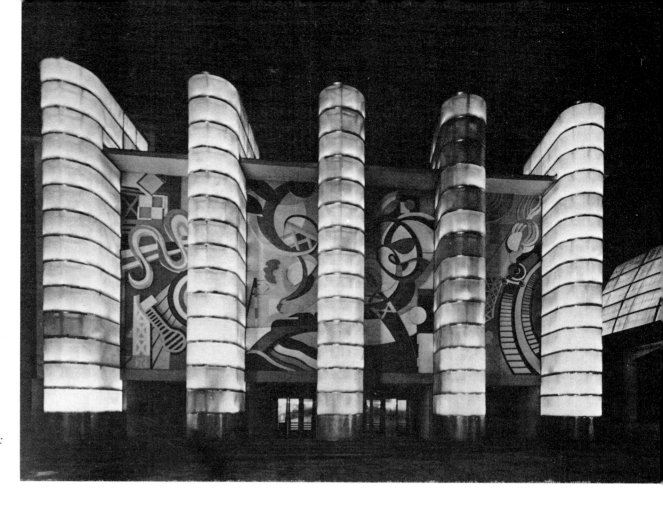

*Robert Delaunay (1885-1941):
Decoration for the Palace of
Railways at the Paris World's
Fair of 1937.*

demands of Robert Delaunay (who now, for the World's Fair, painted some large decorations in the Palace of the Air and the Railways): "We artists, eternal revolutionaries that we are, have some claims of our own to make at the present day. All the civil servants, the workers, the artisans, etc., have obtained vacations with pay, a forty-hour week, etc. As for us, *we demand work...* The work we ask for, to which we have every right, should be organized and it can be very easily" (*Les Cahiers inédits de Robert Delaunay*, 1957).

The international crisis of the thirties made artists keenly aware of their economic dependence. The Paris World's Fair of 1937 gave some of them the chance to experiment with other possibilities, to carry out their ideas about an art for the people, an art having its due place in the community. In a debate at the Maison de la Culture in 1935, Aragon lectured artists on their failure to realize their true position: "Your pictures have been bought and gambled with in the days of prosperity. Then, when dark and uncertain times have come and the crisis is upon you, your patrons have dropped you, as the owners of racing stables drop their overridden horses" (in *La Querelle du Réalisme*, 1936).

Painters were not yet prepared to give up easel painting which, as Léger acknowledged, "controls the evolution of contemporary art and may be expected to control it for a long time to come. The single man as a creative individual will continue for a long time yet to lead the arts... The easel picture is the peculiar expression of that individual. It is the object of art valued for its own sake, depending neither on a piece of architecture nor on any social trend whatever. It embodies pictorial life organized within a frame with its own limits and its own contained emotion" (Fernand Léger, "Colour in the World," in *Europe*, 1938). And Léger concluded with the necessity of leaving the artist completely free in a world situation obviously tending towards socialization: "I know that *the collective forces* are on the march, that the individual is going to be absorbed and aligned, that all too often the individual egoism has taken unfair advantage of things. But in the marvellous realm of creative art where genius functions and fulfils itself through the individual, I say to you: beware. The honour of a

modern society lies in being strong enough, generous enough, to afford the luxury of allowing their freedom to these few individuals whose work will later be recognized and admired" *(ibid.)*.

The buildings of the 1937 World's Fair offered ample wall space, and here mural painters were able to show what they could do. Their works, though variously appreciated, were one of the most memorable features of the Fair. The large scope of the mural programmes planned and carried out offered a free field for experimentation with colour, as Delaunay noted: "The colours had to be related to each other over the whole area. Harmony was very difficult to achieve, for it came to an area of 780 square metres. This was a problem. I don't believe that modern art has ever had such an opportunity" (*Les Cahiers inédits de Robert Delaunay*, 1957). The sheer size of the paintings to be done also meant that teamwork was necessary, as it had been in the Middle Ages. Delaunay in his private notebooks also touches on this point: "An interesting thing about this work is the amount of time it took us, with Callewaert, to prepare this canvas. It took us nine days... Had I been working alone, I dare say it would have taken me a year to do this picture" *(ibid.)*.

Among the painters commissioned to decorate the World's Fair buildings were Sonia Delaunay, who painted the Palace of the Air; Léger, the Palace of Discovery; and Raoul Dufy, the Palace of Electricity; Herbin, Metzinger, Survage and Valmier also painted some monumental works. Le Corbusier expressed his opinion of these mural paintings in a text dated 14 December 1937. What he most admired was the work of Léger and that of Delaunay; the latter was the first who really introduced polychromy into architecture. Le Corbusier however regretted the "forced marriage" which he frequently observed between painters and architects: "What is of real importance is the place offered here to painters with great names. Whole walls have been entrusted to them, walls big enough to hold huge works, and we could try to judge their achievement, if judgment were already called for in this debate so recently opened. For there can only be one indissoluble tie between architecture and the work of art accompanying it, a tie of extreme subtlety, a tie of a mathematical

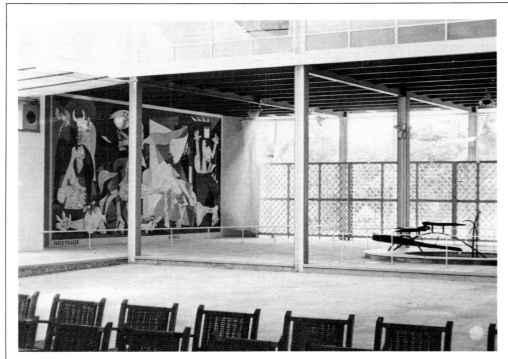

Pavilion of the Spanish Republic at the Paris World's Fair of 1937,
with Picasso's Guernica *on the back wall and Calder's* Fountain of Mercury *on the right.*

Joan Miró (1893): "Help Spain."
Poster, 1937.

Julio Gonzalez (1876-1942):
La Montserrat, 1936-1937. Metal.

order. I would even say, to make myself better understood, that there must needs be a perfect correspondence in the wave-lengths. If that is lacking, then hideous gaps may occur, without our being able to say whether the individual fault lies with the architect or with the painter or sculptor."

The artist then had been asked to come forward in public and speak out, in his own terms. He did, and a new debate followed on the problem of integrating art into architecture. It set much ink flowing, but not much paint. The danger of seeing the artist domesticated by society had not escaped André Breton. In a manifesto entitled "For an Independent Revolutionary Art," which he signed with Diego Rivera in Mexico City in 1938, he wrote: "No, we have too lofty an idea of art's function to deny its influence on the fate of society. We consider that the supreme task of art in our time is to participate consciously and actively in the preparation of the revolution. However, the artist can only serve the emancipatory struggle if he is subjectively penetrated with its social and individual content, if his nerves are imbued with the meaning and drama of it and if he seeks freely to give an artistic embodiment to his inner world."

This is precisely what was achieved in Picasso's *Guernica*, the huge painting exhibited in the Spanish Republican pavilion of the Paris World's Fair in 1937 and one of its most compelling attractions. Amédée Ozenfant described it there in moving terms (*Souvenir de l'Exposition de 1937*, in *Cahiers d'Art*, No. 8-10, 1937): "The vast *Guernica* of the great Spanish painter is before me. This man is always a match for the circumstances he faces... The period we live in today is great, dramatic, dangerous: *Guernica* is worthy of it... What is there so special then in the force of a fine work, if not the power certain forms have of stirring the senses and bringing forth one's intellectual and moral convictions. *Guernica* makes you *feel* the appalling tragedy of a great people given over to tyrants reminiscent of the Middle Ages; and it makes you *think* about this tragedy. The master used only the means properly belonging to the visual arts and yet he makes men of the whole world, if only they have eyes, understand the immense Spanish tragedy."

The Spanish Civil War having broken out in July 1936, Picasso at once aligned himself with the Loyalist Republican government. In

January 1937 he wrote a virulent pamphlet, *Sueño y Mentira de Franco* (The Dream and Lie of Franco), which he illustrated with fourteen etchings and sold for the benefit of the Spanish Republic.

He then promised the Spanish Republican government to take part in decorating its pavilion at the Paris World's Fair, no theme being fixed as yet. On 26 April 1937 German bombers in Franco's service raided the historic Basque town of Guernica, a place of no strategic importance. The town was destroyed and two thousand people killed. Photographs appeared in the press and the world was stunned by the news. Picasso reacted at once to this outrage. Here was the theme of his mural for the Spanish pavilion. On the first of May he set to work on it in his Paris studio in the Rue des Grands-Augustins. Into it went his whole personal mythology as he multiplied his sketches and charted out his picture space and the main features of the tragedy. On 11 May he blocked out his sketches on the huge canvas (11 ½ × 26 feet). He asked Dora Maar to document every stage of the work with her camera.

His picture does not "represent" the bombardment of Guernica, it expresses the drama and tragedy of Spain in 1937, the cry of a civilization ruthlessly destroyed by evil men. To an American journalist Picasso said: "The Spanish war is the fight of reaction against the people, against freedom. My whole life as an artist has been nothing but a continuous struggle against reaction and the death of art. In the panel I am now working on, which I shall call *Guernica*, and in all my recent works, I clearly express my abhorrence of the military caste which has plunged Spain into an ocean of pain and death" (quoted in Pierre Daix, *La Vie de Peintre de Pablo Picasso*, 1977).

The artist's friend Michel Leiris summed up the powerful impression made by the picture in these apt and austere words: "In a black and white rectangle, so that the ancient tragedy is made visible for us, Picasso sends us our letter of bereavement: everything we love is about to die. And so it was necessary that everything we love should be summed up, like the outpouring of great gods, in something unforgettably beautiful."

The Spanish pavilion was designed by José Luis Sert. Shown in it, besides Picasso's *Guernica*, were works by Calder, Gonzalez and Miró. "Sert was against my participation," said Calder, "because obviously I was not a Spaniard, but later when he received a fountain to set off the Almaden Mercury and found it looked like any old fountain he appealed to me to help him out of the difficulty." Julio Gonzalez exhibited *La Montserrat*, an iron sculpture 5 ½ feet high. The sufferings of his fellow countrymen brought the sculptor back to representation, which he felt would better enable him to express his profound revolt and communicate it. He had achieved such mastery in the handling of wrought and welded iron that he could give his figure the features of a woman carrying her child without removing from the hammered volumes any of their aggressive expressiveness. The very coldness of the material, retaining all the scars of the hammer and the welding torch, magnified on the contrary the sense of heroism and resistance conveyed by the figure's conquering movement.

The outbreak of the Spanish Civil War found Miró at Montroig in Catalonia. In his painting of the late thirties he sought to exorcise the suffering and horror of those years. He spoke little of what was happening. But in 1939 he confided something of what he felt to Georges Duthuit: "The horrible tragedy we are undergoing may stimulate a few isolated geniuses and give them an increased vigour. But let these powers of regression known by the name of fascism spread themselves yet further, let them plunge us a little more deeply into the impasse of cruelty and incomprehension, and it will be all over with human dignity" (*Cahiers d'Art*, No. 1-4, 1939).

For the Spanish pavilion Miró painted *The Reaper*, a panel measuring 18 by 10 feet. This monumental painting initiated him into the problems of integrating art into architecture; what he learnt then he turned to good account in the monumental works he painted after the war. He described this experience to Gaëtan Picon: "Nor were there any drawings for *The Reaper*, which was exhibited in the Spanish pavilion at the Paris World's Fair of 1937: I threw myself at that surface like a wild man, and it was twenty feet high. I made a few very rough, insignificant sketches, and then I just tackled the canvas head-on, at the risk of falling off the scaffolding and breaking my neck!" (Joan Miró, *Catalan Notebooks*, 1977).

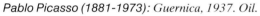

Pablo Picasso (1881-1973): Guernica, 1937. Oil.

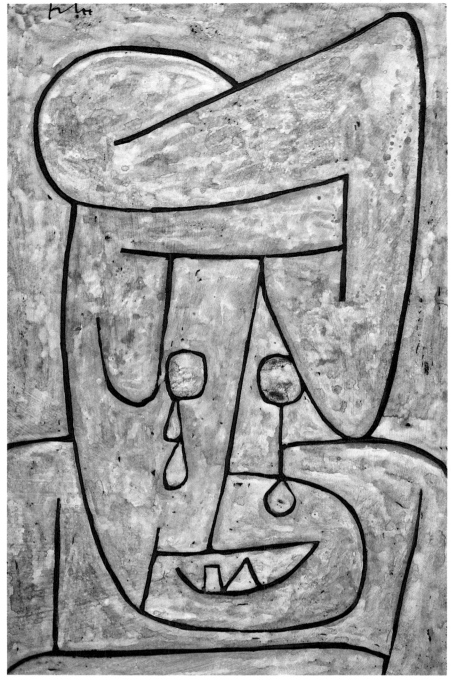

Paul Klee (1879-1940): Weeping Woman, 1939. Watercolour and tempera.

Freedom versus the order of the law

André Masson's tragic sense of life was to find full expression in the political circumstances of the thirties. His subjects and style even gave a further dimension to Expressionism. He lived in Spain from 1934 to 1936, and had already memorably evoked violence and brutality in his works of the early 1930s, as in his *Combats* and *Massacres*, when the Spanish Civil War burst upon him, breaking up his quiet life of hard work at Tossa, in Catalonia. He resolutely took the side of the legally elected Republican government which the insurgent General Franco was out to overthrow. Events around him brought to life, all too grimly, the myths he had hitherto developed in his imagination: it was not so much Masson who was brought back to reality, as reality that suddenly seemed to embody his own forebodings. He was a man obsessed by the tragedy of the human predicament, by the sufferings through which man's fate obliges him to pass. Eros and Thanatos were constantly at war within him: "Eros, the pleasure principle in the Freudian conception of behaviour. Facing it are the impulses of death, of self-destruction, or is it the destruction of *someone else?*... The struggle between these two poles, love and death, is not only a thing of today, although in our day it is producing some impressive effects" (André Masson, *La Mémoire du Monde*, 1974).

Masson now proceeded to transcend Surrealism, in the way later analysed and defined by Georges Bataille: "The art of André Masson was departing slightly but markedly from pure Surrealism, in that the thought which he expressed was no longer, like that of automatic writing, *disengaged* from the world: it invaded the world and merged with it... All we can do is acquiesce and let it carry us to the limits of tension. No use hoping to dismiss the human intelligence (evict it and all that remains is the void, impotence, madness—or else pure aesthetics): from that moment we are left, we are stuck, in the impossible" (*Labyrinthe*, No. 19, Geneva, 1 May 1946).

Even if contemporaries did not always realize it, the art of the 1930s was changing its function and purpose, it was becoming a revolutionary force, a speaking embodiment of modern man's desire for freedom. The fear and respect in which it was held by the totalitarian régimes is proved by the very ferocity with which they attacked it. The most systematic attack of all on modern art was carried out by the Third Reich, which branded it as *degenerate art*. As soon as he came to power in January 1933, Hitler took steps to bring culture under State control, setting up a "Combat Union for German Culture" and promulgating a law of permanent censorship, to be applied through the Reich Ministry of the Arts. A "Cultural Senate" was formed whose "principal duty is to fight against and banish the harmful, to preserve and encourage the good, and to make the artist comply with the new aesthetic ideal whereby he shall feel himself closely bound up with the vital national laws of the German people." At the opening of this Senate in Berlin, on 15 November 1935, Goebbels declared: "In their Führer German artists hail the patron and the shaper of their creative work. He has his guiding hand on everything that concerns the making of a truly German art and culture. German artists are proud and happy to think that he belongs to us all, that He is the Spirit of our spirit, the Impetus of our impetus, the Wing of our fancy, the Star of our hope."

Words soon gave way to deeds in the campaign against what the Nazis called "Kulturbolschewismus". In Munich, in July 1937, opened in the Hofgarten the notorious exhibition of "Entartete Kunst" (Degenerate Art), holding up to public reprobation the works of abstract and expressionist artists, stigmatized as subversive, immoral and communist-inspired, and declared to be in total contradiction with the "dignity and sanity" of Aryan man!

At the same time, in the nearby Haus der Deutschen Kunst in Munich opened—to mark the contrast—an exhibition of approved art in a naturalistic style, on martial and heroic themes, illustrating the Nazi aesthetic. The purpose of the Degenerate Art exhibition was pointedly explained in the catalogue, in a text entitled *Was will die Ausstellung "Entartete Kunst"*: "It is meant, at the start of a new era for the German people, to provide a general survey, by means of original works, of the appalling conclusion reached by the cultural decline of the decades preceding the great change." The purge of German museums had begun in 1935, the criteria being as follows: removal and confiscation of works by Jews, of works with any communist or Marxist connotations, of abstract and expressionist art, of any works thought to advocate peace as against war, etc.

Some 5,000 paintings and sculptures and 12,000 drawings and prints were thus removed from public collections and sent to Berlin, to be disposed of as Hitler might see fit. Realizing that a handsome profit could be made out of them, to the advantage of the State, he set up a committee to choose some works for sale abroad, and a public auction of them was accordingly organized by the German government, in Switzerland, at the Fischer Gallery in Lucerne, on 30 June 1939. Among the works sold there, in addition to those of German artists, were others by Braque, Chagall, Derain, Gauguin, Matisse, Munch, Picasso and Van Gogh. Works considered worthless or un-

saleable were burnt in the courtyard of the main Berlin fire station in March 1939: more than 1,000 oil paintings and sculptures and 3,000 prints and drawings went up in smoke. At the 1937 exhibition of Degenerate Art Paul Klee was represented by 17 paintings, out of 102 of his works belonging to German public collections, which then disappeared or were sold abroad. Luckily, thanks to Alfred H. Barr, Jr., these banned artists found a new and attentive public in the United States, and in 1936 he organized two memorable exhibitions at the Museum of Modern Art, New York: *Cubism and Abstract Art* and *Fantastic Art, Dada, Surrealism*. In London, in 1938, Herbert Read paid tribute to them in an exhibition of *20th Century German Art*.

Shocked and saddened by the turn events had taken, Klee left Germany in 1933 and returned to Berne, where he had grown up. From 1936 on, his anxiety was recorded in a moving expression of suffering and terror; he turned back to the spirit of his earlier work, but the expressionism of this final period assumed a more symbolic form. As his illness grew after 1937, he fused his personal sense of

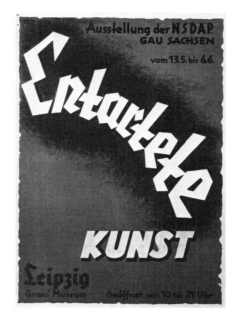
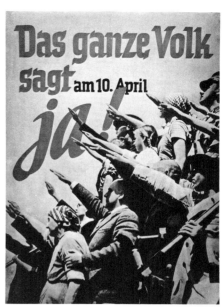

△◁ *Nazi poster for the exhibition of* Degenerate Art, *Leipzig, 1938.*

△ *Poster for the Plebiscite in Austria on 10 April 1938 for union with Germany: "The whole nation says yes."*

◁ *André Masson (1896): Drawing.*

▽ *Wassily Kandinsky (1866-1944): Composition X, 1939. Oil.*

approaching death with his tragic vision of the world predicament. One of his drawings is entitled *When Suffering is Overcome by Mind*. Speaking of his last works, Georg Schmidt, director of the Basle Museum, said: "Not only do they strike a deeper, graver note, but the smile that had gladdened so many of his works seems to have disappeared in the last ones. In them are multiplied the harshest symbols of the inevitable, like the long-prepared finale of a symphony."

Kandinsky too left Germany in 1933, settling in Paris. In 1937 fifty-seven of his works in German museums were confiscated and labelled as degenerate art. But as a Russian he had already lived through too many political storms to allow them to interfere now with his creative work. He rose above them and in his later painting he realized even more serenely than before his dream of the Universal and the Human. He reverted often to the forms he had developed from 1913 on, patterned on amoebae. In their vitality and lyricism they bring to mind today the biomorphic forms of Arp or the elements of plant life taken up by Matisse. Kandinsky often gave them a hieroglyphic aspect, as if in this new form of writing in space he were trying to heighten the communicability of his abstractions.

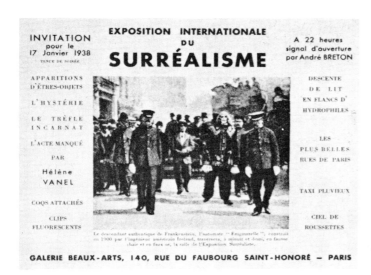

Invitation to the opening of the International Surrealist Exhibition, Galerie Beaux-Arts, Paris, 17 January 1938.

Surrealism invents the environment

Aragon, as a committed communist, became a party man; Breton, though he had flirted with communism, had moved away from it, prizing his personal freedom. Hence the estrangement between them. Under the heading "Aragon" in the *Dictionnaire abrégé du Surréalisme* (1938) Breton wrote: "Surrealist writer, from the beginning of the Movement until 1932, at which time he violently repudiated all his past activity. Became director of the Maison de la Culture, then editor of a big evening newspaper." Actively writing and speaking in all the great debates of the day, Aragon held that the problem of content is all-important and that the message of the work is determinant. For Breton, individual freedom alone could offer hope of transforming the world and making it a fit home for man, for man capable of achieving "a heightened consciousness."

Breton, as the "Pope of Surrealism," was instrumental in organizing the big International Surrealist Exhibition of January-February 1938, at the Galerie Beaux-Arts, Faubourg Saint-Honoré. He probably conceived of it, in his mind, as a counter-blast to the 1937 exhibition of Independent Art at the Petit Palais and to the views of Aragon, also as a challenge to the prevailing resignation and complacency.

The 1938 exhibition was the swan-song of pre-war Surrealism. It was organized by Breton and Eluard, with the resourceful assistance of Marcel Duchamp. In the courtyard, at the entrance, was Dali's *Rainy Taxi*, with piped-in water pouring over the blonde female dummy sitting in the back seat among heads of real lettuce and live crawling snails; offering a good drenching for anyone near it. Inside came a *Surrealist Street* lined with waxworks figures made and costumed by Duchamp, Man Ray, Ernst, Dali, Masson, Arp, Matta, Miró, Paalen and Seligmann. It led to the main room, laid out and "decorated" by Duchamp: from the ceiling hung 1,200 dusty coal sacks, the floor being covered with dead leaves and moss, around a (real) lily pond edged with ferns and reeds. Coffee roasters in the centre of the room gave off "Odours of Brazil"; in the corners, four double-beds, and above one of them hung Masson's *Death of Ophelia*. Erotic overtones were everywhere, in alluring hands and legs; in Kurt Seligmann's *Ultra Modern*, a chair standing on three sleekly clad female legs; in Oscar Dominguez' *Gramophone*, whose leg-filled horn ended in a hand turning on a silent record. Eluard made the opening speech. The catalogue included the "Concise Dictionary of Surrealism" mentioned above, compiled by Breton and Eluard, offering a roll-call of the group and a definition of aims.

Here, for the first time, the *setting* of the exhibition was more important than the works exhibited. Half-jungle, half-cave, the exhibition room looked very much like the working studio of one of those modern artists like Schwitters with a passion for collecting and assem-

Two photographs of the International Surrealist Exhibition, Galerie Beaux-Arts, Paris, January-February 1938: main room with (left) lily pond and double bed and (right) Marcel Duchamp's coal bags hanging from the ceiling.

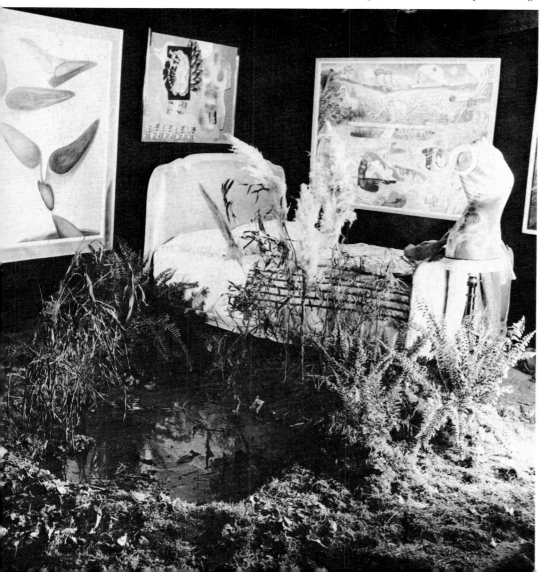

bling odds and ends. The show itself was conceived and presented like a monumental collective Surrealist object. It introduced into modern art the notion of *environment*; it gave already an inkling of the happenings and performances of the 1960s, and more than an inkling, for the dancer Hélène Vanel was called in to improvise "The Unconsummated Act" round the pond in the main room.

Since the 1920s the Surrealist movement had gained an impressive array of international recruits. One was Victor Brauner, a Rumanian, who arrived in Paris in 1930 at the age of twenty-seven. He had a studio next door to that of Yves Tanguy, who in 1933 brought him into the Surrealist circle. Brauner then painted a series of canvases divided into registers or panels where he made fanciful play with shapes suggested by the human body. His style remained uneven, as he was chiefly interested in the narrative possibilities of painting. Oscar Dominguez (1906-1957) joined the group in 1934. A native of the Canary Islands, he at once felt at home in the Surrealist circle and distinguished himself by the skill and subtlety of his inventions. He devised and introduced the technique of "decalcomania", a new form of automatism. Spreading liquid paint over a leaf (for example), he would take an imprint of it on a sheet of paper and thus obtain strange effects reminiscent of minerals or plant life. Breton and the writers of the movement were very much taken with these works. Dominguez also proved himself a resourceful contriver of Surrealist objects.

Wolfgang Paalen (1905-1959), a Viennese, joined the group in Paris in 1935. He devised the new automatic technique of smoke pictures known as fumage. Two Swiss artists also became prominent figures in the Surrealist movement, Meret Oppenheim (1913) and Kurt Seligmann (1901-1962); both were bold inventors of objects, Meret Oppenheim showing her *Fur-Covered Cup, Saucer and Spoon* at the 1938 exhibition. The Chilean-born artist Matta Echaurren (1912) came to Paris in 1934 and studied architecture for two years in Le Corbusier's atelier. Impressed by the 1938 exhibition, he turned to painting and joined the Surrealists. Matta was fascinated by space and created in oils some powerful metaphors of the creation of the world. His large landscapes, arising from his psychic world, he called *Inscapes*. Each of his paintings began as a release of automatic impulses and developed in a free play of spontaneous gestures and free-flowing pigments, often brushed on with a rag. His high-spirited performances relaunched the possibilities of improvised gestualism, and like Masson he had a profound influence on American painting when he took refuge in the United States during the Second World War.

In an article of 1939 on "The More Recent Tendencies of Surrealist Painting" Breton wrote: "In its latest manifestations in the work of men young enough to have no need to make any allowance in their art for their personal antecedents, Surrealist painting has shown a marked return to *automatism*... The collage, the frottage, and the initial products—the least specious and most valid ones—of the so-called paranoiac-critical activity had never ceased to maintain a certain ambivalence between the involuntary and the deliberate; they had given too much room to the reasoning mind. Things only began to be different when there appeared the 'decalcomania without object' of Dominguez and the 'fumage' of Paalen. Both of these artists, in their subsequent work and in the spirit of their latest departures, have remained entirely faithful to the promise of their precious discovery of an earlier day... One of our young friends, Matta Echaurren, is now the master of a brilliant output of pictures. With him, again, there is nothing led and guided, nothing but what springs from the determination to deepen the divining faculty by means of colour, that faculty with which he is gifted to an exceptional degree. Every one of the pictures painted by Matta in the past year is a festival in which all the odds are with him, a pearl gathering other pearls in a snowball effect embodying all rays of light both physical and mental."

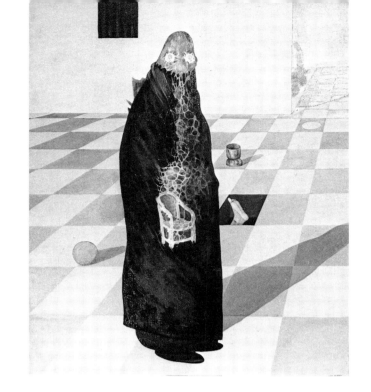

△ Victor Brauner (1903-1966):
Kabyline in Motion, 1933. Oil.

▷ Kurt Seligmann (1901-1962):
The Bird Charmer, etching illustrating Pierre Courthion's Les Vagabondages Héraldiques, *Paris, 1934.*

▽ Roberto Matta Echaurren (1912):
Inscape (Psychological Morphology No. 104), 1939. Oil.

Julius Bissier (1893-1965): Fruit, 1937. Indian ink.

The return of the "subject"

The United States had been opened up to contemporary art, thanks to the efforts of people like Katherine Dreier and Mrs John D. Rockefeller, thanks to the creation of the Museum of Modern Art in New York (1929), thanks to the Guggenheim, Chester Dale, Gallatin, Chrysler and Arensberg collections, to the Harriman, Rosenberg, Pierre Matisse, Levy, Knoedler and Curt Valentin galleries, and to the Carnegie Prizes. After the epoch-making exhibitions organized by Alfred H. Barr, Jr., at the Museum of Modern Art, New York (*Cubism and Abstract Art*, 1936, and *Fantastic Art, Dada, Surrealism*, 1936-1937), America was spiritually ready to welcome the refugee artists from Europe—Dali, Tanguy, Ernst, Matta, Masson, Léger, Mondrian, Ozenfant, Grosz and many others. (From the stimulus they provided was to spring the American "cultural revolution" of the post-war years, whose international stature and achievements struck Europeans with astonishment in the 1950s and '60s.) They found the American public far more open-minded than the public they had left behind in Europe. Significant is the anecdote about Peggy Guggenheim who, at the opening of her Art of This Century Gallery in New York in 1942, was seen wearing two different earrings, one made by Tanguy, one by Calder, in order (as she said) to show her impartiality between Surrealism and Abstract Art! It was this eager, welcoming curiosity about ideas and forms that made the impact of the European exiles so stimulating.

The state of mind of American artists at that time was summed up by Barnett Newman when he said: "In 1940 some of us woke up and discovered that we had nothing to hope for, that painting did not really exist... This awakening had the excitement of a revolution..."

The new trends of American painting were to be shaped by the abandonment of a focused picture space in favour of a flat, unbounded surface expression. Adolph Gottlieb was looking clearly ahead when he said in 1940: "We are believers in large-size forms, because they have the force of the unequivocal. We want to give its full scope to the flat plane surface. We are favorable to forms without depth

because they destroy illusion and reveal truth." The first signs of this new research appeared about 1937 in both Europe and the United States, initially in the form of a gestural brush-writing frequently influenced by the Far East.

The first American painter to impress the European Surrealists was Arshile Gorky (1904-1948), and they very soon considered him to be one of themselves; but at the same time Gorky was one of the first to achieve this abstract transformation of American painting. By the time the exiles arrived in the United States, Gorky's evolution had prepared him for this meeting. A self-taught master, he had long studied the moderns, from Cézanne to Picasso, in order to work out the possibilities of contemporary painting. By about 1936 he had developed a freer handling, close to that of Masson and Miró, which enabled him to give body and shape to an inventive gesture of his own, which went to create biomorphic forms. This breakthrough led him progressively to the expression of his private mythology, in a rich and ambiguous imagery stemming from his Armenian background. Of the younger generation of American avant-garde painters in the

Hans Hartung (1904): Painting T 1936-2, 1936. Oil.

thirties (men like Pollock, Gottlieb, Rothko, Motherwell, Kline, de Kooning), Gorky was the first to achieve the full mastery of self-expression.

Mark Tobey (1890-1976), a Middle Westerner transplanted to the north-west coast, came under the spell of Oriental mysticism in the 1920s. A man of independent mind, he achieved in his "white writing" style a highly personal type of graphism imbued with the meditative calligraphy of Japan (which he visited in 1934). Moving on the fringe of the American School, he developed his own brush-writing in the spirit of Zen, foreshadowing the attraction it was to have for subsequent generations. André Masson too had been fascinated by the pictorial possibilities of Oriental calligraphy. The proverb by Chuang-Tseu that Masson likes to quote might stand as a motto of the Surrealist movement: "The best traveller is the one who does not know where he is going, the best inquirer is the one who does not know what he is looking for."

Practically alone among Western painters, Tobey and Bissier practised something of this Oriental wisdom. Julius Bissier (1893-1965), a German artist from Freiburg-im-Breisgau, also achieved a personal style of sign-writing in the late 1930s. A friend of Willi Baumeister, he took to abstract art from 1929 on. His "psychograms" soon followed. "They appeared in his painting about 1930 and are like the calligraphic equivalent of a poetic sensation. They act as a simple, linear means of transcribing the artist's inner life, of concentrating it on the picture surface, attired in muted yet vivid colours and vagrant gleams of light" (Nello Ponente). Remaining in Germany under the Nazis, Bissier was obliged to live in seclusion, working purely for his own satisfaction. In his Diary (23 March 1943) he wrote: "In three brush-strokes, it should be possible to express everything that matters: the man who sets them down, his make-up and temperament, his period, and more generally his attitude towards life. If everything is not already contained in these three brushstrokes, it will be contained even less in the whole picture."

△ *Mark Tobey (1890-1976): Broadway, 1935. Tempera.*

◁ *Arshile Gorky (1904-1948): Night, Time, Enigma, and Nostalgia, 1934. Oil.*

201

Henri Matisse (1869-1954): The Dancer, 1937-1938. Gouache on paper cut-out.

Hans Hartung has long been an independent explorer of the byways of abstract art, in an expressionist vein of his own. Born in Leipzig in 1904, he early developed his gift for drawing and arrived very quickly at a spontaneous gestual expression. To his surprise, he discovered that it was also being practised by other artists when in 1925 he heard a lecture by Kandinsky. Leaving Germany in 1926, he travelled all over Europe and settled in Paris.

From 1933 on, Hartung reverted to the instinctive art of his boyhood and in 1937 he painted his first canvases in a style later to be called lyrical abstraction. Beginning in 1937 he enlarged the scale of his painting to monumental dimensions, but these works were little seen outside his studio. Also enlarging the size of his drawings, he set himself to convey the conflicting emotions of man grappling with his fate, man questioning the world around him and trying to overcome his dependence on it. For Hartung "to paint is to act on canvas," and by the power of the gesture and the force of the sign his works of the thirties echoed the harshness of the times. As a German exile in Paris and a determined opponent of the Nazis, he experienced that harshness at first hand in his private life. Both his paintings and his drawings are arresting in the intensity of the emotion they convey.

Wols, Michaux and others explored the individual pathways of lyrical abstraction and informal art. Their creed was aptly summed up as follows: "Art is what helps to break free of inertia. What matters is

not the recoil or the generative sense, but the tonic stimulus. In order to capture it, you have to make your way consciously or unconsciously towards a state of maximum élan, to a point of maximum density, of maximum being, of maximum actualization, and from there all the rest is seen to be only the fuel, only the vehicle" (Henri Michaux, *Emergences-Résurgences*, 1972).

By way of this freedom of gesture and brush-writing, the subject found its way back into painting, but only in veiled shapes as yet, and it was not until after the Second World War that the realm of subjectivity—and through it the theories of Freud—was to be recognized as an essential reality.

The necessity of art

In a book published shortly before the war, a remarkable English philosopher wrote: "The artist must prophesy not in the sense that he foretells things to come but in the sense that he tells his audience, at the risk of their displeasure, the secrets of their own hearts. His business as an artist is to speak out, to make a clean breast. But what he has to utter is not, as the individualistic theory of art would have us think, his own secrets. As spokesman of his community, the secrets he must utter are theirs. The reason why they need him is that no community altogether knows its own heart, and by failing in this knowledge a community deceives itself on the one subject concerning which ignorance means death. For the evils which come from that ignorance the poet as prophet suggests no remedy, because he has already given one. The remedy is the poem itself. Art is the community's medicine for the worst disease of mind, the corruption of consciousness" (R.G. Collingwood, *The Principles of Art*, Clarendon Press, Oxford, 1938). Only the conviction that they were applying this medicine gave artists the courage to go on working in the late 1930s, as war loomed up ever more clearly through a cloud of persecution, injustice and brutal obscurantism.

Matisse, like Kandinsky, was now too old a man to take any personal part in the struggle. The one weapon left to him was his art, and in this he showed himself more demanding and more creative than ever. For him the truth of art was the truth of life, and he tried to express this in the seclusion of his studio, to which he was bound by old age and illness. He was well aware of outside events, but as he wrote to Aragon in 1943: "An artist said to me: genius is the power of resisting worries. Not a bad definition, and I think it may apply to me."

To avoid repetition or any impression of stagnation, Matisse made a constant effort to reinvent the signs that entered into his work. "The importance of an artist is to be measured by the number of new signs he has introduced into the language of art," he said to Aragon in 1943. And again: "An object has to be studied a long time in order to find out its sign. Even then, in a composition the object may assume a new sign in keeping with the whole... Each work is an aggregate of signs invented during the execution, for that specific need. Removed from the composition for which they were created, these signs have no more effect. The sign is determined at the moment I employ it and for the object to which it belongs. This is why I cannot determine in advance any unchanging signs which would serve as a handwriting: to do so would paralyse my freedom of invention" (quoted in Gaston Diehl, *Matisse*, 1954). The creative struggle of his later years was focused on the new relations he glimpsed between line and colour. He worked out those relations in the long series of cut-

Henry Moore (1898):
Three Points, 1939-1940.
Cast iron.

and-pasted papers, painted in bright colours. The effect is one of enchanting simplicity and irrepressible *joie de vivre*.

As more and more artists were forced to leave continental Europe and go into exile, many of them stopped for a time in England before going on to the United States. Among them were Mondrian, Gabo, Breuer, Gropius and Mies van der Rohe. Their presence and example had a stimulating effect on the younger generation of English artists. In an important essay published in England in 1937, Gabo summed up the conquests and attitude of the moderns: "In the light of the Constructive idea the purely philosophical wondering about real and unreal is idle. Even more idle is the intention to divide the real into super-real and sub-real, into conscious reality and sub-conscious reali-

Barbara Hepworth (1903-1975): Sculpture in Colour, 1940. Plaster.

ty. The Constructive idea knows only one reality. Nothing is unreal in Art. Whatever is touched by Art becomes reality, and we do not need to undertake remote and distant navigations in the sub-conscious in order to reveal a world which lies in our immediate vicinity. We feel its pulse continually beating in our wrists... There is and there can be only one reality—existence. For the Constructive idea it is more important to know and to use the main fact that Art possesses in its own domain the means to influence the course of this existence enriching its content and stimulating its energy" (Naum Gabo, *The Constructive Idea in Art*, in *Circle, International Survey of Constructive Art*, Faber and Faber, London, 1937).

Gabo's influence made itself felt on the two foremost English sculptors of the day: Henry Moore (1898) and Barbara Hepworth (1903-1975). Both experimented with stringed figures in 1938 and 1939 (Gabo had begun using transparent string for his compositions in 1937). The use of string enabled them to impart a fresh significance to the cavities of their volumes; at the same time the taut string heightened the dynamic impression. This was the period in which Moore's forms became most abstract; like Giacometti a few years earlier, he felt that non-representational art was best suited to the expression of that psychological element whose intensity he was trying to emphasize. In his cast iron sculpture *Three Points* (1939-1940) he produced one of his most dramatic works: the tension he contrives to infuse into the top of this piece, where the three points meet, makes one think of the tension Picasso put into the converging jaws and tongue of the horse in *Guernica*. The sculptor, said Moore in 1937, "must strive continually to think of, and use, form in its full spatial completeness. He gets the solid shape, as it were, inside his head—he thinks of it, whatever its size, as if he were holding it completely enclosed in the hollow of his hand. He mentally visualizes a complex form *from all round itself...* And the sensitive observer of sculpture must also learn to feel shape simply as shape, not as description or reminiscence" (*Notes on Sculpture*, in *The Listener*, 1937).

Pablo Picasso (1881-1973): Pencil Study for Guernica, *1937.*

The images created by Picasso in the context of *Guernica* (1937) remain among the most powerful and most memorable that grief and indignation have ever inspired in a painter. These human figures, which in the presence of death seek escape and merge in a regressive metamorphosis with the lower forms of the vegetable or animal kingdom, also reappear in Miró, whose feelings were aroused by the same tragedy. He conveyed his sense of outrage at man's inhumanity to man in an expressionism of his own invention: the figures swell up in his canvases, their gestures overrun the picture space and proclaim their despair in the intensity of their reaction. Only the dignity of the gesture can answer to their bewilderment, to the degradation they deplore. In their art—the last domain in which they felt themselves still free—Picasso and Miró plead in favour of life, they express what is essential and enduring in the struggle of life against time.

The circumstances of the thirties brought Miró back to figure painting and even to portraiture. *Woman's Head* (1938) is one of his most moving protests against the human predicament of his time: the subject arises like a flaring shadow in a sky of eternity which earthly torments cannot impair.

Europe in 1939 entered the gates of darkness. With that, a distinct period of art came to an end. Divided between abstraction and representation, the artists of the avant-garde, whatever their convictions and allegiance, all contributed to a heightened awareness of life, to a finer sense of nature and art. Their practical aims and ideological quests were now overborne by politics and war. Their challenges failed to obtain a definitive response, but they stated issues of perennial interest. For the achievement of the international avant-garde lies in the questions it raised and the answers, however provisional, that it proposed. It can claim the signal merit of bringing art out of the museum and projecting it into life, for the sake of a fuller sense of living, for the sake of its social value and its liberating power. Because the avant-garde of 1914-1939 devoted itself unstintingly to exploring and following up new ways of expression, our culture today enjoys a richer heritage. Industrialization had destroyed the ethnic identities based on popular culture; the previous generation had shown the unsuspected expressive resources of art; it remained for the artists of this period to champion the existential values of twentieth-century man, who considered himself liberated by science but who had to learn anew how to hearken to the impulses of his inner being.

On the eve of the Second World War, the power and freedom of avant-garde art proved that "official" culture could no longer be confused with culture in the making, that there was a cleavage between what had been and what was becoming, that the new necessarily arose at the expense of the old, for the sake of a widening experience of life. To the question "What are we?", the avant-garde replied: "We are change and growth." The individual can only fulfil himself in his own "being," in the affirmation of his potentialities, in the consciousness of his responsibilities and freedom. The men of this period had the courage to try and overcome the artistic, social and moral divisions that separated them. They saw in creative activity the focal point of truth and liberty, the point where art and life converge. The record of that activity as described and pictured here has lost nothing of its topical interest, even though the freedom they prized is as much in danger today as it was then. This claim of the individual was again asserted, in the midst of the war, by André Breton in his "Prolegomena to a Third Surrealist Manifesto or Else" (1942):

Joan Miró (1893): Woman's Head, 1938. Oil.

More than ever in 1942, the very principle of opposition requires to be strengthened. Every idea that triumphs is heading for disaster. It is absolutely necessary to convince men that, once common assent is reached on a subject, individual resistance is the only key to the prison. But that resistance must be informed and subtle. I will instinctively dissent from the unanimous vote of any assembly which fails to dissent of its own accord from the vote of a larger assembly; but, by the same instinct, I will give my vote to those who rise up, with any new programme tending towards the greater emancipation of man and not yet having undergone the test of facts. Considering the historical process in which needless to say truth is only seen laughing up its sleeve and never grasped, I throw in my lot with that continually renewed minority which acts like a lever: my greatest ambition would be to leave its theoretical sense indefinitely transmissible after me.

André Breton, *Prolegomena to a Third Surrealist Manifesto or Else*, 1942

List of Illustrations

General Index

List of Illustrations

General Index

SKIRA

PUBLISHED SEPTEMBER 1980

PRINTED BY
IMPRIMERIES RÉUNIES S.A., LAUSANNE

BINDING BY
VEIHL S.A., GENEVA